Klaske Muizelaar is an independent scholar and furniture maker. She has lived and worked in Amsterdam for more than thirty years. Derek Phillips is emeritus professor of sociology at the University of Amsterdam. His books include *Wittgenstein and Scientific Knowledge*, *Toward a Just Social Order*, and *Looking Backward: A Critical Appraisal of Communitarian Thought*.

Picturing Men and Women
in the Dutch Golden Age

Paintings and People in Historical Perspective

Klaske Muizelaar and Derek Phillips

YALE UNIVERSITY PRESS
New Haven & London

Designed by Elizabeth McWilliams

Printed in China

Library of Congress Cataloging-in-Publication Data

Muizelaar, Klaske, 1947–
Picturing men and women in the Dutch Golden Age : paintings and people in
historical perspective / Klaske Muizelaar and Derek Phillips.
p. cm.
ISBN 0–300–09817–0
1. Painting in art. 2. Manners and customs in art. 3. Painting, Dutch – 17th
century. 4. Netherlands – Social life and customs – 17th century. I. Phillips,
Derek, 1934- II. Title.
ND1460.P35 M85 2003
759.9492'09'032—dc21
2002151141

A catalogue record for this book is available from The British Library

Endpapers Detail of fig. 23.

Frontispiece Detail of fig. 19.

Page vi Detail of fig. 39.

To one another

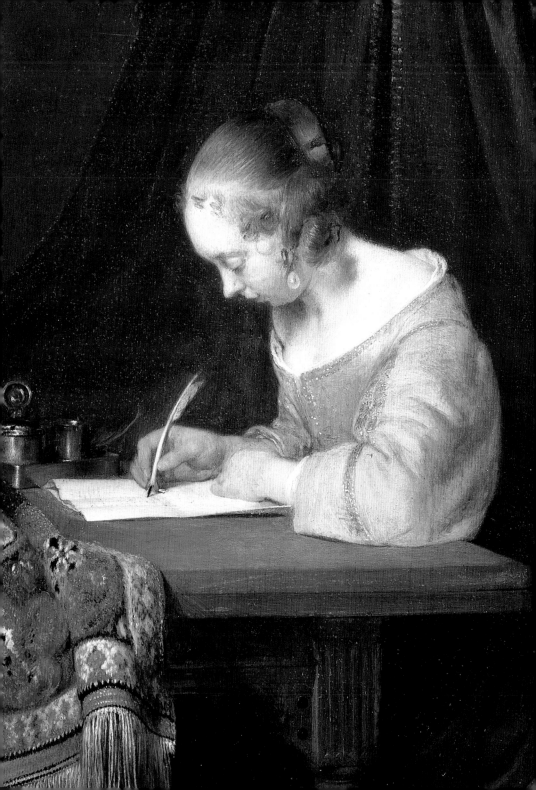

Contents

Acknowledgments

This book is the product of many years of thought and study, and we are pleased to acknowledge our indebtedness to several persons. Klaske Muizelaar gratefully acknowledges the influence of her former teacher, Hans Jaffé, who understood and encouraged her swift passage through the official curriculum of art history. His belief that real knowledge is more than the acquisition of mere facts was extremely welcome. She expresses heartfelt thanks to Phyllis Levenstein for her enthusiastic interest in the research providing the basis of this book. And she thanks Sebastiaan Dudok van Heel for initiating her into the use of the Amsterdam city archives and for suggesting a choice of appropriate inventories for study and analysis.

She is indebted to Jan van der Waals, Roelof van Gelder, and Eric Jan Sluijter for their comments on various materials that, it turns out, are left out of the present book. Henk Zantkuijl read portions of the manuscript concerning seventeenth-century Dutch houses, and patiently explained the architectural development and designs of those houses. His help is gratefully acknowledged.

Both authors wish to thank Marten Jan Bok and Maurice Punch for reading individual chapters, and Richard Quinney and John Michael Montias for their valuable comments on an earlier version of the manuscript. We learned much from each of them. Eliot Freidson and Helen Giambruni offered extensive and critical comments on two earlier versions. Although sometimes acerbic and certainly sobering, their criticisms were particularly beneficial, leading, in fact, to a rethinking and reorganization of the whole manuscript. We owe these two old friends special thanks.

Hans de Beer provided welcome assistance, advice, and criticism regarding our discussion of the height, weight, and appearance of men and women in the Dutch Golden Age. He provided detailed explanations about caloric needs, food consumption, energy expenditures, and other matters. We are grateful for his generosity.

As far as we know, Lawrence and Charlotte Becker have no particular interest in paintings or people in seventeenth-century Holland, and we have not consulted them about this book. Nevertheless, they have been a source of inspiration and influence on our scholarly work and our everyday lives. We wish to record our gratitude to both of them.

Thanks also to Leo Noordegraaf and the two anonymous readers for Yale University Press. All three read the manuscript with critical scrutiny, commented on it with care, and made useful suggestions for improvement. We are pleased to join the long list of Yale authors who offer profound thanks to Gillian Malpass for her good judgment and sage advice. And we wish to express our deep appreciation to her editorial assistant, Sandy Chapman, for her patience and good cheer in answering a multitude of questions, to Delia Gaze for her extraordinary copyediting, and to Elizabeth McWilliams for the handsome design of our book.

Although this book is aimed primarily at the non-specialist reader, we draw on a large number of detailed studies by historians, art historians, sociologists, economists, anthropologists, students of material culture, and other scholars. We acknowledge this range of sources by obeying the scholar's call to provide footnotes. If they are too burdensome, the reader should skip them and move on.

We owe much, then, to many people. But our greatest debt is to each other. During the years we worked on this study, it occupied a prominent position in our everyday lives. It seems as if we talked about it incessantly: sitting at the kitchen table, walking the streets of Amsterdam, and hiking along footpaths in the mountains. We shared new ideas, using some and abandoning others, writing (and rewriting) more versions of some chapters than we care to remember. In finding our way, we experienced ups and downs, breakthroughs and dead ends, good days and bad. We did so together, and thus the reader may understand why we dedicate our book to one another.

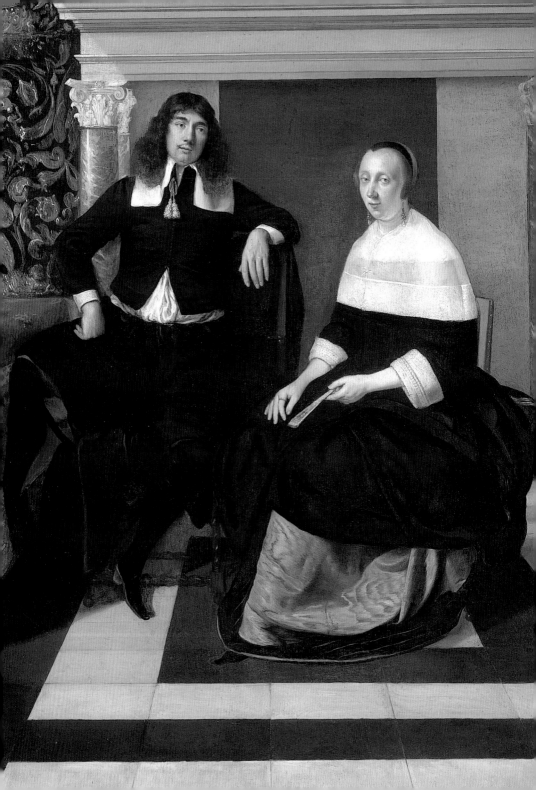

Introduction

Paintings by Rembrandt, Vermeer, Frans Hals, Pieter de Hooch, Jan Steen, and other Dutch "Old Masters" are among the greatest treasures of museums all over the world today. Millions of people view them as part of the permanent collections in some museums and as special exhibits in others. Smaller numbers enjoy the work of these and other seventeenth-century masters in private collections, churches, and public buildings in Europe, the United States, and elsewhere.[1]

The paintings that survive from the Dutch Golden Age represent perhaps 1 percent of the total number produced.[2] Numerous gaps exist in what is known about their history, and few are ever traced back to their original owner.[3] Attempts to identify their successive owners and the prices paid for them are usually unsuccessful. More often than not, the first documented evidence of their existence comes from the eighteenth or nineteenth century.[4]

Seventeenth-century paintings in museums arrived there through a circuitous route that involved not only individual owners, who acquired them through purchase, inheritance, gift, or otherwise, but also collectors, art dealers, galleries, auction houses, churches, and city, state, and national governments. Bought and sold for astronomical amounts, the paintings have acquired a status of almost priceless objects.

In museums, works by Dutch masters are valued as precious works of art: they are responded to in terms of their monetary value, age, rarity, school, period, historical influence, and the names of the artists attached to them. Labels provide titles and artists' names, and sometimes descriptions and even interpretations. Guided tours, video and audio presentations, lectures, and museum catalogs provide additional information.[5] The fame and fortune of individual artists, their place in the history of art, and the public's familiarity with their work and personal lives all influence the amount of attention that paintings receive. What usually counts most is that a painting is a Rembrandt, a Vermeer, a Steen, or a

Facing page Detail of fig. 51.

work by another master who today occupies a secure place in art history. Sensory pleasure is often less important than a painting's intellectual pedigree.[6]

Seventeenth-century paintings are collected, preserved, stored, and made accessible to potential audiences as works of art, systematically organized and arranged in terms of period, school, artist, or position in the hierarchy of artistic significance.[7] Their presence in an institutional setting intended to inspire respect and reverence deems them important and worthy of admiration.[8] In museums, seventeenth-century art is its own locus of value.

By picturing people and things, the paintings also shape viewers' understandings of life three centuries ago. As the Dutch historian Johan Huizinga observed more than half a century ago, "Were we to test the average Dutchman's knowledge of life in the Netherlands during the seventeenth century, we would probably find that it is largely confined to odd stray notions gained from paintings."[9] More recently, Jonathan Israel noted that, thanks to the unique richness of paintings from the time, "the reading and art-loving public" has an unusually vivid perception of Dutch seventeenth-century society.[10] Scholars, too, make heavy use of art works in their studies.[11] In fact, the paintings themselves stand pre-eminently as evidence for the special moment in Dutch history represented by the Golden Age.[12] But these seventeenth-century Dutch paintings are isolated from their earlier settings in physical and cultural space, and viewers are responding today to works produced and viewed under vastly different circumstances. Their significance for the museum visitor is thus not what it was for viewers three centuries ago.

Whatever the various routes that have brought paintings to museums, the private home was usually their intended destination at the time they were produced. Museums were not founded in the Dutch Republic until the late nineteenth century, and not many paintings hung in churches or public buildings.[13] Although ordinary people owned few paintings, the homes of the wealthy contained a large number.[14] It was not unusual for rich families to own twenty-five, fifty, or even more paintings.[15] Almost every painting now displayed as a work of art in the august surroundings of a museum once adorned the walls of a wealthy family's home.

Just as today, a private home was a territory with restricted access. Individuals were born, grew up, fell sick, were nursed, and died at home. People found shelter and protection, stored and cooked their food, ate

their meals, clothed themselves, slept, made love, entertained, and, in fact, spent most of their time at home. Many earned their living there as well.

The division of everyday space in a Dutch home reflected the relationships among household members, and its furnishings shaped and expressed their values, interests, and preferences. The use of specific spaces and of the furnishings and paintings close at hand had, then, a personal significance for the individuals concerned. Paintings that now hang in the clean, blank, sparsely-furnished space of the museum hung then amidst tables, chairs, cupboards, beds, mirrors, and other household goods. Only rarely was a room expressly allocated for the display and viewing of a family's art works, but even then it would contain other furnishings.

Moreover, some furnishings competed with the paintings for people's attention and enjoyment. Silver, porcelain, elaborately-decorated furniture, oriental carpets, and even some books were savored for their superiority of material, design, and beauty. People enjoyed feasting their eyes on these objects, the monetary value of which exceeded that of most paintings. In fact, few paintings with the status of treasures in museums today would have claimed pride of place among the possessions of Dutch families.

Before museums, paintings were experienced in the course of daily life. There were no labels to identify the subject matter, date, or place of execution. Most paintings had no artist's name linked to them, and were anonymous in their execution. When a painting was attributed, viewers would have generally known little about the artist's body of work, reputation, and position in the hierarchy of artistic importance. Such a hierarchy meant little in any case, since art history and aesthetics did not yet exist as academic disciplines.

Seventeenth-century paintings, then, were rarely valued as precious works of art in their original setting. Nor did they function as a realistic mirror of life at the time, since viewers had an everyday familiarity with the society in which they participated and would have recognized that the paintings were neither comprehensive nor accurate in what they depicted. Nevertheless, the paintings were treated with anything but indifference. They had, in fact, a deep and profound impact on the domestic and imaginative lives of men and women of the Dutch Golden Age.

This book takes as its premise the capacity of paintings to impress the mind and excite the emotions. The effects of visual imagery can be imme-

diate and profound. Visual images can evoke childhood memories, family sentiments, and shared experiences. They can inspire moods of religious reverence and stimulate sexual feelings. They can soothe, move, excite, irritate, and arouse. They can move people to laughter and even to tears.[16]

The aim here is to consider paintings through the lens of gender, "picturing" men and women as the producers, subjects, and viewers of art three centuries ago.[17] As far as the producers are concerned, nearly all were men, usually from a relatively privileged segment of society. For most, the production of paintings was more a business than a channel of personal expression and creativity. Like other goods and services, paintings were produced "in the hope of arousing interest and finding a buyer."[18]

Because artists were concerned mainly to sell their work and earn a living, they were highly selective in what they pictured and how they did so. The images that today shape museum visitors' understandings of the Dutch Golden Age are thus the images that privileged male artists thought would appeal to potential buyers. What they ignored, as will be seen, is as important as what they chose to include.[19]

In their paintings, artists pictured men and women in a variety of guises: among them, as figures of noble bearing and appearance, portrayed against a grandiose, classical background; as beautiful or handsome figures in episodes from the lives of the Virgin Mary, Christ, or the saints; as nude or scantily-clad gods and goddesses with attractive bodies; as elegant and fashionably-dressed people in rich interiors; and, representing the lower orders, as squat and coarse-featured creatures with stumpy hands and shapeless faces.

Of course, artists also turned out paintings in which men and women did not feature: depictions of the countryside, ships at sea, fruits and flowers, church interiors, public buildings, and other thematic representations. But images of human faces and figures have a particular fascination for viewers. They attract attention more readily than other subjects, and are especially likely to arouse the emotions.[20] Moreover, such images reflected and helped to shape people's understandings of themselves and others three centuries ago. The focus of this book is thus on portraits, history paintings, and genres or so-called depictions of everyday life.

A special concern is with picturing – in the sense of describing in words – men and women as the *viewers* of paintings. Husbands, wives, and domestic staff looked at paintings on their own and in the presence of others, during the day and in the evening hours, for only a few seconds

and for longer periods. Visitors sometimes had visual access to the paintings as well. Among them were friends, relatives, neighbors, business acquaintances, colleagues, doctors, tailors, seamstresses, chimney sweeps, men delivering wine, wood, and other goods, and various sorts of artisans. Children also saw the paintings.

The aim is to understand the visual appeal of particular images for male and female viewers, the functions they served, and the associations they kindled for members of the two sexes.[21] Most discussions of seventeenth-century Dutch art inconspicuously exclude women. The viewer, the audience, the public, and the like, is almost always assumed to be male. Discussions that do consider female viewers usually exclude men.[22] The gender-oriented inquiry here is concerned with both men and women.

Most of this book concerns paintings in the lives of men and women from wealthy families in the city of Amsterdam, the principal center of art production in the Dutch seventeenth century.[23] The rich and privileged cannot, however, be considered in isolation from the men, women, and children who made up the vast majority of the population in late seventeenth-century Amsterdam. For one thing, the significance of paintings of human faces and figures depended on who was depicted as well as on who viewed them. For another, an understanding of seventeenth-century Dutch society requires knowledge about the lives of different sorts of people in the period. This is necessary to correct certain prevalent misconceptions based on paintings from the time. For these reasons, ordinary people as well as the rich elite are pictured. We are interested in both paintings and people.

As elsewhere in pre-industrial Europe, Dutch society was viewed as a living organism with each of its component parts performing the functions necessary for the welfare of the whole. Underlying this view were certain assumptions about inherent differences in the physical and mental capacities of the few and the many; the emotional makeup of males and females; and the relative contributions of different segments of society to the general welfare, and the need to reward them accordingly.

The standing and dignity of one or another kind of work were linked to the characteristics of the particular groups that performed it. It was assumed that every man and woman ought to fulfil the function that he or she was allotted, for each worked for the sake of the common good.[24] This was, claimed the rich and privileged, the natural order of things. The riffraff, the masses, the multitude — as they were referred to by the

elite – were expected to recognize the wide gulf between their betters and themselves.[25] This view has been characterized as follows: "Let everyone accept that some are born to rule, others to serve. Let people accustom themselves to their lot in life."[26] From early on, children learned that people should be content with their vocation. Most boys and girls were taught to fear God and honor the city governors.

This ideology justified, of course, a fairly rigid hierarchy of ranks and positions among Amsterdam residents. Contact between people differentially located in this hierarchy was regulated by normative expectations concerning deference, demeanor, terms of address, and other acknowledgments of superiority and subordination. Perhaps more importantly, the ideology helped to legitimate differences in people's economic situation, degrees of dependency, and their housing and living conditions.

Central to the value system of the elite was a particular view about work: to have to labor, especially with one's hands, is to be servile and dependent. Mental activity, on the other hand, involving the exercise and development of the intellectual facilities, is basic to civilization, and contributes to the welfare of everyone. The privileged and powerful, then, looked down upon people engaged in manual labor, and had even greater contempt for those who received alms or charity.[27]

Such attitudes are reflected in a description of different "types of people" in Amsterdam in 1696, offered by the Amsterdam broker Joris Craffurd:

> The first are the men in government, those who are dependent on them and those who are moving up into government. The second are the numerous very distinguished, impressive, rich merchants. The third are traders or shop owners including many masters and other craftsmen. The fourth are the ranks by which we mean the lowest sort of people, however, we should exclude the numerous wagon drivers, grain porters, lightermen, peat and beer poorters all of whom receive alms which does not make them the most discreet and civilized people.[28]

As will be seen in Chapter 1, people engaged in ordinary labor (the ranks who are "the lowest sort of people") and those receiving alms together made up a sizable portion of Amsterdam's population.

In Amsterdam, as elsewhere, the relationship between men and women was hierarchical and asymmetrical.[29] What was considered right and proper with regard to people's individual conduct – as well as with institutional arrangements such as work and the family – was partly a conse-

quence of their gender.[30] It was firmly believed that men and women were by creation different sorts of beings. Both the Christian tradition and medical thinking supported this view.[31]

The Dutch Republic was a male-dominated society. Whatever their social level, men had more rights and privileges, more autonomy, and more control over their lives than women. A married woman had an inferior legal status compared to her husband. He could, for example, chastise her with impunity and even physically abuse her, so long as he did not draw blood.[32] Still, males and females had equal rights with inheritances and the first-born enjoyed no special privileges.[33] In this sense, Dutch women were better off than those in other countries.[34]

The family was the model for all superior–subordinate relationships, and most women were in positions of dependence on a man: their father, brother, or other male relative in the case of the unmarried, their husband if they were married. Men were expected to provide for the material and physical well-being of the women in their households. They considered themselves the protectors of the women's honor as well.

More than anything else, a woman's honor and respectability rested on her sexual behavior: virginity was expected of the unmarried, fidelity of the married.[35] What was really at stake, however, was the honor of the men to whom women were related. A man's honor did not rest on his sexual conduct in the same way. In fact, he would often express his masculinity by trying to seduce the women of others. The head of the household was thus keenly aware of the need to exercise vigilance in regard to "his" women. His own honor was defined by his success in doing so.

Men considered women weak, pious, and sexually innocent, and thus requiring protection against the advances of other men. At the same time, they saw women as having an insatiable sexual appetite that derived from their physiology. Both in social stereotypes and the law, women were regarded as the more lustful sex, lying in wait to devour vulnerable males. They were, after all, seen as daughters of Eve. A man trying to avoid being a slave to a woman's unbridled passions was a common theme in jokes, songs, books, the theater, and art works.[36] All were produced by men.

Left to her unbridled passion, a woman was thought capable of doing almost anything to satisfy her sexual hunger.[37] She thus also needed to be protected against her own sexuality. Given the supposed nature of females – as well as the desires and fantasies of many males – a man's concern with the honor of his sisters, his daughters, and his wife is under-

standable. Such a concern, and the double standard underlying it, had a long history.[38]

These assumptions and expectations about the few and the many, the rulers and the ruled, and men and women, are embodied in many paintings from the time. They affected, it will be argued, the appeal of certain themes for male and female viewers, the functions of the paintings in their lives, and the associations they evoked.

The physical appearance of the individuals depicted was also relevant to the role of paintings in the domestic and imaginative lives of men and women in the Dutch Golden Age. In portraits, history paintings, and genre scenes, the facial features and body types of men and women were idealized in varying degrees (but caricatured in low-life genre scenes). Given the concern with physical appearance that marks all societies and periods of history,[39] people no doubt compared themselves with these images and responded to them accordingly. Since women are evaluated more on their appearance than are men, and because of their generally disadvantaged position in society, they are more likely to be conscious of how they measure up to the idealized standards that such images project. An excessive concern with appearance is likelier still in societies – such as the Dutch Republic – where they are confined to the domestic sphere, and therefore reliant on the approval of men. Although men in such societies also compare themselves with the idealized standards of male attractiveness, their involvement in the world outside the family and their domination in the marital relationship mean that they are less likely to define their physical appearance in the image of others. It is to be expected, then, that female and male viewers in Amsterdam homes would have differed in their relationships with paintings of human faces and figures,[40] especially given the fact that the images were usually provided by male artists.

In the following chapters, men and women as the producers, subjects, and viewers of paintings are situated within the context of seventeenth-century Dutch society and Amsterdam in particular.[41] Toward that end, a detailed portrait of Amsterdam is given in Chapter 1. Among its components are the physical circumstances of life in the city; the composition and characteristics of its residents, including their backgrounds, religious affiliations, levels of schooling, types of knowledge, and sources of livelihood; and the quality, size, and internal division of Amsterdam

dwellings. As will be seen, the wealthy lived in different social, economic, political, cultural, and physical worlds than everyone else. Chapter 2 focuses on the material circumstances in which they carried out their daily existence, ate their meals, raised their children, and followed the various routines common to the private realm of familial, domestic, and sexual relations. This was, of course, the realm in which paintings were displayed and looked at. Described and discussed here are the social differentiation and use of space in large Amsterdam homes, their furniture and decorations, and the arrangement of paintings. Detailed attention is also given to the quantity and quality of light inside the houses.

Portrait paintings are the subject of Chapter 3. The discussion begins with portraiture itself, the basic formats of portraits, and the most common types at the time. It is argued that seventeenth-century portraits provide highly idealized interpretations of the faces and figures of the sitters. Portraits in the homes of several specific Amsterdam families are then considered, as are the rooms thought appropriate for the display of different types. Throughout the discussion, the appeal of portraits, their functions for the families who owned them, and the associations they may have kindled for those who viewed them are assessed.

Chapter 4 is devoted to history paintings: art works that portray identifiable human figures in religious scenes, mythological episodes, or allegorical events. In classifying the subject matter of paintings, art theorists placed these at the top of the hierarchy of genres. Most wealthy Amsterdam families owned paintings of themes that were or had been popular in Italy, and these themes are thus described before turning to the history paintings produced by Dutch artists. The significance of religious paintings for the families that owned them is then considered, as are the effects on viewers of those history paintings with a strong erotic undercurrent. Finally, the different responses of men and women to such paintings are discussed.

The analysis of gender-related viewing is continued in Chapter 5, which focuses on genres, or paintings that are often thought to be mirrors of everyday life. They are distinguished from portraits in that the figures are unidentifiable, and from history paintings in that their subjects are rarely based on known stories or mythological themes, although they too often have an obvious erotic content. The analysis makes it clear that genre paintings are anything but depictions of everyday life, and are especially misleading about people's physical appearance. Finally, the appeal of both high- and low-life genre paintings, their functions, and the ways

in which male and female viewers may have responded to them are examined.

In Chapter 6 an attempt is made to explain the enormous fascination of wealthy Dutch families with depictions of sensuous figures, eroticism, and allusions to sexual love. Toward that end, the interplay of certain cultural ideals and actual sexual practices is considered. The seventeenth-century Dutch, this analysis makes clear, were unusually forthright about sex, treating it in a frank, direct, and explicit manner. The erotic representations that adorned the walls were there to provide visual pleasure. In the discussion, further functions of the images are examined.

In Chapter 7 the most important conclusions about people's relationships with paintings in the domestic setting of seventeenth-century Amsterdam homes three centuries ago are reviewed, and these are compared with people's experiences in the contemporary art museum. This comparison reveals how radically the significance and functions of seventeenth-century Dutch art have changed over the centuries, and how much the viewing eye is influenced by time and context.[42] The visual sense has been, of course, the main organ of experience for people throughout history. But there is more to looking than meets the eye.

Chapter 1

Amsterdam in the Golden Age:
The People and their Homes

The Dutch Republic – what is now called the Netherlands – was the most highly urbanized and densely populated country in seventeenth-century Europe. Amsterdam was its largest city.[1] Approximately 200,000 people lived there at the end of the seventeenth century, and the population remained at that level throughout the eighteenth.[2] It was the richest city in the richest nation in the world, with a standard of living higher than elsewhere in Europe.[3] Yet the plight of ordinary people was hard: wages were low, the cost of living high.[4]

Native-Born and Foreigners

Like other pre-industrial cities in western Europe, Amsterdam had a high proportion of migrants. No one knows exactly how many people moved in and out of the city in the seventeenth century, but during the period 1601–80 at least one quarter of a million people came to live there.[5] Tens of thousands came from other countries in Europe. Most came from Germany, but there were also large numbers from the Southern Netherlands, France, Norway, Denmark, Sweden, England, Scotland, and Ireland, and smaller numbers from Portugal, Spain, Italy, Switzerland, Poland, and Russia.

The apparent discrepancy between a population of 200,000 and this large influx is explained by two facts: that throughout the seventeenth century there were more deaths than births in Amsterdam, and that many of the city's residents died while working elsewhere. Infant mortality was high, and bubonic plague and other epidemics of communicable disease were especially common in cities. Epidemics of the plague in Amsterdam in 1655, 1663, and 1664 took a large toll: in 1664 alone, it took the life of one in every eight Amsterdammers.[6] In the period 1602–75, more than

200,000 residents of the Dutch Republic went to Asia under the aegis of the Dutch East India Company (voc). Two-thirds died there. An even larger number left in the last quarter of the seventeenth century; again, only one-third came back.[7] Unknown numbers of men must also have died while serving in the Dutch West India Company, in the navy, and in the whaling and fishing industries. The city would have been unable to maintain its size without a large influx of people from elsewhere.[8]

The large influx of immigrants included Lutherans, Anabaptists, Mennonites, Arminians, Jews, and many dissenters, as well as Roman Catholics who, although officially outlawed, were tolerated so long as they did not practice their religion in public. Calvinists made up only a minority of the populace. Compared with other European countries, there was a high level of religious tolerance in Amsterdam. French Huguenots, Jews from Germany, Portugal, and Spain, and Protestants fleeing from the Southern Netherlands to escape religious persecution all settled there, as did refugees from wars or political oppression.

For every economically active person born in the Republic, there was another: a foreigner.[9] Foreign men of wealth and learning had an obvious advantage, and a few gained access to high positions in the city. Others must have hoped to serve apprenticeships or find work that would give them opportunities for advancement. But foreigners were often received with suspicion and distrust, especially when thought to threaten the economic opportunities of native-born Amsterdammers. The city's guilds discriminated against them or banned them altogether, and there were undoubtedly other forms of discrimination as well.[10] The great majority sought any employment they could find,[11] which usually meant low-paying jobs as laborers. A disproportionate number did work that was heavy, dirty, dangerous, and unhealthy.[12] Many men were vagrants and beggars.

Men and women coming to Amsterdam from so many varied countries obviously differed greatly in appearance, language, traditions, customs, values, and experiences, and even those who came from other parts of the Dutch Republic would often differ in dialect, dress, and other ways.[13] The sounds of different languages and dialects, along with the clamor of church bells, carts, carriages, various building activities, artisans' workshops, and the many markets (for meat, fish, butter, cheese, vegetables, and other goods), were part of daily Amsterdam life. Amsterdammers spoke Dutch – some with a local dialect – but many did so badly. The higher social classes often spoke French at home.

The Two Sexes

Immigrants were disproportionately young, single, and without children. Probably a third or more were women.[14] Large numbers of these women sought work as servants or domestics, and although most would marry, at least 20 percent of the female population did not,[15] and many immigrant women must have left Amsterdam to return to their native town or village.[16] There was a large surplus of women throughout the seventeenth century, with four women for every three men, which made the chances of marrying more difficult for them. Foreign-born women were especially disadvantaged. While Amsterdam-born men and women would usually marry one another, it was advantageous for foreign-born men to marry Amsterdam women, because they would thus automatically acquire citizenship (the sons and daughters of citizens were citizens themselves).[17] Citizenship was an enormously important prerequisite for membership of the guilds.[18]

Despite the strong social, religious, and legal prohibitions against intercourse prior to marriage, love between young persons, and the sexual yearnings connected with it, were widely acknowledged in Dutch society. There was considerable toleration of sexual activity among courting couples, short of intercourse. With *kweesten*, or night-courting,[19] young men spent the night unsupervised in the bedrooms of their sweethearts, with the understanding that they would avoid sexual intercourse, although many failed to do so.[20] If a woman became pregnant, the man responsible was expected to marry her, and the legal authorities might intervene to ensure that he did.[21] Few illegitimate children were born, perhaps one in a hundred at most, even though as many as one of five brides was pregnant at the time of marriage.[22]

Most women did not marry until they were 23–25 years of age, to husbands who were two or three years older. In order to marry, women aged under 20 and men under 25 needed the consent of their parents – or guardians or grandparents if the parents were dead. This was usually no more than a formality, since there had to be an extremely good reason for parents to refuse, and refusal could lead to a court case.[23] Families were small, typically consisting of a husband and wife and two or three surviving children. Mortality for infants and young children was high. Life expectancy for women was around fifty years, and many would spend much of it alternating pregnancies and births with periods of mourning. Others would die in childbirth. Death was a familiar occurrence, and

second and third marriages were not unusual (divorce was extremely rare).[24] In fact, in as many as a third of Dutch couples, one or both partners had been married before. Wealthy widowers remarried more often than widows,[25] frequently to a woman several years younger than their first wife. A surviving spouse ordinarily had to wait four to six months before remarrying,[26] although widows under the age of 50 had to wait for nine months, in case they were pregnant by their deceased husband.[27]

Widows were in a disadvantaged position. Most had been financially dependent on their husbands, and on their own were unable to earn enough to sustain themselves. Financial security was often their main concern in seeking a new husband, especially if they had children, but the more children they had, the less likely they were to find a man willing to take on the burden of a new family.[28] Many widows were thus condemned to receiving municipal poor relief. The spouses of those who did remarry often had a similar occupation to that of the deceased husband.[29] Widows who could survive financially had more freedom and autonomy than either married or unmarried women, since they were accountable neither to spouse nor parents.[30]

Only a small minority of married women – the wives of city governors, wealthy merchants, investors, and other men with high incomes – were relatively free of the burden of domestic chores. They ran large houses and supervised the work of domestic staff. Most married women in seventeenth-century Amsterdam had primary (and usually sole) responsibility for the functioning and daily care of the household: shopping, cooking, cleaning, washing, ironing, raising and supervising infants and small children, nursing the sick, and other tasks. Relatively few households had domestic help. Although servants figure prominently in seventeenth-century Dutch paintings, only 10–20 percent of all Dutch families had a servant in their home.[31] No exact figures are available for Amsterdam, but the percentage was probably about the same. More women were servants than employers.

Married women also had to be ready to assist their husbands, many of whom worked in their dwellings. Although they and any other females in the household – including unmarried daughters and sisters – often performed tasks associated with the head of the household's occupation, these were nevertheless designated as "men's work" and the women were usually seen simply as "helping out."[32] The wives of small shopkeepers and artisans sometimes handled business and money affairs, and those of sea-going men managed everything in their husband's absence. Wives

of men of higher economic standing took over various administrative responsibilities when their husbands were abroad. Widows frequently assumed the running of a business after a spouse's death.[33]

Unmarried women have received scant attention in descriptions of life in the Dutch Golden Age, although feminist scholars have begun to remedy this shortcoming. Given the surplus of females over males, a large number of unmarried women had to find some way to support themselves. Most worked as servants, when they would receive room and board as well as their wages. Of the wage-earning population of Amsterdam, servants were far and away the largest category, and most were women.[34] (Foreign-born women, many from Germany, constituted a significant part of this total.) Servants not only performed the hardest and dirtiest work in the household, but were vulnerable to sexual abuse by men in the house: fathers, sons, brothers, and family friends.[35] Many moved from employer to employer, often continuing to do domestic work throughout their working lives.[36]

Seamstresses were probably the second largest category of employed women.[37] Other women worked as washerwomen, fishmongers, in shops, and elsewhere, while some were midwives. It was mainly menial work that was open to women, and the wages were lower than those paid to men doing similar kinds of work.[38] There were undoubtedly some married women among the seamstresses, and perhaps even a few among those doing domestic work. Many women worked as prostitutes, with an estimated 1,000 in the city at any given time. They were mostly born outside Amsterdam, mainly in the provinces. This was a young woman's profession: most were between 19 and 25 years of age.[39]

Education

From the beginning, males and females were prepared differently for their positions in the gendered division of labor. This can be seen clearly with schooling.[40] Children were not required to attend school, and formal education was considered less necessary for girls than for boys. Elementary schools, for children between the ages of five and ten, taught reading, writing, and religious education. Girls also learned to sew and perform other "feminine" tasks. Classes met for three hours on weekday mornings and afternoons, as well as Saturday mornings. All learning was by rote, and children proceeded at their own pace. A child needed between one and three years to learn to read, and a further three years to learn to

write.[41] With reading, the primary emphasis was on memorizing the essentials of religious faith: the Lord's Prayer, the Ten Commandments, and a basic catechism. Learning to write was considered less essential.

The educational system was expected to preserve the hierarchical distinctions in Dutch society, and it was considered unnecessary for most children to have any further schooling. The children of wealthy families were an exception. Boys and girls from the age of six to ten attended the expensive and elite "French" secondary schools, where they were taught history and geography, to speak and write fluent French, and to conduct themselves as young ladies and gentlemen. The boys also learned mathematics and bookkeeping, while the girls had courses in music, dance, and needlework.

Boys from wealthy families were then usually enrolled in the Latin school,[42] which not only prepared them for university study but also readied them for their responsibilities as part of Europe's social and cultural elite.[43] At the core of the curriculum was instruction in Latin grammar, literature, and rhetoric. Ancient history, logic, ethics, geography, physics, and the history of religion were also taught.[44] Emphasis was laid on the classical tradition, especially Roman authors such as Cicero, Virgil, Horace, and Ovid; Greek writings were secondary. Both the Latin school and the universities were closed to girls, so that most women lacked knowledge of classical languages, history, and culture.[45] While wealthy young men were attending the university, their sisters were often spending time in Paris, learning about French culture first-hand.

Despite the fact that most Amsterdam children spent only a few years of formal education in the elementary school, 75 percent of Amsterdam-born bridegrooms and 53 percent of brides were able to sign their names in 1700. The figures for people born elsewhere were little different, except for women born abroad, only 30 percent of whom could sign their names.[46] A higher percentage would have been able to read. The Dutch Republic had the highest level of literacy in Europe, measured by the ability to sign one's name on a marriage certificate or other legal document.[47]

But the ability to sign one's name and identify set forms of words, pertaining mainly to religious matters, were only the most basic elements of literacy. It indicated nothing about the ability, say, to write a letter or read a book. More broadly considered, literacy involves access to the world of knowledge, ideas, information, and – at that time – the cultural products of Dutch and European society.

Work and the Occupational Structure

As far as earning a living was concerned, this type of literacy was irrelevant for most people. In Amsterdam, the bulk of jobs required little or no training and no special skills.[48] Most men worked in unskilled and menial occupations, as day-laborers, dock hands, sailors, and seamen. These were physically demanding and disagreeable jobs, involving bad working conditions, low pay, and uncertain employment. They attracted a surplus of the poor and desperate. Often referred to as the "rabble," these men experienced a lifetime of dependence on the better situated.

Other men, but certainly a minority of the working population, were able to exercise some independence. Although working with their hands, they had training, schooling, skills, or a qualification that enabled them to exercise a degree of autonomy in earning their livelihoods. Some were skilled artisans: bricklayers, carpenters, stone masons, glaziers, plasterers, plumbers, shoemakers, tailors, bakers, brewers, butchers, and tavern keepers.

Men with a skilled trade usually belonged to one of Amsterdam's forty or so guilds, the earliest of which dated from the fourteenth century. The guilds functioned to regulate the length of the workday and other work conditions, to limit competition and control the local market, to ensure quality in their members' work, and to provide sick care, pensions, and other financial benefits for members and their widows. In 1688, Amsterdam's guilds had roughly 13,000 members,[49] who constituted between 25 and 30 percent of all adult males in the city. Most guilds had no women members, although a few belonged to such guilds as that for second-hand dealers.[50]

Guilds were crucial to the control of employment and wages in Amsterdam, but membership was restricted to Amsterdam citizens. After 1650, those lacking the status of *poorter* (citizen) could acquire it at a cost of 50 guilders. Since the average yearly income was around 350 guilders, this sum was the equivalent of two or three months wages, an amount that most people were unable to pay. But even citizenship was no guarantee of guild membership. Jews could become citizens, but they were excluded from guild membership as well as from much of retailing and manufacturing (these restrictions were approved by the city government). They were employed in the tobacco, sugar, chocolate, silk, diamond, and publishing industries, which were not organized as guilds,[51] and many others worked as small-scale merchants.

Guild members often prepared their sons for the trade, but other families had to pay for a child's training. A formal apprenticeship contract would be signed with a master, who was responsible for providing room and board, clothing and other essentials, as well as the boy's education in the craft. The training normally lasted several years, at the end of which the apprentice was required to demonstrate the mastery of his craft and pay an entrance fee to become a guild member himself. The sons of guild masters often paid a lower entrance fee, and would acquire work more easily.[52]

Different guilds trained children from different socioeconomic levels. Guilds for masons, carpenters, and other construction trades were less exclusive than those for surgeons or painters. Among the largest, with several hundred members, were guilds for tailors, bakers, shoemakers, and the trades connected with ships and ship-building. The surgeon's guild, apparently the most expensive one to enter, with an entry fee of 250 guilders at a somewhat later period, attracted young men from comparatively well-off Amsterdam families.[53] Towards the end of the seventeenth century, Amsterdam had 241 surgeons.[54] Painters also came from a relatively privileged segment of society, and belonged to the guild of Sint Lucas.[55] Their training, averaging between four and six years, was longer than that for most other guilds and therefore more expensive.[56] The total cost was around 600–700 guilders, about two years income for an average family.[57] Although women could become members, few families were able or willing to pay such a high amount for the training of a daughter.

There were no art academies in the Dutch Republic, and no self-taught painters. A young man learned the trade by studying with a master painter, often with other students. Atelier culture was characterized by strict discipline and systematic training, which included the study of perspective, the principles of composition, and the handling of color and light. The most important part of the training involved the study of the human body, its anatomy and proportions. An aspirant painter would learn to draw first heads, then different parts of the body, and, finally, entire figures. He would move on to copy faces and figures made of plaster and clay, and then, eventually, to draw from live models, both nude and dressed.[58] Students would study prints, drawings, and copies of paintings to familiarize themselves with the works of famous masters, both living and dead. Amsterdam was a particularly favorable location for these exercises.

The few women who became artists were usually the daughters, sisters, or wives of male artists,[59] who could be trained in the atelier within the family circle. The names of more than seventy active women painters in seventeenth-century Holland have been recovered, although works do not survive for all of them.[60] They mainly turned out still lifes and portraits, since it was considered inappropriate for women to wander about with their sketch-pads and paint the kinds of "low" subjects (e.g., unruly peasants and prostitutes) depicted in many genre paintings, or to paint historical subjects that showed nude men and women.[61] In any case, they did not have access to nude models and were unable to travel abroad to see well-known art works or study with famous painters.

Most of the seventeenth-century records of the Sint Lucas guild in Amsterdam have been lost, and less is known about the situation there than in other cities, but surviving evidence from 1688 indicates that there were 350 to 400 members.[62] In every other city, the guild included *kladschilders* − sign and house painters and the like − decorators, and engravers, as well as those who might be termed artist-painters. Roughly half of the guild members in Delft were artist-painters, and the same was probably true for Amsterdam.[63] If so, this would place the number at about 175–200 towards the end of the century.[64]

Intermediate between skilled craftsmen and the wealthy were various medium-level city employees, lawyers, real estate brokers, pharmacists, notaries, ministers, schoolteachers, and other professionals. Merchants were found at every level of Amsterdam society, for the description "merchant" (*koopman*) was a vague one, then "applicable to hundreds, perhaps thousands of Amsterdammers."[65] They included smaller traders and shopkeepers, as well as those involved in overseas commerce.

Above these men was a small number of rentiers (people who lived from their investments), industrialists, traders, the more prosperous merchants, and high-placed members of the city government. As elsewhere in the Dutch Republic, Amsterdam was governed by the *magistraat* or magistracy. This body of men consisted of four *burgemeesters* or burgomasters (or mayors), a *schout* or sheriff, and nine *schepenen* or judges. They were responsible for managing the governmental and economic affairs of the city, although all matters of importance were supposed to be discussed with a second body, the *Vroedschap* or council (made up of thirty-six men with life tenure). Women were excluded from such political functions.

In Amsterdam, the form of government was oligarchic, and ordinary people were excluded from active political participation: their role was to

obey.[66] The burgomasters were the most important members of the city government, with responsibility for the day-to-day running of the city. Each held the position for a term of two years and then was ineligible for a period of one year, after that being eligible for another term. In the intervals, they occupied other high positions in the city government. Many served over and over again during the seventeenth century, and, along with the ex-burgomasters, controlled the patronage of numerous positions. These men were not elected but appointed, essentially by one another. The burgomasters had enormous power. In 1679 the English ambassador, Sir Henry Sidney, wrote the following about Burgomaster Valckenier:

> I assure you, the Great Turk hath no more absolute dominion and power over any of his countrymen than he hath in Amsterdam. What he saith is ever done without contradiction; he turns out and puts in who he likes; raises what money he pleases, does whatever he has in mind to . . .[67]

The most lucrative position in the city government was that of *schout*, mainly because the man occupying it received a percentage of the fines imposed on people for misconduct.[68] For example, Amsterdam men accused of crimes – or caught *in flagrante* in adultery cases – were often allowed to discharge liability of conviction through payment of a penalty, and this could be 1,000 guilders or more.[69] The *schout*'s main concern, however, was public safety. Pick-pockets, groups of thieves, burglars, and street-robbers were all a threat to the person and property of Amsterdam residents. The city's gates were locked every night, and barriers in the canals prevented strangers from entering the city by water.[70] After 1670, neighborhood watches and street lanterns were provided, but it was still not unusual for men to go about the city armed, and wealthy families often had firearms in their homes.[71]

Holding high office in city government defined men as regents or *regenten*.[72] In both theory and law, their power verged on the absolute.[73] The Amsterdam regents saw it, in fact, as "God's will" that they should rule. Their wealth, they believed, was a sign of his intentions. Moreover, freedom from the necessity of earning a living enabled them to devote themselves to public affairs, and was a safeguard against the misuse of public office for personal gain.[74] Only men free from material want, from manual labor, and dependency on others could, they argued, devote themselves to ensuring the common good of all the city's residents.

Even so, it was widely recognized that high government office was a sure path to riches. Men filling such positions used them to benefit themselves, their families, and their friends.[75] For example, Amsterdam regents involved in making decisions about the expansion of the city's canals used that information to enrich themselves by speculating in land. Some regents had made their money through investments, trade, manufacture, or in some other kind of business. Others had inherited a fortune or married into a rich family. Much of their wealth was the result of their earnings on loans to the government. By the end of the seventeenth century, many of the political elite had moved away from involvement in business and were full-time politicians.[76]

The economic activities of the city were controlled by a relatively small number of wealthy families. In addition to the regents, they included those merchants and investors who earned the highest incomes in Amsterdam.[77] Keenly aware of the great importance of trade for the Amsterdam economy, the regents were sensitive to the needs of merchants, traders, and industrialists, some of whom must have gained informal access to them at social gatherings and through ties of marriage and kinship.[78] In no other country in Europe did regents and merchants acquire such political and economic power as they did in the Dutch Republic, far exceeding that of the nobility. The nobility, which consisted of some two or three hundred families living mostly in and around The Hague, counted for little in Amsterdam.[79]

These wealthy Amsterdam families realized a degree of independence unknown to other people in the city. The children attended the city's French and Latin schools. Many sons went on to one of the five universities in the Dutch Republic, often studying law in preparation for public life.[80] Graduation was often followed by the "Grand Tour," a leisurely cultural trip through France and Italy. This not only acquainted young men with the customs and manners of others, it was also an opportunity for them to indulge their sexual appetites before settling down to marriage.[81] Wealthy gentlemen, their wives, and children had sufficient leisure to pursue various pleasures, the money to do so, and the expectation of deference and respect from ordinary people. Some rich families, however, fell upon hard times. Sons experienced economic problems or even bankruptcy; daughters made bad marriages. But the rich – whether regents, merchants, or men who made their money in some other way – usually recovered from financial setbacks and were again able to resume their way of life. They did what they could to take care of their own.

The Distribution of Incomes

The social distance between the small group of wealthy families and most ordinary Amsterdammers was enormous. After all, the seventeenth-century Dutch Republic was a class society, and the economic structure was all-important: status and power followed wealth and income, in Amsterdam as elsewhere.[82] Social distinctions were maintained everywhere – even in the "House of the Lord." Most ordinary people stood during church services, while seats and pews were assigned on the basis of a family's social position, and wealthy families had their own. Separate pews were reserved for burgomasters, ex-burgomasters, and other high city officials, who sat on soft velvet cushions bearing their names and coats of arms.

Most people, however, must have been more concerned with keeping poverty from the door than preserving social distinctions. Many households had difficulty in making ends meet, and poverty was often just around the corner. Although there was considerable variation, the average size of a household was about four people. Most consisted of husband, wife, and children. But 40 percent were made up of a widow or widower, an unmarried man, or a woman alone or with her children.[83] It was rare to find an extended family with parents, aunts and uncles, or other relatives, living under the same roof.

The majority of men in seventeenth-century Amsterdam labored for an average of 260–70 days per year, although the exact amount is uncertain.[84] They toiled between eleven and thirteen hours per day in the summer months, starting work at 5:00 a.m. and going on until 7:00 in the evening. There was apparently more flexibility in the times of work in the dark winter months, when seven to eight hours were worked per day.

Most people earned low wages. Ordinary laborers earned about 22 stuivers per day (20 stuivers = 1 guilder), which amounted to around 300 guilders per year.[85] Wages for identical unskilled work done by women and children were much less, half that earned by men.[86] Craftsmen earned higher wages. In the last quarter of the seventeenth century, a master craftsman earned a daily wage of about 28 stuivers, or 370 guilders a year, although this differed according to the guild.[87] A journeyman earned about 10 percent less, about 330 guilders per year. Little is otherwise known about the incomes and earnings associated with most kinds of work around 1700 or the bases on which they were established. But evidence from remaining tax records for a slightly later period is highly

Table 1 Distribution of Incomes in Amsterdam around 1700

Income Class	Percentage of Total
Less than 300 guilders	15
300–349 guilders	30
350–399 guilders	15
400–499 guilders	10
500–599 guilders	8
600–999 guilders	10
1,000–1,999 guilders	7
2,000–3,999 guilders	3
4,000 guilders and above	2
Total	**100**

Sources indicated below (see also nn. 88 and 90).

informative as to the comparative earnings of people in different occupations.

The *Personele Quotisatie* of 1742 was a special city assessment in which all Amsterdam households – including people living alone – were assessed a tax payment on the basis of what they earned.[88] The pattern of earning fifty or so years earlier would not have differed substantially. Comparing inequality in Amsterdam over four centuries, one scholar found that this rose until 1700 and then remained the same for almost a half century.[89]

Households with a yearly income of 600 guilders or more were assessed a tax; those below were not. The records indicate that 77 percent paid no taxes, that is, they earned less than 600 guilders per year. A detailed analysis of these and other tax records from the time provides an estimate of the proportion of households in different income categories among those earning less than 600 guilders per year.[90] Table 1, which shows what the distribution of incomes in Amsterdam probably looked like in the period around 1700, combines these figures with what is known about households earning more than 600 guilders.

Fifteen percent of Amsterdam households had a yearly income below 300 guilders.[91] Since it has been estimated that a family of husband, wife, and two children needed about 300 guilders a year to survive, many in this poorest segment of the population lived below the poverty line. They struggled just to make ends meet. Such households sometimes spent one-

half of a year's income on bread, leaving little for other necessities.[92] In many, even six- or seven-year-old children were expected to work. If the help of family members was insufficient, people turned first to friends and neighbors, before seeking the help of the church to which they belonged, or the city of Amsterdam.[93] About 13 percent of Amsterdam families received "poor relief." Old people without any income, widows with young children, individuals too sick to work, older dependent persons, tramps, and beggars were even worse off.[94] No one starved, and charity was available for the desperately needy,[95] but many Amsterdammers lived in what has been described as stable poverty.[96]

Throughout the seventeenth and much of the eighteenth century, 10–15 percent of city residents lived at the poverty level. The percentage must have been higher during the "hunger years," which occurred thirty-eight times in the period 1595–1715, when between 50 and 75 percent of Amsterdammers were dependent on some sort of food distribution.[97] Perhaps as many as 5 percent were permanently poor and many more experienced periods of poverty. In fact, as much as one-quarter of the population required regular charitable assistance at one time or another during their lives.[98] Just above this poorest segment of the population, another 30 percent of households earned between 300 and 350 guilders a year. These included soldiers, sailors, ships' carpenters, and a large number of ordinary laborers. In total, then, more than two-fifths of Amsterdam households lived either below or just above the poverty line.

Another large segment, one-third of all households, earned between 350 and 600 guilders per year. At the bottom end of the scale it included many new apprentices, journeymen, small merchants, and people who performed various lower functions for the city, including a few women. Closer to the 600-guilder level were some master artisans, and people with schooling, such as office personnel and schoolteachers. An artisan's earnings were largely a function of the particular guild to which he belonged. In at least twelve guilds, most members earned less than 600 guilders per annum.[99] Among these were cobblers, weavers, peddlers, navigators, basket makers, and fruit sellers. Only about one-fifth of the tailors, the largest artisan group in Amsterdam, had an income of 600 guilders or more.[100] Most shoemakers and blacksmiths also made less than 600. The 10 percent of households who earned between 600 and 1,000 guilders per year included men from the guilds with higher earnings: goldsmiths and silversmiths, tinsmiths, wine merchants, bookstore owners, and surgeons. A minority of members from other guilds were

also in this category: grocers, tobacconists, tavern keepers, hatters, carpenters, bricklayers, and bakers. This category included many merchants as well.

As can be seen from table 1, around 12 percent of Amsterdam households had a yearly income above 1,000 guilders. These included physicians, notaries, lawyers, some jewelers, manufacturers, high military officers, a few tavern keepers, clerks and bookkeepers who worked for the city, rentiers, some wine merchants, and a wide variety of other successful merchants. A small proportion of households – about 2 percent of the total – had yearly incomes of 4,000 guilders or more. Roughly half were either merchants or rentiers (like merchants, rentiers could be found in every income category). Highly-placed members of the city government, though far fewer in number, had the highest earnings of any group in Amsterdam. The average income for high government functionaries in sixteen Dutch cities in 1742 was more than 7,000 guilders,[101] and in Amsterdam it was even higher. The tax records do not distinguish between current and former members of the city government in listing incomes, but four members of the town council (*raad*) had a yearly income of more than 16,000 guilders, as did eleven men who were or had been burgomasters, and thirteen town magistrates.[102]

Amsterdam Dwellings

The quality, location, size, appearance, internal division, and comfort of Amsterdam dwellings depended on the economic standing of the families who inhabited them. Then, as now, an individual's home was at the heart of his or her everyday life. Yet many of the poor had no more permanent shelter than the homeless of today, and wandered through the city, sleeping in alleys, passages, and the entrances of buildings.

Just above the poorest segment were people huddled together in one or two rooms, with a fireplace for cooking and heat. Large families were crowded into primitive backhouses, tiny rooms, and damp basements, located in back alleys and off hallways shared with other families.[103] Constructed on small lots, in narrow streets, or along narrow canals, these dwellings were often in areas that were uniformly poor. Probably more than two of every five households lived in such circumstances.[104]

The size of a family's dwelling dictated the patterns and quality of its members' everyday lives: among other things, their eating and sleeping arrangements, the amount of privacy, the level of hygiene, and their

general well-being. Amsterdam families rented as many rooms as they could afford. A single room had to suffice for some, with everyone sleeping on straw or mattresses on the floor. In such circumstances, children had an early introduction to copulation.

An open fire was the only source of warmth, with peat the usual fuel in most dwellings.[105] An enormous amount of peat was consumed in an effort to keep warm: an estimated 1.6 tons annually for each city resident during the seventeenth century.[106] Even so, people wore several layers of clothing most of the time. The open fire was also often the only source of light on dark days, because candles were expensive.[107] But it produced foul-smelling smoke and soot, and fire was a constant danger. Such dwellings were poorly ventilated and reeked of cooking odors. There was no running water, and the privies or *secreten* were outside, located either against the exterior walls of the building or placed away from it in the backyard. They were shared by several families.[108]

Although water was needed for preparing food, cleaning, washing, and bathing, little was used. Rainwater or clean well-water was difficult to obtain, because it had to be fetched, often from some distance. Ordinary people usually drank milk or beer instead, the latter being the most common beverage among Amsterdam adults. People rarely bathed, and the unexposed parts of their bodies were seldom washed. Household almanacs recommended that a yearly bath should be taken in spring in order to destroy the insects that laid their eggs in people's hair and clothes.[109] Head lice were picked out rather than washed away. The cramming of large numbers of unwashed men, women, and children into damp, poorly ventilated, and unsanitary rooms created the conditions in which the plague bacterium grew and spread. It was transmitted to people from fleas from infected rats that were carried by ships from port to port. As a result, thousands of Amsterdammers died in plague epidemics.

Many artisans and shopkeepers had larger dwellings. In addition to the one or two rooms in which the family cooked, ate, slept, and spent their leisure time, about 40 percent of homes had a *voorhuis* or front room used for earning a living: as a shop, an artisan's workshop, or other work-related activity.[110] Some buildings had a *secreet* inside, used by everyone living there. Located in a sort of wooden cupboard with a door, it consisted of a wooden bench with a round hole in the middle over a wooden (later brick) cesspool.

There remain few depictions of the streets in seventeenth-century Amsterdam where artisans and shopkeepers lived, and portrayals of their

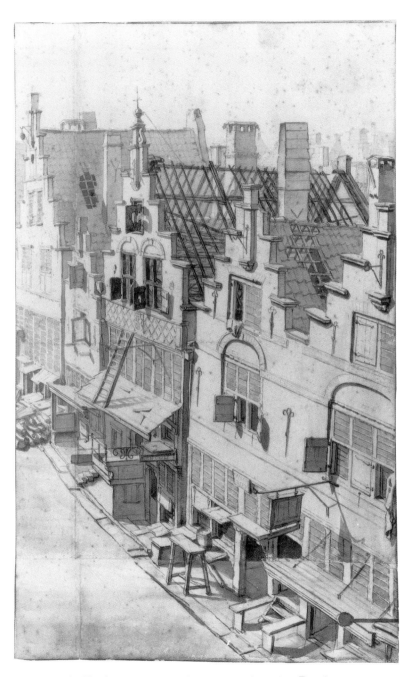

1 Jan van der Heyden. *Houses in the Gravenstraat, Amsterdam.* Drawing, 37 × 22.9 cm.
Amsterdam, Gemeentearchief.

dwellings are also rare. Figure 1, a drawing made towards the end of the century, is one of them. The artist, Jan van der Heyden (1637–1712), was also chief of the fire brigade. His main concern was to portray the ruins of the burned-out school building, but he drew in the houses next to it as well.[111]

Amsterdam houses were built mainly of small, dark-red bricks, and had red-tile roofs. The houses were supported by a dozen or more wooden pilings driven through the marshy surface soil to reach firmer ground some 20 meters below. Because the costs of both land and such foundations were high, most houses were tall and narrow. Staircases within the houses were small, steep, and winding, which necessitated a sort of block and tackle arrangement to raise and lower furniture and other household goods from outside. The pulley was attached to a beam jutting forth from the gable of the house, like the one shown in figure 1. They are still used today.

Building plans for a property built in 1623 on the Slijkstraat, one of the narrowest streets in the city, give an idea of the kind of small multi-family house in which many Amsterdammers lived (see fig. 2). It was 4.7 meters wide and 9.4 meters deep, and contained three dwellings: one unit downstairs, another upstairs, and a third in the backhouse.[112] Like most smaller houses at the time, it had two front doors.

The door on the left gave access to the downstairs unit, which was made up of three rooms: a *voorhuis* or front room, a living room/kitchen (*woonkeuken*) in the basement (*souterrain*), and a sort of mezzanine room a few steps higher than the *voorhuis* and reached from it by a short stairway. The mezzanine room had a fireplace on the left wall, and three windows overlooking the courtyard. Built into the wall opposite the fireplace were three bedsteads (*bedsteden*), which took up about a third of the space in the room. They probably served the needs of a married couple and one or two children. Enclosed on three sides and screened with a curtain, a bedstead protected sleepers from the cold and ensured a degree of privacy.

The second, upstairs, unit was reached by entering the door on the right of the house and going up a spiral staircase to the left. This unit consisted of two floors and an attic. It would have contained bedsteads, a fireplace for cooking and heat, and windows in both the front and back walls. The third unit, in the backhouse, consisted of three small rooms with a fireplace and probably bedsteads as well. A family in the downstairs dwelling would have assembled everything they owned in a space

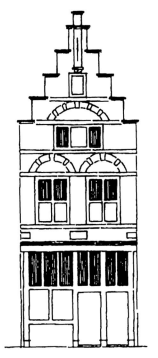 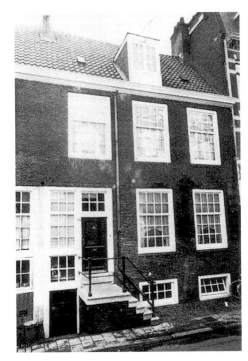

2 (*left*) House on Slijkstraat in Amsterdam. Reconstruction drawing by H. J. Zantkuijl.

3 (*right*) House in the Noortsche Bos, 2e Weteringdwarsstraat 64.

of around 40 square meters, but the other two dwellings were even smaller.

Around 1670, multi-family rental houses designed by Philips Vingboons (1607–1678) were built in the "Noortsche Bos," the area south of the Prinsengracht between the Spiegelstraat and the Reguliersgracht. They were intended to attract people working in the textile industries, especially weaving, and to breathe new life into the weaving and woolen industry in Amsterdam.[113] Four hundred houses were planned, but just over half were built (one is shown in fig. 3). About 8 meters wide and 6 meters deep, and intended for master artisans and their families, they were somewhat larger and more comfortable than the house described above. Unusually, the larger unit had a separate kitchen.

Each house contained two dwellings, one of which was in the basement. Vingboons's plans for the larger unit show a *voorhuis* or front room

and a sort of living room large enough to hold a loom as well as a bed-stead in the corner. There was also a *rolkoets* (a child's bed that could be rolled under the bedstead when not in use) in the living room. At the back of the house was a kitchen with a built-in food cupboard, a special box for peat, and a second bedstead. A *secreet* was situated off the kitchen. From the *voorhuis*, a staircase went to the floor above and then to the attic. There would have been bedsteads on these floors as well, although none of the rooms was intended solely for sleeping. But family members would have more privacy here than did those living in any of the three dwellings in the house on the Slijkstraat.

During the last quarter of the seventeenth century, the larger units in the Noortsche Bos were rented out for an average of 90 guilders per year.[114] In this period, between 5 and 15 percent of a worker's budget would go on rent.[115] Assuming that the rent paid for these dwellings was 10 per cent of the budget, then the families living here must have earned around 900 guilders per year. This, as is shown in Table 1.1, would have placed them in the top one-fifth of Amsterdam incomes.

The second door in the houses on the Noortsche Bos led to a base-ment unit, which was smaller than the main part of the house and con-sisted of just one room. There was a fireplace for heat and cooking, but no separate kitchen. Vingboons's plans indicate the presence of only one bedstead. The dwelling was rented for about 30 guilders a year, which indicates that the occupiers had a yearly income of around 300 guilders.[116]

The dwellings of ordinary people were quite sparsely furnished. All had either bedsteads or mattresses to be placed on the floor. Most had a cupboard or chest for storage, since built-in closets were rare. In addi-tion, the dwellings would have contained a table, some chairs, a couple of benches, two or three cushions, mats on the floor, curtains at the windows, and a mirror. One or two prints or small paintings may have hung on the walls; there was little space for more. Beds, bedding, and clothing usually made up more than half the total value of a family's household goods.[117] The clothing of ordinary men and women was drab, dark in color, and of coarse material. Although less often second-hand, worn, and threadbare than that worn by the poor, ordinary people's cloth-ing reflected their social position and the kinds of work they did.

Some families inhabited whole houses, not only the rich but also households headed by doctors, lawyers, bookstore owners, successful shopkeepers and merchants, and some master artisans. Master carpenters and bricklayers sometimes built a house for their own use.[118] Spread

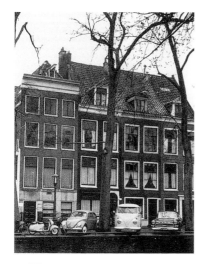

4 Houses on Prinsengracht, nos. 586–90.

through various districts of the city, these one-family houses were often located on the side streets of the main canals or in areas adjacent to those where the rich lived. They consisted of rooms of different sizes on several floors.

Three houses on the Prinsengracht, commissioned by their owners and built in 1671, exemplify a very traditional type of one-family house (fig. 4).[119] No information about their dimensions is available, but such houses were usually 5 or 6 meters wide and 10 meters or so deep. Although not much larger than the houses described above, they accommodated a single family. The floor plan was identical in all three houses. Nothing is known about the use of space in the basement and attic.

On the main floor was a small *voorhuis* with a staircase and hall behind it. Next to the *voorhuis* was a somewhat larger side room (*zijkamer*) with two windows facing the street. This room gave access to the living room/kitchen, which contained a fireplace and a built-in bedstead next to it. A back room behind the living room/kitchen contained another fireplace, and there were two windows in the rear wall.

On the landing of the staircase leading upwards were a portable *gemakskofferje* (a sort of privy) and a bedstead. The two rooms on the floor above each contained two bedsteads. The room facing the front of the house had two windows and contained a fireplace. There was also a fireplace in the room at the rear, which was lit by a sort of dormer window. The house also contained a basement and an attic. Such one-family dwellings would have their own *secreet*, but it is unknown where this was located in the Prinsengracht houses.

These houses would have been better furnished than the dwellings of ordinary people. As well as built-in bedsteads, some had a *ledikant* or free-standing bed. There would be several cupboards, tables, and chairs, some of which were probably upholstered, and probably two or three

mirrors on the walls. Several paintings may have hung there as well. The families would have owned more clothing than ordinary Amsterdammers, and this was likely to be lighter in color and made of better fabric.

The Amsterdam elite – regents and other wealthy families – lived in expensive brick or stone houses with many rooms, either on the main canals or in other fashionable districts. The political and financial elite lived mostly on the Herengracht and the Keizersgracht, although many rich people lived on the Prinsengracht and Singel, the Warmoesstraat, the Leidsegracht, the Kloveniersburgwal, and a number of other desirable locations. These families employed one or more servants, often owned country estates, and had the carriage and horses necessary to reach them.[120] Only people located in the top 5 percent of the city's economic hierarchy had such estates.

The explosive growth of population during the sixteenth and seventeenth centuries led to the expansion of Amsterdam, in four phases.[121] The first two phases, in 1585 and 1593, extended the city on the eastern side. The third, in 1613, began by laying out the streets and canals on the western side of the city. This involved the city's three principal canals: the Herengracht, the Keizersgracht, and the Prinsengracht. With the fourth phase, in the 1650s and 1660s, the three canals were extended from the Leidsegracht eastward to the River Amstel and beyond to the so-called Oostelijke Eilanden, giving the city the half-moon shape it has today.

The primary purpose of these three wide canals was practical, for shipping was the most efficient way of transporting goods. Each was 26 to 28 meters in width, with a quay of about 11 meters on each side. The property lining them was intended as a residential area for the rich. Beginning in 1614, land there was auctioned off for the building of mansions, sometimes so large as to be constructed on double lots. Plots on the Herengracht were the most expensive, some selling for 7,000 guilders each, while those on the Prinsengracht were the least costly.[122]

Over the course of the seventeenth century, changes occurred in the layout of rich people's homes and the way in which the rooms were used. These changes reflected the transformation of what was essentially a merchant's house into one suitable for a gentleman. The most notable change was in the *voorhuis*. Earlier in the century, it sometimes took up the whole front part of the house and was used largely for business purposes. In time, however, a wall was erected to form the *zijkamer*, a side room with a chimney (as in the houses on the Prinsengracht described above). Even-

tually, the side room became larger and the *voorhuis* correspondingly smaller, until, towards the end of the century, the *voorhuis* evolved into an entrance hall.[123]

While the *voorhuis* was used less and less often for transacting business, changes also occurred in the use of other parts of the house. Merchants had earlier kept at least some of their wares in the basement and attic. This changed during the seventeenth century, since goods came to be stored in warehouses on the so-called *Eilanden* (islands) near the wharves where the merchandise was loaded and unloaded. The basements were thus freed for use as children's rooms, offices, and, most especially, kitchens. Attics, however, were still used for storage.

Each of the new mansions contained a *zaal* (also spelled *sael* and *saal*), the most important and formal room in the house. Generally located at the rear, on the floor above the entrance, it was meant for special occasions, such as entertaining visitors. It was almost always the largest and most expensively-furnished room in the house. A tighter architectural plan was also developed, creating greater uniformity among the different rooms in a large house.[124] More rooms began to be designated for specific functions, with separate rooms for cooking, sleeping, family activities, entertaining, and conducting business. Rooms designated as bedrooms, when these existed, were usually on the upper floors.[125]

Although no one type of house was built for wealthy merchants and city governors later in the seventeenth century, some were built on plots of double width. The main entrance was usually above street level, in the middle of the façade, with steps leading up to it. Such houses were large and massive, with three to five windows across the front to enable light to penetrate into the deep interiors. Even so, little outside light reached the inner rooms of Amsterdam houses. Paintings of seventeenth-century Dutch interiors are misleading in this regard.[126] People trying to read or women sewing would have sat in front of a window to get sufficient light, as in figure 5, an etching done by Rembrandt in 1647. It shows a man, Jan Six, leaning on the window sill to read a book.

Herengracht 466 is an example of a house built on a plot of double width. The architect was Philips Vingboons, who designed the houses in the Noortsche Bosch. Built for Hieronimo Haase, a wealthy merchant, it was completed in 1671. Situated near what is now the Nieuwe Spiegelstraat, it was about 14 meters wide and more than 22 meters deep.[127] The main entrance was placed in the middle of the façade, above street level and approached by several steps (see fig. 6). The *zijkamer*,

5 (*above*) Rembrandt van Rijn. *Jan Six Reading at the Window* (1647). Etching, drypoint, and burin, 24.4 × 19.1 cm. Amsterdam, Collectie Six.

6 (*right*) Herengracht 466. Engraving from 1696. Amsterdam, Monumentenzorg.

which measured about 5 × 11 meters, was located on the entrance floor to the left of the long hallway. Behind it was a room designated as a bedroom, containing a separate alcove for a bed. Opposite the *zijkamer* was an office for the house owner, Hieronimo Haase, in a position occupied by the *voorhuis* in many other large homes. Behind the office was a room for daily use. A small outbuilding, with a *secreet* or privy, was attached to the back wall of the house. It had a terrace on top, then an unusual feature.

The main floor, on the level above, had a long hallway that ran from front to back and led to the formal rooms. There was a large *zaal* on the left, with another room behind it. On the right was a room leading to the terrace at the back (on top of the outbuilding) which, according to the designer, allowed for a "very pleasant view of many gardens."[128]

A semi-underground basement or *onderhuis* was situated below the entrance floor. There was a large kitchen at the rear on the right side of the basement, and attached to it at the back was the outbuilding, which contained a *secreet* and a washbasin, for which water would have been pumped from a well. Only the wealthiest families had such a luxury. The rest of the basement was used for storage. Behind the house were a courtyard and garden, and further back, another *secreet* (probably for the servants), and some chicken coops. Stables bordered on the Nieuwe Spiegelstraat, the nearest side street. Between the stables and the garden was a cobbled area and a bleaching field for drying laundry. The top floors of the house are not described.

Such large houses usually contained expensive furnishings. These are described in the following chapter, which focuses on the conditions in which paintings were viewed in wealthy Amsterdam families.

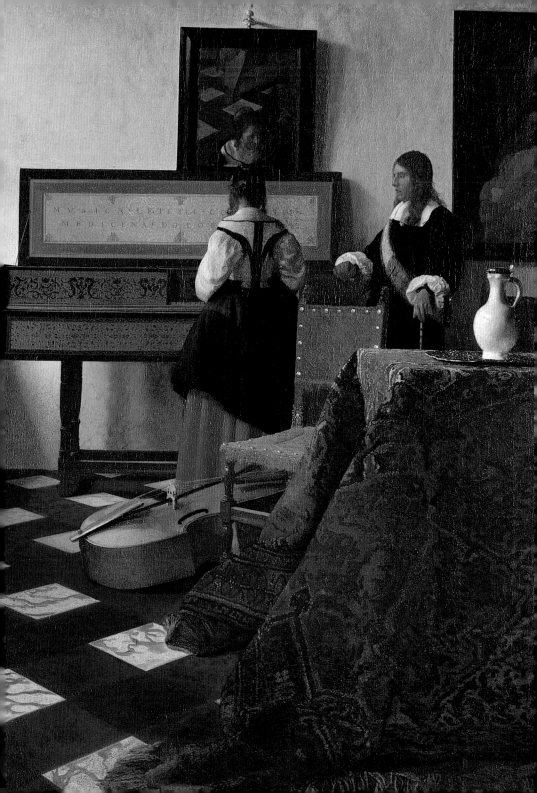

Chapter 2

Inside the Homes of the Wealthy:
The Conditions for Viewing Paintings

A wealthy Amsterdam family would often own at least fifty paintings. Rooms intended solely for their display were rare, although the more formal rooms – especially the *zaal* and the *zijkamer* – would contain both the most expensive and the largest number of pictures. Otherwise, paintings were usually distributed among the rooms in which members of the family and their household staff carried out a wide variety of everyday activities.

Just as seventeenth-century Dutch paintings were viewed under different conditions from those in museums today, so people's relationships with them differed as well. For the institutional setting of art museums and the domestic setting of private homes frame different visual experiences.[1] In order to understand the role of paintings in the lives of men, women, and children at the end of the Dutch Golden Age, the domestic routines of the elite that owned them are considered, as are the conditions under which they were encountered and looked at.

The Social Differentiation of Space

Opportunities for encountering paintings in large seventeenth-century houses were not the same for everyone. A family's home was a territory with restricted access, and the use of specific spaces reflected the relationships among both its inhabitants and men and women from outside. Space was not only physically but also socially differentiated, into three separate areas: one restricted to the use of the family; another where outsiders were received and entertained; and a third where the domestic help worked and slept. The areas were not always fully distinct and were not the same in every house, but patterns of admission to the different spaces reflected the social relationships among the individuals involved.

Facing page Detail of fig. 16.

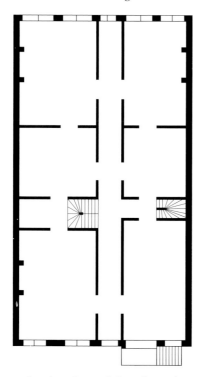

7 Imaginary layout of a large Amsterdam house in 1700 (approx. 18 × 11 m.). Klaske Muizelaar.

People usually entered these large homes through the *voorhuis*. Some – tradesmen, for example – were admitted no further. Others were allowed entry to a separate room, such as the *comptoir* or office of the owner of the house. Business discussions could also take place in one of the more formal rooms. Friends, relatives, and a small number of other people from outside the immediate family were allowed to penetrate further, to one room or another set aside for ceremonial purposes and formal activities, usually the *zaal* and the *zijkamer* or side room. Some houses had additional formal rooms. It was their intended function that mattered, not what they were called.

Figure 7 shows the ground-floor layout of a large (imaginary) Amsterdam house.[2] The front door on the right side was approached by several steps and opened into the *voorhuis*, an entry hall with a window next to the door. Across the passage running from the front to the back of the house was a door to the *zijkamer* or side room, which had the main staircase behind it. Behind the *voorhuis* was a small spiral staircase used by servants, so as not to disturb the family. It led to the attic and other top floors, where the servants' rooms were situated and where laundry was hung up to dry (the wealthy had their laundry washed elsewhere, but brought it home to dry in the attic). Sometimes the servants' staircase was located at the back of the house.

Four other rooms opened off the hallway behind the *voorhuis* and the *zijkamer*. The two rooms at the back each contained a fireplace and two windows, but the two in the middle had neither. Exactly how the rooms were designated and used differed from one house to another, but the kitchen was usually located at the back, as was a sort of daily room or parlor used for ordinary family activities. One of the inner rooms may

have been used as the owner's *comptoir* or office. There would have been a basement below.

The main staircase, with a landing (called a *portaal*), led to the floor above. The *zaal*, the largest room, was usually located at the back of the house on this level. The bedrooms, the wife's room (if there was such a designation), and perhaps a room used exclusively for eating were also on this floor. The last, however, could also be located on the ground floor.

Amsterdammers visited one another regularly. Almost any pretext would do: the birth of a child, a baptism, an infant's weaning, a birthday, a saint's day, a public holiday, an engagement, a marriage, the purchase of a house, an anniversary, a business success, an appointment to public office, a departure for an extended trip, an arrival home, an illness, a recovery, a funeral, and numerous other reasons.[3] Rich families spent considerable amounts of time on such visits. Merchants discussed business; city officials and board members of the Dutch East India Company would entertain their colleagues; women invited friends and relatives for afternoon tea. In some houses, a particular room with tea tables and a special sideboard was set aside for this purpose. In warm weather, tea was served in the garden by the servants.

Although Amsterdam was large, there was a dense network of overlapping relationships among the economic and political elite. Many wealthy families were related by blood or marriage, or both. Family members had intimate ties with relatives and close friends, routine ties with business associates and colleagues, and a variety of other social ties. Men, women, and children were linked by being a "friend of a friend," a "relative of a relative," and so on.[4]

Distances were small in the city, and people could easily walk to the homes of colleagues, business associates, relatives, and friends. When necessary, a horse-drawn carriage was used, either the family's own or a sort of taxi. Only the rich had such carriages, since they were very expensive: a new one would cost around 700 guilders and a horse at least 120 guilders.[5] There was plenty of sleeping space in these large houses, and guests from the provinces or abroad might stay for a weekend or longer.

Most often, however, it was relatives and close friends who were invited for elaborate meals with large amounts of food and wine. Wine always played an important role in sociability among the wealthy.[6] Banquets for ten or more guests were not unusual. The family used the dining room or *eetkamer*, if they had such a room; otherwise, they would sit down to eat in the *zaal* or other special room reserved for receiving guests. After

the meal, in the same or another room, they would all play cards or some other game, listen to music, talk, drink, perhaps look at paintings, and enjoy one another's company.[7]

For most people, the division of the day by meal-times helped to structure daily life. Most people ate three meals a day, but men engaged in manual labor would also eat once or twice in between. Breakfast consisted mainly of bread, butter, and cheese, although some wealthy families ate meat. Bread was the main staple, its quality varying according to the different social levels. Milk was consumed mainly as the liquid ingredient in different types of porridge.

The main repast of the day was a warm midday meal, eaten around noon by wealthy families and somewhat earlier by ordinary ones. (On weekdays, the time of breakfast and the midday meal would be governed by school hours.) Wealthy families ate three courses, ordinary people usually two. The first course consisted of generous portions of meat and/or fish (both of which were expensive), and such vegetables as cabbage, carrots, onions, parsnips, peas, and beans. The meat eaten by the well-to-do included beef, veal, mutton, pork, and venison, in season. The second course was eggs, bread, butter, and cheese. A third course sometimes included a *salade*, a dish imported from southern Europe, which comprised raw or cooked vegetables eaten cold with some kind of spicy sauce. The rich could afford fruit, sometimes from their own country estates. Cakes, biscuits, waffles, and pancakes were common.

The midday meal might stretch on for several hours. In the second half of the seventeenth century, the arrival of tea, coffee, and chocolate from Asia and a special craze for tea led to afternoon tea parties. Expensive silver teapots, porcelain cups and saucers, and similar kinds of services for coffee and chocolate were acquired. Some women spent hours drinking tea and consuming still more food.

Wealthy families also often ate a similar meal in the evening. Other families, who had eaten perhaps a stew with vegetables and a small amount of meat at midday, ate left-overs, and a great deal of bread, butter, and cheese. The poor ate larger quantities of bread, some carrots, parsnips, and other vegetables, but seldom any meat or fish. In general, people ate larger quantities of everything than is normal today. Consumption by the rich, whose tables were laden with meat and fish, was especially extravagant. The rich drank wine with their meals; ordinary people drank beer, since it was cheaper than wine and purer than water. Most people ate with a knife, spoon, and their fingers. Only the higher social classes owned

and used forks. In the general absence of water for washing their hands, people made wide use of napkins. Men would smoke between courses.[8]

In most Dutch households, 70–80 percent of the income went on food.[9] The many Amsterdammers dependent on various sorts of poor relief and food distribution often failed to obtain the required level of calories, although they did not starve. This affected not only their growth and daily functioning, but also the appearance of their skin, eyes, hair, and teeth. The wealthy, on the other hand, were overfed.[10] The amount and quality of the food they ate reflected both what they could afford and their beliefs about what was appropriate for members of their standing. Physiological necessity was relatively unimportant. Many men, women, and children in these families must have been grossly overweight.

The family domain consisted of various private or more intimate rooms used by its members: the children's rooms, the owner's office, perhaps a similar room belonging to the mistress of the house, and sometimes the rooms where the husband and wife slept, either together or separately. Servants had regular access to all the rooms, but only at the pleasure and instruction of their employers. Otherwise, they were restricted to their own quarters and to the parts of the house where they did their work. In addition to those who slept in the house, some families had day help who came in to cook or perform other services.

Cutting across the social differentiation of space in wealthy homes was a separation of gender domains.[11] It must be emphasized that this applied exclusively to the homes of the rich and more affluent. The overwhelming majority of Amsterdammers lived in dwellings with too few rooms and too little space to allow for separate domains for men and women, although there was still a division of labor within the home according to gender.

In wealthy homes, the kitchen, cellar, laundry room, and attic were the domain of women, although a male servant might sometimes be found there. The maidservants and day help would spend much of their time in these areas, under the supervision of the mistress of the house. When a man carried on business at home, his office was regarded as male territory, but his wife might use the room in his absence. It was here that he saw to his correspondence and bookkeeping, and there were undoubtedly occasions when husband and wife discussed financial and other matters in the room.[12]

Since women were largely excluded from the public world in which men participated, the domestic space of the family home was the special

domain of the wealthy woman. A wife was expected to see to the needs of her husband, bear and raise their children, maintain contact with other relatives, organize the entertainment of guests, manage the household, and do whatever else was necessary to create a comfortable domestic environment. This included the furnishing and decorating of the home.[13] It is not known, however, whether this included how and where to display the family's artworks. One scholar has argued that this was indeed the case,[14] but this may have depended, as suggested below, on their representational content.

Furnishing a Wealthy Home

Wealthy families in late seventeenth-century Amsterdam furnished their homes with goods acquired at different times and in various ways. Although it is rarely known exactly when or how different furnishings entered a household, it is safe to assume that most domestic objects were acquired on particular occasions: at marriage, the birth of children, and the death of parents.[15]

Impending marriage was the time in a young man's life when he undertook to furnish the house in which he would receive his bride. This is unlikely to have been an exclusively male affair, but there is little evidence about how young men and women went about acquiring their household furnishings at the time of marriage. Both bride and groom brought material goods to the partnership and these were often gender-related. The bride, for example, would bring linens, tea sets, porcelain, and jewelry; the groom a desk, maps, and books. Clothing and silver objects were brought by both, as were paintings. Most items were probably purchased new, especially in wealthy families.

With the birth of children, couples would acquire appropriate goods for furnishing the rooms of their male and female offspring. In later years, they perhaps inherited household furnishings from their parents. Much was probably sold off or given away, but certain items were surely retained, whether because of their monetary value, beauty, or the memories attached to them. Although paintings might be among the inherited goods, most were acquired from art dealers, from artists themselves, or in other private transactions. Fewer were purchased through auctions. A recent study of paintings bought at auctions has found that Amsterdam couples acquired paintings during the first several years of marriage.[16] This was probably also true for most other paintings that people owned.

It was a fundamental goal of all families to secure, maintain, and – if possible – strengthen its ownership of property: money, land, real estate, and other possessions.[17] Inheritance was an important mechanism in this regard, for the division of property among living heirs was crucial to the well-being of all members of the family. The disposition of a couple's material goods was always specified in a written document or will. A widow would retain ownership of her dowry linen, clothing, gifts, jewels, paintings, and whatever else she had brought to the marriage. Goods that had been acquired jointly by the couple were credited to the family estate. The widow also had authority over her deceased husband's possessions and exercised control over the economic situation of the offspring. She would usually give the children a portion of the estate when they married, but would retain enough to retain some leverage over the younger generation. Eventually the family property would pass to the couple's children. This procedure was also followed if the wife died first.[18]

The household furnishings were more than just physical objects in a family's home: they were repositories of individual and familial meanings. Some were suggestive of the family's history or lineage; some kindled memories of how and when the objects were acquired; some expressed the individuality of a particular family member; some were cherished for their monetary value, some for their beauty, some for their comfort or utility, and some for other reasons. Families varied greatly in the amounts they spent on particular furnishings and the ways in which they combined them, as well as in what they retained from inheritances.[19] Furniture and decorations also constituted an important element in the viewing of art works.

The furniture in wealthy homes was generally made to order. Artisan workshops turned out both plain, functional pieces and elaborate ones of great beauty: cupboards, freestanding beds, chairs, tables, chests, and benches. Oak and walnut were most common with various exotic woods often used for refinement, especially for large cupboards. (Pine was used for poorer people.)

Built-in closets were rare, and cupboards were a basic item of furniture in every home. Two types were used for storage: the linen closet for tablecloths, napkins, sheets, blankets, clothing, silver and gold pieces, jewels, bibles, and various family treasures; and the china closet for storing and displaying plates, saucers, cups, and other items.[20] Cupboards took up considerable wall space, which restricted the area available for hanging paintings.

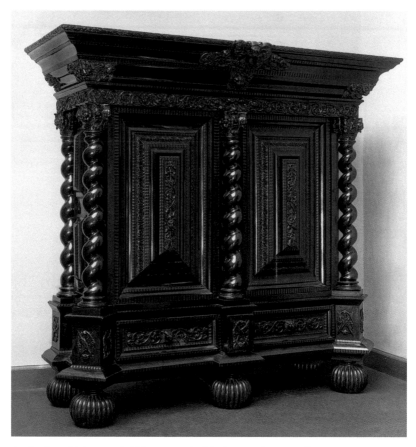

8 Cupboard (1650–1700). Oak, veneered with ebony and rosewood, 249 × 266.5 × 103 cm. Amsterdam, Rijksmuseum.

Most wealthy families had anywhere from eight to twelve large cupboards in their homes.[21] The *zaal* was always furnished with at least one cupboard, those for porcelain often having glass doors to protect the contents from dust and soot. Rooms where people slept usually contained one or more cupboards for linens and clothing. The side room almost always held a cupboard, as did the kitchen and any separate dining room. Figure 8 shows a fine example from the second half of the seventeenth century. Made of oak and veneered with ebony and rosewood, it is more than 2.5 meters wide, almost the same height, and more than a meter deep.[22] It must have been costly and was probably regarded as a piece of art.

9 (*facing page*) Four-poster bed (1700–1725). Pine and oak, hung with European silk damask and Chinese embroidered silk damask, 330 × 175 × 215 cm. Amsterdam, Rijksmuseum.

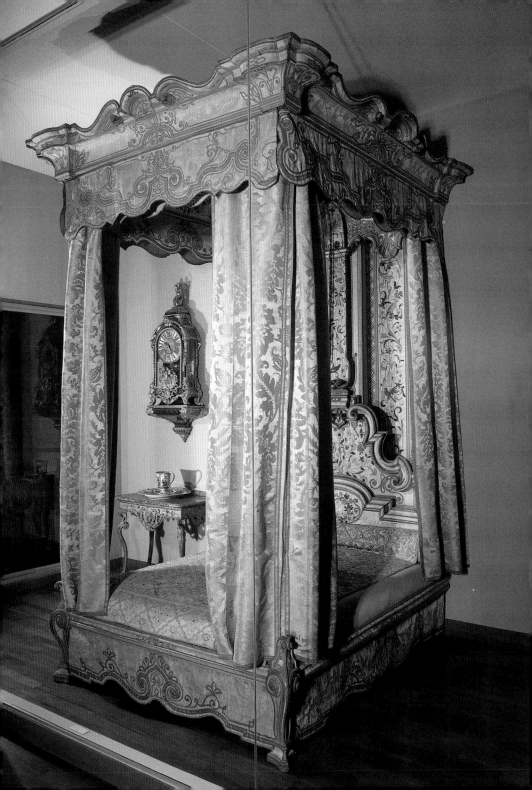

Four-poster beds could also be expensive works of art. Made of oak or walnut, they were often massive and impressive, dominating the rooms in which they stood. They usually stood with the head against a wall close to the corner, with three sides exposed. They frequently extended 2 meters in each direction, the bed posts rising close to the ceiling, as in the example shown in figure 9, which is in a style characteristic of the years around 1700.[23] Each four-poster bed had at least one mattress, several pillows, and a bolster, with costly linen or cotton sheets, blankets, and a decorative quilt. Three or four curtains hung from the top rails, providing added warmth and privacy. Textiles were the most conspicuous parts of these beds: richly colored velvet, silk, damask, and other materials embroidered in gold or silver. Beds for young children were small and less ornate than those for adults, averaging perhaps a meter in width and more than a meter in length and height. Servants slept in what were often described as "small beds."[24] In addition, many rooms had built-in bedsteads, and some also contained a couch (*rustbank* or *slaapbank*).

Since relatively few rooms had a specialized function as bedrooms, most rooms were used for sleeping.[25] Certain rooms always contained beds: those described as "bedrooms," children's rooms (when there was such a designation), and servants' rooms. Most rooms on upper floors held beds, as the attic often did. On average, a wealthy Amsterdam home had eight or more beds distributed over various rooms. The *zaal* would often contain one or more beds, which would almost always be the most expensive in the house. There was always a fireplace in that room to provide warmth. Some beds were considered objects of great beauty, to be seen and admired by visitors. People were born and died in bed, made love in bed, and took to their beds when ill. Three centuries ago, they spent more time in bed than is usual today. They would retire to their beds when darkness fell, especially in periods of cold and damp weather. Some wealthy people would receive visitors there as well.

Chairs were the most common item of furniture in seventeenth-century Dutch houses. They differed in type, size, height, the kind of wood they were made of, and whether or not they had armrests, were upholstered or could be folded up.[26] Some forty or fifty would be distributed around a wealthy Amsterdam house, with every room holding at least one. They were especially plentiful in the rooms where guests were received; there were often a dozen or more in the *zaal* and the side room, and almost as many in the dining room. Rooms identified as bedrooms always contained several chairs. But the *voorhuis*, a rather narrow room,

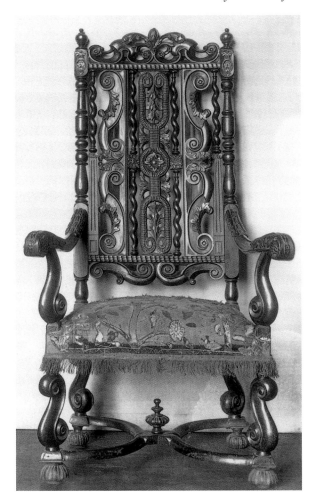

10 Armchair (1680–1700). Walnut, varnished black, upholstered in velvet with impressed motifs, 129 × 74 × 71.5 cm. Amsterdam, Rijksmuseum.

seldom had more than a single chair. Most chairs had high backs and low covered seats, on which thick cushions were often placed. Armchairs, which were intended for either the master of the house or important guests, were usually somewhat wider and higher than chairs without arm-rests, especially earlier in the seventeenth century. Some chairs, especially those made of rare or exotic woods and upholstered with expensive materials, were particularly highly valued. One walnut armchair, with intricate carvings, varnished black, and upholstered in velvet, is shown in figure 10.[27]

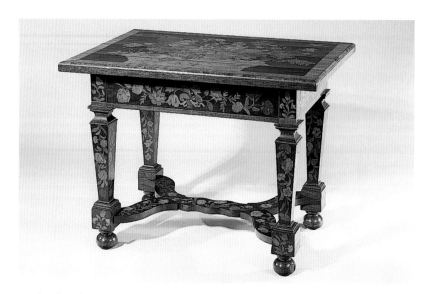

11 Attributed to Jan van Mekeren. Table (1690–1710). Oak, veneered with king-wood, ebony, rosewood, sycamore, and other woods, 77 × 100 × 69.5 cm. Amsterdam, Rijksmuseum.

Tables, of various types, were made of wood or marble. Oak and walnut were used for most, and more costly tables were inlaid with ebony, rose-wood, or another expensive wood. Some were designed for games (e.g., backgammon or cards); others were used for serving tea. Most tables were about one meter square, and a little less than one meter high. Figure 11 shows an elaborately decorated table made of oak and veneered with kingwood, rosewood, ebony, sycamore, and other woods. It dates from about 1690–1710 and is attributed to Jan van Mekeren, a well-known artisan.[28] Wealthy families often had ten or more tables, with more in the *zaal*, the side room, and the dining room (when there was one) than else-where. Inventories seldom give any indication about the specific use of a table for dining, but both folding tables and tables that could be extended were common, and both types could have been used for this purpose.

Many wealthy families decorated one or more rooms with some sort of wall covering. They were a striking feature, and rooms were often named after the coverings they contained. Apart from their decorative function, they helped to provide protection against the cold. Gilt leather, for which Amsterdam was particularly famed, was the most common type.[29] Other, less costly, coverings were made of cotton, linen, silk, damask, and various woolen upholstery materials.

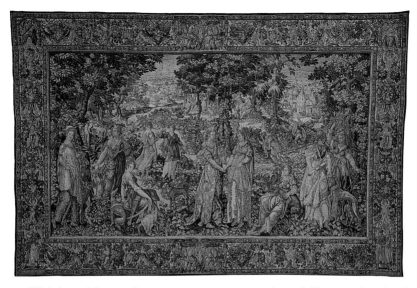

12 Workshop of François Spiering. *Cephalus and Procris* (*c.* 1610). Tapestry of wool and silk on woolen warp, 345 × 520 cm. Amsterdam, Rijksmuseum.

Tapestries were greatly appreciated for their scale and intricate crafts-manship, but they were the most expensive type of wall covering and only a few rich families owned them.[30] Extremely work-intensive weaving techniques were employed in their production, which required a large site, a team of skilled workers, miles of thread, and months of labor.[31] Available in different qualities, even tapestries with coarse weaves were expensive. The finest examples were made by weavers in France and Flanders.[32] Some were 2 meters or more in each direction. Red was usually their dominant color. The early seventeenth-century tapestry shown in figure 12, which shows a series of scenes from the story of "Cephalus and Procris" from Ovid's *Metamorphoses*, is made of wool and silk on woolen warp. It came from the workshop of François Spiering in Delft.

Colorful oriental carpets were objects of great beauty and much admired. Seventeenth-century Dutch genre paintings, portraits, still lifes, and history paintings show them being used as both floor and table coverings. Their presence in so many paintings might seem to suggest that they were an integral part of the furnishings of wealthy homes,[33] but in fact oriental carpets were sometimes supplied by the artists themselves, and a single carpet might be used over and over again by generations of artists.[34] One carpet of unknown origin is represented in several paintings

by Caspar Netscher (1639–1684) and was used thirty years later by his son, Constantijn Netscher (1668–1723). Johannes Vermeer (1632–1675) used an identical oriental carpet in several of his paintings.[35]

Mirrors were found in every wealthy home. They were valued not only as looking glasses, but also for their ability to reflect – and therefore enhance – the light within a room. The *zaal* and the side room contained the largest number, but mirrors hung almost everywhere, although seldom in the sparsely furnished rooms where servants slept. Clocks were comparatively expensive, and only the well-to-do owned them.[36] For most people in Amsterdam, time was tolled by the bells of the city's churches. The *voorhuis* was the usual location for a clock, but sometimes it stood on the landing (*portaal*) between the floors or in the owner's office.

Seventeenth-century paintings of domestic interiors often depict someone reading, usually a woman. Affluent families owned a variety of books, including what might be termed professional books, associated with the work of doctors, lawyers, and merchants. Many books in foreign languages were related to a merchant's involvement in overseas trade. Much business-related correspondence was carried on in French, and sometimes in English and Italian as well.

Most wealthy families owned a few maps, which were often connected to their business activities. They were usually hung in the *voorhuis*, in halls, on the stairs, on the stair landing, or in the garden house, but not in rooms where guests were entertained. Some families also owned atlases. The most famous was the Blaeu *Atlas Maior* or *Grand Atlas*, which contained 600 maps covering all the European countries, the British Isles, Africa, and America, as well as an enormous range of information about distant lands.[37] According to one scholar, the Blaeu atlas was the most expensive printed book of the second half of the seventeenth century.[38] It was designed exclusively for "those members of the patriciate who could command both the material and the intellectual resources that were needed to buy it and to appreciate it,"[39] and the United Republic would present it as a gift to royal and other distinguished personages.[40] No more than 300 copies were printed in the Dutch, French, and Latin editions. In 1670 the Dutch edition cost 450 guilders, more than the average yearly income of an ordinary Amsterdam household.

Figure 13 shows a painting by Jan van der Heyden of an open atlas and two globes on an oriental rug that covers a large table. The presence of a well-filled bookcase as well as various exotic spears and lances in this (invented or designed) painting suggests the office or library of a wealthy

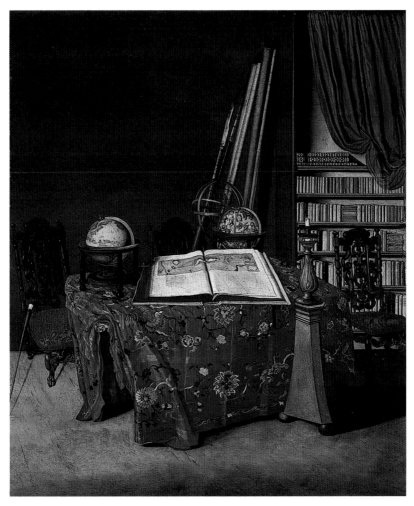

13 Jan van der Heyden. *Interior of a Study* (*c.* 1710–12). Oil on canvas, 77 × 63.5 cm.
© Museo Thyssen-Bornemisza, Madrid.

gentleman with an interest in the wider world of learning. Were it
not for the spears and lances, it might be imagined that the globes and
open atlas related to the commercial activities of a wealthy Amsterdam
merchant.

It has been claimed that music was extremely important to people in
the Dutch Republic.[41] But although musical instruments – clavichords,

harpsichords, cellos, and others – are certainly common in paintings of domestic interiors by Vermeer, de Hooch, and other seventeenth-century Dutch artists, few instruments are listed in contemporary household inventories. They appear to have been uncommon even in the homes of the wealthy.[42] Even if singing was common in the family circle or with friends, playing a musical instrument must have been rare.

Silver plates, vases, beakers, teapots, sugar bowls, candlesticks, snuff boxes, and other objects were considered desirable and appropriate for those families who could afford them.[43] Some silver objects were virtually devoid of ornamentation; others were elaborately decorated with fruit and flower motifs, human figures, animal motifs, plants and foliage, hunting scenes, and biblical and mythological themes represented in the finest detail. The extravagant engraving, embossing, and other precision work done by the best Dutch silversmiths – among them immigrants from Germany and elsewhere – required years of training and enormous skill. Some were among the greatest artists of their time.

The monetary value of a silver object was based first on the value of the silver itself, and second on the work of the master silversmith who produced it; there were extra costs for unusually fine engraving or workmanship. Silver items were an investment as well as a thing of beauty, and a purchaser would weigh the metal first to determine its value. Since silver was a convertible commodity, they could always be melted down. Silver objects were sometimes displayed in a prominent manner, on top of tables and cupboards or in cupboards with glass doors. The *zaal* and the side room were the usual locations, where they would surely have caught people's attention. Figure 14 shows a silver tea canister with a design of flowers and leaf motifs; dated 1677, it was made by an anonymous Amsterdam silversmith.

Porcelain was displayed in a similar way to silver, as well as on fireplace mantels and above doorways. In the early seventeenth century, porcelain was known as white gold and was as valuable as gold or precious jewels. All porcelain then came from China, and later from Japan. The porcelain imported into Europe was predominantly blue-and-white, frequently decorated with two alternating designs: often flowerwork and good luck symbols on the outside, and birds or other creatures on the inside. Human figures and landscapes were also common.[44] A finely-decorated Chinese dish from the period 1640–50 is shown in figure 15. Potters in Delft attempted to reproduce this much-admired porcelain, but although some seventeenth-century Dutch earthenware is highly decorative, it is not

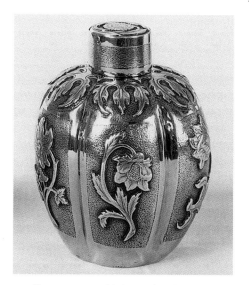

14 Tea canister in gilded silver (1677). 8.8 × 7.5 cm. Amsterdam, Rijksmuseum.

15 Chinese dish (1640–50). Diameter 37 cm. Leeuwarden, Keramiekmuseum het Princessehof.

porcelain. True porcelain, characterized by its whiteness and translucency, was not produced in Europe until 1708, when the formula was discovered.[45]

Although some scholars have considered that drawings, prints, maps, coats of arms, and sculptures made of alabaster or wood constituted objects of artistic significance in Dutch homes, the evidence from inventories does not suggest that they were a particularly important feature, because their monetary worth was only a portion of that of paintings.[46] Inventories show that wealthy Amsterdam families regarded elaborately decorated furniture, tapestries, silver objects, porcelain, and paintings as art works. In most cases, however, silver objects had a far higher monetary value than paintings, as did porcelain, books and atlases, tapestries, and certain other items of furniture.

Rich Amsterdammers had the financial means to acquire practically any painting they may have wanted. As Jonathan Brown has noted, fine paintings were inexpensive compared to other items of luxury consumption such as jewelry or silver plate.[47] They were therefore an easily affordable luxury for the top echelon of society. But few of the paintings owned by the social, political, and economic elite were among the most expen-

sive of the paintings available. A family's paintings, however, usually had other functions than as precious works of art.

The brief overview presented here reveals the inadequacy of seventeenth-century depictions of the domestic interior as evidence for the tastes and patterns of consumption of Dutch families. As the inventories reveal, they not only include objects – tapestries, carpets, and musical instruments – that were seldom found in wealthy homes, but they also omit much of what was actually there. An examination of several hundred reproductions of scenes set in the interiors of large homes has revealed none showing a high density of furnishings.

In an apparent endeavor to convey an appearance of harmony, peace, and serenity, Dutch artists depicted rooms as ordered and uncluttered.[48] Paintings of domestic interiors are largely inventions, not accurate representations of an actual room. Apart from the lack of clutter, the presence of marble floors, oriental carpets, musical instruments, light streaming into the room, and the progression of views into other rooms through perfectly aligned doorways make this clear.[49]

As with other types of paintings, artists were highly selective in what they depicted. Their main concern was to sell their work, and they thus chose themes and subjects that would appeal to potential buyers. Viewers must have enjoyed feasting their eyes on attractive figures in sparsely, but expensively furnished, interiors. Such paintings perhaps served as an ideal of refined and elegant living for the couples who hung them in their homes. In Vermeer's *A Lady at the Virginals with a Gentleman* (fig. 16), the viewer's attention is drawn to the richly dressed young man and woman, the two musical instruments, the mirror, the colorful oriental carpet, and the beautiful tiled floor. A wine jug rests on the rug, and a portion of a painting can be seen at the right. The painting is an emblem of serenity.

Understandably, depictions of a small number of clearly visible and beautiful objects in well-appointed rooms would be more appealing to wealthy families than the densely-furnished rooms with which they were familiar. While many viewers today regard the paintings as mirrors of reality, seventeenth-century viewers would not have mistaken the depictions for the real thing.

Like most other seventeenth-century Dutch paintings, nearly all paintings of domestic interiors were done by men. Although there are examples of works by female painters showing mothers and children in various everyday scenes, depictions of elegant men and women in domestic

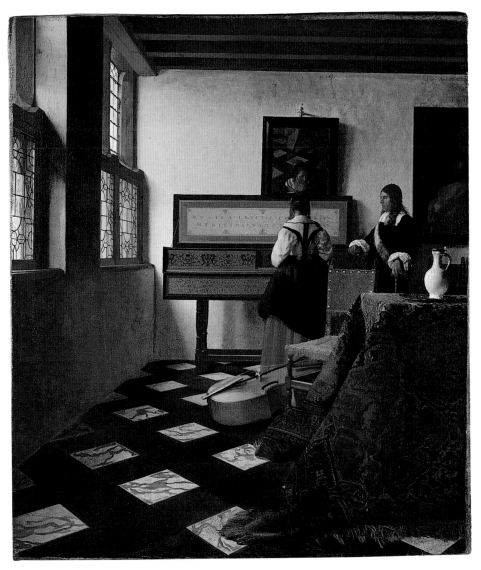

16 Johannes Vermeer. *A Lady at the Virginals with a Gentleman* (*c.* 1644). Oil on canvas, 73.6 × 64.1 cm. The Royal Collection © 2002, Her Majesty Queen Elizabeth II.

interiors seem to be unknown. Yet women were more intimately familiar with the layout, use, and furnishings of the various rooms, and might be expected to give greater attention to everyday furnishings than men.

Light

Light in interiors has seldom received the attention it deserves from scholars interested in seventeenth-century painting, or from historians of the Dutch Republic and other pre-industrial societies.[50] When it is considered, the emphasis is almost exclusively on its lack at night. As Thornton notes, writing on seventeenth-century interior decoration, it is "difficult for us to conceive how little light there normally was in a seventeenth-century house after dark."[51] Bourne and Brett also make this point in their historical survey of the forms of lighting used in the domestic interior in Europe and North America.[52] Neither study mentions light conditions during the daytime hours.

The weather in seventeenth-century Holland was much as it is now – heavy rain, intermittent drizzle, and cloudy skies throughout much of the year[53] – but the winters were more severe.[54] These conditions obviously affected the intensity of light inside people's homes and thus the visibility of whatever paintings hung there, as well as the types of shadows and reflections the paintings gave and received.

Towards the end of the seventeenth century, most windows had crossbar sash frames of wood with four or perhaps six large panels of clear glass. These replaced windows with fifty or more smaller panes of glass set in lead, which had been common earlier.[55] The houses of the wealthy had large windows in several rooms. Various combinations of curtains, shutters, and half-shutters were used to retain warmth or (less often) exclude sunlight. Privacy was not an important consideration in the *zaal* or the *zijkamer*, where the most valuable paintings would normally be displayed, because they were usually above street level.

The more formal rooms – located at either the front or the back of the house – usually had two windows, which filled two-thirds to three-quarters of the wall in which they were placed. Because most Amsterdam houses abutted each other in rows, they had no side windows. A corner house might have three or four windows in its more important rooms. In a few wealthy homes there was also an inner courtyard that served as a lightshaft for the rooms facing onto it. In most large houses, however, outside light entered rooms at the front and back of the house through

two windows. The inner rooms normally contained no windows at all (see fig. 7).

During the day, the main source of interior illumination was a mixture of direct sunlight and the diffuse light from the sky.[56] The quantity and quality of natural light in a room depended on several factors: the floor on which it was located, its dimensions, the number and size of its windows, the presence or absence of curtains and their materials, other furnishings and decorations, and the proximity of other houses. Moreover, its intensity varied within the same room, and there were always dark corners. Natural light was inadequate for viewing paintings on roughly 10 percent of the days of the year,[57] as well as in certain rooms at different times of day.

The intensity of daylight inside a house probably differed by a factor of at least 40 during the year.[58] There were tremendous fluctuations in different seasons, at different times of the day, and even within a period of a few minutes. Since the sun changes in height, direction, and color over the course of a day, the time at which paintings can be looked at will differ. The amount of light entering a room and the illumination of the different walls will also vary, so that a particular painting will be clearly visible at one time and place and not at another.

When illumination was inadequate during the day, auxiliary light was necessary. In most Amsterdam dwellings, this came mainly from a single fireplace, but the homes of the wealthy contained several fires. In addition to the one used for cooking in the kitchen, fireplaces were found in the side room, the *zaal*, any dining room, and sometimes in the rooms designated as bedrooms. There was no fireplace in the *voorhuis*, since the front door opened onto it, or in the halls, office, many children's rooms, or the rooms where the servants slept.

The fireplace in a seventeenth-century home has been described as the "seat of warmth, light and therefore, by implication, of life itself."[59] The principal feature in a room, it was usually situated on the wall opposite the entrance (although not directly opposite the door), and was thus in everyone's line of vision. The size and location of a fireplace dictated the way in which the rest of the room was used, as well as how and where paintings were displayed.

The Dutch fireplace was open on three sides. It had an overhanging hood, supported on columns or brackets, and a mantel above. In wealthy homes, the fireplace was often 2 meters or more in width, protruding 0.5 meters into the room, with a mantel as much as 2 meters high. Since

many ceilings could be more than 4 meters in height, there was ample space to display pieces of porcelain on the mantel or hang a large painting above it.

Apart from the fireplace, candles were the most common source of light. They were expensive, however, and most families used them sparingly, and poor people very rarely.[60] The "same care was bestowed on candles as on the household linen."[61] Ordinary families used tallow candles, which provided less light than the more expensive beeswax candles, were smelly, burned rapidly, and quickly deteriorated, often within twenty minutes or half an hour. Candles were much cruder than those in use today, which are usually made of paraffin wax, and it was not until the end of the eighteenth century that improvements began to be made.[62]

For most families, only the light from the fireplace lessened the abrupt contrast between day and night. Candles were used very sparingly even at night. In fact, ordinary people probably used candles almost exclusively to grope their way from a room with an open fire to another that lay in absolute darkness.[63] With such use, a candle would last for several days. It is understandable that "early to bed" was the general rule.[64] These constrictions, however, surely applied less to the wealthy, who had several fireplaces in their homes and could afford to use tallow or wax candles, as well as oil lamps. The latter, made of metal with small panes of glass, gave about the same light as a tallow candle,[65] but they cast formidable shadows.[66]

Light sources varied considerably in the care required to sustain them, the area they illuminated, and the intensity and duration of the light they provided. Candles made of tallow had a lower melting point than those of beeswax and produced a large amount of hot fat. A bigger wick was needed to burn up the excess fat,[67] and they had to be snuffed two or three times an hour. Left unsnuffed, they would give only a portion of their original light and could easily go out. A candle snuffer, which resembled a pair of scissors, was used to remove the end of a charred wick before it could fall into the molten tallow and cause the hot fat to run down the sides of the candle. Beeswax candles, on the other hand, could be left for hours without attention.

In wealthy homes, the rooms to be illuminated on dark days and at night would depend on the social organization of space. On their own after dark, family members may have gathered in one room with a lit fireplace and shared a single candle, perhaps amplifying the light through the use of mirrors. Rooms not in use would have had no light at all, and the office and the rooms used exclusively for sleeping would have had just

one candle. When in use, the *zaal*, the side room, and any dining room would have been lit by several candles as well as a fireplace. In general, the more formal rooms were better lit than those reserved for the family.

Although depictions of Dutch interiors show large brass chandeliers suspended from the ceiling, they were apparently quite rare in private homes, even the most fashionable ones.[68] They gave artists an opportunity to demonstrate their virtuosity, however.[69] The main type of candle-holder was the candlestick or candelabra, made of silver, brass, bronze, pewter, or glass. It came in various sizes, and could either stand on a flat surface or be carried from one place to another. A sconce was also quite common in the homes of the wealthy. Made of the same materials as a candlestick, it was attached with an arm to the wall, and had a reflector behind it. Lanterns containing candles sometimes hung from the ceiling.

Paintings are misleading guides to lighting: artists who included a candle in a night scene exaggerated what could actually be seen by its light.[70] But in any case few night scenes show the sources of light in a room; in fact, paintings show little in the way of lighting apparatus. Although there are fireplaces, there are rarely fires. One or two candle-sticks may be on the fireplace mantel or a table, but the candles are seldom lit. Chandeliers, whether real or imagined, hold few candles. Light and shadow are shown, but not their sources. The general absence of light sources in Dutch seventeenth-century paintings is quite astounding.

Gerard Dou's *The Night School* (see fig. 17) does show several light sources: a candle held by the child on the left, a second one in front of the child in the middle of the painting, another candle in a lantern on the floor, and still another dimly viewed in the distance. Dou (1613–1675) was known for his great skill in representing burning candles. Although the painting's title indicates that this is a depiction of a schoolroom in the evening, it could also show a schoolroom early on a winter morning. In either case, the different candles provide little illumination.

What, then, was it like to look at a painting at night or on a particularly dark day? The painting's visibility and the appearance of its colors depended, of course, on the light sources in the room where it hung. Although the open fire was the most brilliant individual source of light, it would illuminate only a portion of the room, and very unevenly at that. Still, the paintings in its vicinity would be visible, and smaller paintings could be taken over to the fireplace to be viewed, just as they could be taken to a sconce attached to the wall. Probably the most common way of viewing a particular painting was to take a candle to where it hung. A

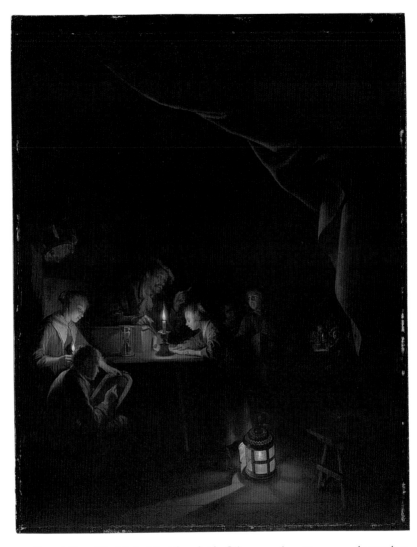

17　Gerard Dou. *The Night School* (no date). Oil on panel, 53 × 40.3 cm. Amsterdam, Rijksmuseum.

study of different lighting devices found that a single candle producing only one-hundredth as much light as a 60-watt light bulb could still effectively light up an object brought close to it.[71] The light from a single candle is never very good, however, and its flickering would impede focused vision, so that most paintings would have appeared more blurry

and ill-defined than in the hours of daylight.[72] An expensive wax candle, especially one of large diameter, would enable a painting to be visible for quite some time, and it was probably this type that was used for viewing paintings.[73]

Whether viewed by daylight, firelight, or the light of precious candles, paintings in seventeenth-century Dutch homes were less clearly and uniformly visible than they are in the controlled environment of a museum today. Light entering from the outside was subject to unpredictable change, and even the more controllable light provided by fire and candles would still create problematic bright spots and areas of excessive darkness.

The Arrangement of Paintings

It is not known how paintings were arranged in Dutch homes in the seventeenth century. As Loughman and Montias note, inventories fail to give an impression of the way in which they were hung,[74] and the most useful sources are paintings of domestic interiors and surviving dolls' houses. These scholars recognize, however, that such paintings give a mistaken impression of what the interior of a wealthy home actually looked like, because only a low density of paintings is shown, usually hung in a single row, "with considerable areas of unfilled space between each."[75] They note that this conflicts with the evidence provided by inventories, for in many instances rooms are listed as holding a large number of paintings. They suggest that the large number indicates that paintings must have been arranged in tiers.[76]

Loughman and Montias consider that dolls' houses are a more accurate record of contemporary practices than paintings of interiors, because of their comprehensiveness and attention to detail.[77] Dolls' houses were expensive art objects made by and for rich Amsterdam women in the period around 1700, and contained miniature furniture and other household objects, made to scale by skilled craftsmen. Three examples survive.[78] They each have a reception room, a lying-in room, a kitchen, an attic, and a provision room. It needs to be recognized, however, that dolls' houses were concerned mainly with how rooms in wealthy homes "ought" to look.

In both paintings and dolls' houses, these scholars noted "an almost obsessive concern with symmetry" in the arrangement of paintings.[79] This is manifested in the vertical and horizontal alignments of paintings with each other, with architectural features such as doors and fireplaces, and with furnishings.[80] Such harmony would have been difficult to achieve in

real homes because of the diversity of architectural features and the density of furnishings, but symmetry was probably still a consideration in arranging paintings in the late seventeenth century, just as it is today. As Gombrich observed, "We all know that the demand for alignment is so strong that most of us cannot bear it if a painting hangs askew."[81]

Another apparent feature of the seventeenth-century arrangement of paintings was "skying," or hanging paintings very high. According to Loughman and Montias, this practice evolved in the sixteenth century, when paintings were arranged in the narrow strip of wall between the ceiling and the wainscot or tapestry. In the Dutch Republic during the seventeenth century, wooden paneling was reduced in height and tapestries were hung only in the wealthiest of homes, but paintings and prints still continued to be hung high.[82]

An example is shown in figure 18, the *Woman Reading with a Maid Sweeping* by Pieter Janssens Elinga (1623–*c.* 1683). This obviously "designed" or made-up painting shows a large and sparsely furnished room with four chairs, a table, a mirror, and six paintings. The room seems to be at the rear of the house, with an extension behind it. A landscape painting in a tall, upright format is displayed above the door on the back wall. A portrait of similar size and format hangs at the same height on the left wall with a small seascape beneath it. Another landscape is placed quite high up, near but not next to the ceiling, with two small paintings below. The woman who is reading is illuminated by light coming through the upper part of the window on the left. The larger paintings are shown hung high on the walls, and the smaller ones at eye level where they would be more visible. Enough space remains for another row of small paintings above the tops of the chairs, but none is depicted there.

In actual rooms, the only way in which large numbers of paintings could be accommodated amidst furnishings and architectural features was for them to be hung high, with a second tier below. It is questionable, however, whether this was the preferred way of displaying them, especially when rooms could be 4 or 5 meters in height. As Loughman and Montias have pointed out, it is unlikely that all the details in pictures hung at such heights could be fully apprehended.[83] Even if they were canted slightly to make them more visible, viewers would still have to suffer the discomfort of craning their necks to see them. The presence of four-poster beds, tables, and other furniture in the room would also have made it difficult to stand back and view them from a distance. Moreover, their elevated position would have compromised the light they received,

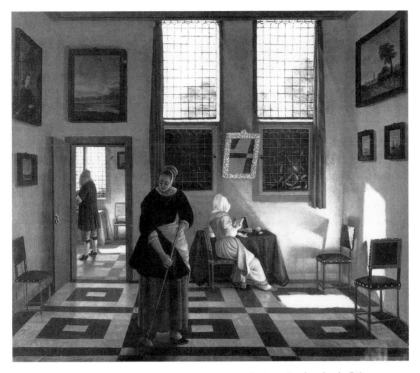

18 Pieter Janssens Elinga. *Woman Reading with a Maid Sweeping* (no date). Oil on canvas, 83.7 × 100 cm. Frankfurt am Main, Städelsches Kunstinstitut.

which would affect the appearance of their colors as well as their general visibility. Possibly the less favored paintings were placed here. The question as to how paintings would have been displayed on crowded walls, and the related one of their visibility, remains unresolved, since written sources make no mention of conditions of viewing, and the visual evidence must be treated with caution.

The focus in the rest of this book is on the role of paintings in the lives of wealthy Amsterdam families, particularly those in which human figures feature prominently: portraits, so-called scenes of everyday life, and depictions of historical subjects. Although conditions of viewing receive little further attention, they were always relevant to the viewing experience, and the reader is asked to keep them in mind.

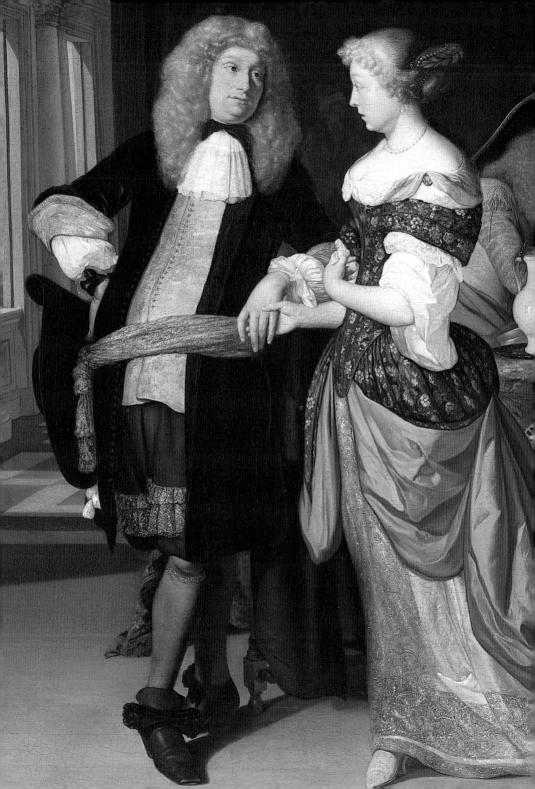

Chapter 3

Portraits: Family Members, Ancestors, and Public Figures

Although many portraits survive from the Dutch Golden Age, the vast majority of dwellings had none. Few families would inherit portraits, and most could ill afford the luxury of commissioning them: it would cost at least 6 guilders, roughly a week's wages for the average Amsterdammer, to have a portrait painted by even a workaday artist.[1] This not only means that the likenesses of nearly all Amsterdammers remain unknown to us, but also that most people lacked visual reminders about their past and present. For portraits represented gestures of respect and affection for the living, and were a way of preserving the likeness and memory of ancestors and immediate family. As Constantijn Huygens, the Dutch humanist and diplomat, put it in his diary, portraits "perform a noble work, that more than any other is necessary for our human needs, that through them we in a true sense do not die; furthermore as descendants we can speak intimately with our most distant ancestors."[2]

The elite both inherited and commissioned portraits. These recorded the family's continuity, important familial events, and family allegiances. Relatives and ancestors were not only depicted in familial roles, but also in their capacities as social and political figures.[3] This applied particularly to regent families, who generally owned the most portraits. Genealogy and the family's standing seem to have been more important to them, and their long and prominent history meant that they inherited a larger number of portraits of illustrious ancestors than other rich families. Portraits helped to concretize a family's genealogy, indicating their general worthiness.[4] Although they did not bestow status, they contributed to a family's image of who and what they were.

Probably one-fifth of the portraits in wealthy Dutch homes were of public figures unrelated to the family: government dignitaries, royalty, military and naval heroes, poets, philosophers, and religious figures.[5]

Facing page Detail of fig. 26.

Nearly all were men; the women were almost exclusively figures of royal lineage.

In trying to understand portraits in the lives of wealthy seventeenth-century Amsterdam families, portraiture itself and the relationship between the sitter and the artist are first considered, and the basic types and formats of portraits noted. The portraits owned by four wealthy Amsterdam families in the period around 1700 are then examined, and special attention is given to several portraits now in museums that once hung in Amsterdam homes.[6] Also discussed are the functions of portraits for the people who owned them, and the associations they might have kindled both in family members and outsiders.

Artists and Sitters

Before photography, portraiture was the principal means of recording and preserving an individual's identity (which involves personal character and conduct as well as appearance). Only rarely, however, does a single image, whether a photograph or a portrait, capture the many nuances of bearing, glances and gestures, body language, mood, temperament, and facial appearance that distinguish a particular person.[7] Although a large number of photographs, as in a family album, may convey an individual's particular way of sitting, standing, looking at other people, and expressing various emotions – aided by different settings, clothing, and material objects – the individual pictures can show only one particular moment, and there is no way of combining them to reveal the subject's complexity.

Portraits, particularly those done by gifted artists, may convey a richness and depth that the camera cannot capture. For a commissioned portrait – and these were expensive in the seventeenth-century Dutch Republic – a sitter would meet with an artist several times. During the many hours that they spent together, the subject would show a variety of moods, emotions, and expressions, and perhaps indicate a range of thoughts, desires, and preferences – not least about the portrait itself. The artist would see nuances in an individual's physical appearance and behavior that could never be simultaneously exhibited. Combining and interweaving these glimpses into the sitter's identity over an extended period of time, emphasizing some details and ignoring others, the artist would create a presence that would differ from what was revealed at any particular moment.[8]

Portraiture, however, also involves a degree of negotiation – explicit or implicit – between the artist and the subject. While the artist will want to use his skills and imagination to reveal the subject's identity and provide a credible likeness, the sitter may be more concerned with a pleasing appearance, so that she or he is presented in as favorable a light as possible. Portraits, then, cannot be taken at face value: even the surviving portraits of identifiable individuals are not literal representations of how they looked and who they were. Whatever the clothing worn, the pose, the objects present, or the background, in almost all seventeenth-century Dutch portraits the sitters are portrayed in an idealized manner. Arnold Houbraken, the biographer of seventeenth-century artists, provides a telling example concerning the Amsterdam painter Nicolaes Maes (1632–1693):

A certain lady (whose name I do not wish to mention), far from the fairest in the land, had her portrait painted by him, which he depicted as it was with all the pockmarks and scars. When she arose and beheld herself in all her ugliness she said to him: "The devil, Maas, what kind of monstrous face have you painted of me! I do not wish it thus, the dogs would bark at it were it to be carried in the street like this." Maas, who saw in a trice what was required of him, said: "Madame, it is not yet finished," and asked her to be seated once more. He took a badger-hair brush and removed all those pockmarks, put a blush on the cheeks and said: "Madame, now it is ready, please come and inspect it." Having done so she said: "Yes, that is as it should be." She was satisfied when it did not resemble her.[9]

Artists worked hard to improve the appearance of their sitters, particularly their faces. They did this mainly by eliminating various features that were considered undesirable, such as the scars or pock-marks caused by smallpox and other disfiguring diseases. Portraits very rarely show moles, warts, freckles, large pores, bad complexions, facial hair among women, bags under the eyes, bulging or squinty eyes, or unusually long or short necks. There are few flat or wide noses, big ears, receding or double chins. Even wrinkles are uncommon. No one has yellow or discolored teeth. In fact, teeth are seldom shown at all. Tooth brushes did not exist; there were no orthodontists to tend to crooked teeth; extractions involved the use of something akin to a pair of pliers; and false teeth were extremely primitive. Since the condition of many people's teeth must have been deplorable, it is understandable that they kept their mouths

closed when sitting for portraits. Although overweight people do appear in surviving seventeenth-century Dutch portraits, they are rare, and are more often men than women.[10] Most women are portrayed as free of excess fat, especially when wearing fashionably low-cut gowns. Still, there had to be some resemblance between the portrait and the portrayed. After all, both the artist and the sitter would be aware that viewers – who would include relatives, friends, acquaintances, and servants – had to be able to recognize the individual depicted.

Most portraits of wealthy seventeenth-century Dutch family members are formal, sober depictions of men and women in dark clothing, against a neutral background. Simple in pose and setting, they communicate moderation, restraint, calm, and decorum.[11] But there are exceptions, especially in portraits from regent families, where the men and women are modishly dressed and portrayed against grandiose, often classical backgrounds.[12] Sometimes musical instruments, oriental carpets, books, maps, globes, jewelry, or other objects that were either intrinsically valuable or related to the sitter's social or political positions are included. These "props" were usually supplied by the artist, as in the case of the Amsterdam painter Michiel van Musscher (1645–1705), who specialized in portraits of regents and other wealthy families.[13] Figure 19 shows the artist in his Amsterdam studio in 1679. According to an inventory, his atelier contained a *viola de gamba*, a guitar, a harp, a lyre, two violins, two *citers* (the oval-shaped instruments seen in seventeenth-century paintings), and bagpipes. There were also a globe (fairly rare, even among wealthy families), a suit of armor, seven Cupid-like hanging statues, and various other objects used by artists and listed in their inventories. Three table-carpets were among them, including perhaps the oriental carpet that van Musscher used in fourteen different paintings.[14]

Little is known about the amounts that artists were paid for commissioned portraits in the seventeenth-century Dutch Republic.[15] Rembrandt, for example, was renowned at the time and had many clients among the city's ruling elite, yet there are only two portrait commissions for which the amount paid to him is known.[16] One is the full-length *Portrait of Andries de Graeff* (see fig. 24), for which he was paid 500 guilders in 1639. Rembrandt was still regarded as basically a tradesman.[17] While today possession of a painting by him serves as a grand symbol of prosperity and status, in seventeenth-century Amsterdam regent families were already at the top of the social ladder and did not need to concern themselves with status-enhancing pursuits. In fact, the relation-

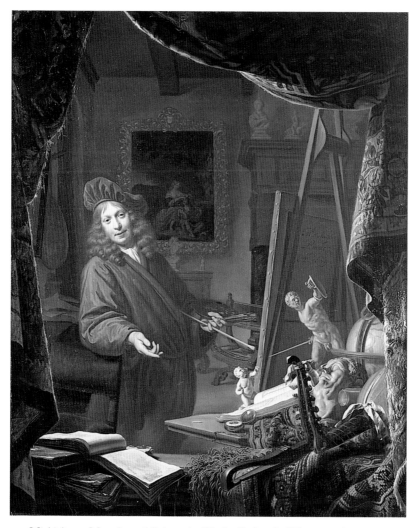

19 Michiel van Musscher. *A Painter in His Studio* (1679). Oil on panel, 48 × 47 cm. Rotterdam, Historisch Museum.

ship usually went the other way: the presence of an artist's work in a wealthy home often helped to establish or maintain his (or, rarely, her) reputation.[18]

In 1654 Rembrandt was commissioned to paint his now-famous *Portrait of Jan Six* (see fig. 20). He and this wealthy patron (who is discussed below) knew one another well, and had spent time together over a period

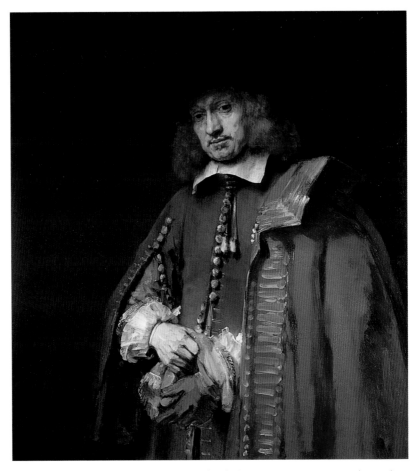

20　Rembrandt van Rijn. *Portrait of Jan Six* (1654). Oil on canvas, 112 × 102 cm. Amsterdam, Collectie Six.

of several years, so that the portrait is more likely than most to capture the unique identity of the sitter.[19] Six, who was twelve years younger than Rembrandt, had become acquainted with the artist in 1647 and owned several paintings and drawings by him. He thought highly enough of Rembrandt to loan him 1,000 guilders in 1656. For unknown reasons, he asked for the money back, but Rembrandt was unable to pay. Six arranged for a third party to take over the debt at a discount, which ended his relationship with the artist. In the portrait, Six wears what appears to be a partially-buttoned long gray tunic, with a gold-braided red coat casu-

ally draped over one shoulder. There is a sober expression on his face, his head is turned slightly to one side, and his eyes are partly hidden by the shadows cast by the hat. He comes across as serious and reflective, lost in thought as he pulls on his glove.

Seventeenth-century Dutch portraits are in four basic formats: bust-length, half-length, three-quarter length, and full-length. In general, these represented a hierarchy of cost as well as size. The bust-length portrait was the most common format among the less well-to-do, and the finest portrait painters of the period seldom used it. Most portraits were in the half- and three-quarter-length formats. Full-length portraits were the least common, because they were more expensive and required more space for display. According to Smith, this more formal format also created a sense of distance between the sitter and the viewer.[20] This may well have been the intention of the patron, since full-length portraits appealed mainly to members of the regent class. Most of the portraits present the sitter in full or three-quarter face rather than in profile, looking directly at the viewer. Whether or not this was the wish of the portraitist or the patron, it creates a more lifelike effect.

Matched portraits or pendant pairs were generally the most highly evaluated type of portrait in wealthy homes. Such a pair is shown in a painting by Jacob Ochtervelt (1634–1682). They are hung very high, almost touching the ceiling, and with a narrow gap between them (see fig. 21). Although there is space for further paintings below, none is depicted. The room's furnishings suggest that it is intended to depict a *zaal* in a rich household. Pendant pairs were much more common in seventeenth-century Holland than double portraits (where a husband and wife are shown in the same painting).[21] This may be because pendant portraits maintained the autonomy or indi-

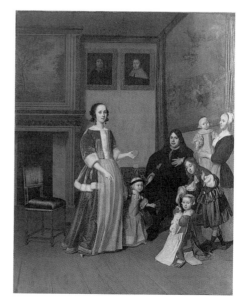

21 Jacob Ochtervelt. *Family Portrait* (*c.* 1664). Oil on canvas, 29.9 × 24.1 cm. Hartford, Conn., Wadsworth Atheneum.

viduality of both husband and wife. In addition, Dutch homes rarely had enough continuous wall space to accommodate the wider double format,[22] although this would hardly have been a consideration for the families who lived in large double-fronted houses.

Portraits in the Lives of Wealthy Families

The first of the four families to be examined here is Jan Six, who is depicted in Rembrandt's portrait discussed above. Born into a regent family, Six married Margareta Tulp at the age of 37 in 1655. Then aged 20, she was the daughter of Dr. Nicolaes Tulp, a former burgomaster. An art lover and a writer of plays and poetry, Six served as an Amsterdam burgomaster, was a member of the city council, and occupied other important positions in the city government. In 1674 his wealth was estimated at 280,000 guilders. His house, Herengracht 619, was designed for him by Adriaan Dortsman (1636–1682) and built in the period 1667–69. It is extremely large and imposing, but little is known about its original interior layout. The façade was divided into three bays, rather than the normal five for a house on a double lot.[23]

Jan Six died in 1700 and his wife in 1709. At that time, more than eighty paintings adorned their residence,[24] of which forty-four were portraits.[25] The Six house contained a room (the *konstzaal*) that was expressly intended for the display and viewing of art works, a very unusual feature for an Amsterdam home at this time. Located on the ground floor at the front of the house, it received light through a large window facing onto the Herengracht. The Rembrandt portrait was displayed there, as were ten other portraits of friends and relatives. The descriptions of some of these included the title of the government position occupied by the sitter: two portraits of Burgomaster Six and his wife ("de heer Burgemeester Six en vrouw"), two of Burgomaster Six alone, and two others of Margareta's father, Burgomeester Tulp. There were also six other paintings in this room: a "grand" (*Capitael*) landscape by Hendrick Vroom (1566–1640), another landscape in which Burgomaster Tulp was shown, a depiction of Hercules and Venus by Jan Gossaert (*fl.* 1503–32), a small history painting by Gijsbert Sybilla (*fl.* 1635–52), an unattributed still life, and a large painting by Anthony van Dyck (1599–1641), which filled the space above the fireplace mantel.

Compared to other rooms in the Six home, the art gallery was sparsely furnished, so that despite a large window, fireplace, and door, there was

plenty of space to display the paintings. It held five chairs, upholstered with green velour, an oak table, three cupboards, and an iron chest. Among the contents of the cupboards and chest were porcelain, various medals, silver objects, compasses, a magnifying glass, jewels, gold coins, books, a personal journal, and other documents, including the couple's marriage agreement. A family coat of arms or heraldic shield hung on the wall. In the public rooms of most grand houses, there would be a large number of chairs lined up against the walls, their high backs restricting the hanging space for pictures. Here, however, the presence of just five chairs meant that they could be placed near the center of the room, or moved at will for people to sit and examine the paintings.

Above the art gallery was a room with furnishings that suggest it was used as a bedroom by Margareta. It contained a four-poster bed, ten chairs, a cupboard, a mirror, and various other items of furniture. The cupboard held napkins, sheets and blankets, and an unspecified number of silver objects. Twenty portraits hung in the room, several of which Margareta had brought with her when she married. All were of family members and ancestors, but no one is identified specifically by title or function in the inventories. A large window, a fireplace, and two candlestands provided light. Two female servants slept in the room next door, which was simply furnished and contained a bed with a straw mattress, a table, a small cupboard, two hat-racks, and a clothes brush.

It is unknown who in the Six family decided where to hang this unusually large number of portraits, but given the fact that they included depictions of husband and wife as well as the ancestors of both, it seems likely that the couple took this decision jointly. Those portraying Jan or other family members in their official capacities were hung in the special art gallery, together with a small number of other valuable paintings. The paintings in the art gallery were, so to speak, for public display. In line with common practice, portraits of a more personal nature were hung in private rooms, away from public gaze.[26]

The family of Pieter de Graeff and his wife, Jacoba Bicker,[27] who also lived on the Herengracht, far exceeded the Sixes – as well as most other wealthy Amsterdammers – in the number of paintings they possessed that concerned their history and position in the Dutch social hierarchy. Pieter de Graeff was born in 1638. Like his father, he attended the Latin School, but it is unknown whether he went on to university (there is no record of his obtaining a degree). He was later to be an Amsterdam burgomaster, to occupy other positions in the city government, and to serve

as an officer of the Dutch East India Company. Although not a member of the nobility, he also bore a title. His grandfather, Jacob, had purchased the manor of Zuid-Polsbroek in Soestdijk from a prince of the Southern Netherlands in 1611.[28] Ownership enabled him to call himself Lord (*Vrijheer*) of Zuid-Polsbroek, and succeeding generations of de Graeffs also used the title. Like coats of arms and hunting rights, the use of titles was supposed to be the exclusive prerogative of the nobility, but as their power and wealth dwindled so did their privileges.[29] The cost of purchasing a title was considerable, more than 10,000 guilders around 1700.[30] Possession of a title bestowed a certain prestige, even on families who did not actually belong to the nobility. Although wealthy regents began to display their coats of arms, as Jan Six did,[31] few used titles. The de Graeffs, however, certainly made a point of doing so.[32]

In 1662, when Pieter de Graeff was 24 years old, he married Jacoba Bicker, aged 22. The Bicker family also belonged to one of the great Amsterdam regent dynasties of the seventeenth century, and was conceivably the most powerful in the city.[33] The couple's large house on the Herengracht had been built in 1664 for Pieter's parents, Cornelis de Graeff and Catherina Hooft, but his father died in the year it was finished and the house was given to him and his wife by his mother.[34] Erected on a double lot, it was 14.7 meters wide and more than 18 meters deep.[35] More than a hundred paintings hung in eight rooms of the house. Roughly half seem to have been portraits, and only three among the identified ones were of figures outside the family. There were three pendant pairs (but no double portraits) listed in the inventory, including those mentioned below. In several portraits, Pieter de Graeff and Jacoba Bicker are described as Lord and Lady of Polsbroek.

The de Graeffs could watch the family genealogy unfold before their eyes in the *Groote kamer* or great room, where fifteen portraits were displayed, more than anywhere else in the house. The equivalent of the *zaal* in other houses, this room was exceptionally large by Amsterdam standards:[36] it was probably about 11 meters long, 8 meters wide, and had a ceiling 5 or 6 meters high.[37] It held three still-life paintings as well as the fifteen portraits, a sizable number of pictures for a room that contained many other decorations and furnishings, in addition to a large fireplace and several doors and windows. Among the contents of the room were a large four-poster bed with bedclothes and curtains, six upholstered walnut chairs, six chairs without upholstery, five armchairs, several cupboards, three mirrors, some gilded coats of arms, a joint genealogical chart

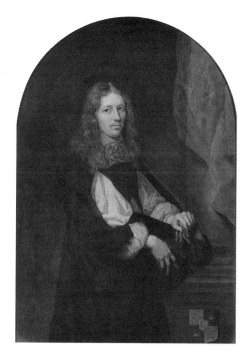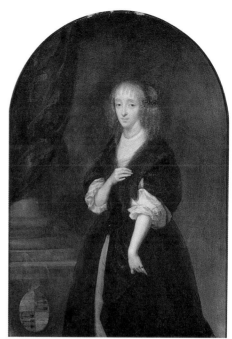

22 Caspar Netscher. Portraits of *Pieter de Graeff, Lord of Zuid-Polsbroek, Purmerland and Illpendam, Alderman of Amsterdam* and *Jacoba Bicker, Wife of Pieter de Graeff* (1663). Both oil on panel, 51 × 36 cm. Amsterdam, Rijksmuseum.

of the de Graeff and Bicker families, separate charts for each of them, and four walnut candlestands.

There were also a marble portrait bust of Pieter's uncle, Burgomaster Andries de Graeff (1611–1678), and another of the powerful Johan de Wit (1623–1672), Pensionary of Holland and effective head of government, who was married to Pieter's aunt. Placed on pedestals, the former was 75 cm high and the latter 95 cm. Both were done by Artus Quellinus (1609–1668), a distinguished sculptor living in Amsterdam at the time. The statue of Andries de Graeff depicted the burgomaster as a Roman consul, one reflection of the family's ambition to be compared with the statesmen of ancient Rome.[38]

In the prime position above the mantel of the fireplace was a portrait of Cornelis de Graeff painted by Jan Lievens (1607–1674). The other fourteen portraits were distributed among the many furnishings and decorations of the room. This would have made it difficult for people to focus on them, unless some were in their line of vision when seated on chairs.

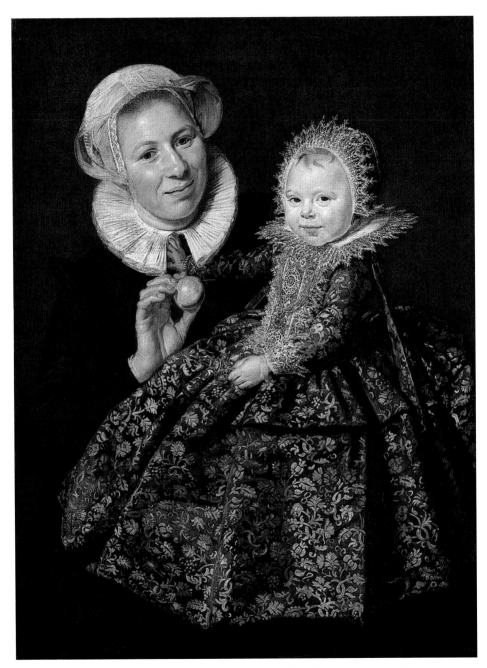

23 Frans Hals. *Catherina Hooft at the Age of Two Years with Her Wet Nurse* (*c.* 1619–20). Oil on canvas, 91.8 × 68.3 cm. Berlin, Staatliche Museen.

Many of the sitters were identified by their titles, and all by name. There were two sets of portraits of Pieter de Graeff and his wife. The pendant pair of three-quarter-length portraits by Caspar Netscher (1639–1684), dated 1663, was painted shortly after the couple's marriage (see fig. 22). A portrait of Pieter by Gerard ter Borch the Younger (1617–1681) and one of Jacoba by Gerard van Zuil (1607–1665) were both done in 1665, but it is unclear whether they were pendants. Both they and the Netscher pair of portraits were appraised at 160 guilders. Other paintings in this room were also painted by famous portraitists, including Michiel van Musscher (1645–1705) and Bartholomeus van der Helst (1613?–1670).

There were another thirteen portraits in the "green room," a room used by the mistress of the house. Few were identified by name or title; most were described simply as "a portrait," or perhaps as "a portrait of a woman." Among the identified ones was a matched pair of Pieter de Graeff and his wife, and a portrait of a woman and child by Frans Hals (see fig. 23), which depicts Pieter's mother, Catharina Hooft, at the age of two with her wet nurse.[39] In fact, Pieter de Graeff and Jacoba Bicker owned only two intimate family portraits, that is, portraits showing parents and children together. Most of their portraits were of a single family member.

Other paintings and objects in the de Graeff home celebrated the history and importance of the family. In the dining room was a painting appraised at 100 guilders and described as a company of citizens ("een Companie burgers") by Gerard Lundens (1622–1683). A greatly reduced copy of Rembrandt's so-called *Night Watch* (Amsterdam, Rijksmuseum), it includes a portrayal of the militia captain, Frans Banning Cocq, who was related to the de Graeff and Hooft families. *A Company of Citizens* is now in the National Gallery in London. In the small side room with portraits of other relatives was Rembrandt's full-length *Portrait of Andries de Graeff*, Pieter de Graeff's uncle (see fig. 24). Given the size of the room where this large painting hung, no one would have been able to stand far enough back to view it in its entirety. Despite the fact that Rembrandt was paid 500 guilders for it in 1639, it was appraised for a considerably lower sum in the inventory of the de Graeff paintings: 120 guilders. It may be that the appraisal was perfunctory, since the portrait was to remain in the de Graeff family. It is also possible that the art appraiser considered that its market value was much less than the sum paid for it. Although painted by a famous artist, few outside the family would have had much interest in its subject matter.

24 (*right*)　Rembrandt van Rijn.
Portrait of Andries de Graeff (1639).
Oil on canvas, 199 × 123.5 cm. Kassel,
Staatliche Museen.

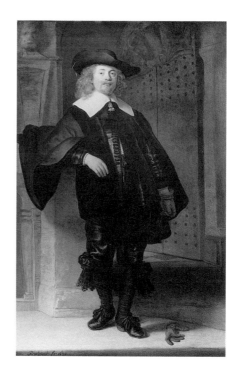

25 (*facing page*)　Thomas de Keyser
and Jacob van Ruysdael. *A Wooded
Scene near The Hague with Family
Portrait of the de Graeff* (*c*. 1655). Oil
on canvas, 171 × 117 cm. Dublin,
National Gallery of Ireland.

Several maps of the Polsbroek estate in Soestdijk, as well as of the de
Graeff farm in Ilpendam, also hung in the house. Moreover, at least eight
landscape paintings depicted family properties. One painted jointly by
Thomas de Keyser (1597–1667) and Jacob van Ruysdael (1629/30–1681)
showed the Cornelis de Graeffs (Pieter's parents) at their Soestdijk estate
(see fig. 25). A mansion in the background, an expensively decorated
coach pulled by four horses, and the entourage accompanying the Lord
and Lady of Polsbroek are central to this depiction of a family who
wanted to present themselves as landed aristocrats. Pieter de Graeff
inherited the painting from his parents, and it hung in the room of his
daughter Agneta. Another painting depicted him at a hunt.

Like some other rich families, the de Graeffs sought to emulate the
ancient Roman landed aristocrats. The education that Pieter de Graeff
and his father had received at the Latin School surely familiarized
them with the Roman poets Horace, Virgil, and Ovid, and thus with the
ancient celebration of the pastoral life, an ideal that appealed to many
city-dwellers in seventeenth-century Europe. A rural, agricultural exis-
tence, they argued, fostered a love of liberty, a sense of temperance, and

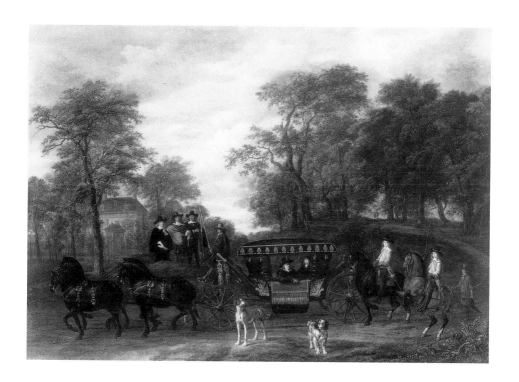

a degree of independence lacking in people who made their homes in the city. But like the ancient Romans, they enjoyed a luxurious life-style that was far removed from the rustic existence they celebrated.

More is known about the de Graeff paintings than those of their Amsterdam contemporaries, largely because their portraits and some other pictures remained in the family until 1872, which was extremely unusual. They also owned two works by Philips Wouwerman (1619–1668), two by the Italian artist Palma Giovane (*c.* 1548–1628), and a few other paintings by well-known artists. Wouwerman, as a painter of landscapes with horses, was popular among families who enjoyed hunting. The two works by Palma Giovane were paintings of nude gods and goddesses. As with the paintings in other wealthy households, most of the couple's paintings were unattributed.

It seems unlikely that either Pieter de Graeff or Jacoba Bicker had a strong interest in art per se. Nor did they show any particular interest in expensive furniture. Although the rooms were all densely furnished, the furniture was of modest value. In the *groote kamer*, for example, the four-poster bed and its bedding were appraised at 30 guilders, two walnut cup-

boards at 20 guilders, six upholstered chairs at 90, and six other chairs at just 12 guilders. The couple's porcelain, on the other hand, was worth several hundred guilders, and their jewelry around 800 guilders. They were especially interested in silver: this was valued at 12,234 guilders. There is no indication of where it was located. The de Graeffs may have had more of an aesthetic feeling for silver than they did for paintings, or perhaps just regarded it as money in the bank.

Among the rich families that owned a comparatively small number of paintings were Maria Elenora Huydecoper van Maarsseveen and Pieter Reael, who lived in a large house on the Singel that was built for Maria's grandfather between 1639 and 1642; it has been described as "a spectacular urban palace."[40] Both Maria Elenora's father and grandfather had been burgomasters of Amsterdam. Her husband, Pieter Reael, was also from a regent family background and occupied high office in the city government.

Lord and Lady Vreeland, as the couple were known, were extremely wealthy. When Maria Elenora died in 1706, their twenty-three paintings were appraised at 2,148 guilders.[41] This was an unusually high evaluation: an average of more than 90 guilders per painting, even though three pictures were appraised at less than 10 guilders. The paintings were not listed according to the room in which they were hung, so it is not known where specific works were placed.

Twelve of the twenty-three paintings were portraits. A pendant pair of Lord and Lady Vreeland by Caspar Netscher received the highest appraisal, Zomer giving the two a value of 400 guilders. A portrait of Lady Vreeland alone, by Netscher's son, Constantijn, was appraised at 150 guilders. Another portrait by Constantijn Netscher, of an unidentified female relative, was valued at 100 guilders. The rest of the portraits were not attributed to any specific artist, and each was evaluated at between 20 and 40 guilders. A portrait of the couple's four oldest children was appraised at 40 guilders.

Maria Elenora and Pieter owned other valuable pictures besides costly portraits. The most highly appraised painting in their large house on the Singel was a depiction of *Christ Bearing the Cross* by the German graphic artist and painter Albrecht Dürer (1471–1528), which was valued at 300 guilders.[42] Three were landscape paintings: a grand battle scene and a painting of a hunt by Philips Wouwerman, both appraised at 250 guilders, and a landscape with horses and other animals by Jan Asselyn (*c.* 1610–1652), valued at 200 guilders. Since the couple owned a country home in

Maarssen, where they would have hunted and gone horseback riding, such paintings probably had a personal significance for them.

Pieter and his wife spent eighteen years of married life together (Maria Elenora survived her husband for six years, and died at the age of 48). Like many rich couples, they maintained separate bedrooms, and, again as was usual, the wife's had the more expensive decoration.[43] The four-poster bed and bedding in Pieter's bedroom were valued together at 40 guilders, a cupboard at 20 guilders, eight chairs at 10, a mirror at 8, and a table covering at 3 guilders; eight small lacquered boxes were valued at 8 and nine pairs of gloves at just 2 guilders. The large oak bed in Maria Elenora's bedroom was valued at 235 guilders, an olive-wood cupboard at 100 guilders, sixteen "English" chairs at 112 guilders, ten other chairs at 12 guilders, a mirror at 18 guilders, four maps at 8 guilders, and two oak chests at 8 guilders.

Apart from the bed, the most costly items of furniture in the house were a carpet on the floor in the *zijkamer* evaluated at 130 guilders and three olive-wood cupboards (including the one in Maria Elenora's bedroom), appraised at 100 guilders each. No clock or musical instruments are mentioned. Maria Elenora possessed unusually valuable jewelry, however, including diamonds, rings, and gold buttons appraised at 5,547 guilders, which were kept out of sight in one of the cupboards. Silver objects, on the other hand, were appraised at less than 300 guilders. Porcelain in the side room, the *zaal*, the dining room, and elsewhere was valued at more than 1,600 guilders. The porcelain teapots, beakers, plates, cups, saucers, and other objects were displayed prominently on top of an olive-wood cupboard and above the fireplace mantel.

The most highly valued category in the house, however, were the linens, which were appraised at more than 6,000 guilders. They also were kept in cupboards. There were hundreds of napkins, tablecloths, hand towels, sheets, blankets, and handkerchiefs, as well as various costly items of women's clothing, including nightshirts, chemises, gloves, stockings, dresses, and skirts. Some of the clothing was of silk and satin, and there were also East Indian (*oostindische*) skirts embroidered with gold thread. Few households would have contained such expensive linens and clothing.

Maria Elenora had developed her appetite for expensive clothing while living in Paris, where there was a much greater emphasis on fine attire than in Holland. In Paris, she would have improved her spoken and written French, followed dance classes, and become acquainted with French culture and high society.[44] She went there in the period 1678–80,

between the ages of 20 and 22, at a time when France was assuming a dominant position in Europe. In one of her weekly letters (it was the custom for daughters to write to their mothers and sons to their fathers), she informed her mother that she needed extra money for new clothing, because in Paris one was expected always to be nicely dressed. Whether or not the money was sent, her mother passed on her father's wish that she try to be more thrifty. Maria Elenora returned to her parents' home in September 1680 and remained there until her marriage to Pieter Raeal in the spring of 1683.[45]

A painting by Eglon van der Neer (see fig. 26), which may be intended as a brothel scene, shows fashionably dressed men and women in an interior in 1678. The materials are costly and colorful, the men have beautifully coifed wigs, and the women appear to wear whalebone corsets under their low-necked gowns.[46] This sort of shoulder-to-shoulder décolleté can be seen in many contemporary portraits. The painting, however, is more idealized than realistic:[47] the classicizing architectural elements and the furnishings show that it is a "made-up" painting and not the interior of a real home.

Carel Rudolf van Kuffeler and his second wife, Adriana van Dam, who lived on the Binnen Amstel, owned more than ninety paintings, which included a different mixture of portraits than in the households examined thus far.[48] Van Kuffeler had six children from a previous marriage, and one from his marriage to Adriana van Dam. He died in 1702 at the age of 58. Eight portraits of the family and relatives were hung in the front room upstairs, which was intended for family use. They included a pendant pair of van Kuffeler and his second wife, valued together at 280 guilders; another of "father and mother," evaluated at 200 guilders; and a pair described as "grandfather and grandmother," appraised at 30 guilders. Another portrait valued at 200 guilders was of "grandfather with his wife and children." Despite the high evaluations, no painters' names are provided for any of the pictures.

In his treatise on art written in 1621, Giulio Mancini advised that "portraits of illustrious personages, either in peace, war, or in contemplative matters, as well as portraits of popes, cardinals, emperors, kings, and other princes, should be in those places accessible to everyone."[49] In the *zaal*, van Kuffeler and his wife displayed portraits that expressed their allegiances.[50] They had an entirely different character from those in the room upstairs. With one possible exception, all were associated with Prussia, where van Kuffeler had been an official envoy to the king. Far

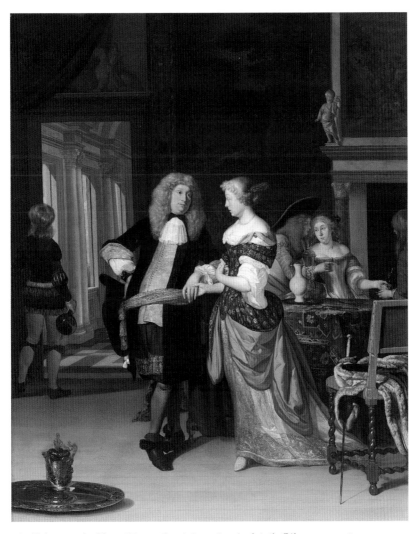

26　Eglon van der Neer. *Elegant Couple in an Interior* (1678). Oil on canvas, 85.5 × 70.1 cm. Johnny Van Haeften Ltd., London.

and away the most highly evaluated was a portrait of the King of Prussia ("De Koninck van Pruyssen"), which was appraised at 1,450 guilders. Its monetary value was largely dependent on its frame, however, which was inlaid with diamonds, the reason that the special art expert classified it separately from the rest of the paintings. Three other portraits showed

the King of Prussia on a horse. Two were evaluated together at 300 guilders, and the third at 80 guilders. A portrait of the King of England ("De Koninck van Engeland"), described as life size (*levensgroote*), was evaluated at 150 guilders. The only portrait not depicting a public figure was of the three van Kuffeler brothers. It was appraised at 80 guilders.

Families, then, valued their portraits for different reasons. Jan Six is frequently described as a collector and lover of art,[51] and he and his wife, Margareta Tulp, not only owned portraits by well-known artists – as well as many other valuable paintings – but had a special art gallery in which to exhibit and look at them. By contrast, the de Graeffs, who commissioned paintings from several famous artists – Rembrandt, Frans Hals, Caspar Netscher, Gerard ter Borch, Bartholomeus van der Helst, and Jacob van Ruysdael – appear to have done so mainly to record and celebrate their own importance. For some, the associations that portraits evoked were probably more important than the artist who created them. Although Pieter de Graeff and Jacoba Bicker probably knew that their painting of Pieter's mother with her wet nurse was by Frans Hals (see fig. 23), its value to them no doubt rested primarily on its associations: for Pieter, it was a representation of his mother; for Jacoba, an image of the woman who was to become her mother-in-law. If she had had a wet nurse herself, it may also have been a reminder of her own infant experiences.

Particular portraits must have kindled a variety of feelings, from pride to love and affection, but some must have caused negative memories and feelings. The portraits of Maria Elenora's parents, Joan Huydecoper and Sophia Coymans, in the house that she shared with her husband, Pieter Reael, may be a case in point. According to a study based on the Huydecoper family archives, there was a bitter feud between Pieter Reael and his parents-in-law, which began when two of his wife's brothers reported to their father that Pieter had made insulting remarks about him. Other episodes soon followed.[52] A serious fight broke out when Pieter advised Maria Elenora, eight months pregnant with their second child, not to breast-feed the child but to engage a wet nurse.[53] Whatever his reasons, her parents were outraged and thought Reael ought be thwarted.[54] Although Maria was eventually able to reconcile her father and husband, her mother was less forgiving. In any case, Pieter and his in-laws did not care much for one another, and their relationship remained tense to the end. Portraits evoking negative feelings would probably still have been displayed, particularly while the subjects themselves were alive.

Portraits preserved the likeness and memory of ancestors and close family members, recorded important family events and relationships, helped to consolidate solidarities across generations, contributed to a family's self-image, and indicated a family's familial and political allegiances. Those in the homes of the city governors, successful merchants, and other prominent families may have served an exemplary function as well. Depictions of self-discipline and restraint provided models of behavior and reflected the importance of the Stoic ideal of tranquility.[55] As Westermann notes, "Preferred qualities in portraiture of the citizenship elite included moral strength, moderation, learning, eloquence, social grace, and fidelity to spouse, profession, and city."[56] Depictions of wives and mothers, on the other hand, were supposed to display exemplary virtue. Portraits shaped both attitudes and behavior. They would remind husbands and wives of their respective responsibilities and prerogatives, and help to inculcate a "proper" morality in children, who were perhaps taken by the hand to view the portrait of a particular ancestor and listen to a recitation of his or her special virtues. If nothing else, they made the sons and daughters of the elite conscious of how they differed from ordinary people.

In the absence of written documentation, there is no way of knowing how visitors responded to portraits seen in a home. Clothing would have indicated when a portrait was painted, but not who the sitter was. Did outsiders ask about the identity of the person depicted? If so, did they ask anything more about the person? There are no answers to such questions. It seems safe to assume, however, that representations of a family's illustrious ancestors would kindle feelings of awe, admiration, and respect in many visitors from outside the family circle. According to some scholars, they may also have represented an ideal to strive towards. Deference may have been one response,[57] feelings of envy, jealousy, disapproval, and irritation may have been others, particularly in such homes as the de Graeffs, where an unusually large number of portraits were displayed. But whatever the functions of the portraits hung in Amsterdam homes – and the varied responses to them – the situation in the seventeenth-century was different from that in museums today, where it is the artists rather than the sitters who attract attention.

Chapter 4

Christ, the Virgin Mary, Venus,
and other Religious and Mythological Figures

In the seventeenth-century Dutch Republic, history paintings – works with identifiable human figures in religious, mythological, or allegorical scenes – were usually larger than paintings in other genres, and thus often the most prominent art works in the rooms in which they hung.[1] They were also the most valuable paintings, and those by foreign masters were generally more valuable still. Italian paintings, especially ones from earlier periods, were particularly costly. Although only a few Dutch families owned such works, most of those who did had paintings of subjects that were or had been popular in Italy. This chapter thus begins with a brief consideration of the cultural–historical context in which history paintings were produced in fifteenth- and sixteenth-century Italy and then goes on to examine the subjects of the paintings. The display of such subjects in some seventeenth-century Amsterdam homes, their possible significance for the people who owned them, and the response of men and women to erotically charged pictures are then discussed.

The Subjects and Themes of History Paintings

Most fifteenth-century art works in Italy were religious paintings intended for churches and other religious buildings, created as objects of veneration, mystical contemplation, and religious instruction. Wall paintings, altarpieces, and other panel paintings mainly portrayed narratives from the New Testament. Scenes from the Life of Christ, particularly his Birth, Passion, and Resurrection, and portrayals of the Virgin Mary, the Christ Child, the four evangelists and various other saints were particularly popular, as were some Old Testament figures.[2] Such themes were also common in paintings produced for princely courts, popes and cardinals, poets and scholars, doctors and lawyers. Dozens of Italian masters

Facing page Detail of fig. 37.

were kept busy turning out innumerable compositions of the Virgin and Child for private devotion too. Wealthy patrons desired paintings that would appeal primarily to the senses; intellectual stimulation or moral instruction were secondary considerations. The emotions depicted were intended to kindle feelings of empathy and compassion, to stimulate a viewer's religious sensibilities, especially paintings of the Passion of Christ – the Flagellation, the Crowning with Thorns, the Carrying of the Cross, the Crucifixion, and the Descent.[3]

Under the influence of the humanists, who expressed an enthusiasm for classical literature and ideals, the dominance of religious themes in art began to weaken.[4] For humanists, the Greek and Roman past was the model and guide for erudition, education, manners, dress, aesthetic sensitivity, and conduct more generally. Italian artists began to draw heavily upon forms of classical imagery in their work, and excavated antique statues were followed as models of ideal classical beauty. The themes of classical antiquity with their gods and goddesses were revived and used in the service of the Christian religion.[5] Images in both the public and private world thus became more secularized,[6] especially in Venice. By the end of the fifteenth century, mythological themes were treated as part of history painting.[7]

Works by the classical poets Ovid, Homer, and Virgil provided the source for most non-religious art produced in Italy up to the eighteenth century.[8] But although a painting's status might be improved if its subject could be associated with a classical text, artists did not provide slavish pictorial equivalents of the ancient themes. Few painters, as one scholar remarked, "composed with a copy of the text propped up by their easel."[9] Themes were also often chosen because they enabled artists to provide the kind of explicitly erotic representations that would evoke sexual responses.[10] The following passage from a letter written by the famous sixteenth-century poet Annibal Caro to Giorgio Vasari, referring to a painting he had commissioned from the artist, shows that some patrons specified that such figures should be included, in this case leaving it to the artist to select a suitable theme:

> Provided there are two nude figures, a male and a female (which are the most worthy objects of your art), you can compose any story and any attitudes you like. Apart from these two protagonists I do not mind whether there are many other figures provided they are small and far away; for it seems to me that a good deal of landscape adds grace and

creates a feeling of depth. Should you want to know my inclination I would think that Adonis and Venus would form an arrangement of the two most beautiful bodies you could make, even though this has been done before.[11]

Caro's principal concern was to acquire a satisfactory and attractive composition; the subject of Venus and Adonis was not chosen for any intrinsic meaning but because it was an appropriate one for such a painting.[12]

As wealthy connoisseurs and collectors increased their demand for such pictures, so Italian artists extended their range of subject matter. Around 1500, for example, the sleeping female nude became a popular theme in non-religious paintings. The *Sleeping Woman in a Landscape* (Dresden, Gemäldegalerie), usually attributed to Giorgione but more recently given to Titian, became the prototype of innumerable sleeping or reclining female nudes by various artists in Venice and elsewhere. The figure may represent Venus, goddess of love and one of the twelve great Olympian divinities, although sleeping Venus is a conception unknown to classical literature and art.[13] Usually portrayed nude or scantily-clad, Venus was the subject of various myths and legends and inspired artists through the ages. Such paintings were typically painted for the private enjoyment of a culturally sophisticated elite.[14]

But it was not only mythological paintings that provided vehicles for erotic representations. Many paintings based on Old Testament themes have an obvious sexual allure, and the erotic undercurrent in depictions of nude or scantily-clad men and women – often in situations that refer directly to human sexual nature – probably made more of an impact on most viewers than the religious meaning. After all, as one writer notes, paintings call out not only to the mind and to the emotions, "but also to the body (consider the immediate physical impact of erotic images)."[15] In the Middle Ages, the contemplation of a nude female body was regarded as sinful spying,[16] and it was not until the early sixteenth century that such biblical subjects as Lot and his daughters and Susanna and the elders began to be represented with nude figures.[17] Bathsheba, Salome, and Judith were also popular religious subjects in which female nudity (complete or partial) was portrayed.

Some of these subjects had an overt erotic content. Susanna was regarded as a paragon of virtue, because she spurned the advances of two elders of the community who accosted her while she was bathing naked in her garden. The story is one of several biblical tales that revolve around

27 Hendrick Goltzius. *Lot and His Daughters* (1616). Oil on canvas, 135 × 295 cm. Amsterdam, Rijksmuseum.

rape or the threat of sexual assault.[18] Male viewers may have regarded Susanna as a seductress who inflamed the passion of men by bathing naked, while female viewers perhaps recognized her vulnerability to male ideas about women's nature and sexuality. In the seduction of Lot, his daughters first make their father drunk and then lie with him in turn, in the belief that only they and their father remain alive to perpetuate the family. Figure 27 shows Hendrick Goltzius's interpretation of this theme. The nipples of one of the daughter's breasts are erect, as in many paintings in which a young woman's bare breasts are displayed. Images of this subject could be seen as challenging the taboo against incest, but for those unaware of the story, the visible age difference between the man and the two women could suggest another conclusion to the male viewer: "erotic prowess need not fail with the years."[19]

Many sixteenth- and seventeenth-century history paintings presented scenes that were normally forbidden to the gaze of men and women, since

nudity usually demands privacy. Some appealed to a voyeuristic impulse, as in the Susanna story, where a woman is spied upon while bathing. The fact that she is being watched makes a beautiful woman even more enticing.[20] Nudity in a painting is obviously different from accidentally catching a glimpse of someone without clothing.[21] The nude in art challenges the cultural proscription of voyeurism as well as of nudity itself.[22]

Nudity per se, however, is not erotic. It depends on the context, the pose of those depicted, and their physical appearance. The Christ Child, for example, was commonly represented without clothes in late medieval and early Renaissance art, as were Adam and Eve, and sometimes David, Noah, Samson, and Jacob. But most of the men and women portrayed nude in the paintings discussed here are exceptionally beautiful human beings. Seventeenth-century Dutch artists as well as Renaissance ones chose subjects (and models) that made such portrayals of nude beauty possible. And, of course, a partially draped male or female figure is often more erotically appealing than one who is wholly undressed. The revealed portion of a human body concentrates attention on what is covered.

Even images of the Virgin Mary baring a holy breast to nurse the Christ Child could have erotic connotations for some viewers. In fifteenth-century Italy, for example, some argued that her bare breast violated the principle of decorum.[23] Scholars today debate whether the Virgin's bared breast was understood in terms of established religious doctrine, or whether it "had the potential to trigger erotic associations."[24] The exposed breast is, in any case, a complex symbol: both the source of maternal nurture and of sexual pleasure.

Images of Saint Mary Magdalene often received a predominantly erotic interpretation. Unlike the Virgin Mary, who was considered virginal, humble, and flawless in beauty and soul, the Magdalene had been a prostitute (she had repented of her sinful ways after hearing the words of Christ).[25] Images of this reformed courtesan, a popular saint, were used by the Roman Catholic Church to foster devotion to the sacrament of penance: she is often shown anointing Christ's feet. The Magdalene's sexual history, however, enabled sixteenth- and seventeenth-century artists to portray a blatantly sensuous woman within a religious context. According to Haskins, the "predominant image we have of her is of a beautiful woman with long golden hair, weeping for her sins, the very incarnation of the age-old equation between feminine beauty, sexuality and sin." In Titian's painting (see fig. 28), the prototype for numerous nude and erotic portrayals of the saint, the penitent Magdalene is shown

28 Titian. *The Magdalene* (*c.* 1533). Oil on canvas, 84 × 69 cm. Florence, Galleria Palatina.

with voluptuous body, full breasts, and red-gold tresses. While the hermits, ascetics, and penitents who often appear in Christian art naked or clad in loincloths or animal skins (such as Saint John the Baptist and Saint Jerome) are meant to indicate rejection of the world's vanities, Mary Magdalene's nudity inevitably relates to her sexuality.[26]

In sixteenth-century Rome, erotically-charged depictions of the Magdalene were often hung in the private apartments of the wealthy. These "penitential pin-ups," as they have been described, were sometimes small-scale works painted on copper.[27] Although they would seem to have an obvious erotic content, some scholars have argued that depictions of the Magdalene's bare breasts should be seen as having religious significance. According to Hart and Stevenson, before the Magdalene's penitence, her "hugh, tense, breasts" had been both the "advertisement of her trade and her weapon of seduction." After she repented, her breasts performed a different function: they would still appeal to the male viewer, but they now offered "a first sensory step on his path towards salvation." There was no theological justification for showing her bare-breasted, however, since she could be "amply and chastely covered by her prodigiously long hair."[28] Theologians often regarded the Magdalene as a bridge between Eve and the Virgin, a "bridge which common humanity could cross."[29] But as Mormando notes, it is unlikely that many viewers – if any – would have responded in such a "spiritually edifying fashion" to the "naked flesh of a sensually painted saint, male or female."[30]

In a few religious paintings, male nudity was the chief erotic ingredient.[31] David and Samson were often shown as attractive and well-developed men, as were some of the saints. Saint Sebastian, an early Christian martyr, was frequently used by Italian artists as the subject for a standing male nude. Bound to a tree or pillar, he is shown pierced by several arrows, but his wounds rarely bleed. He is usually depicted as a handsome and well-developed young man. It is also possible that representations of the beautiful body of Christ, clad only in a loincloth, may have aroused erotic feelings in some viewers.

Dutch History Paintings

The heirs of Giorgione and Titian and other sixteenth-century Venetian painters were found in Rome, Madrid, Paris, London, Antwerp, and Amsterdam.[32] In the Southern Netherlands, Peter Paul Rubens (1577–1640) emulated Titian's lush and dynamic style, copying works by him as well as by Raphael, Tintoretto, Paolo Veronese, and other artists he admired. The female nude predominates in his late work, and in 1628, on a diplomatic visit to Madrid, he copied all the paintings by Titian he saw there, including "Diana and Actaeon," "Diana and Callisto," the "Rape of Europa," "Venus and Adonis," "Venus and Cupid," and "Adam and Eve."[33]

In the Northern Netherlands, the main centers for history painting were Haarlem, Amsterdam, Utrecht, Leiden, and Dordrecht.[34] The richly colorful historical themes familiar to artists in Italy were first painted there in the 1590s.[35] Most Dutch history paintings represented episodes from the Bible. Others were mythological,[36] and a few were of allegorical subjects. Artists found their inspiration in the art of the High Renaissance, particularly in its beautiful and sensuous nude figures, and many spent time in Italy. But although the paintings were intended to emulate the Italian manner – and some were based on Italian-inspired compositions by Rubens – they were recognizably Dutch. Their ideal body types, for example, are often somewhat shorter and a little more stocky than those in Italian and classical paintings.

Artists depicted the idealized bodies of women as well-rounded, even voluptuous, with shapely thighs, and large but firm breasts. Although their bodies are fully mature, the women are almost always young. The ideal body type for men was muscular and well-developed: broad-shouldered and thin-hipped, with firm buttocks. Neither men nor women had body hair, and both were endowed with attractive faces.

Rembrandt's women are obvious exceptions, and they were criticized on this account at the time. Remarking on Rembrandt's female nudes in 1681, the poet Andries Pels wrote: "When he would paint a naked woman, as sometimes happened, he chose no Greek Venus as his model." Instead, he chose women with "flabby breasts" and "the marks of corset-lacing on the stomach and of the stockings round the legs."[37] Pels seems to be echoing comments that the artist Jan de Bisschop (*c.* 1628–1671) made some ten years earlier about depictions of Leda or Danaë, "in which a nude woman was represented with a big and swollen belly, hanging breasts, pinches from the garter in her legs and many more deformities."[38] Some scholars have suggested that Rembrandt depicted the physical characteristics actually found attractive in those days: "plump shoulders, relatively modest breasts, a very pronounced belly and sturdy legs."[39] But a comparison of his women with those depicted by other Dutch painters shows that this is unlikely, because they have neither sagging breasts nor large rolls of fat around the middle. In any case, Rembrandt painted relatively few female nudes, and even fewer male ones.

* * *

History Paintings in Amsterdam Homes

Wealthy Amsterdam families owned history paintings by all the principal Dutch artists, and a few also had paintings by Italian and other foreign masters. Subjects were drawn more from the Bible and the lives of the saints than from the Greco-Roman world, although most households contained some paintings with mythological themes.[40] Art appraisers described the paintings according to their subject. Religious ones were listed as a Madonna, a Descent from the Cross, a Christ Child, a Mary Magdalene, a Bathsheba, a Susanna, and so on, mythological ones as a Venus, a Diana, and so forth. Few were attributed to specific artists. Probably as many as half the religious paintings owned by these families depicted women – and often men as well – in sexually-tinged situations, and sometimes nude. Some, for example, owned paintings of Bathsheba bathing, where she is depicted at her toilet in various degrees of nudity; Cornelis van Haarlem's depiction (fig. 29) is an example.

Subjects from the New Testament were preferred by Roman Catholic families, while Reformed (Calvinist) families seem to have liked Old Testament ones. The Dutch Reformed Church had become the recognized public church in Holland at the Union of Utrecht in 1579, supplanting the older Catholic faith. Calvinism was officially the main religion, and Catholic worship was banned. In Amsterdam, however, where Catholics made up about a quarter of the population, it was unofficially tolerated, though not in public. The mass therefore took place in private homes, where its concealment was perfunctory. The most frequently occurring subject in paintings owned by Catholic families was the Crucifixion, with the Carrying of the Cross and the Descent from the Cross, followed by paintings of other

29 Cornelis Cornelisz van Haarlem. *Bathsheba in the Bath* (1594). Oil on canvas, 77.5 × 64 cm. Amsterdam, Rijksmuseum.

episodes from the lives of Christ and the Virgin Mary, including the Nativity.[41]

The Virgin and Child was a theme that received relatively little attention from seventeenth-century Dutch artists.[42] Those in Dutch Catholic homes were intended to inspire a mood of reverence, meditation, and prayer. They transformed the space in which they hung, creating a setting wherein devotion was the appropriate response, unlike examples in museums today.[43] The Virgin would usually be accompanied by various identificatory symbols (e.g., a radiant sun above her head, a crescent moon beneath her feet, a rose, or a lily), and was inevitably portrayed as an attractive young woman. Artists would use their wives, daughters, sisters, mistresses, and sometimes even prostitutes as models, capitalizing on references to the Virgin's "timeless beauty." Depictions of the Virgin in Amsterdam homes served various different purposes: some functioned as objects of devotion, some as works of art, and others perhaps primarily as images of a lovely woman.

Jacob van Ring and his wife, Maria Heymerik, favored history paintings with religious themes.[44] Originally from Delft, van Ring was a lawyer of the Roman Catholic persuasion. They married in 1671, when Maria Heymerik was 41 years of age. Jacob was several years older and had children from a previous marriage. The couple had no children of their own, and Maria survived her husband for thirty years, dying in 1708. Their portraits, by Horatio Paulijn (c. 1644/45–1682), who also painted one of their religious histories, are shown in figures 30 and 31.[45]

Seventy-seven paintings hung in the couple's large house on the Singel. Of the twenty-two history paintings, twenty had religious themes. They included the Birth of Christ, different versions of the Virgin and Child, Christ on the Cross, and a Descent from the Cross by Rubens. The last may have been a version of his magnificent *Descent from the Cross* in Antwerp Cathedral, since he is known to have done several paintings of this theme. Two paintings had saints as their focus: Christ and Saint John by Paulijn and an unattributed painting of Saint Francis of Assisi. Rubens's large Descent from the Cross and Paulijn's painting of Christ and Saint John hung in the *voorhuis*, where they might have been visible to passers by, and certainly to anyone entering the house.

All the other religious paintings hung in the upstairs bedrooms or other private rooms, some of which contained crucifixes and other religious items. In one bedroom there were seven paintings with religious subjects, as well as a family portrait. Most paintings in the private rooms, even the

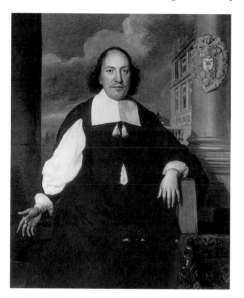

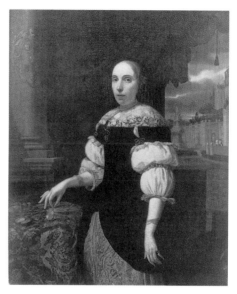

30 Horatio Paulijn. *Portrait of Jacob van Ring* (no date). Oil on canvas, 44 × 38 cm. Private Collection.

31 Horatio Paulijn. *Portrait of Maria Heymerick* (no date). Oil on canvas, 44 × 38 cm. Auction, Drouot, Paris, June 1983.

upstairs hall, had religious themes, in fact, but it is unlikely that people from outside the household would have seen them. They included a small unattributed painting of Christ on the Cross between the two thieves in an upstairs bedroom, the same room as a painting of Christ Carrying the Cross by Maerten van Heemskerck, a sixteenth-century Catholic artist from Utrecht who had spent time in Italy and painted large works with religious themes. Only six of the van Ring's twenty works with a religious theme were given an attribution, and half were appraised at less than 10 guilders. No doubt they were cherished more for their devotional function than for their artistic or monetary value, particularly two paintings they had of the Virgin and Child.

Paintings of secular subjects – some of which were of high quality – also hung in the van Ring home, but they were displayed in the *zaal* and the side room instead of the family rooms upstairs. Two paintings by Gerard Dou (1613–1675), then one of Holland's most highly esteemed artists, received the highest appraisals in the inventory of the family's possessions. They were described as "A maid with a can" and "A woman with

a herring," and were appraised, respectively, at 200 and 300 guilders.[46] The next most highly evaluated paintings were two landscapes – a "white horse" and a painting of a horse and figure – by Philips Wouwerman, both appraised at 100 guilders. Two other landscapes by Wouwerman were given lower appraisals.

The van Rings were unusual in separating sacred and secular images, hanging the sacred images in the private space of the family rooms. Some other wealthy Roman Catholic families in Amsterdam commonly juxtaposed them. Charles Lemaître, a Roman Catholic priest who visited Amsterdam in 1681, expressed shock at seeing paintings of impure subjects opposite ones with religious themes in one Catholic home he went to.[47]

Among the families who hung sacred and secular paintings next to one another were Valerius Röver and Catharina Elisabeth Bode, who lived on the Keizersgracht with one male and two female servants[48] Röver was a merchant from a rich family and quickly accumulated great wealth himself; his wife also came from a well-to-do background. The couple married in 1682, when he was 28 and she 23. Five children were born before his death in 1693, although two died very young.[49] At the time of her death in 1703 at the age of 44, Catharina owned several houses in Amsterdam and a farmstead outside the city: Geinwijk near Baambrug.

Sixty-eight paintings hung in the Rövers' Keizersgracht house. Thirteen were history paintings, two-thirds with religious themes. In the *zijdekamer* was a painting by Rembrandt depicting *Christ on the Cross*, which hangs today among other religious works in a parish church in Lot et Garonne, France.[50] It hung next to a rather unusual work by the Flemish artist Frans Snyders (1579–1657), a friend and collaborator of Rubens, who was considered a master at painting animals.[51] The painting eventually passed to one of the Rövers' two sons, also named Valerius, who later became an art dealer. In a catalogue he prepared for the sale of some of his paintings, he described the Snyders as a large painting "full of all sorts of animals, such as deer, dogs, peacocks, hares, rabbits, etc. by Snyders, in which Rubens and his wife, life-size, with a basket of fruit on her head, are portrayed as farmers." He indicates that the art expert Zomer had appraised the painting at 500 guilders and that different art lovers had offered him 2,000 guilders for it. It may have been the one shown in figure 32;[52] if so, it would have dwarfed the Rembrandt painting hanging next to it.

The Rövers used the *zijdekamer* as a sort of art gallery for displaying some of their most valuable paintings. Eleven paintings were hung here,

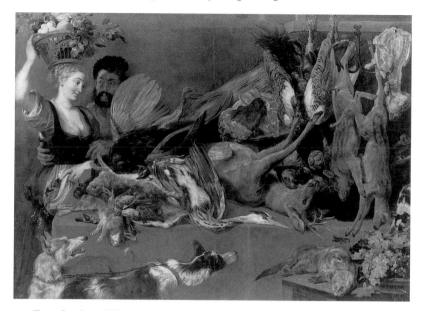

32 Frans Snyders. *A Kitchen Piece* (no date). Oil on canvas, 163 × 243 cm. Kassel, Staatliche Museen.

including the works by Rembrandt and Snyders. The room was fairly sparsely furnished, with no beds, which indicates that the paintings had pride of place. In addition to ten chairs, it contained a walnut table, a cupboard (holding gold coins and some medals), two olive-wood candlestands, and a mirror. A metal grating and damask curtains covered the inside of the room's four windows. The presence of four windows indicates that it was a corner room, which would thus receive more outside light. The Rövers clearly had a deep and serious interest in art. Although Rembrandt's portrayal of Christ nailed to the cross with bleeding hands and feet may have aroused deep feelings in virtually everyone who looked at it, in this home it was probably primarily valued as a work of art rather than as object of devotion.

Jacob Jacobsz Hinloopen and his wife Debora Popta were a wealthy couple who owned several houses in Amsterdam, two country homes, a considerable amount of land, and a *trekjacht*, a flat-bottomed boat pulled by horses along canals and other waterways. They lived at what is today Herengracht 470, a large double-fronted house. Built in 1669, it was

acquired by Hinloopen at auction in 1680 for 37,230 guilders. Two maid-servants provided household help.

When he was 47 years of age, Hinloopen was appointed *schout* or chief judicial officer, which meant that he would be entitled to a percentage of the fines imposed for misconduct. There was little control over the activities of the *schouten* and their reputations, as one writer notes, were "far from spotless."[53] Men serving as *schouten* in Amsterdam during the period 1669–1732 earned roughly 6,000 to 9,000 guilders per year,[54] but Hinloopen averaged 10,000 guilders per year during his time in office.

Although Hinloopen was in a position to commission works from the best artists of the day or to purchase paintings of the highest quality, he and his wife spent relatively little on art. The Hinloopens had seventy-nine paintings hanging in their home on the Herengracht,[55] many of them inherited from Jacob Jacobsz's father and probably his uncle as well.[56] The special art appraiser attributed about one-third of them to a particular artist. There were thirteen history paintings with religious themes and six with mythological themes. Several of the former received low appraisals: 12 guilders for a painting of the Holy Family by Jan Lievens, 8 guilders for a painting of the Virgin Mary by Govert Flinck (1615–1660), 8 guilders for an unattributed painting of Mary Magdalene, 6 guilders for an unattributed painting of Saint John the Baptist, and 3 guilders for an unattributed picture of the Virgin and Child. A painting of Samson by Rembrandt was valued at 42 guilders, however, and an unattributed painting of "Saint Peter's ship" at 150 guilders. It has been suggested that the latter was also by Rembrandt,[57] but it seems strange that the art appraiser did not recognize this if so. Altogether, the paintings in the Hinloopen home were appraised at just over 4,000 guilders. Also in the house were porcelain, gold and silver objects worth more than 10,000 guilders, as well as a large amount of jewelry.

Half of the total value of the couple's art works came from just one painting: Rembrandt's *The Woman Taken in Adultery* (see fig. 33), which was appraised at 2,000 guilders. Hinloopen inherited it either from his father or his uncle, both of whom had been acquainted with Rembrandt, and one of them had bought it at an auction in 1657 for 1,500 guilders.[58] Rembrandt's version differs from many depictions of this theme, in which the woman has braided hair and a bared breast – the attributes of a courtesan. The story of the woman taken in adultery concerns the hypocrisy of the self-righteous. While Christ was teaching in the Temple, the Phar-

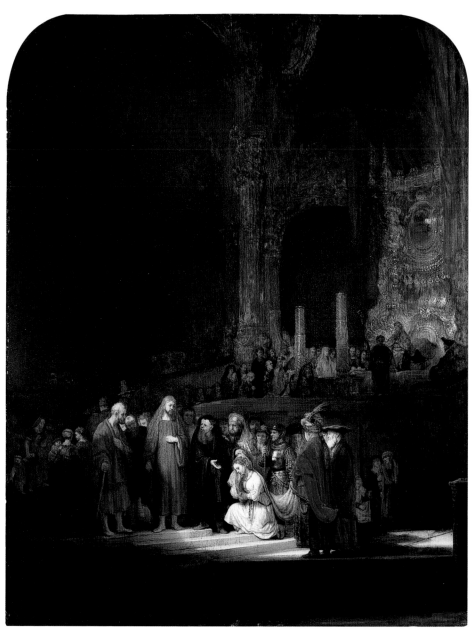

33 Rembrandt van Rijn. *The Woman Taken in Adultery* (1644). Oil on oak, 83.8 × 65.4 cm. London, National Gallery.

isees questioned him about a woman who had been caught in the act of adultery. When they insisted on the law of Moses, which commanded that such a woman be stoned, Christ replied: "He that is without sin among you, let him first cast a stone at her." He then sent the woman on her way, with the words "go, and sin no more" (John 8: 2–11). Whether or not the Hinloopens associated the painting with this moral message, it is likely that they responded to it as an unusually valuable work by a highly-respected artist. There was also an unattributed depiction of Bathsheba in the same room.

The Hinloopens must have displayed the Rembrandt in a prominent manner, but it is not clear how. Although it was common for families to hang their showpiece painting on the chimneybreast in the *zaal*, in this home an exceptional number of porcelain objects was massed there. It included twenty-eight deep bowls of what was known as *klapmuts* shape, sixty-six large and small plates, eighteen butter plates, roughly two hundred cups and saucers – some colored, some not – and two colored shaving bowls. Alluring, exotic, and fragile, porcelain pieces were works of great beauty, admired for their delicacy, exquisite decorations, and striking blue, turquoise, purple, black, and iron-red colors. The sheer number would have created what has been termed "a dazzlingly elaborate multi-patterned effect."[59] The display must have extended almost to the ceiling, and was more likely than the Rembrandt painting to attract the attention of most people entering the room.[60]

The regent Pieter Six and his wife Ammerentia Dijman, who had married in 1682, also lived on the Herengracht.[61] Pieter was a lawyer and the nephew of Jan Six, whose portraits were discussed in Chapter 3. At their marriage, Ammerentia's jewels and other possessions were valued at almost 110,000 guilders; by the time of Pieter's death in 1703 at the age of 48, they had acquired goods worth another 110,000 guilders.

The couple was exceptional among rich Amsterdam families in owning a large number of Italian masterpieces.[62] Thirty of the eighty-six art works in the Herengracht house were by Italian artists, among them Titian, Palma Vecchio, Raphael, Giovanni Bellini, and Tintoretto. Most were history paintings, divided almost equally between religious and mythological themes. They also owned history paintings by Rembrandt, Gerard de Lairesse, and a few other Dutch artists. Together with a painting of the Three Kings, a painting of the Nativity by Cornelis van Poelenburgh (1594/95–1667) was evaluated at 600 guilders, while a depiction of the Holy Family by Raphael was appraised at 176 guilders. Paintings of Christ

attributed to Palma Giovane, Giovanni Bellini, and Titian were given lower values.[63]

There were also two paintings of Saint Mary Magdalene, a popular figure even among non-Catholic families in Amsterdam. They were displayed in the large side room, a formal room for entertaining guests, in close proximity to depictions of Christ. One, attributed to "Carracci," was valued at 67 guilders;[64] the other, attributed to Titian, was appraised at 410 guilders. The latter may have been a version of the painting shown in figure 28. The couple also possessed a painting of Lot and his daughters by the sixteenth-century Dutch artist Lucas van Leiden, which was appraised at 21 guilders, and two paintings of Susanna and the elders. One, attributed to Palma Giovane, was not appraised; the other, attributed to the Dutch painter T. van Tulden, was valued at 14 guilders. They owned two paintings of Venus and Cupid, one attributed to Rembrandt and appraised at 65 guilders, the other, by Carel van Savoyen (1621–1665), valued at 30 guilders and described as "life-size" (*levensgroote*). Such a "life-size" representation of this subject, by Caesar van Everdingen, several of whose paintings hung in Amsterdam homes, is shown in figure 34. Such huge paintings surely drew the gaze of all who encountered them.

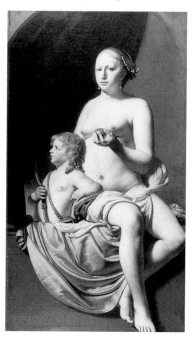

34 Caesar van Everdingen. *Venus and Cupid* (no date). Oil on canvas, 138.2 × 81.2 cm. Alkmaar, Stedelijk Museum.

Jacoba Victoria Bartolotti van den Heuvel, the daughter of the banker and merchant Guillielmo Bartolotti van den Heuvel, who left an estate of more than one million guilders, was one wealthy woman in seventeenth-century Amsterdam whose dowry included paintings. Her husband, Coenraad van Beuningen, was an influential Amsterdam regent. Born in 1622, he finished his university studies in Leiden at the age of 20. By the time he died in 1693, at the age of 71, he

had been a leading figure in the *vroedschap* (city council) for more than thirty years, had served as burgomaster several times, was an experienced diplomat, and a powerful figure in running the Dutch East India Company.[65]

The couple married late in life, when he was 64 and she 47. From all accounts, it was an unhappy relationship. One contemporary commented that van Beuningen had made a serious mistake in marrying a "young, lascivious, and very worldly person" in his old age.[66] Jacoba Victoria is described as a woman who had been flirting with all kinds of men for twenty years, had been on the point of marrying more than once, and even bore an illegitimate child. Van Beuningen became mentally disturbed in 1688 and subsequently held no important public offices.[67] His wife's licentious behavior was partly blamed.

The inventory made up after van Beuningen's death shows that husband and wife each brought fifteen paintings to the marriage.[68] Six of his were portraits of public figures, and four were history paintings with mythological themes. Jacoba Victoria's paintings included no portraits, but six history paintings, including a depiction of Cimon and Pero, which was appraised at 150 guilders (by contrast, a painting of Susanna was valued at just 3 guilders). This made it the most valuable painting in the couple's Amsterdam home. The special art expert described it as being "in the manner" of Rubens, and it may have resembled his famous painting of the subject shown in figure 35.

In this story, the elderly Cimon is condemned to starve to death in prison. He is kept alive by his dutiful daughter, Pero, who nourishes him from her breast on her daily visits. Rubens shows a beautiful young woman giving her breast to her father to suck, and the viewer's attention is drawn to a part of the body associated with sex and sensuality. As Freedberg notes, the image "blatantly, almost palpably, arouses the senses. Furthermore, it does so sexually, or at the very minimum *could* do so."[69]

Venus was a popular mythological subject in the Dutch Republic, and as many as a third of wealthy Amsterdam families seem to have displayed a painting of her in their homes, with Venus and Cupid being the most common theme. Most were unattributed. The influential regent Jan Six and his wife Margareta Tulp displayed two paintings of Venus in their art gallery, the room that also contained Rembrandt's portrait of him (see fig. 20). The one showing Venus and Cupid was unattributed; the other, depicting Venus and Hercules, was attributed to Jan Gossaert, known as "Mabuse," who was famous for his nude figures. (Partial or total male

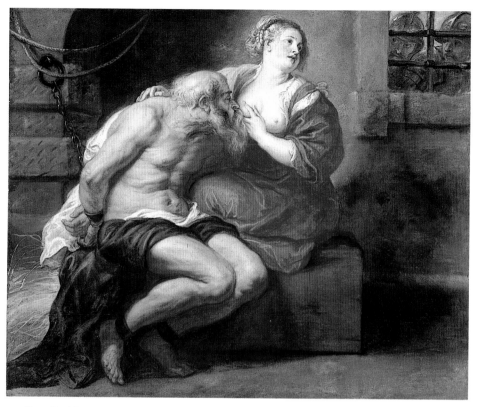

35 Peter Paul Rubens. *Cimon and Pero* (1630–40). Oil on canvas, 155 × 190 cm. Amsterdam, Rijksmuseum.

nudity may have been an important ingredient of its eroticism: Hercules was usually depicted as handsome and extremely muscular, even physically perfect, as were Apollo, Adonis, Bacchus, and Neptune.) Pieter de Graeff and Jacoba Bicker owned two paintings in which Venus was featured: one with Cupid, the other with Adonis. The special art appraiser valued them at 2 and 3 guilders respectively. They both hung in a room with a painting of the Virgin, two paintings of the de Graeff's country estates, several portraits, and a depiction of Diana, another Olympian deity. Several families owned paintings in which Venus was shown with Vulcan or Mars, or else the three of them together. A common theme was Venus and her lover, Mars, being surprised by her husband, Vulcan, as in figure 36. In Joachim Wttewael's colorful depiction, the meticulously

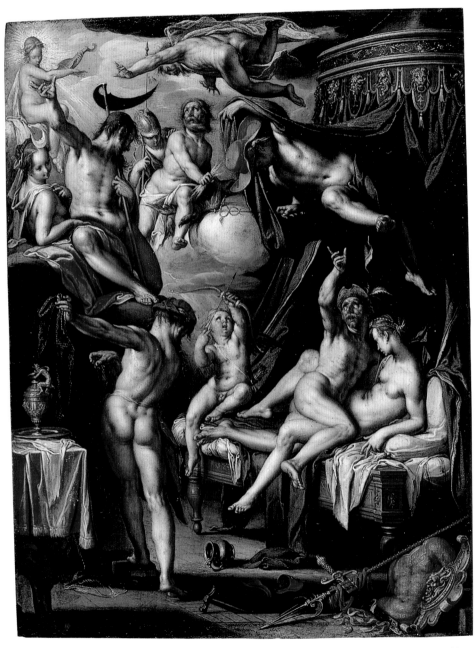

36 Joachim Wttewael. *Venus and Mars Surprised by Vulcan* (*c.* 1601). Oil on copper, 21.0 × 15.5 cm. The Hague, Mauritshuis.

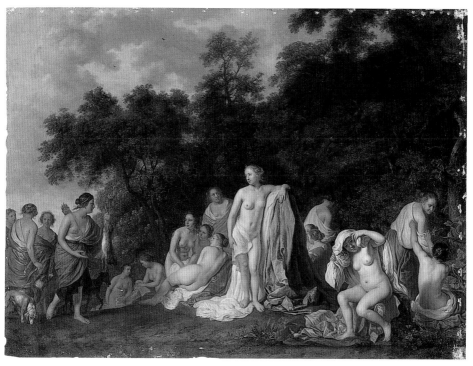

37 Jacob van Loo. *Diana and Her Nymphs* (1654). Oil on canvas, 99.5 × 135.5 cm. Copenhagen, Statens Museum for Kunst.

sculpted and seductive bodies are arranged to emphasize their sexual potential.

Diana, the goddess of the hunt, who was often painted in the nude, was another popular figure. In the idealized rendering of feminine beauty and sexual attractiveness shown in figure 37, a painting of Diana and her nymphs by Jacob van Loo (*c.* 1614–1670), the erotic dimension is obvious. As in paintings of Bathsheba, male viewers may have seen the women as seductive and sexually provocative. Many Amsterdam families also owned paintings of the Judgment of Paris, where Paris, a shepherd, has to judge the beauty of three goddesses. Jupiter and Callisto, Minerva, and the Three Graces were other recurring themes that usually featured nude or partially-nude figures, as did paintings of Bacchus, the god of wine, whose rites were accompanied by frenzied orgies. More often than not, no attributions were made for these paintings in appraisals.

The value of mythological figures varied greatly, as shown by appraisals of paintings of Diana. For example, an unattributed depiction of the goddess owned by the de Graeffs was valued at just 1 guilder, while one attributed to Joachim Wttewael in the room where Valerius Röver and Catharine Bode slept was valued at 18 guilders. A painting of Diana in the home of Jacob Jacobsz Hinloopen and Debora Popta, who also owned Rembrandt's *The Woman Taken in Adultery*, was appraised at 400 guilders. Surprisingly, given its value, the art appraiser made no attribution. The vast differences in these monetary values seem to point to differences in artistic quality, although there is no way of knowing. The first painting must have been considered mediocre, but there is no clue as to its appearance, since the artist is unknown. It is possible that the unattributed depiction appraised at 400 guilders may now hang in some museum with an artist's name attached to it, since high-quality works had a better chance of surviving.

It is unknown whether the owners of these paintings, other members of the household, or visitors were "informed viewers," able to identity all the figures, stories, and episodes represented and with the capacity to understand any moral messages that the paintings contained.[70] Based on what is known about church attendance and religious training in Amsterdam, it seems likely that virtually every adult could have identified images of Adam and Eve, the Virgin Mary, and Christ (who is almost always shown slender, bearded, subdued, and ascetic), even if fewer would have recognized specific saints or such Old Testament figures as Cain and Abel. Some Protestants, for example, may not have been able to identify all the events depicted in association with the Virgin, which included her immaculate conception, miraculous birth, presentation in the temple, marriage to Joseph, the Annunciation, and the Visitation. People in any case varied considerably in their detailed knowledge about the essence of different stories. Valerius Röver and Catharina Bode were quite exceptional in having two volumes concerning biblical figures and religious history among their many books. The supposed messages of religious history paintings included: resisting temptation, avoiding self-righteous behavior and hypocrisy, the need for repentance, virtuous conduct, and filial piety. For example, according to some scholars, paintings of Susanna served to convey a message about the triumph of virtue over evil. But despite their biblical pedigree and moral messages, the paintings must have sometimes simultaneously evoked erotic associations and kindled sexual feelings.

Men who had been educated at the Latin school (females, as noted earlier, were excluded from it) were certainly in a position to identify themes and figures taken from classical literature or mythology, and they could have familiarized their wives and children with them.[71] It is also possible that some men and women learned the stories from reading Ovid's *Erotic Poems* or his *Metamorphoses*, which was available in illustrated translations, from other classical writings, from reference books, or from art-theoretical treatises. But books listed in household inventories do not suggest a wide readership of such literature. Valerius Röver and Catharina Bode were again an exception, owning works by both Ovid and Plutarch. Couples such as Pieter Six and his wife who were known art lovers might have also been familiar with the contents of their mythological paintings, although this does not necessarily mean that they were aware of specific moral messages or that the messages were the most important aspect of their viewing experiences.

Erotic Representations and their Male and Female Viewers

Whatever their knowledge of the themes depicted or of the artists who painted them, viewers were surely not blind to the erotic content of some history paintings. Today, of course, nudity and sexual suggestiveness are ever-present – in fashion, on television, in movies, and in magazines – but, even so, erotically-tinged paintings are likely to draw people's attention. Although sex is central to the lives of most human beings,[72] sexual feelings and emotions are often feared and frequently repressed. Puritanical repression was not, however, dominant among wealthy Amsterdammers three centuries ago, and no cultural taboo prevented them from hanging erotic images on the walls of their homes. The images were there to be looked at and enjoyed. The figures were physically attractive, and presented in an inviting manner. People's reaction to them, however, is unknown. Did they sit or stand directly in front of them and gaze at them, or just steal glances now and then? Did family members and their guests talk about the paintings, comparing their merits as erotic representations, or did they ignore them altogether? In any case, viewers' relationships with erotically-tinged paintings must have been influenced by their gender, as already suggested above in relation to depictions of Susanna and the elders.

It was male artists who provided the erotic images that hung in Dutch homes, and it is often assumed that the paintings were intended solely

for male viewers and that it was men who purchased them. It is not known how often women purchased paintings in the seventeenth-century Dutch Republic. In fact, little is known about the involvement of women – or of other family members – in household purchases at the time.[73] Decision-making between husbands and wives is an unexplored subject,[74] but in more general discussions of consumption, women are often portrayed in a negative light, and "relentlessly derided for their petty materialism and love of ostentation." Men produce, women consume.[75] Even so, women would have regularly encountered the paintings in the daily life of the household, because with the exception of the children's rooms, the kitchen, and the rooms where the servants slept, erotically-tinged history paintings hung throughout the homes of wealthy families, although most were displayed in the *zaal* and the *zijdekamer*, where both family members and visitors had access to them.

Because they were generally larger than other art works, history paintings were hung fairly high up, with smaller paintings in a second tier below them. Given their size, they would have been clearly visible in daylight. Not all viewers – particularly the elderly, especially women – would have been drawn to images of love and sensuality, but for those who did take notice, three aspects of the viewing experience can be distinguished: deriving pleasure from looking at depictions of attractive faces and bodies; being sexually attracted to them; and being sexually aroused by them. A fourth aspect of the viewing experience, using the paintings to encourage sexual activity, is discussed in Chapter 6.

Amsterdammers of both sexes would no doubt have derived pleasure from viewing these idealized figures,[76] although the pleasure was probably greater for male viewers, since representations of female bodies were more common than those of males.[77] Moreover, the male obsession with the female body is well documented.[78] Sexual attraction is central to the experience of romantic love.[79] Findings from biology, psychology, and anthropology all point to sexual attraction and romantic longings as universal human qualities.[80] The basis for sexual attraction appears to be hard-wired into the nervous system,[81] but sexual contact is more important for men and emotional intimacy for women.[82] Men are also more easily aroused by visual stimuli than women,[83] and many paintings were probably intended to arouse their sexual feelings. Depictions of alluring nude or partially-nude female bodies must have kindled a sexual response in many men, which would be heightened by the belief that these women were basically seductive and had insatiable sexual appetites. According to

Freedberg, in all cultures the bared female breast and exposed genitalia have a psychosexual dimension;[84] legs, thighs, and buttocks might be added as well if one looks at figure 36.

Assuming that erotic-tinged images in the Dutch Republic were intended solely for men, most scholars have focused exclusively on the attractiveness of the women depicted. In commenting on paintings that deal "with feminine pulchritude and seduction, love and desire, chastity and lasciviousness," Sluijter takes it for granted that they were intended for male viewers and ignores female viewers altogether.[85] He does not address the sexual implication of images of well-developed young men for female viewers, and for some males as well. In any case, both sexes would encounter idealized depictions of Hercules, Adonis, Apollo, Mars, Neptune, and other male figures in Amsterdam houses.

As for women's responses, Freedberg notes that women may be aroused by knowing how the sight of a bare female breast – or a naked female body – affects men,[86] and this was probably also true for some women in the seventeenth century. A few women may have been aroused by depictions of female nude bodies, although both men and women were culturally forbidden to take pleasure in the look of the body of their own sex.

This discussion of people's responses to physically attractive human figures draws on the work of contemporary scholars regarding certain universal human qualities that would have influenced male and female viewers in the seventeenth century. But the beliefs that those viewers held about sex and love undoubtedly also had an influence, particularly the beliefs about woman's nature. Men and women were thought, by creation, to be different sorts of being. According to one writer, "the conviction that woman is weaker, inferior and in need of masculine guidance was voiced as firmly by women, even individual and able women, as by men."[87] This view was supported by classical thinkers, the Christian tradition, moral and political theorists, and contemporary medical thinking.[88] Women were predestined to be subordinate, and subservient to their fathers, brothers, and husbands. They were considered sexually innocent and in need of protection against the advances of men. At the same time, they were regarded as lustful and in need of protection against their own sexuality. A woman's lasciviousness was a matter of physiological predetermination, and was evidence of her inferiority.

For those men who attended the Latin school, this stereotype was reinforced by reading Aristotle, Horace, and Ovid. Ovid's *Erotic Poems*

described the female as wild and passionate, in an animal sense, and as a more than willing accomplice to the male whose sole concern was to get her into bed.[89] In his *Metamorphoses*, the myth of the wise Tiresias, who experienced sex both as a man and as a woman, makes it clear that women get more pleasure out of sex than men do. Tiresias had come upon two snakes coupling, had struck them with his staff, and was miraculously changed into a woman for seven years. When called upon to settle an argument between Jupiter and Juno about whether men or women felt more pleasure in sexual intercourse, Tiresias replied that women did.[90]

Whether or not women's beliefs about their own nature and sexual appetites corresponded to those of men is unknown, for documentary evidence that might shed light on these matters is lacking.[91] Still, throughout history women's views of themselves have certainly been shaped by men's ideas about their nature,[92] and, more importantly, their behavior has been shaped as well. In the Dutch Golden Age it may have included not only their responses to the female figures that men depicted in history paintings but also to those shown in many genre paintings, which are examined in the next chapter.

Chapter 5

Elegant Men and Women,
Peasants, and Prostitutes

More than any other seventeenth-century art works, genre paintings shape museum visitors' images of people in the Dutch Golden Age: what they looked like, how they dressed, their domestic life, the way they spent their leisure time, the kinds of work they did, relations between the sexes, and other aspects of daily life.

Soldiers and other men in taverns and brothels are represented drinking, playing cards, and leering at attractive young women; peasants are shown guzzling beer, smoking tobacco, and generally enjoying themselves at fairs, weddings, and other countryside pursuits. Domestic life is represented largely as the world of women and children, with attentive mothers breast-feeding infants, reading to their children, combing their hair to get rid of lice, sewing, spinning, making lace, overseeing the work of servants, and engaged in other activities associated with feminine virtue. The mistress of the house is seldom shown cooking, cleaning, or making up the beds, because such chores were left to servants. Adult males are generally absent from domestic scenes.[1] Other paintings show both men and women in well-appointed urban interiors: reading and writing letters, playing backgammon or other games, making music and listening to it, singing, dancing, drinking, talking, and engaged in romantic interludes. They are usually depicted as young and fashionably dressed. Such pictures represented an ideal of domestic living and sophistication for the rich and powerful three centuries ago.[2]

Genre paintings seem "to provide a pictorial record of life in the Dutch Republic during the seventeenth century."[3] They are "like snapshots, as though the painter had recorded them on the spot."[4] They were, however, composed in the artist's studio, and are artistic constructions, not documentary photographs.[5] In fact, they are neither comprehensive nor accurate representations of reality. Like other types of paintings, genre scenes

are overwhelmingly men's representations. The artists were highly selective in who and what they depicted and in how they did so. Many categories of people and numerous aspects of daily life are ignored, and those that do appear are often far from the way they actually were. For example, there are few depictions of men and women in foreign – or regional – costumes, despite the high proportion of immigrants in Amsterdam and elsewhere in the Dutch Republic.

Genre paintings also fail to reflect the social composition and occupational structure of the population. The world of work is represented in paintings of doctors, dentists, alchemists, astrologers, astronomers, school teachers, and artists; but bricklayers, carpenters, and stone masons – the men who built the homes of the rich – are rarely shown, or glaziers, plasterers, plumbers, day-laborers, and children engaged in work. Silver objects are often depicted, but there are no silversmiths. Similarly, men and women are shown writing, receiving, and reading letters, but there is no sign of the post-riders who would have transported the mail across the country. Sutton notes the surprisingly few genre paintings showing sailors, dock workers, or merchant marines, a group that may have made up as much as one-tenth of the Dutch population.[6]

Comical portrayals of peasants and of country life are common, but peasants are seldom shown tending their crops, harvesting, dairying, or cleaning out sheds; nor do paintings show the building of dikes, the draining of swamps and bogs to create polders, or the cutting of peat. There are no representations of the large number of landless laborers, or of the deprivation and poverty accompanying the agricultural depression of the second half of the seventeenth century.[7] Depictions of tiny rooms, small houses, beggars, and sick people do exist, but crowded and primitive living conditions, crime, misery, and suffering are conspicuous by their absence, as are depictions of people selling and buying the used garments that clothed the poor. Perhaps understandably, the well-to-do did not want such subjects hanging in their homes, so artists did not produce them.

Among the themes or subjects that do appear, two had a special appeal for wealthy Amsterdam families: high- and low-life genre paintings, which were largely idealized depictions of the upper orders and caricatures of the lower.[8] Among the terms used to refer to them in inventories of household goods are *vroutje* (a young woman), *conversatie* (a conversation), *gezelschap* (a group of people enjoying one another's company), *boerengezelschap* (a group of peasants doing the same), and

bordeel (a brothel scene). Their popularity raises the obvious question of what people at the time actually looked like, a question that has received little attention in historical accounts of life in the Dutch Golden Age.

People's Appearance in the Golden Age

Appearance touches everyone, in all ages and cultures.[9] In an essay on physiognomy published in 1588, Montaigne mentions the views of Socrates, Plato, and Aristotle on the importance of appearance. He then goes on to write:

> I cannot say often enough how highly I rate beauty, a powerful and most beneficial quality. We have no other qualities which surpass it in repute. It holds the highest rank in human intercourse: it runs ahead of the others, carries off our judgment and biases it with its great authority and its wonderful impact.[10]

Seventeenth-century Amsterdam was a multi-cultural city with residents from many different countries. Anyone walking around it would have noticed that the hair peeking forth from a hat or cap, or worn as a wig, was sometimes blond, but also black, brown, or even red; that eyes could be blue, brown, green, or gray; and that some people had pockmarks or other facial blemishes. Other differences in appearance, most obviously in size and shape, depended on a complex array of factors. The most important determinant of height was the nutritional value of people's diets while they were growing up, minus the demands made on that nutritional value by cold, disease, and physical activity.[11] Both these factors, as well as their diets as adults, affected people's weight.

Both energy intake and expenditure were related to an individual's position in the city's social hierarchy. For the poorest 15–20 percent of the population, the nutritional value of the proteins, fats, and carbohydrates eaten by men, women, and children provided insufficient calories for meeting the demands of cold, disease, and heavy labor.[12] People living in crowded, poorly ventilated, unsanitary, cold, damp dwellings were highly susceptible to typhus, diphtheria, smallpox, measles, and other infectious diseases. The labor performed by most men was physically demanding: many carried out heavy work involving movement of the whole body from eleven to thirteen hours per day in the summer months and a few hours less in winter. The labor of women at home was also often quite heavy, as was that done by some children.[13]

Consequently, those at the bottom of the social ladder were in a perpetual state of undernourishment. Fatigue, apathy, ill health, and weight loss were among the results. The height of many adults was also stunted by poverty and deprivation during infancy and early youth. The average height of men would probably have been about 1.64 meters and that of women around 1.54 meters;[14] in other words, they were relatively short. Few people were overweight. The energy that men, women, and children expended in keeping warm, fighting disease, and performing physical labor inside and outside the rooms they called home made it difficult to maintain even an adequate body weight.[15] In the poorest families, everyone must have been overly thin, frail, pale, and in a constant state of poor health.

As one moved up the social ladder, housing conditions improved. Families lived in larger, warmer, better ventilated, and more hygienic surroundings, and were thus less susceptible to infectious diseases. Their work was also less physically demanding. According to modern recommendations, the nutritional value of their diets was fully adequate for normal growth and a healthy, active life. Greater height and weight accompanied these more advantageous circumstances: men had an average height of 1.66 meters and women an average height of 1.56 meters.

The wealthy were the heaviest and tallest people in the city.[16] Although not tall by today's standards, men had an average height of about 1.69 meters, and women a height of around 1.59 meters.[17] As well as having a superior diet and easier work lives, they were able to take better care of themselves, and almost surely placed more emphasis on the importance of a youthful, trim, and sensual body, although the superabundance of food they consumed must have ensured that many were overweight.[18] As noted in Chapter 2, their diet included large amounts of meat and fish, a wide variety of vegetables, eggs, cheese, bread, butter, fruit, various sweets, and a considerable amount of wine.[19]

The affluent were anything but moderate in what they consumed,[20] and their energy expenditure generally fell short of their energy intake. Walking was probably the most demanding physical activity. Members of the city government, merchants, and others walked to and from the town hall, the offices of the East and West India Companies, other places of business, and the stock market. They also walked to church and to visit friends, and some perhaps to the charitable institutions on whose governing boards they served. On their country estates, they did some walking, went horseback riding, worked in their gardens, and went ice skating in winter. Their wives were involved in similar activities. Wealthy

women had servants, and thus seldom carried out heavy domestic chores, but they might accompany a servant to the city's markets to purchase flowers, food, and other household necessities, or go there alone.

Although men and women in the upper reaches of Amsterdam's economic and social elite did not lead completely sedentary lives, most expended insufficient energy to avoid becoming overweight. (Women, of course, had special energy requirements during their pregnancies, and many never regained their earlier weight.) Consequently, the bodies of few approximated to the classical proportions of the figures in history paintings or the svelte and elegant figures depicted in high-life genre scenes. Instead, men often had jowly faces, double chins, thick necks, an ample girth, and bulky, protruding stomachs; while flabby faces, wrinkled necks, fleshy arms, sagging breasts, thick waists, hefty hips, and sturdy legs would not have been uncommon among women.

As far as people's faces are concerned, another type of genre painting, a *tronie* (popularized by Rembrandt), came closer than other types of painting to resembling the appearance of real people, with all their imperfections. This may be the reason why there was a fairly large market for them in the seventeenth century. *Tronies* consist of an unarticulated background depicting a head or bust of an anonymous contemporary person, often an elderly man or woman.[21] Far from being idealized, *tronies* emphasize wrinkles, puckered skin, and withered faces. Franits suggests that artists used physiognomy in *tronies* as a vehicle to explore such emotional states as suffering, piety, pride, and spiritual ardor.[22] Figure 38 shows a *tronie* by Rembrandt of a bust of an old man. It once hung in the home of Catharina Bode and Valerius Röver, who were considered in the previous chapter, but it was displayed in a room they used for sleeping, and not with their most valuable paintings in the *zaal*. It is quite small, and the special art expert appraised it at 30 guilders.[23]

38 Rembrandt van Rijn. *Bearded Old Man with a Gold Chain* (1632). Oil on panel, 59.3 × 49.3 cm. Kassel, Staatliche Museen.

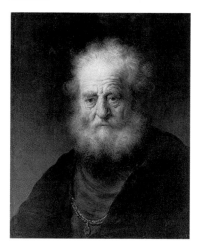

High-Life Genres

Seventeenth-century art theorists recommended that painters of high-life genres pay close attention to the carriage, manners, elegance, and refinement of the elite, which would assist them to depict true beauty.[24] Whether or not they read their treatises or were aware of their recommendations, artists depicted the men and women in these genre scenes as decently – usually elegantly – dressed, with attractive bodies, erect postures, delicate hands, flawless skin, and controlled expressions on their faces.[25] Smiles are rare; unlike country folk, the rich and powerful do not grin or expose their teeth. In paintings, if not in life, the affluence, leisure, and freedom of wealthy women place them on an equal footing with men.

Among the high-life paintings that hung in Amsterdam homes were works by Johannes Vermeer, Pieter de Hooch (1629–1684), Gerard Dou, Caspar Netscher (1639–1684), Frans van Mieris (1635–1681), Gabriel Metsu (1629–1667), Eglon van der Neer (1634–1703), and Gerard ter Borch the Younger, as well as an unknown number of unidentified artists. Alison Kettering has focused on Gerard ter Borch's paintings of elegant women in order to distinguish between the responses of female and male viewers in seventeenth-century Holland, although, as she points out, "historical proof for a specifically male or specifically female way of viewing is hard to muster."[26] A female viewer of his pictures would, she claims, have found it natural to identify personally with the ladylike women who formed the focus of his paintings.

> At the most basic level, she could have enjoyed the imagined pleasure of posing center-stage, admired and perceived as beautiful. Equally immediate would have been her identification with the depicted lady's delight in wearing such a shimmering gown. By imaginatively projecting herself into this pictorial context, a woman transported herself into a milieu of leisure and beauty.[27]

But it seems unlikely that *every* female would have found this natural and easy, and a female viewer's response would surely have depended on the social distance between herself and the fashionable women shown, especially in a hierarchical society such as the Dutch Republic where there was rarely opportunity for social mobility. Not only did elegant women make up only a tiny portion of the Dutch population, but they, like the men, saw themselves as socially and morally superior to the rest. Ordinary people surely knew how they were regarded by the privileged few, and it consequently seems more likely that they would *not* have iden-

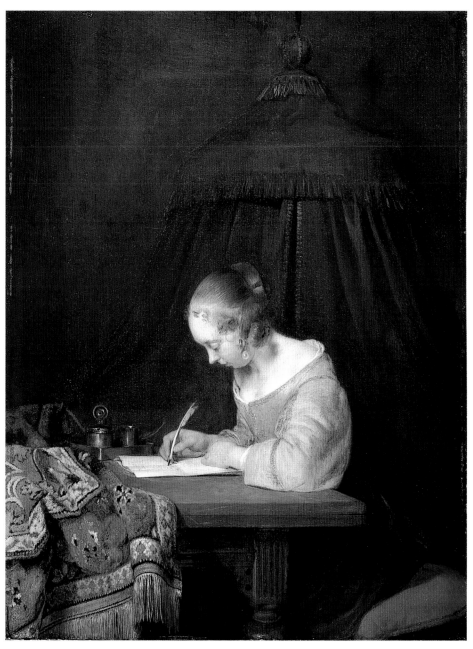

39 Gerard ter Borch. *The Letter Writer* (1655). Oil on panel, 39 × 29.5 cm. The Hague, Mauritshuis.

tified personally with the women in ter Borch's paintings. In any case, responses to a particular work of art and the associations evoked would also be influenced by age, religion, and educational background, but no documentary evidence is available to shed light on these ways of viewing.

Kettering considers that the ter Borch paintings functioned both to convey prevailing ideals about women's behavior and to help construct them.[28] She notes that at the center of the value system that ter Borch shared with his audience lay various notions of how women should look, behave, and particularly how they should interact with men.[29] The male response to these elegant women would therefore be different from that of female viewers. Kettering supposes that some focused on the women themselves, viewing them "as secular Virgins – inspiring in their perfection, their virtue, their chastity," or as figures to be desired rather than adored, or perhaps even as women who were vain and socially pretentious.[30] Others would concentrate on the splendor of their attire and respond to the women as attractive commodities.

A painting by Gerard ter Borch of a woman writing a letter hung in the home of Albert Houting and his wife, Magdalena Paters.[31] The couple had four children. Houting began work as a clerk for the East India Company around 1667, and had advanced to a position as a bookkeeper by the time he died in 1704. The family owned several genre paintings, one of which was attributed to Pieter de Hooch, and two others to Gerard ter Borch: a woman drinking and a woman writing a letter. The latter was probably a version of the painting shown in figure 39. A young woman with flawless complexion, fine hands, and beautifully braided hair sits at a table writing a letter. She wears a satin dress with a low-cut neckline; a pearl earring with a blue ribbon is her only jewelry. There is a costly rug on the table. The young woman is of marriageable age. Her physical appearance, expensive dress, and ability to write a letter identify her as someone of refined tastes, the daughter of a wealthy family. Given that many different artists depicted such women with similar attributes, it is likely that they were intended to represent an ideal of feminine attractiveness.

According to Kettering's argument considered above, both Albert Houting's wife, Magdalena, and their daughter, Agata, would have identified with this woman. Although they were more likely to identify with her than the maidservant would have done, mother and daughter would not necessarily respond in the same way, and each may have responded in different ways at different times.

When Agata was a young girl, the woman in *The Letter Writer* perhaps functioned to convey the prevailing ideal about what she should look like. The child would have responded to the painting accordingly, hoping that when she grew up she would be thin and attractive, have a flawless complexion, beautiful hair, a graceful posture, and be able to dress in expensive clothes. Although few of the women she encountered in everyday life would resemble the elegant figure in the painting, the child probably enjoyed looking at it; it gave her pleasure. Ten years later, however, she no doubt responded differently. Now approaching adulthood, she may very well have resented the presence of the painting if she failed to resemble the woman shown there. It would be a daily reminder of her failure to achieve the ideal that Kettering suggests such a painting conveyed.

As for Agata's mother, Magdalena, how might she have responded? In addition to arguing that female viewers would have identified with elegant women, Kettering also acknowledges that they might have responded in a similar way to men. "Living within a patriarchal culture," she notes, "women traditionally have adopted the male perspective."[32] So Magdalena may have responded just as Kettering suggests some men did: less to the figure in the painting than to her rich attire. As the mother of four children, born within six years, Magdalena was surely not as young as the subject of the painting, or as slim and physically attractive. Yet whatever her personal appearance, she could still afford to dress herself in expensive clothes, similar to those worn by the woman in the painting, and it may have been these that attracted her attention.

The couple's three sons may have all perhaps enjoyed looking at the painting. For Nicolaes, the oldest, the image of an attractive woman may have engendered thoughts about the woman of his dreams, the woman he hoped to marry, the mother of his children. He may, then, have been romantically attracted to the figure. Like his sister, he may have responded differently when he was older. For his father, Albert, the painting could easily have served as an unwelcome reminder of how things might have been. Although no convincing evidence is available to support either Kettering's arguments or these speculations, the possible responses of male and female viewers to a depiction of such a woman in one wealthy Amsterdam home are still worth considering.

The model for *The Letter Writer* was Gerard ter Borch's half-sister, Gesina, who would have been in her early twenties at the time. She modeled for at least twenty of his paintings.[33] A comparison between two of his drawings of the head of Gesina as a young girl, which shows her

40 Gerard ter Borch. *Two Studies of Gesina*. Drawing,
19.8 × 10.7 cm. Amsterdam, Rijksprentenkabinet.

with a long nose and a very weak chin (see fig. 40),[34] and her appearance in the paintings suggests that Gerard idealized her features in the latter, presumably to make his model more attractive. As Schatborn points out, the figure drawings were "often made from reality and were the starting point for paintings made in the studios."[35] While the paintings were intended for outside viewers, the drawings were usually not.

Although this discussion has focused on possible responses to ter Borch's *The Letter Writer* in an Amsterdam household, the implications extend to paintings of the human face and figure more generally. The paintings of elegant, richly-dressed women alone were outnumbered in many wealthy homes by paintings of merry companies, musical parties, courting couples, and other depictions of such women in men's company in well-appointed interiors. The men and women are almost always youthful and physically attractive.[36] In Caspar Netscher's *Musical Company* (see fig. 41), two men and two women form a music party. The scene is lit from an unknown source. The young women wear satin dresses, and, in one case at least, a portion of the breasts is revealed above the neckline. There is a colorful oriental rug on the table. The finely-dressed young man at the left is playing a theorbo. The woman on the near side of the table sings from a song book, while the man opposite has song books spread in front of him. He seems to be giving a lingering sidelong glance to the woman holding a lapdog.

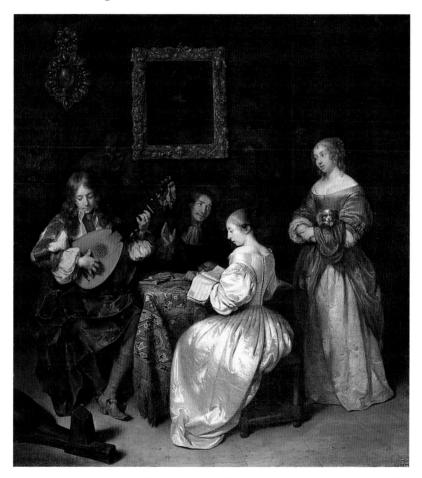

41 Caspar Netscher. *Musical Company* (1665). Oil on canvas, 50.4 × 45.9 cm. Munich, Alte Pinakothek.

What was the appeal of these sorts of high-life genre paintings? What functions did they have in people's lives? Some scholars have argued that they were allegories with a moralizing intent, providing instruction about domestic virtue and right living.[37] But seventeenth-century art treatises make no mention of didactic objectives in genre paintings, and there is no contemporary documentary evidence about the meanings that such paintings had for their viewers.[38] It seems more likely that their appeal

lay elsewhere: mainly in the eroticism and allusions to romantic love so apparent in representations of people in rich, sensuous interiors. The postures and facial expressions of these men and women, eating and drinking, playing or listening to music, singing, dancing, gaming, or simply enjoying one another's company, suggest sexual attraction and temptation.

Amsterdammers of both sexes must have taken pleasure in viewing such paintings, especially the young. But although the figures depicted may have kindled feelings of romantic longing in many young men and women, it is improbable that viewers found this type of high-life genre sexually arousing, for the idealized body types differ from the alluring nudes in many history paintings. The women are less well-rounded and seldom voluptuous; the men are leaner and less muscular. Moreover, the faces of both men and women are usually more refined and serene.

Although very few would look like the men and women in the paintings, wealthy viewers would surely recognize that there was a hierarchical grading of faces and figures according to the genre. In the case of history paintings and high-life genres, it is likely that some compared themselves with the people shown. A woman would be more apt to do so than her husband, and would be more self-conscious about how she measured up to the dominant standards of physical attractiveness, given the importance of a woman's appearance to men generally. For older viewers, high-life genre paintings may have kindled memories of the past, and a range of emotions. While some would have compared themselves to the young people in such paintings with regret, the value that others attached to an attractive face and a trim, young, sensual body probably lessened as they grew older.

Here, too, however, a double standard existed: in this instance, that associated with aging. The ideal of attractiveness for a woman was restricted largely to qualities associated with youth. As a woman aged, and certainly if she experienced several pregnancies, her attractiveness in the eyes of men would fade quickly. Men, on the other hand, were judged more by their power and success in the public sphere than by looks, so a husband would have been less concerned with his appearance than his wife was with hers. A man's achievements probably also imbued him with attributes that gave him a "distinguished" appearance in the eyes of many women. Wealthy Amsterdam men probably compared themselves with the men in paintings less often than their wives did with the women. These distinctions would also apply to comparisons that men and women

made about their mates. With both history paintings and high-life genres, a man would have been more likely to compare his wife's appearance with that of the women depicted than vice versa.

Low-Life Genres

Low-life genre paintings were also popular among Amsterdam families, although writers of art treatises were highly critical of artists who chose low and vulgar subjects for their paintings.[39] Scenes of peasants, country fairs, taverns, tobacco-smokers, gamblers, brothels, and other lowly themes were to be avoided, because the lower orders lacked grace, dignity, and good manners. Their appearance and behavior, it was claimed, revealed their inferior moral standing.[40] Many highly positioned and well-educated people held similar views. In any case, art theorists cautioned them against hanging paintings of such figures in their homes.[41]

There were a number of standard themes in low-life genre paintings, many representing comic visions of life in the country. Peasants were portrayed in unrestrained enjoyment in drinking beer, gorging themselves, smoking tobacco, playing a fiddle, dancing, shooting dice, busy at cards, half-dozing in a chair, and engaging in knife-fights and other violent acts. Men were shown urinating against a wall, while mothers breast-fed their children. Other women were depicted in various stages of undress, their clothing in disarray, and being pawed by men. Dogs were often part of the scene, sometimes fornicating in a corner. Depictions of rural life could be respectful and sympathetic, but more often they were not.

Carel Rudolf van Kuffeler, the former envoy to the King of Prussia, owned two low-life genre paintings, one depicting a peasant and his wife fighting, the other showing peasants playing cards. The first was appraised at 15 guilders, the second at 3 guilders, and neither was attributed. Both hung in the *zaal*, the one with the card-playing peasants next to the two portraits of the King of Prussia appraised at 300 guilders. Van Kuffeler and his wife clearly did not find such scenes offensive, or mind hanging paintings of greatly differing monetary worth side by side.

The van Kuffelers owned only two low-life paintings, but some rich Amsterdammers had a special liking for the genre. Eleven of the twenty-nine paintings owned by the merchant Jacob Vermis and his wife, who lived on the Singel, portrayed peasants and country scenes.[42] A painting of a country fair and two others of merry-making peasants were displayed in the side room, all three attributed to Gillis Winter (*c.* 1650–1720), an

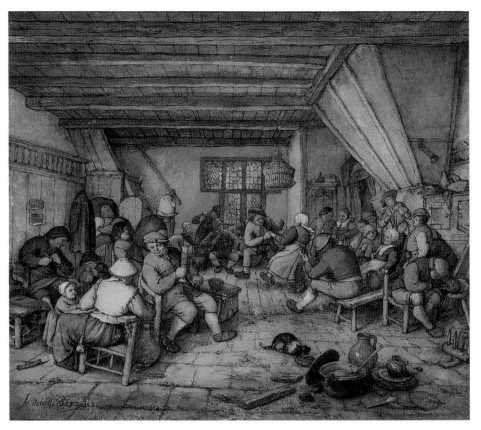

42 Adriaen van Ostade. *Interior of a Country Inn* (1673). Watercolor and oil on canvas, 25.7 × 21.8 cm. Amsterdam, Amsterdams Historisch Museum.

Amsterdam artist. A painting of peasants "in the manner" of Cornelis Bega (1631/32?–1664) hung in the hall. Five other depictions were displayed in the family room: a *gezelschap* "in the manner of" Frans Hals, a painting of merry-making peasants attributed to Jan Molenaer (*c.* 1610–1668), a painting of mussels-eaters by Philips Koninck (1619–1688), and two other paintings of merry-making peasants by Adriaen van Ostade (1610–1685). Figure 42 shows one of van Ostade's many paintings of this theme.

Paulus Huntum also had a special liking for genre pieces,[43] for thirteen of his forty-two paintings were in this category. Huntum, who

was unmarried, lived on the Herengracht with his niece, Wilhelmina Keller, and a maid. He owned houses on the Prinsengracht and the Leidsegracht, but let both of them, a fairly common practice among the wealthy. He paid rent of 430 guilders per year for the house in which he lived. Huntum was also the owner of a whaling ship (*walvisjager*), and had part interest – between one-sixteenth and one-thirty-second – in seven other ships. He also owned a plantation in Suriname named "Huntum's Hope" (in English), an unspecified number of slaves, and other property there. Although less wealthy than many regent families, he was certainly well-off: when he died, he had more than 30,000 guilders in the bank, as well as 6,000 guilders in cash and 2,400 guilders worth of silver and gold in the house. Apart from the bequest to his heirs, 500 guilders went to the Lutheran community, 400 to the Lutheran orphanage, and 550 guilders to other religious charities. He also left 6 guilders 6 stuivers to the Lutheran Church for his pew. The maidservant, Maria ("Maria de dienstmaagt"), received 100 guilders, an unusually large bequest for a servant.

Huntum's wealth was not reflected in the monetary value of his paintings. The forty-two listed in the inventory were given a total value of 498 guilders, an average of less than 12 guilders each. They were distributed over seven rooms, and most were unattributed. The others included a peasants' fair attributed to Brueghel (which one was not specified), a sleeping woman by Caspar Netscher, another painting "in the manner of" Netscher, and a country fair by Jan Steen (1625/26–1679). None was appraised at more than 30 guilders.

Although paintings of so-called vulgar subjects seem to have been less common in the homes of regents than other wealthy families, neither was much influenced by theorists who considered these paintings inappropriate for artists and viewers alike. This may have been because treatises dealt with paintings in terms of intellectual refinement and moral considerations, and ignored the sensory pleasures involved in looking at art. But why would well-positioned people own paintings of "low" subjects? What was their appeal and how would male and female viewers respond to them? Some modern scholars have claimed that such paintings, like high-life genres, had a didactic function and were viewed as warnings against the dangers of various earthly enjoyments. According to one, the "joyful, often coarse domestic and tavern scenes have been convincingly established as instructive lessons, warnings against sin, recalling death, challenging the viewer to lead a God-fearing life."[44] But although rich

urban families were surely familiar with the cultural ideals about proper conduct, and would know that the kinds of boorish and vulgar behavior depicted in some genre paintings were inappropriate for people like themselves, it seems unlikely that they displayed these paintings just as warnings about untoward behavior.

The paintings must have had other functions. For one, depictions of peasants and their simple pleasures and surroundings must have provided humor and entertainment.[45] It is easy to imagine rich viewers laughing aloud at some of them. Whether or not they recognized the extent of the exaggerated stereotypes of peasant life, they would realize that the paintings were caricatures or parodies, and served to distance the people represented from the viewers, allowing some of them to feel superior. Scenes of drunkenness and vulgarity, and others disparaging the imperfections of the lower orders, as well as the ungainly posture, awkward movements, and uncontrolled facial expressions of the lower classes, functioned to mark the privileged position of the men and women who consumed the paintings.[46] Images of peasants may also have helped to educate children about differences between their world and that of people in the countryside, although notions of superiority and inferiority would also be an aspect of what they learned.

Artists who painted low-life genre scenes, who included Jan Steen, Adriaen van Ostade and his brother Isaak (1621–1649), Cornelis Bega, Pieter de Bloot (*c.* 1601/02–1658), Adriaan Brouwer (1605/06–1638), and David Vingboons (1575–*c.* 1632), chose subjects that responded to public taste.[47] Their primary concern was to earn a decent livelihood. In Jan Steen's *A Pig Belongs in the Sty* (see fig. 43), there is a pig at the lower right, with a young boy who is either getting ready to feed it or has just done so. The two are gazing with intense curiosity at the fiddler and the intoxicated peasants in the center of the painting. Two women stand in front of a drunken reveler at the left. Both have their breasts partly uncovered, a convention often used for erotic effects in depictions of people from the lower orders.

Representations of peasants show different body types and facial features than those depicted in history paintings and high-life genres. Men especially are depicted as squat and coarse-featured, with stumpy hands, disproportionately large heads, and smiling, shapeless faces.[48] Bega's depictions are an exception, as are those by Jan Steen. The hands of many of Steen's peasants are as refined as those in his high-life genres, but their behavior reflects the chaos, disorder, and lack of self-control

43 Jan Steen. *A Pig Belongs in the Sty* (*c.* 1674–78). Oil on canvas, 47.2 × 66 cm. The Hague, Mauritshuis.

found in most other peasant paintings. It is doubtful, however, that peasants were as short and squat as those in the paintings; in fact, even though they performed physically-demanding labor, country people were probably taller and healthier than most people in Amsterdam.[49] Despite much rural poverty, country folk had cleaner air and water, lived in less crowded

conditions, and were less susceptible to infectious diseases. They may also have eaten more meat and have had a better diet. Artists, who were from the city, may have seen few peasants in the flesh.

Although scholars sometimes speculate about the meanings of these paintings for the men and women who viewed them, they do not mention children or servants. Household staff must have been aware of the dominant elite's feelings of superiority, particularly given the social distance that separated them from their employers. Since many servants originally came from the countryside, they must have recognized that the paintings often disparaged the lives of "simple folk" like themselves. No doubt they would have resented this, but they surely did not make their feelings known to those who employed them. In their presence, obedience, deference, and dissimulation would have been the norm; only offstage could they remove their masks and express their true feelings. The voices of the powerless seldom reach us today.[50] In any case, it is doubtful that the rich gave any thought as to how their servants responded to their art works. Although the master and mistress of the house would allow servants into the rooms where they slept, undressed in front of them, talked openly about intimate and private matters in their presence, and perhaps even confided in them, elite Amsterdammers generally regarded the servants as creatures of a lesser sort. As Maza notes, it would rarely cross their minds that servants were beings like themselves.[51]

Some viewers would have been attracted by the obvious eroticism in many depictions of peasants: gropings and fondlings in a general atmosphere of sexual license. The women, who usually have overly large breasts, are represented as undisciplined and lustful creatures. One popular low-life theme depicted women getting dressed or preparing for bed. In some, an attractive young woman is shown either pulling on or taking off her stockings. In most instances, her breasts are partially uncovered or their fullness revealed by an open jacket or nightdress. One example is Jan Steen's *Woman at Her Toilet* (see fig. 44). According to Chapman, it "provides a subtly erotic glimpse of a woman preparing for bed." Her pose is revealing and extremely suggestive, but only inadvertently so: "She looks down at her foot, seemingly unaware of the viewer's presence." Chapman goes on to remark that the "painting's naughtiness relates to its voyeuristic character."[52] This was much greater in the seventeenth century than it is today, of course, for there was a strong cultural taboo against women exposing their legs. Women's legs had a sort of mesmeric power if accidentally exposed,[53] and here the painter allows the male viewer a peek at

44 Jan Steen. *Woman at Her Toilet* (1663–65). Oil on panel, 37 × 27.5 cm. Amsterdam, Rijksmuseum.

what was ordinarily forbidden. The theme was a low-life counterpart to the paintings of women attending to their toilet depicted by Titian and other Italian artists, variations of which hung in some Amsterdam homes. In these, a woman is shown primping before a mirror, with a dressing table covered with combs, perfumes, and cosmetics; invariably attractive, she usually had long, flowing tresses, and is either bare-breasted or her clothing is in erotic disarray.[54]

The Steen painting was intended to be erotic, as were many paintings where a woman's low neckline not only reveals the area between the clavicle and the swelling of her breast, but shows the edge of the nipple as well. A good example is *On the Way to Market* by Jan van Bijlert (1597–1671) shown in figure 45. Brothel scenes were another popular subject. Hufton, a feminist historian, describes them nicely: "The women are joyful, rowdy, flirtatious, lustful, handsome and well-dressed. The services of the more exquisitely robed are negotiated by a madame. The poorer contemplate their drunken clientele with a mixture of philo-

45 Jan van Bijlert. *On the Way to Market* (*c.* 1640). Oil on canvas,
84.8 × 67.8 cm. Utrecht, Centraal Museum.

sophy, resignation and greed."[55] Vermeer, Steen, Dirck van Baburen
(*c.* 1590/95–1624), Gerard van Honthhorst (1590–1656), Gerard ter Borch,
Gabriel Metsu, and Frans van Mieris, as well as numerous anonymous
artists, all painted brothel scenes that hung in private homes. In addition
to presenting images of prostitutes, madames, and their customers, they
also often portrayed drunken men being robbed and others proposition-
ing women who may or may not have been prostitutes.

Figure 46 shows the *Brothel Scene* by Nicolaus Knüpfer (*c.* 1603–1655).
In this lively and colorful painting, a woman with large breasts is partly
undressed; the men are either drinking or in a drunken stupor. Everyone
seems to be having a good time, and little is left to the imagination. Its
original owner is unknown. In *The Glory of the Golden Age* catalog, it is

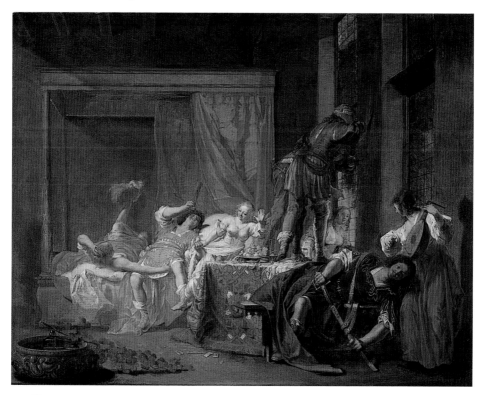

46 Nicolaus Knüpfer. *Brothel Scene* (*c.* 1650). Oil on panel, 60 × 74.5 cm. Amsterdam, Rijksmuseum.

described as "portraying a sinful existence", with the comment that in the Calvinist Netherlands it was meant to serve a negative example.[56]

Most brothel paintings capitalize on the erotic potential of women's breasts, exaggerating their display. Breasts are either fully exposed, as in the Knüpfer painting, or tightly laced and uplifted. In Dutch bordello paintings, prostitutes are often depicted as licentious, with their ample breasts overflowing their low-cut bodices, and their sexual appetites equal to those of their male clients.[57] Such paintings were, of course, portrayals of overt sexuality.[58] Dirck van Baburen's painting of *The Procuress*, shown in figure 47, depicts the madame in a brothel demanding payment from a smiling client before allowing him to enjoy the favors of the sensuously-portrayed young prostitute. In 1641 this brothel painting almost

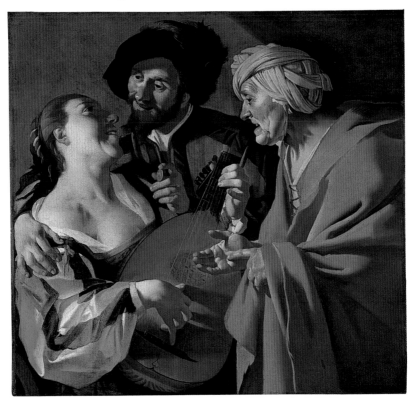

47 Dirck van Baburen. *The Procuress* (1622). Oil on canvas, 101.5 × 107.6 cm. Courtesy Museum of Fine Arts, Boston. Reproduced with permission.

certainly hung in the home of Maria Thins, the future mother-in-law of Johannes Vermeer,[59] who had brought the painting with her to her home in Delft, where Vermeer probably also lived. He later painted Baburen's composition into the background of two of his own works: *The Concert* (untraced, ex-Boston, Isabella Stewart Gardner Museum) and *The Lady Seated at the Virginals* (London, National Gallery).[60]

Depictions of brothels hung in the homes of an unknown number of respectable Dutch families, including that of Adolf Visscher and Louise Blaeu.[61] Visscher was a rich sugar-baker and businessman; his wife was the daughter of the famous Amsterdam cartographer, Dr. Joan Blaeu, whose atlas was mentioned in Chapter 2. Less than ten months after their marriage in 1681, the couple's first child was born, and a further four were

born over the next eight years. Visscher was the son of a Lutheran minister, and was himself a church warden. Louise Blaeu was one of the *regentessen* (female regents) in the *Aalmoezeniersweeshuis*, a city orphanage founded in 1664. Only the most respectable and trustworthy citizens were appointed to such positions.[62]

In the *zaal*, the room holding their most valuable paintings, the couple displayed a depiction of *The Prodigal Son* by Gabriel Metsu. Visscher's painting was probably a version of a work by Metsu with the same title – sometimes identified as a brothel scene – that hangs today in the Hermitage in St. Petersburg. It shows a young man carousing in a brothel, and despite the fact that it was displayed amid a high density of other paintings and furnishings, members of the family, friends, relatives, and perhaps acquaintances from the church and the orphanage would have been able to see it. The special art expert who appraised the Metsu painting described it as referring to the Parable of the Prodigal Son. In this biblical parable, the younger of two sons, who squandered his portion of an inheritance on carousing and whoring, was reduced to tending pigs, but later returned home repentant and was forgiven.

Visscher, a church warden, must have been familiar with this parable, able to understand its message about repentance and forgiveness, but whether or not he and his household sought moral instruction from it is unknown. It seems, unlikely, however, for, as Sluijter notes, "Few seventeenth-century viewers would have expected to be edified by the visually appealing images of vice, pleasurable pastimes, and amorous or erotically-tinged scenes that were so frequently found in Dutch paintings at the time."[63] Nonetheless, some people may have justified the acquisition of such works in terms of their possible edification: "Let that be a warning to us all!" Others perhaps considered that the paintings provided visual evidence of the conduct of people far removed from their own high standards of comportment.[64] And artists may have justified their production of these images in the same way. In any case, there was clearly a demand for such paintings among wealthy Amsterdammers.[65]

In brothel scenes, sexually hungry women take advantage of young men in pursuit of money. The women are portrayed differently from those in erotically-tinged history paintings, where sex is usually placed within a context of love and intimacy. Paintings of prostitutes depict women in ways that are intended to arouse men sexually. They were directed at male viewers, and no doubt reminded some of their own sexual experiences with prostitutes. But women would also encounter such paintings. Some

perhaps accepted them without question; others may have reacted differently, considering that brothel scenes showed contempt for women by reducing them to their sexual functions and to instruments for the sexual pleasure of men.

Paintings of brothels were a reminder of the widespread prostitution that existed in Dutch society, of stereotypes about the uncontrolled wanton desires of women, and of the fact that women (or at least prostitutes) were the sexual servants of men. Whether or not some female viewers felt humiliated by the sexual objectification that bordello paintings represented, and whether they expressed their feelings, is unknown. It is not even known whether, when, and to whom women expressed dissatisfaction about their subordinate position in the family and Dutch society more generally.

Autobiographies by women were rare in the seventeenth-century Dutch Republic, and few women published any other sorts of personal writings.[66] An exception is Anna Maria van Schurman (1607–1678), perhaps the most famous woman of the time. In 1641 she published her *Dissertatio*, which argued that women had as much capacity as men for scholarship and learning. Written in Latin, it was not translated into Dutch until 1996. *Eucleria*, a spiritual autobiography, also written in Latin, was published in 1673 and translated into Dutch in 1684. Both books challenged contemporary views about gender roles.[67] Some learned men felt that van Schurman's erudition and development went too far for a woman, that she was pretentious, and even antisocial (*asociaal*). Similar complaints were made about another unusual woman, Maria Tesselschade (1594–1649), the talented daughter of a wealthy Amsterdam merchant.[68] A member of a circle of poets and writers, she was known for her poetry, musical skills, singing, keen intelligence, and sharp tongue.

But neither of these women wrote about the sorts of oppression that many married women experienced in their everyday lives. Nor does it seem that other Dutch women complained in writing about their disadvantaged position in a male-dominated culture.[69] Certainly no woman published her thoughts about the widespread stereotype of the seductress, the woman seen as enticing and sexually insatiable.[70] Some may have broached these subjects in letters or private discussions with other women, although they would have to be prudent and refer to such matters obliquely.[71] It is in any case likely that their economic dependence would have made them reluctant to express their grievances and dissatisfactions to their husbands.

There were enormous discrepancies in the economic power of husband and wife in the seventeenth century. Whatever monetary resources she brought to the marriage, a married women was usually economically dependent on her husband. As always, economic dependence bred other types of dependence: on his good will, approval, praise, admiration, benevolence, or indulgence. Such gender inequality could be psychologically damaging to married women, affecting their autonomy and self-respect. There would have been instances in every marriage when disagreement or the withholding of consent was an appropriate reaction by either partner. A couple had to decide how much money was to be spent and for what purposes, about expenditures of leisure time, about the frequency of sexual relations, and a myriad of aspects of their life together. In every instance, it would have been far more difficult for a wife than for her husband to withhold consent, especially given the fact that women owed obedience to their husbands, and were dependent on them legally and emotionally as well as economically. In any case, it is doubtful that many wives voiced an objection to the bordello paintings displayed in the rooms where family and friends were entertained. They may, in fact, have hung the paintings there themselves.

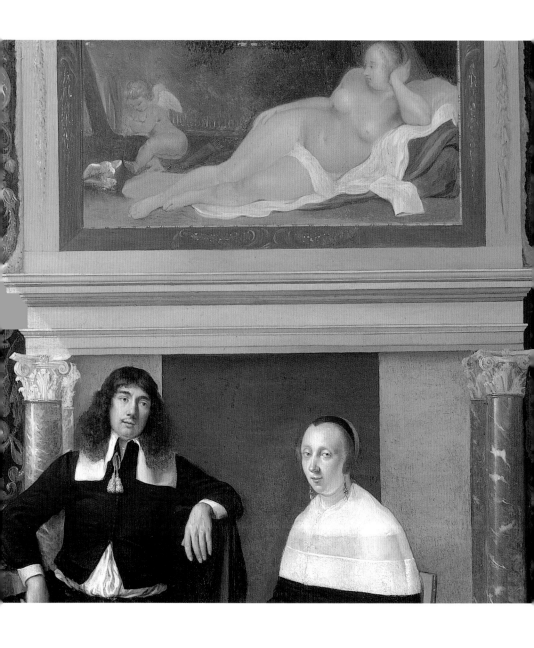

Chapter 6

Erotic Images in the Domestic Interior: Cultural Ideals and Social Practices

The capacity of paintings to excite the mind and the emotions has already been discussed. Images of unusually attractive men and women are particularly compelling. They speak a universal language, comprehensible to practically everyone, man or woman, young or old, learned or ignorant, religious or not. Both in bodily proportion and facial feature, they are very different from what people see around them. Images of seductive nudity especially draw the concentrated gaze of most viewers. The impact of erotic images is often immediate and strong: nothing so concentrates the mind as sexual arousal.[1]

Even so, the taste of wealthy Amsterdam men and women for images of physical love and eroticism, and the fact that the paintings hung in public rooms, needs to be investigated further. This chapter therefore considers the interplay of certain cultural ideals and social practices three centuries ago. The ideals specified the appropriate conduct for different categories of people, while the practices were what actually occurred in everyday life.

Ideals of Display and Viewing

Since the time of Plato and Aristotle, it has been recognized that visual representations have the capacity to move people in harmful as well as beneficial ways, and that some censorship is desirable.[2] In the *Politics*, for example, Aristotle notes that "gazing at debased paintings or stories" should be forbidden. "Let it therefore be a duty of the rulers to see that there shall be nothing at all, statue or painting, that is a representation of unseemly actions."[3]

Questions about the suitability of certain images also preoccupied art theorists from the beginning of art criticism in the Renaissance until the

end of the eighteenth century. Leon Battista Alberti, the most influential art theorist of the Renaissance, encouraged artists to become "professional visualizers" of stories that would exert a positive moral influence on the minds of their audience.[4] The truth of biblical narratives and the moral content of mythological stories had to be asserted, and the appearance, dress, bearing, and facial expressions of figures had to be depicted in ways appropriate to their age, gender, and social position, as well as to their surroundings and the seasons of the year. Gratuitous nudity was to be avoided, as were images that aroused inappropriate feelings or breached the canons of good taste.[5]

In the service of Christianity, art was to instruct, edify, aid the memory, and excite the emotions in the appropriate way. History paintings were to move viewers to empathy and compassion, and to lead the mind upward. But, it was emphasized, such paintings could also excite emotion in the wrong way: they were capable of arousing the flesh. The more skilled the artist, in fact, the greater the harm done by erotic representations, that is, the more capable such depictions were of arousing strong sexual feelings in viewers. Thus Michelangelo was criticized for the nude figures in his *Last Judgment*, and nude images of Venus were considered by some to be a filthy and obscene thing.[6]

Titian's so-called *Venus of Urbino* (Florence, Uffizi) was described by its first owner in 1538 simply as "the naked woman." In a reply to a request for a copy of it in 1598, the Duke of Urbino asked not to be identified as its owner and explained that he kept this "lascivious work" in his collection only because it was by Titian.[7] The reclining nude women in paintings that Titian supplied to his non-Venetian patrons were given the attributes of Venus or Danäe. After he sent a painting of Danäe to Philip II of Spain, the king commissioned Titian to paint a series of mythological history paintings based on Ovidian themes. Philip kept these erotic paintings hidden behind a curtain, showing them only to "visitors of his choosing."[8]

Many paintings with Ovidian themes were intended for private chambers or bedrooms. Rather than being allegories, the paintings that Correggio produced for private patrons were intended to stimulate private sexuality.[9] And Palma Vecchio made a living by supplying Venetian patrons with paintings in which female figures were presented as objects of sexual interest.[10] Although these artists were often criticized for their choice of erotic subject matter, their work was much in demand.

Treatises by churchmen cautioned against indecency in paintings in both private homes and churches. The Church encouraged a devotional

gaze, but at the same time the faculty of vision was closely associated with temptation and sin in Christian theology. Men and women were instructed to guard their sight against illicit images such as the female body, which was linked to the sin of lust. As Christ cautioned, "But I say unto you, That, whosoever looketh on a woman to lust after her hath committed adultery with her already in his heart."[11] And, as the biblical story relates, Adam's and Eve's realization of the shame of nakedness and carnal lust was associated with sight.[12]

The Council of Trent, which was convened to reform the Roman Catholic Church in several sessions from 1545, laid down guidelines for sacred art. These included a general proscription against unnecessary nudity, including nude representations of the Infant Christ and being suckled by his virgin mother as a baby.[13] It was advised that "all lasciviousness should be avoided, so that images shall not be painted and adorned with a seductive charm."[14] This was strikingly at odds with the splendid nudity and erotic themes in many contemporary religious and mythological paintings by Italian artists, which found a ready market among wealthy cultured patrons, some of whom chose the subject matter.

Seventeenth-century art-theoretical writings in the Dutch Republic repeated the directives found in treatises by Alberti and other earlier writers about the appropriate kinds of images for representation and viewing. They argued that historical themes were the most suitable subject for art, since they dealt with morally uplifting themes and figures of beauty. Even so, artists were cautioned against nudity or inappropriately situating biblical and classical stories in contemporary settings. These remarks were also directed at their highly positioned and well-educated patrons.[15]

Conduct treatises also warned against the dangers of viewing beautiful faces and finely-proportioned nude bodies, because such images were capable of exciting the emotions in the wrong way, stimulating sexuality, and arousing the flesh. Jacob Cats (1577–1660), whose popular moral treatises extolled Calvinist virtues, warned against unchaste subjects in art, especially those that aroused evil lusts in the young, such as David and Bathsheba, the Rape of Europa, Leda and the Swan, and Lot and his daughters.[16] Johan van Beverwijck (1594–1647), author of influential medical treatises, similarly cautioned against "any amorous or frivolous paintings," which "also cunningly lead to promiscuity."[17]

In the exhibition catalog *Dutch Classicism in Seventeenth-Century Painting*, Blankert emphasizes that the depiction of a nude of idealized

beauty – the loftiest of themes for some artists – also implied an erotic context, and points out the difficulty of establishing where the dividing line lay.[18] Several other contributors suggest that seventeenth-century families would have hesitated to display history paintings containing nudes in their homes for this reason.

In apparent agreement, Honig, a feminist art historian, argues that wealthy women would not have allowed such sexually provocative paintings to hang in their homes. (Her suggestion that it was the wives in seventeenth-century Holland who would decide about the display of paintings in the home was mentioned on p. 10.) She considers that it would be they who would often purchase the paintings, so that these were made not just to be seen by women "but to *appeal* to their ideals, their gazes, their tastes." They thus had to have qualities that a woman "would wish to integrate into the domestic world that she controlled and inhabited." Accordingly, a prime concern for the historian of much of Dutch painting is the feminine gaze; the masculine (husband's) one, which viewed a wife's choices, is less important.[19] The logical conclusion of this argument is that the erotic images adorning the walls of Amsterdam homes were there because they appealed to the ideals, gazes, and tastes of the women who regulated the domestic space in which they were displayed.

In connection with the etching of Rembrandt's *Half-Dressed Woman by a Stove*, however, which shows a woman in what is obviously a studio, Honig writes: "Rembrandt's image brings the viewer uncomfortably into a realm that is at once the studio and the home, a place provided with a simple stove to keep the woman – or the model – warm as she undresses. I say 'uncomfortable' because home is *not* the place in which the display or viewing of unclothed women was socially permissible."[20] Rembrandt's studio nudes make the viewer uncomfortable, it is claimed, because the artist draws attention to the fact that the paintings were produced in the private, domestic sphere of his home. Unclothed women should not be viewed here – neither Rembrandt's studio nudes nor those by other Dutch painters. Honig, however, does not address the issue of paintings of unclothed women that did *not* draw attention to the fact that they were studio nudes. Was it also impermissible to display and view biblical and mythological figures without clothes? The force of her argument certainly suggests such a conclusion. This, however, undercuts the claim that the paintings in seventeenth-century homes would have had qualities that a woman would want to see there. In any case, nudes and other erotic paintings were in fact hung in homes, not only in Amsterdam but in

Delft, Utrecht, The Hague, Dordrecht, Leiden, and elsewhere, and it is unknown whether decisions about their display were made by wives, husbands, or were negotiated between the sexes.

Social Practices: The Display and Functions of Erotic Art

Some scholars have argued it was the pronouncements of art theorists that provided a pretext for people to hang such paintings in their homes, because they supplied a decorous interpretation for the nudity and eroticism depicted.[21] Biblical and literary references, and the moral warnings that accompanied them, thus legitimated the presence of erotic images hanging on the walls. Although it is doubtful that many wealthy Amsterdammers either read art treatises or were familiar with the views expressed there, some may have considered that erotic ingenuity and sexual candor were justified by the subject matter. This certainly applied elsewhere in Europe, but in other countries the presence of erotic images in a family's home was governed by a second constraint: that they be restricted to the private chamber or bedroom. In other words, visual access to sexual representations had to be limited. A third constraint, at least in cultured Renaissance circles, was that the paintings should be costly works by recognized artists.[22]

Wealthy Amsterdammers, however, did not limit their erotically-charged history paintings exclusively to private rooms, but displayed them quite openly in the rooms where they entertained guests: the *zaal* and the *zijdekamer*. (The paintings were not even usually costly, or attributed to particular artists.) In so doing, they acknowledged the pleasure of looking at such art works, and gave their guests visual access to them as well. They considered their eroticism acceptable, and neither unseemly nor perilously obscene. This also applies to other types of paintings with an erotic appeal.[23]

In Chapter 4, distinctions were made between the probable reactions of male and female viewers to erotic pictures, and three likely responses were discussed. It is also possible that at times paintings were used to encourage sexuality and procreation, and that some images were believed to help ensure the birth of beautiful children.

In Renaissance Italy, Alberti had written that portrayals of beautiful nude boys and handsome and dignified men were appropriate for the conjugal chamber.[24] It was thought that these paintings could influence the sex and appearance of future offspring through a sort of visual imprinting. Male children were preferred, hence Alberti's advice. Nude and

cavorting boys were depicted not only in paintings, but also on the reverse sides of specially painted birth trays and bowls, which were used to bring food and drinks to women awaiting labor. Such representations "functioned as a birth talisman to stimulate the mother's imagination toward the procreation of similarly healthy, hearty sons."[25] This was also true of paintings of the Christ Child. According to Murphy, "While meditating on the little sleeping Child in the painting, a woman could imagine that the child in her own womb was precisely the same in appearance as the baby depicted in the picture, and this correspondence would supposedly facilitate the process of image transferal."[26]

Similarly, erotic figures such as Susanna, Bathsheba, and Mars and Venus represented on walls, marriage chests, birth trays, and bowls also had special functions: to encourage sexuality, to set the desired mood for marital consummation, and to help husband and wife achieve the sexual excitement and mutual orgasms thought necessary for producing attractive and healthy children.[27] In his manual for the art lover, written in 1621, Giulio Mancini is clear about their functions: "And such lascivious pictures are appropriate in such places where one stays with one's spouse, because this kind of sight is really conducive to excitement and to the making of beautiful, healthy, and strong children."[28] But Mancini cautioned that lascivious paintings must be concealed from children, old maids, and strangers, and unveiled only when a man was with his wife. This is the main reason that they were sometimes equipped with a cloth cover or curtain. The presence of such visual displays in the conjugal chamber certainly attests to their supposed power and influence.

An obvious question is whether visual images served similar functions for married couples in seventeenth-century Amsterdam. Some surely did, since it was considered the duty of every Christian couple to beget children. Married women were defined as vessels for the reproduction of the species, and the absence of children represented failure and inadequacy: to be barren was a judgment from God.[29] The Roman Catholic couple Jacob van Ring and Maria Heymerik, mentioned in Chapter 4, hung two paintings of the Christ Child and one of the Virgin and Child in the room where they slept. In addition to their devotional function, these sacred images were perhaps intended to help Maria conceive and deliver a child resembling the Christ Child in the paintings. There is no record of her having had any children after her relatively late marriage at the age of 41, however, and in any case the van Rings were exceptional in having paintings of the Christ Child in the room they used as a bedroom. The

Dutch painter and art theorist Gerard de Lairesse (1641–1711) suggested that husband and wife hang paintings of nude children and pretty faces in the room where they slept,[30] but he does not say why, and Amsterdam families owned few paintings of nude children. Although depictions of nude children often decorated candlestands, silver pieces, and table ornaments, it is unknown whether they had the same function in Amsterdam as in an earlier period in Italy.

What, then, was the function of the sexual representations in homes if not to encourage procreation? Most married couples would have had intercourse far more often than was needed to conceive, and erotic images may have functioned more to stimulate sexual relations as an end in itself than to ensure procreation. In Amsterdam homes such images were present not only in paintings, but also as decorations on household furnishings. Nude or partly-nude gods and goddesses, as well as some biblical figures, decorated table ornaments, plates, and other silver objects, jewel boxes, cabinets for curiosities, and song books, and were often shown in suggestive poses and situations. Sexual rapport between men and women was, however, most likely to have been stimulated by paintings, whether genre or history paintings, landscapes with nude figures, or even some portraits. Although these differed in their degree of eroticism, it is still quite remarkable that so many were hung in public rooms. The *zaal* and the *zijdekamer* were, of course, not exclusively used for eating and entertaining guests; they were also the rooms where the husband, the wife, or both, slept – and no doubt made love as well.

The childless couple Frederick Willem and Alida van Loon lived in a sixteen-room house on the Keizersgracht, with a garden house behind it; they also owned two country houses, land-holdings outside Amsterdam, and a farm.[31] A regent, Frederick Willem was the son of a former burgomaster; Alida was his cousin, the daughter of his uncle Pieter. Married in 1682 when they were both 37, they had no children. Their home was expensively furnished. A large tapestry, appraised at 360 guilders, covered most of a wall in the *zaal*, and gilt leather, valued at 100 guilders, decorated the walls in the *goudleer* room. There were also many books and atlases in the *goudleer* room, and a special book appraiser was called in to evaluate them. The couple must have owned more than one atlas, since these were valued at 664 guilders, and there is no indication that the famous Blaeu atlas was among them. The total for the atlases and books together was 1,490 guilders, compared to 20 guilders for each of five family portraits hanging in this room. The van Loon's collection of

medals was appraised at 576 guilders, and their silver valued at 1,829 guilders, but there is no indication of how and where the plate was displayed. Porcelain was located throughout the house, but little of it was appraised. It may have been brought by Alida to the marriage.

The fifty-three paintings in the van Loon home were appraised at 1,759 guilders. One-third were portraits, all but three of ancestors, including an unattributed pendant pair of Frederick Willem's parents. Unattributed pendant portraits of Frederick Willem and Alida were displayed in the small gold leather room (*goudleer kamertje*), together with three other unattributed portraits. The five paintings were hung over the gold leather that covered the walls, and there was another painting over the fireplace. The couple slept in the *zijdekamer*, which contained twenty-two paintings, none of which was appraised at more than 80 guilders, and their four-poster bed, which with its bedclothes and curtains was appraised at 300 guilders.

Among the paintings of the *zijdekamer* were seven works by Daniel Vertangen (1598–*c.*1681/84), a painter of history paintings with mythological themes, as well as landscapes with nude figures. Most of his works show a strong erotic quality, as in his *Sleeping Venus and Two Satyrs* (see fig. 48). He is not well-known today, and there are no examples of his work in Dutch public collections,[32] although several paintings hang in museums elsewhere in Europe and in the United States. His history paintings are generally smaller than most, measuring about 10 × 15 cm, so that it would have been possible for people to remove them from the wall, hold them in their hands in the best light, and examine them closely.

The Vertangen paintings in the van Loon home had both religious and mythological themes: the Dance around the Golden Calf, Moses and the Tables of the Law, Bathsheba, Apollo and Daphne, a Bacchanal, and two of reclining women. The seven paintings were appraised together at 220 guilders, less than the monetary value of the four-poster bed. They were probably valued more for their erotic imagery, however, which may have functioned to arouse the couple's sexual feelings. Two depictions of Mary Magdalene hanging next to the Vertangen paintings perhaps did the same. Although there were no young sons or daughters in the van Loon household to see the kinds of erotically-tinged paintings that some people argued ought to be hidden from the eyes of children, their two female servants surely saw the paintings regularly, and the male servant may have caught a glimpse of some of them when he carried in peat or wood for the fire.

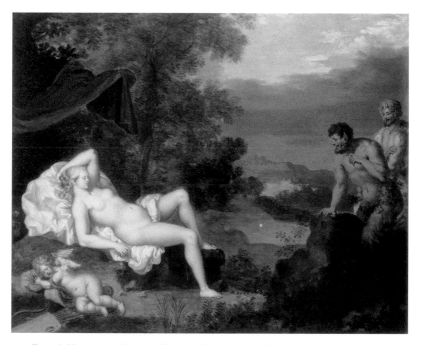

48 Daniel Vertangen. *Sleeping Venus with Two Satyrs* (no date). Oil on canvas, 18 ×
24 cm. Bergamo, Accademia Carrara.

Twelve paintings decorated the walls in the *zijdekamer* in the home of
Aernout Stevens and his wife, Sara Witte.[33] Born in Germany, probably
around 1660, Stevens had been a spice merchant (*kruidenier*) in Keulen
before becoming an Amsterdam citizen in 1683. He and his wife, who
was from Haarlem, married in 1690. A daughter, Anna Maghtalena
Stevens, was born eight years later. Aernout Stevens became a wine mer-
chant in Amsterdam, and there was a large quantity of wine in his home
when he died in 1706, at about the age of 45.

Aernout (and sometimes, no doubt, his wife as well) slept in the
zijdekamer. Among the paintings were one by Vertangen of Cephalus and
Procris, a young couple in Greek mythology, often portrayed in an erotic
manner; a landscape with nude figures by Johan van Haensbergen
(1642–1705); and an unattributed painting of the Judgment of Paris. A
silver plate, engraved with an image of Susanna and attributed to the
famous silversmith Paulus van Vianen, hung on the wall next to the Ver-

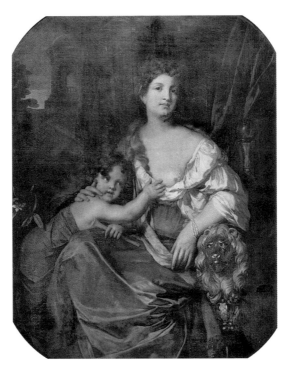

49 Gerard de Lairesse. *Portrait of Amélia van Anhalt Dessah and Her Son* (1689). Oil on canvas, 138 × 112 cm. Quimper, Musée des Beaux-Arts.

tangen painting. Since nothing is known about the household routines of the family, it is impossible to say how often the Stevens's eight-year-old daughter would have entered the *zijdekamer*, but if and when she did, she would have encountered the erotic images that hung on its walls. It is easy to imagine many children, especially adolescent boys, taking a peek at such paintings.[34]

Sexual Ideals and Practices in the Golden Age

The enormous fascination with depictions of sensuous nude bodies and allusions to sexual love documented above extended particularly to female nudity, and women's breasts were especially fetishized. As one scholar notes, "In a society in which women were usually shrouded in textiles from neck to feet, the portrayal of a woman without any clothes on must have had a different effect from that in our society, where nudity is prof-

fered in large daily doses."[35] It is questionable, however, whether women's bodies were really entirely covered by clothing in the Dutch Republic. Total nudity was certainly considered offensive, but women did uncover their necks, shoulders, and portions of their breasts in public.

Although clergymen and other moral watchdogs may have been scandalized by low-cut dresses, many women wore them. Manuth claims that a display of cleavage was rare in the Dutch Republic, except at the "internationally-oriented court" in The Hague, and that such an attire would immediately identify a woman as a prostitute.[36] If this were true, there would be fewer low-cut gowns in the portraits of the well-to-do and in genre paintings of women in interiors. Even if some genres were intended as depictions of prostitutes, not all of them were. The portraits by such artists as Caspar Netscher, Michiel van Musscher, Gerard van Honthorst, Nicolaes Maes, and Govert Flinck (1615–1660) that hung in Amsterdam homes certainly did not depict prostitutes. In fact, it was fashionable for women to show a little cleavage, and a few revealed still more.

Some wealthy Dutch women chose – or were perhaps persuaded by their husbands – to be portrayed as a shepherdess or other mythological figure. Figure 49 shows a *Portrait of Amélia van Anhalt Dessab and Her Son*, painted by Gerard de Lairesse in 1683. Their pose, and her bare breast, indicate that the painting is intended to depict Venus and Cupid. Another portrait based on a mythological theme is shown in figure 50, a painting by Gerard van Honthorst from 1645. Here the daughters of Johan van Reede pose as the Three Graces, or three attendants of Venus. The Graces are usually depicted as smiling, either nude or partly-nude, with the two outer figures facing the viewer and the one in the middle facing away. Here, the three young women are somewhat indecorously clad, and the daughter in the middle allows her breast to slip out and be exposed. Paintings such as these probably hung in private rooms and were not seen by visitors.

The liberal attitude of such families toward eroticism in art works, despite the warnings of critics and moralists, will come as a surprise to those who think of Dutch Calvinists as pious churchgoers, stiff, dour, and forbidding, with extreme and rigid attitudes toward pleasure and enjoyment.[37] Some Calvinists, it is true, believed that dancing, drinking, cardplaying, and other forms of entertainment broke God's commandments. There was also a strong emphasis on public adherence to the Christian faith in the Dutch Republic. Social thinkers agreed, according to van Eijnatten, that it was best "to conform one's private desires to what the

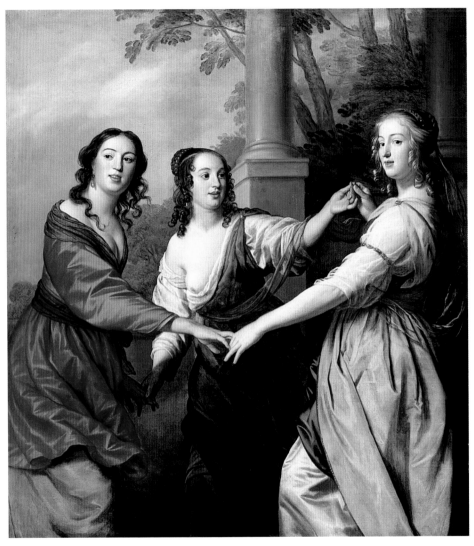

50 Gerard van Honthorst. *The Daughters of Johan van Reede as the Three Graces* (1645). Oil on canvas, 168 × 150 cm. Oud-Zuilen, Museum Slot Zuylen.

public sphere demands."[38] Weekly church attendance and a charitable concern for the welfare of others were the outward signs of being a good Christian,[39] but many did so in a matter-of-fact way, without any particular commitment to religious doctrine or any ostentatious expressions of faith.[40]

Dutch public life was characterized by restraint and propriety. Prominent men, especially, were expected to act in a reserved, solemn, and proper manner in public.[41] Women were supposed to be demure, prim, and modest.[42] Even if men and women did not allow such social standards actually to regulate their private conduct, there was a pragmatic acceptance of the need to act as if they did.

Bodily and emotional self-control, reliability, loyalty, and adherence to duty were highly valued. Most important was respectability, a good reputation. By and large, this rested on an individual's public behavior, on what occurred in the presence of people outside the circle of family and other intimate relationships. Individuals conducted themselves less by abstract moral standards than by how others perceived them. Shame, rather than guilt, regulated their conduct. Both serve to facilitate socially acceptable behavior, but whereas guilt concerns sanctions that are internal to the individual, shame concerns others.[43] The Dutch Republic was basically a shame culture.

With family and friends, reserve, propriety, and decorum could be set aside. In such circumstances, the seventeenth-century Dutch – or at least large numbers of them – were a gregarious, fun-loving, extroverted people, who loved to eat, drink, smoke, laugh, and make merry.[44] They were known for their collective addiction to drinking and smoking, their continual eating, and the large amounts of food they consumed. Banquets, feasts, celebrations, and parties were occasions for satisfying their appetites.[45] Given the opportunity, they would satisfy their sexual appetites as well.

The Dutch today are unusually forthright about sex, and this was also the case during the seventeenth century, a period of great sexual candor, although less so towards the end of the century than earlier.[46] The Dutch had a generally open attitude toward sexuality and eroticism in the theater, popular books, poetry, and paintings. Most jokes, either directly or indirectly, concerned sex.[47] Some song books contained erotic verses. One of the milder, a description of an amorous encounter, reads as follows:

> He stuck his pretty flute
> Between my breasts.
> "Away, away," said I, "you rogue,
> What does love mean?
> While on your flute, you play,
> Play as you should!
> It won't bore me:
> It's happened often enough!"[48]

Both males and females acknowledged the body's capacity to give pleasure. This was what concerned the guardians of morality.

Many descriptions of life in the Dutch Golden Age take the norms set forth in domestic conduct books by Jacob Cats and other moralists as an accurate reflection of the way that people behaved. It is more likely, however, that such books were written because people did *not* behave in the ways they should and thus needed instruction in proper behavior. It is also often assumed that books extolling Calvinist values had a strong influence on people's conduct. There was certainly a large public for these treatises, which concerned the roles of the sexes, the conduct of young unmarried men and women, and the sanctity of marriage and the family:[49] twenty-one editions of Cats's work appeared during the seventeenth and eighteenth centuries.

Like other domestic conduct treatises in the Netherlands and elsewhere in Europe, Cats's writings set forth cultural ideals about people's behavior, and contained rules governing the appropriate conduct for various categories of people at different stages in life. All the treatises were written by men, and all advanced ideas widely embraced in the theoretical and popular writings of Catholics and Protestants, humanists and scholastics, Englishmen and continental Europeans. This is not surprising, since the authors "shared a common intellectual heritage, read largely the same books, and respected the same authorities,"[50] which included Aristotle, Xenophon, Plutarch, and other classical authors, the Bible, and various Renaissance writers.[51] The writers were united in their views on sexual conduct. They exhorted young women to avoid temptation and to remain chaste until marriage. Sexual pleasure was recognized as natural and desirable, but procreation was its legitimate object. Sex was thus permissible only between husband and wife.

But the morality represented in these domestic treatises competed with other ideals, values, beliefs, and everyday practices. As elsewhere in pre-

industrial Europe, two, somewhat overlapping, milieus of sexuality existed in the Dutch Republic: a licit one involving marriage and an illicit one. In theory at least, sexual pleasure was to be realized solely in the marital relationship. In fact, sexual intercourse before marriage was common.

Among married couples, sexual desire and the pleasures of love were openly acknowledged, highly valued, and actively pursued. It was widely recognized that sexual intercourse was for the physical expression of married love as well as for the procreation of children. Although the man was assumed to be the master, the woman's needs were recognized.[52] Little is known about the frequency of sexual relations, for personal memoirs, diaries, and other documents reveal little about this aspect of their lives. One notable exception is the diary kept by the wealthy regent, Joan Huydecoper, the father of Maria whose portraits are mentioned above. In his diary, Huydecoper kept a meticulous account of the favors he did for others and they for him, his visits and visitors, his smoking and drinking, and his daily activities at home and work. He also recorded the number of times he had sexual intercourse with his wife, Sophia Coymans.[53]

Joan and Sophia had been married in 1656, and a son was born nine-and-a-half months later. From that date on, Joan recorded in a sort of code the days on which he and Sophia made love, including occasions when they did so twice in the same day. During the year 1659, after three years of marriage, he and his wife had sexual intercourse seventy-five times. Couples were supposed to refrain from intercourse during a pregnancy (and during menstruation and periods of breast-feeding), but during the first months of Sophia's pregnancy in 1659, she and Joan had intercourse on average once in three days. Only during the eighth month of her pregnancy was there a period of abstinence, broken once two weeks before she gave birth. During a previous pregnancy, the couple had made love for the last time six weeks before the birth of the child. Sophia was pregnant during much of their marriage, over a period of twenty-one years.[54] There was a strong bond of love and affection between the couple, who wrote regularly to one another when they were apart. Even after twenty-five years of marriage, Joan wrote to his wife telling her how much he looked forward to seeing her, holding her in his arms, and caressing her.[55]

The second milieu of sexuality was constituted by pre-marital and extra-marital sexual relations, brothels and prostitution, same-sex relations, erotic literature, and other sexual outlets. Since most young men

and women did not marry until well into their twenties, several years after sexual maturity, it is not surprising that they had sexual relationships. Attempts were made in every country to regulate contact between unmarried young people,[56] and those in countries with more repressive mechanisms of social control seem to have been less sexually active.[57] Foreign visitors often remarked on the enormous freedom that young people enjoyed in the Dutch Republic, and it does appear that courting was more often outside parental control than was the case elsewhere in Europe. One reason may have been that the Northern Netherlands, which included Amsterdam, was the most highly urbanized and densely populated region in Europe.[58] Several seventeenth-century books provided readers with lists of the most popular locales in Amsterdam and other cities for meeting members of the opposite sex.[59] The children of wealthy families had an especially busy social life, going out several times every week, although they were expected to restrict their social contacts to people within their own circles and were probably watched closely.[60] They met one another at birthday celebrations, on family visits, at card evenings, at carriage outings in the country, and at dances and ice skating.

The situations of unmarried men and women were radically different. While unmarried men could be forgiven for visiting brothels in search of sexual satisfaction, nothing similar was available for women. In fact, the gender and economic hierarchies ensured that much sexuality among Amsterdammers was exploitative, involving relationships between (relatively) powerful men and subservient women, who included the large surplus of unmarried women who supported themselves in various types of poorly-paid work. For these women, affection and sexual pleasure sometimes depended on surrendering to the advances of men from the higher echelons of Amsterdam society.

The unmarried also included widows and widowers. Widowers were more likely to remarry than widows, but those who did not had to seek their sexual contacts outside the marital relationship. Those widows who remained single out of choice often preferred freedom from the patriarchal domination of a husband, including perhaps the sexual obligations connected with marriage and the dangers and pain of childbirth. The authors of domestic conduct treatises, who warned women repeatedly about the importance of proper conduct, were especially obsessed with the uncontrollable sexual urges of widows, assuming that women who had experienced sex relations would be unable to resist carnal stirrings and the temptations of the flesh. As daughters of Eve, women were easily

tempted to lust. Young widows in particular were viewed as a threat to social stability. They were encouraged to remarry in the name of public morality, to avoid becoming targets of the amorous advances of both unmarried and married men.

Married men had more opportunities for extra-marital sexual relations than their wives.[61] Merchants spent time in other cities and countries, while men in the navy or employed by the East India Company were away from home for long periods of time. No other country in the world had such a high percentage of the male population engaged in seafaring or trading activities. In the absence of the normal mechanisms of social control, some men violated the moral and legal demands of monogamy.[62] A wife would be expected to blame the wanton nature of other women if her husband were unfaithful.

Women were much less free from surveillance, discipline, and control, and widows were especially closely scrutinized. As far as a married woman's sexual conduct was concerned, neighbors and relatives would have been the strongest source of social control. The fact that most Amsterdammers lived in multiple dwellings, with shared entrances and facilities, meant that little could be kept secret. Given the importance of "respectability," the fear of gossip made most married women hesitant before involving themselves in illicit relationships. They would also be in danger of discovery by the law. The approximately 150 members of local citizen organizations, who guarded against robbery and other crimes in the city, enforced sexual decency and informed the *schout* of any unacceptable behavior.[63] Those who did come into contact with the law sometimes claimed that they had received word of their husband's death.[64] Although the wives of Amsterdam regents and other prominent men would usually have been subject to the close supervision of a large family structure, they probably had more freedom of movement than most other women in the city.

Travel to fairs and other amusements outside one's usual place of residence provided married men – and a small number of married women – with the sexual opportunities they lacked at home. Men frequented taverns, public houses, gaming-houses, and so-called music houses in Amsterdam, where they could eat, drink, and listen to music. Many of these expensively-decorated establishments were essentially brothels, often disguised as a house of the well-to-do. They catered to a wealthy clientele, who were sometimes served by bare-breasted or even naked young women.

Prostitution was an everyday occurrence in the cities. Although not legal, the existence of brothels and prostitution was recognized and tolerated. When there were crackdowns, unmarried men were seldom prosecuted. Jews were a notable exception, for they were legally forbidden from marrying or having sexual relations with Christians. But there were relatively few Jews in Amsterdam, and it was married Christian men who were the favorite target for the *schouten*. Threatened with prosecution for adultery, married men were often willing to pay a considerable sum to have the charges dropped. The amount paid varied from a few hundred to more than 3,000 guilders.[65] For the *schouten* – men like Jacob Jacobsz Hinloopen – this was a rich source of income.

University students also enjoyed rich men's justice in matters of sexual misconduct. This was clear at the University of Leiden, where the students were notoriously badly behaved.[66] Their rowdy behavior sometimes included sexually molesting servants, prostitutes, and other young women from the so-called lower orders of Dutch society. Groups of students grabbed women under their skirts, fondled their breasts, and even sexually assaulted them. Rape and the threat of rape were a major force in the subjugation of women in the Dutch Republic.

When a student's misconduct came to the attention of the authorities, the young man was tried by his university's legal system. If a victim of rape became pregnant, her assailant was acquitted, for the pregnancy was proof that she had enjoyed the act and experienced the orgasm thought necessary for conception.[67] She must, then, have consented to have sexual relations. With other types of sexual assault by students, or when a rape victim did not become pregnant, the woman was often accused of having invited attention because of her dress or comportment. It was, after all, a woman's responsibility to avoid producing sexual desire in men. Thus the judges – professors from the university – imposed no more than a reprimand or a fine for a student's misconduct. One example is the case of Aernout Bitter, an Amsterdammer who studied in Leiden. On 30 May 1686 Bitter, who had just finished his law degree, raped a young woman in Leiden, assisted by two fellow students. The woman did not become pregnant. Bitter was required to a pay a fine of 400 guilders, more than a year's wages for an ordinary worker but easily affordable for a wealthy family.[68]

When a woman accused a man of rape in situations outside the university setting, the court always took into account her age and sexual experience as well as the behavior of the offender. The rape of a young

woman with no previous sexual experience was taken much more seriously than that of one who had already lost her virginity. The court would be particularly unsympathetic towards a married woman claiming to have been raped, believing that her sexual nature and sexual experience made her the perpetrator rather than the victim. Married or unmarried, however, a man was unlikely to be convicted of rape in the absence of witnesses.[69]

Elite families would be especially concerned about a pregnancy resulting from sexual relations between their sons and a servant or another woman from the lower echelons. When this occurred, the young woman had a right to file a paternity suit against the man in question. The family sometimes bought her silence, but if not, and if the young man was found guilty, he was often obliged to marry the woman. In such an event, he and his family lost any chance of aligning themselves with another elite family.

Same-sex relations were another form of unauthorized sexual behavior in the Dutch Golden Age. A relation between men, classified as sodomy, was regarded as a deadly sin and prohibited by religious doctrine and law. Sex between women was not specifically prohibited, because the notion of sex without a penis was difficult for people to accept,[70] and it was believed that a woman's sexual satisfaction required male penetration.[71] Although homosexuals had special meeting places in Amsterdam and other cities in the seventeenth century, the legal authorities seem to have had no particular interest in same-sex relationships. Legal documents and other written sources seldom bear witness to such behavior between males and not at all between women.[72] After 1730, however, the authorities were vigilant in prosecuting sex between males, while it was not until 1793 that a woman was convicted of having sex with another woman.[73]

According to van der Meer, there is no reason to think that there were fewer sexual relationships between men in the seventeenth-century Dutch Republic than a century later.[74] In the eighteenth century these included both brief sexual encounters and long-term relationships between, for example, wealthy men (married and unmarried) and their male household servants.

The explicit presence of sexuality in literature and the arts is another aspect of "the liberality of Dutch bourgeois sexual morals" in the seventeenth century.[75] Erotic novels, written to excite the passions, could be bought openly and were on display in bookshop windows. Numerous

sexually-explicit books were published in the Dutch Republic, although few had Dutch authors; in those that did, the themes were conventional and the illustrations tame and even chaste. There was, as Mijnhardt notes, "hardly any cataloguing of sexual variations, nor any substantial discussion of masturbation, sodomy, incest, or homosexuality."[76] Many sexual and erotic guidebooks also appeared, one even depicting an Amsterdam "dildo-shop" on its title page.[77] The most popular was the Dutch adaptation of Nicolas Venette's well-known manual *Tableau de l'amour*, published in Dutch as *Venus minsieke gasthuis* (Venus' guesthouse for lovers), in which diverse variations of sexual intercourse and different ways of obtaining maximum sexual pleasure were frankly discussed. To maintain good health and produce fertile semen, it warned, four or five ejaculations per night ought to be the maximum.[78] Produced in a relatively inexpensive illustrated edition, the guidebook went into seven editions between 1687 and 1715.[79] Books were expensive, and not more than 2–5 percent of the population bought them. The readers of these erotic novels must, then, have been the socially well placed.[80]

What is seen, then, is an openness toward sexuality and erotic love that is very much at odds with a stereotype of rigid and repressed Calvinists three hundred years ago. The Dutch recognized sexual need, desire, and pleasure, and were relatively tolerant in allowing the satisfaction of the sexual appetites.[81] A double standard of sexual morality was firmly established, however, and a woman's sexual life was supposed to be restricted to what occurred in the marital relationship; often, as noted above, it was not.

Religious and/or government interference in the sexual sphere was rare, and this also applied to the censorship of erotically-tinged paintings. The Dutch clergy did not seem to evidence any particular opposition to morally incorrect paintings. "A small minority of fundamentalist Protestants," as one scholar notes, "rejected the visual arts altogether, but otherwise, protests against lowly and vulgar paintings were limited to a small number of books on art which addressed a restricted audience."[82]

One of the few recorded instances of government interference concerns an artist known as Torrentius (Johannes Symonis van der Beek, 1589–1644), who was arrested for religious heresy and blasphemy. Although his conviction gave rise to public outrage, Torrentius was imprisoned and his paintings seized. Among them was a depiction of Adam and Eve, with Adam's flesh described as "very ruddy;" a depiction of a woman "pissing in a man's ear;" and another of a young woman who

seems to have been masturbating. Such images apparently exceeded the limits of what was permissible and the paintings may even have been burned. The case of Torrentius was, however, exceptional. Moreover, it was his openly anti-religious remarks about Christ and the Bible that originally got him in trouble – not his art works.[83]

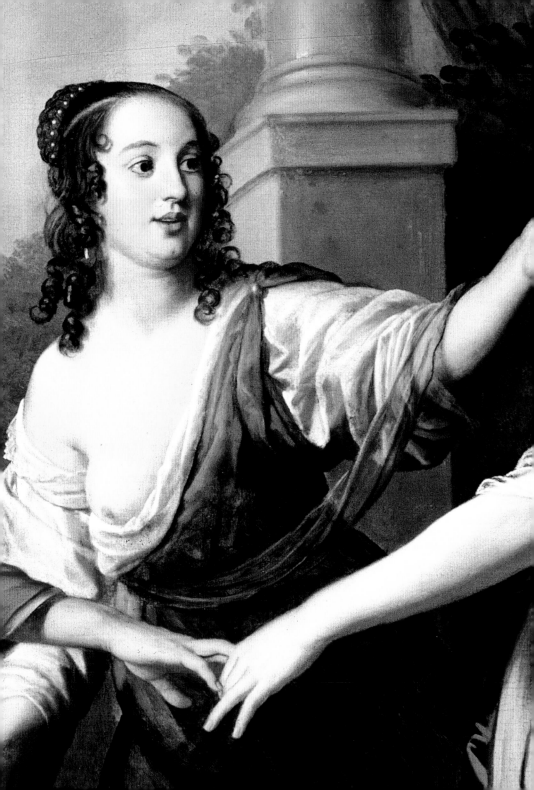

Chapter 7

Confronting Seventeenth-Century Art:
Then and Now

People's relationships with seventeenth-century Dutch art are influenced by the context in which the paintings are encountered. The domestic setting of Amsterdam homes three centuries ago and the institutional setting of contemporary art museums frame people's visual experiences in radically different ways. In the museum, paintings are valued as precious works of art. They serve also to shape viewers' ideas about the Dutch Golden Age. For many, these visual representations constitute an accurate pictorial record of people's appearance at the time and of their everyday lives. The paintings, however, are neither accurate nor comprehensive.

Although there are differences among art museums, all aim to create an optimal physical environment for viewing paintings. Furniture and decorations are kept to a minimum; the paintings are adequately spaced; and objects that might prevent people from seeing them clearly are removed. Light is carefully controlled, as are temperature and relative humidity.

Light is a concern in every museum. As one museum curator put it, "The means of admitting and controlling daylight are of the utmost importance to the effects that can be created in an exhibition."[1] Most museums use some combination of horizontally placed skylights and roof or ceiling lights to ensure that light is distributed evenly. Partially translucent skylights mingle diffuse light from the sky and direct sunlight. If the illumination they provide is insufficient, artificial light may also be used, and this is used, of course, in rooms without skylights or windows, on dark days, and in the evening. As far as possible, a painting should make the same impression on a viewer at night as in the daytime.

When paintings are hung in museums, the visual capacities of human beings are taken into consideration.[2] Without turning their heads, individuals with normal sight are able to see everything within a horizontal

core of vision extending outward from the eyes at an angle of about 50 degrees, 25 degrees on each side. This core can be extended to an angle of about 45 degrees on each side by moving the head slightly to the left or to the right. The vertical core is somewhat smaller. Holding their heads still, most people can see everything within a core extending about 30 degrees upward and 40 degrees downward. This vertical core can be increased by tilting the head forwards or backwards another 30 degrees.

But the physical visibility of a painting also depends on its size. Because their details are ill-defined from too far away and tend to fuse into larger areas, smaller paintings are hung at eye level or slightly lower.[3] Large paintings – such as many seventeenth-century history paintings – cannot be viewed in their entirety from a position too close to them. They are thus hung at a higher level or in rooms large enough for people to stand sufficiently far back when looking at them. Roughly speaking, a person with normal vision can see a total painting at a distance of about twice its diagonal measurement.

Although museum professionals take the size of the room, the size of the paintings, and people's normal visual capacities into account in deciding how to hang and arrange paintings, this does not necessarily ensure that the paintings will be visible to visitors. For the public's viewing habits and preferences also influence what they are able to see.

When walking through rooms with paintings, most museum visitors focus on a strip of wall-space extending from a little more than 0.5 meter above eye level down to 1 meter below it. Even though people have the visual capacity to observe a larger area, most of them restrict their vision to a horizontal strip of about 1.5 meters. Paintings in museums are, in fact, usually displayed within this visual band.[4]

It is recognized that paintings differ in their capacity to attract the attention of the public. According to one museum curator, it is thus necessary to "make pragmatic judgments about the differential power of attraction of paintings placed in proximity to one another."[5] Paintings with the greatest perceived power of attraction are generally distributed evenly around the gallery. Consequently, there is always "a conventional hierarchy of placement within any given gallery space, and of the relative power of visual attraction among paintings for viewers, both immediately and for sustained attention."[6]

Museums are in principle open to everyone, although it is disproportionately the affluent and well-educated who visit them.[7] Visitors differ in their approach to works of art. The goal of most, according to a study

commissioned by the Getty Museum and Center for Education in the Arts, is "simply to 'do' the museum, to walk through it so that they can say they have been to it, nodding on the way to those familiar objects that justify the institution's renown."[8] With special exhibitions, it is not uncommon for people to spend more time reading the accompanying texts than looking at what is displayed.[9] The time-famine and hurry-sickness endemic to modern society make it difficult for people to slow down and concentrate on paintings.[10] Typically, they linger less than twenty seconds in front of most of them.[11]

Whatever the motivation of some, others are seriously interested in art and visit museums and exhibitions to see specific paintings or the work of particular artists. On any given day, visitors can be seen moving from painting to painting, leaning forward to read their titles and attributions, dismissing some, stepping back to contemplate others solemnly, perhaps quietly discussing them, and then silently moving on to the next one. A few viewers give every painting their full attention, but this is rare. It is fatiguing to stand still and then walk slowly on.

While concerts, operas, and plays may be enjoyed in the presence of other people, the *visual* experience of looking at paintings requires solitude. Being able to see a painting as opposed merely to looking at it, to commune with a painting, requires time alone or relatively alone in a quiet setting free of distractions. But opportunities for private and leisurely encounters with works of art are rare. An individual viewing a painting by Rembrandt or another "Old Master" usually does so in the presence of other people, often a large number of them.

Along with guards and conducted tours, fellow visitors are a major source of distraction (and irritation) in an art museum. They often make it difficult to notice what hangs on the walls, to spend a quiet time alone with a painting, look at it closely, and actually see it. Museum and exhibition curators and directors acknowledge this, but are faced with the financial imperatives of increasing the numbers of visitors.

The attraction of the paintings in a museum is not, of course, entirely "visual." That is to say, there is more to viewing than meets the eye. While everyone has a daily familiarity with visual images from television, movies, computer screens, newspapers, magazines, books, billboards, and family photograph albums, museum-goers have learned that the aesthetic experience of looking at works of art differs from ordinary visual encounters.

Viewers are encouraged by curators and art historians to respond to art works intellectually: on the basis of knowledge that enables them to

locate the paintings historically, art historically, and with reference to the artists who produced them; to appreciate their style, form, color, composition, balance, harmony, and other qualities; and to understand the meanings of what is depicted. This is, of course, the reason for labels, catalogs, and guidebooks providing information about the artists and the paintings, as well as the views of specialists on both. Museum visitors are expected to steep themselves in facts, thus avoiding visual illiteracy.[12]

Personal reactions and responses are usually considered irrelevant in viewing the works of art displayed in museums. "We have been so schooled in a particular form of aesthetic criticism," notes one dissident voice among art historians, "that we suppress acknowledgement of the basic elements of cognition and appetite, or admit them only with difficulty."[13] Museum-goers seldom acknowledge a painting's capacity to excite, evoke, stimulate, and arouse. When they do, denial, repression, and embarrassment often result.

The claims made by some scholars about the moral meanings that different types of history and genre paintings had for informed viewers in the seventeenth-century Dutch Republic have already been mentioned. They assume a hierarchy of surface and subsurface, and that an informed viewer would be able to interpret a painting's symbolic elements correctly and grasp its meaning.[14]

For the seventeenth-century viewer, according to this interpretation, mythological scenes "often provided warnings about the temptations of the sensual world and the need to live a life of moderation."[15] Depictions of card-players in genre paintings are said to refer to the transience of earthly delights, while representations of coarse and bawdy peasants were reminders not to succumb to sensual pleasures.[16] A depiction of shoes had erotic significance and brooms signified purity.[17] Musical instruments were metaphors for familial harmony, mirrors stood for self-reflection, snails for apathy, and mussels for lust. In other words, more or less everything meant something else.[18] The paintings' original viewers, it is argued, recognized what the various subjects and themes stood for.

Since a painting's meaning was supposedly hidden, lying beneath what is ostensibly a realistic representation, the seventeenth-century viewer had to be able to uncover and decipher the disguised meaning and the moral message it contained.[19] As an informed viewer, the individual could grasp the painting's meaning, lying beneath the surface – like a nut within a shell.

Others argue that meanings are not hidden at all, but are directly available to the viewer – or at least would have been to Dutch viewers of the

seventeenth century. "Although symbolic motifs are at times difficult for the modern viewer to detect, let alone understand," notes Franits, "they must have been readily apparent to the seventeenth-century viewer because they were immediately perceived on the surface of the painting."[20] Scholars disagree, then, about the extent to which meanings were either hidden or directly available to Dutch viewers in the seventeenth century. They all assume, however, that the symbolic motifs had the same meaning for everyone at the time.

The catalog accompanying an exhibition in Amsterdam entitled *The Glory of the Golden Age* discusses several paintings with hidden meanings: among them, a landscape with two sleeping nude figures, warning the viewer about the sins of both indolence and lust; a painting of a procuress, representing illicit lust; biblical scenes with "a moral that was abundantly clear to 17th-century viewers: opulence and pleasure-seeking should not be condoned;" a painting by Vermeer with a stained-glass window, containing a moralizing commentary about temperance; and depictions of a partly-nude Venus with Adonis, popular because of the moral component regarding the latter's reckless youth.[21] Remarkably, nothing is said about the appeal of the images for different viewers, the functions they had in people's lives, or the responses they might have evoked.

Seventeenth-century Dutch paintings are, of course, now isolated from their earlier settings in physical and cultural space. Since museums did not then exist, and few homes contained many pictures, most people had limited access to paintings. But wealthy families owned a large number, and paintings were experienced by household members in the course of daily life.

With few exceptions, families used the rooms in which paintings were displayed for other purposes as well: sleeping, eating, conducting business, entertaining guests, and making love. The pictures thus hung amongst other furnishings, often a large number. The density of furniture and decorations affected the amount of wall-space available for hanging paintings, their arrangement, and their physical visibility. When a room held a large number of paintings, they were hung in two or three tiers, and some perhaps just below the cornice.

The number and size of the paintings in a room had obvious consequences for the way in which the individual pictures were arranged and displayed, as did the names of the artists who were linked to them. While most paintings in Amsterdam homes were unattributed, others were transmuted into works of higher monetary value by being linked to artists

of reputation and fame. Due to their relative scarcity and high cost, paintings by Italian, French, German, and Flemish artists, and by Dutch masters from earlier periods, were accorded an especially privileged status in seventeenth-century Holland.

The monetary value of the different paintings in a room, which often depended on their attribution or lack of it, also influenced their mode of display. Those with the highest monetary value were usually displayed most conspicuously, but paintings in general had to fend more for themselves than they do in museums today, in that their capacity for attracting people's attention lay much less in the name of the artist who produced them.

Taking notice of a particular painting, giving it one's focused attention, and actually seeing it, are all affected by what else is in the surroundings. Other furnishings and decorations were potential distractions in a seventeenth-century home. Whether viewed by natural light, firelight, or candles, paintings were not uniformly visible. Thus visual engagement and absorption in a particular painting required much more of a viewer than it does in a museum today. As far as possible, the viewer had to look at it from close by, often holding up a candle to provide illumination.

But at least some household members could look at the paintings whenever they wished to – or at least whenever there was adequate light. They not only had opportunities for unhurried viewing, but the abundance of chairs enabled them to sit and contemplate the paintings in a restful way. Moving from one chair to another, they could examine each painting from a seated position.

Paintings were a relatively inexpensive form of luxury decoration. Most were anonymous in their execution, and their monetary value was modest. Families spent more on silver and porcelain – and sometimes on tapestries, beds, and other furnishings as well – than on paintings. Family members would seldom have related to their paintings as precious works of art.

Instead, for most, the representational content of paintings was of primary importance.[22] For prior to the inventions of lithography and photography, paintings were unusual as color representations that could turn the transient into the lasting. As images of the real and the imaginary, they functioned as visual substitutes for what was not there.[23] They provided visual entertainment, and served to stimulate thought and the senses of the people who looked at them.

Paintings, it has been argued, often had a deep and profound meaning for viewers in the Dutch Republic. But the meaning was not that claimed

by those today who write about disguised meanings, symbolic motifs, and moral messages. The meanings did not (and do not) reside solely in the paintings themselves, but depended as much on what individual viewers brought to the paintings they encountered.[24] Important in this connection were the backgrounds, experiences, and assumptions of the men and women who confronted the paintings.

Seventeenth-century paintings were repositories of both personal and collective significance, and viewers experienced and responded to them accordingly.[25] People's reactions to particular paintings, and their interpretations of them, were constituent elements of what those paintings meant *to them*. Individuals encountered few visual images in the Dutch Golden Age, and the capacity of paintings to excite the mind and the emotions was considerable.

In earlier chapters, the wide range of emotional responses to depictions of human faces and figures in the Dutch Golden Age was discussed. These include pride and affection among some viewers of portraits, and envy or jealousy in others; compassion among Catholics at some images of Christ; sexual desire in those looking at alluring nude and partially-nude bodies in religious and mythological paintings; romantic longing and attraction in those viewing elegant young men and women in rich, sensuous interiors; feelings of superiority in wealthy viewers of images disparaging people from the social orders below them; and lust in the male viewers of brothel scenes, and feelings of humiliation in women. These formed part of the spectrum of human response.

The power of representation was almost exclusively in the hands of privileged male artists. It was mostly they who selected certain characteristics for emphasis in their depiction of men and women in portraits, history paintings, and genres. Hence the idealized faces and figures in portraits, history paintings, and high-life genres, and the caricatures in low-life genre paintings.

Throughout history, such visual representations have had an enormous power and persuasiveness.[26] In seventeenth-century Amsterdam, they reflected and also surely influenced the modes of consciousness of both male and female viewers. Particularly important here were the standards of physical appearance for women. Then, as now, a preoccupation with appearance affected women more than men.

Much is written nowadays about the tyranny of physical attractiveness. As one feminist critic points out, "We are presented everywhere with images of perfect female beauty – at the drugstore cosmetics display, the

supermarket magazine counter, on television. These images remind us constantly that we fail to measure up."[27] There is, she notes, "something obsessional in the preoccupation of many women with their bodies." But the magnitude of this obsession, she emphasizes, "will vary somewhat with the presence or absence in a woman's life of other sources of self-esteem and with her capacity to gain a living independent of her looks."[28]

But images of female attractiveness have also existed in other periods, including the Dutch Golden Age. While not presented with advertising images, wealthy women encountered representations of attractive female faces and figures in the portraits, history paintings, and high-life genre paintings hanging on the walls of their own homes. Many portraits depicted women with clear complexions, soft and smooth skin, and lustrous hair. In history paintings, the women, often nude or partially undressed, were represented as young, with lovely faces, and well-rounded, even voluptuous bodies (see fig. 51). High-life genre paintings depicted young women with refined and serene faces, flawless complexions, beautiful hair, and attractive bodies. The extent to which the women who viewed these images were "obsessed" with their own appearance is unknown, but the conditions for such an obsession were surely present. Excluded from the public realm and generally unable to maintain an independent economic existence, women gave priority to the private realms of marriage, motherhood, and the family.

An important aspect of raising children was ensuring that they learned the different assumptions, norms, and expectations associated with being male or female.[29] Both boys and girls learned that fathers were active in the world outside the dwelling, while mothers remained at home. The success and power of men in the public sphere and their ability to ensure the economic well-being of their families were highly valued, but no equivalent value was accorded to women's contributions in the domestic sphere.

Lacking a firm basis for self-esteem, it would not be surprising if many women were preoccupied with their physical appearance. Although they would know that paintings were not accurate depictions of what most women actually looked like, at the same time they would recognize the hierarchical grading of faces and figures that the paintings represented. Like many visual images today, then, the pictures in wealthy Amsterdam homes must have reflected and helped shape women's self-images, attitudes, and behavior.

* * *

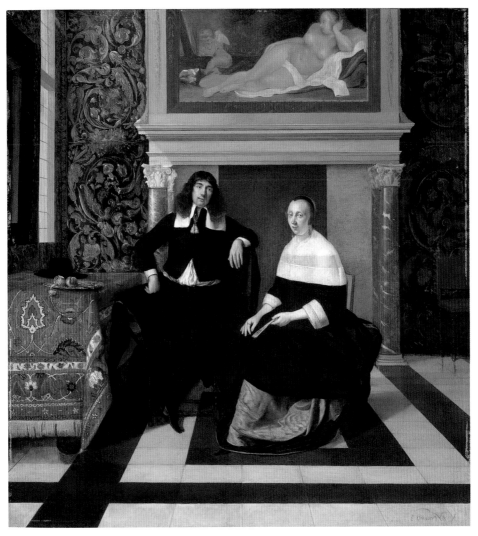

51 Eglon van der Neer. *Portrait of a Man and a Woman in an Interior* (*c.* 1675). Oil on panel, 73.9 × 67.6 cm. Courtesy, Museum of Fine Arts, Boston. Reproduced with permission.

In considering the impact of seventeenth-century paintings through the lens of gender, men and women have been pictured as the producers, subjects, and viewers of art in the Dutch Golden Age. Our main concern has been with the visual appeal that portraits, history paintings, and genres had for wealthy male and female viewers at the time, the functions they served, and the associations they would have evoked.

One of the original aims of the investigation, however, has not been accomplished. We began with the intention of exploring the role of paintings in the lives of both ordinary people and the elite. This is because we were intrigued by the frequent claim that the seventeenth-century Dutch had a passion for paintings and that art works hung in every home. As Brown notes, "The Dutch hunger for paintings astonished visitors,"[30] while Chong comments on "the democratic distribution of paintings among the various levels of Dutch society" and points out that the "Netherlands abounded with collectors spanning the social spectrum."[31]

In the hope of learning something about paintings in the lives of families of a more modest standing, we collected information from the household inventories of 256 people: among them, tailors, bakers, shoemakers, and other craftsmen, shopkeepers, and small-scale merchants. Our analysis revealed that most households contained few paintings, that only 20 percent were described as anything other than a "painting," and that only a handful had the name of an artist attached to them. With so little information, our plan to investigate the role of paintings in the lives of more ordinary Amsterdam families was abandoned.

It is in any case unlikely that any of the paintings owned by these more ordinary families has survived. Although the survival rate for paintings owned by the Amsterdam elite in the seventeenth century is unknown, it is probably somewhat higher than the estimate of 1 percent made for all paintings produced in the Dutch Republic during the Golden Age.[32] Of those seventeenth-century paintings that do survive, some have been hanging on the walls of one or other museum for half a century or longer, functioning as valuable works of art. Their tenure in an Amsterdam home three centuries ago, however, was usually much shorter, as a consideration of the acquisition and disposal of paintings in households at the time will show.

Bride and groom both brought paintings to a marriage. During their years together, the couple purchased more paintings at auctions, from art dealers, from the artists who produced them, and in other private transactions. In addition, a small number were acquired through inheritance:

the central mechanism for the continuity and well-being of the family in the Dutch Golden Age.

The disposition of a family estate was always specified by husband and wife in their marital agreement, although these were often amended in the following years. A detailed inventory of all goods and possessions had to be prepared within a year of the deceased party's death. With wealthy families, the estate often included porcelain, paintings, silver, books, furniture, large amounts of cash, and holdings in land and real estate. Special appraisers were often called in to attach a monetary value to the paintings, porcelain, silver, and books.

Testators specified different procedures for dividing family estates in the seventeenth century. They sometimes specified that the executors – appointed to execute the will – should sell all the furniture, decorations, and other household goods at public auction, and divide the proceeds equally among the heirs. Such auctions were regularly announced in the newspaper. Paintings were included among the goods to be sold, although the will might earmark one or another for a specific family member.

Portraits, however, usually remained within the family. Although all children had equal rights under Dutch law, the oldest son occupied a special position. As the new head of the family, he had responsibility for maintaining the family's social position and continuity. In addition to inheriting the family's genealogical charts and coats of arms, the oldest son inherited those portraits in which different generations of family members were depicted. All were esteemed for their emotional and dynastic value.

Another procedure followed in dividing an estate was for the executors to divide everything into a number of equal lots corresponding to the number of heirs. Such divisions were done almost to the penny. The capital and real estate were divided equally in each lot, as were the porcelain, paintings, furniture, silver, books, and other family possessions. With three heirs, for example, one lot was designated A, a second B, and the third C. Lots were then drawn, thus determining the goods inherited by each heir. Since the total monetary value of the paintings in each lot had to be the same, some lots contained more paintings than others. The lots also differed in the subject matter of the paintings and the names of the artists who had produced them.

In some instances, although not very often, testators specified which heir would have first choice among the paintings, so long as each heir ended up with goods of the same monetary value. There is, in fact, little

evidence that the heirs to most wealthy estates had any particular interest in acquiring the paintings that once hung in their parents' home. The paintings were regarded neither as status symbols nor as objects of investment.

However famous the artists who produced them, the paintings would not have enhanced the social standing of men and women from powerful and influential families. Instead, the fortune and fame of individual artists benefited from the presence of their paintings in wealthy Dutch homes. Nor were paintings regarded as suitable objects for investment, since they cost relatively little and were unlikely to increase much in value. Real estate and securities were much more attractive investments. The value of paintings, for wealthy families at least, was certainly not monetary.

The paintings valued by a husband and wife seldom had the same value for their offspring. Had this been the case, the heirs could have made provisions to acquire the paintings from the other heirs in exchange for their value in cash. This seldom occurred. So whatever the paintings meant to a man and his wife, and however long they were hung in their homes, most were sold at public auction when they died. By then, of course, the couple's children were usually married, had acquired their own homes, and furnished them along new lines.

And so it went, generation after generation. Young Dutch men and women brought paintings to their marriages, acquired more during their years together, made wills in which they specified the future dispositions of their possessions, sometimes remarried after the death of their spouse, amended their wills, lived happily or unhappily, and eventually died. The paintings were thus redistributed every generation: they were experienced in the course of daily life first in one household, then another, then still another.

Knowledge about the life histories of seventeenth-century Dutch paintings is usually fragmentary and incomplete, and most seem to have had relatively short lives. The earliest documentation concerning the origin and history of the paintings in museums is usually from the eighteenth and nineteenth centuries. Even by that time, the vast majority of paintings from the seventeenth century had disappeared. One economic historian studying the survival rate of art works from the Dutch Golden Age has estimated that "by 1800 more than 90 percent of the paintings existing around 1700 had been lost."[33] After four generations of households, fewer than 10 percent of the stock of paintings from 1700 still survived.

In accounting for this low survival rate, van der Woude points to some of the conditions destructive of paintings in pre-modern Europe: the extreme dampness of most houses, the open fires that created smoke, soot, and vapor, which became attached to everything, and the harmful effects of candles and oil used for lighting. Given these conditions, a survival rate of only 10 percent after a hundred years is quite understandable.[34]

Paintings had a far better chance of survival in large, solidly-build houses, with a separate room for cooking, and with servants to keep the house and the paintings relatively clean, than in small, poorly-ventilated dwellings, where cooking, heating, eating, and other activities took place in one room. But even in the homes of wealthy families, a painting's location was important in determining its chances of survival. Some rooms were heated and others not, and rooms differed in the amount of direct sunlight – injurious to oil paintings – that they received.

The attitudes of individual men and women toward particular paintings had, then, an influence on the care and attention they received. Some were cherished; others were regarded with indifference. As a rule, families separated paintings with a special value or significance and hung them in the rooms deemed appropriate for their standing and content, relegating paintings of little interest to less important rooms.

It is unknown who actually decided about the location, arrangement, and display of a family's paintings in an Amsterdam home. Husband and wife may have undertaken the task together, or perhaps the husband, as head of the family, decided where the art works should hang. But given the usual division of labor within Dutch families, it is more likely that the wife had the main responsibility for decorating and furnishing the house. As noted earlier, this probably depended on a painting's thematic content. When one spouse died, the surviving partner had to make decisions about where paintings should be hung. No doubt the decision was usually made passively; paintings were left hanging where they were. But if the widow or widower remarried, there would have been a rearrangement of at least some of the paintings in the house that became the new marital home. Portraits especially would often have been moved to other locations, sometimes to make room for new ones. When the paintings passed to another generation, whether by way of inheritance or by purchase, the new owners had to make decisions about their display, which would have consequences for their preservation.

Little is known, however, about the conditions that made some paintings more viable candidates for survival than others. An artist's reputa-

tion within his professional world certainly had an influence on the survival of his work, as did his renown within the larger community,[35] which must have been influenced by the fame and fortune of the people who owned his work. According to one specialist on the survival rate of seventeenth-century Dutch paintings, "All of the good pieces have not been preserved, but most of the pieces that remain belong to the qualitative top of the production."[36] Whether or not this is correct, it is clear that the posthumous reputations of artists from the time are linked to surviving examples of their oeuvres. Even the posthumous "rediscovery" of Vermeer required the tangible survival of a body of his work.[37]

Although the content and artistic quality of surviving paintings have remained constant over the centuries, their role in people's lives has changed enormously. Whether attributed to Vermeer, to Rembrandt, to Hals, to Steen, to another famous Dutch "Old Master," or to an artist whose name is recognizable only to a handful of specialists, the paintings are today preserved as valued objects of high culture. They are displayed and admired as works of art. Visual enjoyment and sensory pleasure are secondary.

It is almost as if paintings from the seventeenth century have lost their affective power. They do not have the same appeal, serve the same functions, or kindle the same responses for museum-goers as they did for viewers three centuries ago. Of course they cannot, since they are isolated from their earlier historical settings. According to the critical creed of "art-for-art's-sake," art has its own locus of value and should never be assessed in terms of such alien values as use or function. But such a presumption obscures an interest in the appeal of particular images and the functions that they have served in people's lives.[38] In our exploration of the role of paintings in the domestic and imaginative lives of people three centuries ago we reject this commitment to art for art's sake. Our concern throughout has been with art for *life's* sake among men and women in the Dutch Golden Age.

Appendix

Evidence about Paintings in Seventeenth-Century Homes: Household Inventories

Our discussion of the number of paintings in Amsterdam homes, their monetary value, the names of the artists who produced them, as well as our discussion of other furnishings and decorations, rely heavily on studies utilizing household inventories. Our own evidence, based on what we call the Zomer inventories, is used to supplement the findings of other investigators. In the following pages, household inventories more generally are described, and the Zomer inventories in particular.

Ideally, information about the contents of Amsterdam homes should come from individuals who actually spent time in many of them, but few people would have had the occasion to do so. Doctors did, as did perhaps chimney sweeps, men who delivered peat or other fuel, certain kinds of artisans and tradesmen, and servants and other household staff. But with the exception of the servants, none had reason to enter all the rooms in a house and, more importantly, to record what they saw.

The only people who had regular and privileged access to a large number of Amsterdam homes were the men and women charged with the responsibility of making household inventories of people's material possessions. Inventories were drawn up for reasons of inheritance, guardianship for an orphan, and bankruptcy. As legal documents, they were required by law. These inventories concerned people's "personal estates" or movable wealth.

Often done in considerable detail, the inventories usually listed all the objects found in a house, whatever their value, from basement to attic. They frequently specified the rooms in which the objects were located as well. Those inventories that survive today provide the most complete remaining record of the paintings that people owned, the artists who produced them, the rooms where the paintings hung, and the other furnishings and decorations in those rooms.

Every inventory drawn up in seventeenth-century Amsterdam was the joint product of several people: a notary or *curateur*, one or more clerks, a household appraiser, and sometimes a special appraiser as well. The notary was responsible for the accuracy and completeness of the inventory when someone died and either the movable goods, or the money received when they were sold, were to be divided among the heirs. This included instances of a guardianship when the goods were left to an orphaned child or children. The *curateur*, appointed by the city fathers, saw to it that an insolvent person's house was sealed and made off-limits to him and his (or, rarely, her) family; that account books and business papers were confiscated; and that a complete and accurate inventory was made of all the material goods in the house.

Many, but not all, insolvencies became bankruptcies. Two stages were involved. First, the household goods were listed in detail without a monetary value being attached to them. The insolvent individual had a period of six weeks to reach an agreement with those to whom he owned money.[1] If he did so, he could regain possession of his goods and his house. If not, he was formally declared bankrupt.[2] At stage two, an official appraiser was enlisted to attach monetary values to the household goods. They were then sold by the city in order to pay at least a portion of the bankrupt person's debts.[3] His house, along with any land or real estate, was also put up for public sale.[4]

Although the notary and the *curateur* were responsible for an inventory being made of all someone's household possessions, a clerk apparently did the actual listing of the material goods in a house. The clerk's name is never indicated, and nothing is known about them. But the individual performing this function would surely have had to be able to write, to do so legibly, and to spell a great variety of words.[5] The clerks either wrote down what they saw when they walked through a house or were told what to list and how to describe it. In the absence of information about the exact task of the clerk, the safest assumption is that the notary or *curateur* and the clerk performed this task together.

It was usually routine work and those doing it would seldom have had to think much about the correct or best description of an item. Most dwellings were small and had (according, of course, to inventory evidence) a minimum of goods. The kinds of large houses lived in by the elite, however, contained not only a far greater quantity of basic goods but also jewelry, silverware, porcelain, books, and, of course, paintings. There was

considerable variation among inventories as to how much detail was provided about the various material goods in a household.

With paintings, descriptions differed in the details given about their size (only rarely mentioned after the mid-seventeenth century), thematic content, the name of the artist or school that produced them, their authenticity (original or copy), and monetary value. Montias's research in Delft and Amsterdam and Wijsenbeek's in Delft show that most paintings were not described by subject. They were simply listed as a "painting," with no further information provided.[6] "When the notary or his clerk was a little more interested in the item," notes Montias, "he would write down 'a landscape,' 'kitchen,' 'a pot of flowers,' or something else."[7] Most paintings were not attributed to a specific artist.[8]

Appraising the monetary worth of paintings and other material goods was a separate task from describing them. Along with the notary or *curateur* and the clerk, an official appraiser was present to attach a monetary value to all the household goods. Licensed by the city of Amsterdam, this function was always fulfilled by a woman called a *schatster*. Until 1610, two *schatsters* were officially licensed by the city. After that date, there were four. Most worked at their profession for many years.[9]

Like the notaries, the *curateuren*, and their clerks, the *schatsters* had privileged access to the homes of Amsterdam residents. In fact, they probably went inside a larger number than anyone else. While many different individuals acted as notaries, *curateuren*, and clerks in Amsterdam, only the four *schatsters* were involved in the appraisal of household goods. The judgment of a *schatster* about the monetary value of the material goods in a household had direct consequences for the heirs of the deceased, for the guardian of an orphan (and for the orphan concerned), and for those people who would receive a portion of the proceeds from the sale of the household goods of a bankrupt person.[10]

Making appraisals demanded a broad knowledge of the market for many kinds of goods. With paintings, the *schatsters* regularly attached a monetary value to the works they encountered – even when they did not describe them or make an attribution. Judging by the assessed amounts, most paintings were regarded as having no particular artistic value. But there were exceptions, with *schatsters* sometimes attaching a high monetary value to paintings attributed to recognized artists.

In any case, the descriptions and appraisals of paintings in most Dutch homes – as with the other material goods people owned – were a result

of the collaborative efforts of notaries or *curateuren*, clerks, and *schatsters*. They produced most of the household inventories in seventeenth-century Holland. Only rarely did special appraisers participate in the making of household inventories.[11]

Special Appraisers: Their Influence and Importance

There were, however, occasions when a special appraiser was appointed by the city governors. Such a person was appointed when a household contained either a large number or especially valuable paintings. With few exceptions, these were the homes of the rich. This special expert was regarded as a fully-fledged connoisseur, with sufficient discernment to be able to judge the art works properly. He was officially empowered to judge quality, make attributions, and establish the market value of the paintings. His judgments about their authorship and market value obviously had important consequences for the families who owned them. These judgments also had an influence on which artists gained recognition and financial success. Special art appraisers thus exercised power and influence in the Dutch art world.

When a special appraiser was appointed, it was customary to use the services of master painters from the Sint Lucas guild. But sometimes art dealers or other knowledgeable people were asked to perform this task.[12] When special appraisers were involved in making up an inventory, the thematic content of the paintings was much more often specified than was normally the case. Like the ordinary appraisers (the *schatsters*), the special appraisers provided a monetary value for most of the paintings they saw.

These special art experts were expected, of course, to judge paintings properly. Providing attributions was part of this. The categories employed then were much as they are now: "attributed to," "after" or "in the manner of," "the school or studio of," "copy of," and "imitation of."[13] But attributing was even less an exact science three centuries ago than it is today. Attributions must have been made on many different grounds.[14]

Then, as now, the individuals doing the attributions could have been influenced by business dealings. "Attribution is not to be taken lightly when money is on the line," notes Jonathan Brown. Since "human judgment, the progenitor of human error" is at the core of the enterprise, there is much room for disagreement, mistake, and dishonesty.[15] Without questioning the professional skills or honesty of special art experts in the sev-

enteenth century, it is obvious that art attribution is highly demanding and inexact.

Most of the paintings in wealthy Amsterdam households were in any case not attributed to any particular artist. An art appraiser would provide an attribution on the basis of an artist's signature or monogram – which were not common in this period – receipts or other family documents that concerned the painting, or on its artistic qualities, which depended on his familiarity with an artist's work. Family members themselves may have provided the information, but it is likely that few would have been able to attach an artist's name to a painting, and in the case of bankruptcies they were not allowed to be present at all.[16]

Apart from any possible lack of scrupulousness in their attributions, different art experts would still have reached different conclusions with their attributions. For instance, some may have attributed a painting to a particular artist only when they felt that there was "absolutely no doubt" about who had done the painting. Others may have taken a less conservative position, attributing a painting to a particular artist when there seemed a "reasonable" basis for doing so. Such distinctions are less than precise.[17] But the decisions of these special art appraisers had consequences for the people who owned or were to inherit particular art works and for the artists who painted them.

Even today – three centuries later – the influence of the special appraisers continues. Empirical studies of paintings in seventeenth-century Dutch homes increasingly rely on household inventories. Such studies often show large variations in the monetary values and the names of the artists associated with the paintings owned by various families. To an unknown extent, these variations are a consequence of whether or not the art works were appraised by a special art expert. Moreover, they are the result, as indicated above, of the appraisals having been done by different experts.

The "Zomer" Inventories

Whenever appropriate in this book, evidence about the paintings in the homes of seventeenth-century Amsterdam families has been drawn from the findings of empirical investigations. But, as noted above, these inventories often contain limited information about the paintings. They list the number and sometimes their monetary value, but do not usually describe their thematic content. More often than not, each is simply

described as "a painting," and few are attributed to a specific artist. Given the concern with the thematic content of the paintings viewed by men and women in the Dutch Golden Age, more information is needed.

The main sources here are the Amsterdam inventories that involve an expert whose name appears more often than that of anyone else at the time: a man named Jan Pietersz Zomer. During the years 1687–1720, Zomer appraised the paintings in forty-three Amsterdam households for reasons of inheritance and in nineteen households where a bankruptcy was involved.[18] Most men and women in these households had been born in the period 1640–60, and thus lived during the second half of the seventeenth century. All sixty-two families were highly placed in the socioeconomic hierarchy of the city. Among these merchants, financiers, and city governors were some of the wealthiest and most powerful individuals in Amsterdam.[19]

Born in Amsterdam in 1641, Zomer began his professional life as a trained glass-engraver and owned a glass shop in the Zoutsteeg.[20] He moved at some point to the Nieuwe Zijds Achterburgwal, where he remained until his death in 1724.[21] By 1690, he had established himself as a respected art dealer, selling drawings, paintings, and prints. He was a member of the Sint Lucas guild. Figure 52 shows a portrait of Zomer by Norbertus van Bloemen (1670–*c.* 1747).

Towards the end of the seventeenth century, the art market in certain European countries began to be dictated by public auctions: first in Amsterdam, then in London and Paris. These auctions, notes Pomian, took place increasingly frequently. They were advertised in advance and usually involved the publication of catalogues.[22] With the public auctions, the tasks of art dealers expanded considerably, and they came to perform an increasingly important role in the art market. They began to provide descriptions of the paintings to be auctioned, attributed as many as possible, and specified the artistic and monetary value of the paintings listed. Considerable prestige accrued to the art dealers who performed these tasks.[23] One indication was the placement of the dealer's name when an auction was announced. In the mid-seventeenth century, the name was listed at the bottom of the announcement, but by the early 1700s it was printed predominantly in the heading.

In Amsterdam, art dealers required the approval of the city government if they were going to be involved in the auction of paintings.[24] Zomer is known to have organized eighty-five auctions during the period between 1699 and 1724. Some involved paintings from inventories in

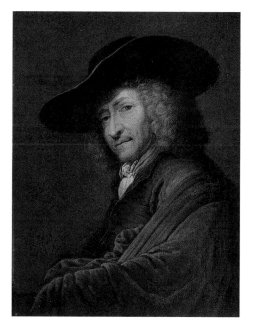

52 Norbertus van Bloemen. *Jan Pietersz Zomer,*
Amsterdam Art Dealer (no date). Oil on canvas on
panel, 37 × 29 cm. Amsterdam, Rijksmuseum.

which he had acted as the special appraiser.[25] The first auction in which
he participated, on 12 February 1699, concerned art works by Maria
Sibylla Merian (1647–1717), one of a small number of seventeenth-century
women artists whose names are still known. The works included water-
colors of flowers, herbs, fruit, and beetles.[26]

As an art dealer, Zomer had considerable experience and familiarity
with drawings, paintings, and prints. His own collection of drawings
included work by seventeenth-century Dutch and Flemish artists, as well
as by Italian masters. A catalog, which Zomer compiled for the purpose
of selling his large collection of drawings and prints, has been preserved.
It was probably printed around 1720. The title page indicates that Zomer
had assembled his collection over a period of more than fifty years. A
German bibliophile who visited his large collection in 1711 wrote that
Zomer owned more than 30,000 drawings and prints.[27] His large collec-
tion must have been visited by many other collectors and connoisseurs at

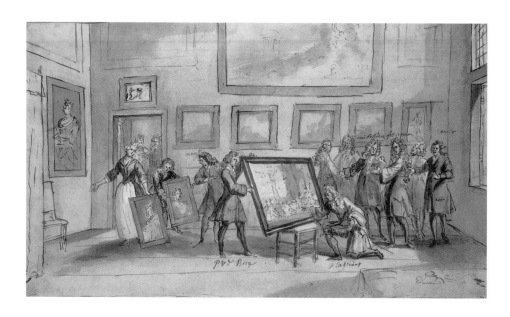

53 (*above*) Pieter van der Berge. *Prince Eugenius of Savoy Visiting Jan Pietersz Zomer, April 1701*. Drawing, 23.6 × 40.8 cm. Amsterdam, Rijksprentenkabinet.

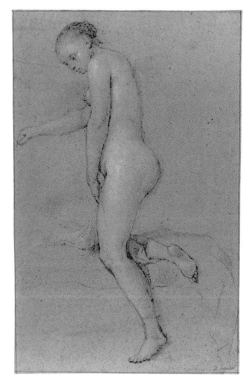

54 (*right*) Jan Pietersz Zomer. *Standing Female Nude*. Drawing, 31.2 × 20.2 cm. Rotterdam, Museum Boymans-van Beuningen.

the time. A visit by Prince Eugenius of Savoy, identified as a collector and connoisseur, was the subject of a print by Pieter van der Berge (*c.* 1660–1737), reproduced in figure 53.

Paintings by hundreds of different artists hung in Amsterdam homes at the time. Zomer knew many seventeenth-century artists personally, and was familiar with other Dutch, Flemish, and Italian masters, both from their paintings and from the many prints and drawings of their work that he owned. As well as being an art expert and dealer, Zomer was a painter and engraver. His drawing of a nude woman is shown in figure 54. The Amsterdam city fathers must have respected his knowledge of artistic quality and his familiarity with the art market in Amsterdam and elsewhere in Europe. Otherwise, they would not have appointed him as a special expert to appraise paintings for reasons of inheritance, guardianship, and bankruptcy for more than sixty families in the period 1687–1720.

In discussing paintings in the lives of wealthy Amsterdammers in the Dutch Golden Age, both the Zomer inventories and the findings of other investigators who have analyzed household inventories from seventeenth-century Amsterdam have been used.[28] But in discussions of the paintings and other household furnishings in the homes of specific families, the source is exclusively the former.[29]

Notes

Introduction

1 Sutton 1990, 104–19.

2 Although the exact number is unknown, hundreds, if not thousands of painters were active in the seventeenth-century Dutch Republic, producing a million or more paintings. Montias estimates that between 650 and 750 painters produced somewhere between 1.3 and 1.4 million paintings in the period 1640–59 alone. Montias 1990. For the period 1580–1800, van der Woude suggests that a total of 5,000 painters produced between 9 and 10 million paintings. Van der Woude 1991. Montias and van der Woude both estimate that fewer than 1 percent survive in museums and private collections today.

3 The idea of the life history of commodities is discussed in Kopytoff 1986.

4 Broos discusses attempts to provide the provenance of each painting shown in an exhibition of (mostly) seventeenth-century Dutch art. Broos 1991. Examination of the provenances of the paintings by the present authors has revealed that 12.3 percent have been traced back to an owner in the seventeenth century, 31.5 percent to an owner in the eighteenth, 38.4 percent to an owner in the nineteenth, and 17.8 percent to an owner in the twentieth century. In other words, nothing is known about the history of more than half the paintings before the beginning of the nineteenth century, i.e., between roughly 100 and 200 years *after* they were produced.

5 See, for example, the discussion in Csikszentmihalyi and Robinson 1990.

6 For a lively criticism of those art historians who focus on the intellectual understanding of paintings and ignore the pleasures of viewing them, see Starn 1995, 151–62.

7 See Hudson 1987; DiMaggio 1991, 39–50; Karp, Kreamer, and Lavine 1992; Zolberg 1992; Pearce 1994; and Alexander 1996. Especially enlightening is Gaskell 2000.

8 Leppert writes of this in terms of the institutional frames for art. Leppert 1996, 12–14. Needless to say, hierarchies of prestige among museums have a strong influence on the careers and reputations of painters. Since critics and art scholars often experience art through encounters in museums, the way in which an artist's work is displayed is likely to have an impact on his or her contemporary and historical standing in the art world. Becker 1982; Alexander 1996.

9 Huizinga 1968, 9 (originally published in 1941).

10 Israel 1987, 1267–68. This is a review of Schama's colorful and fascinating book about the Dutch Golden Age in which he relies heavily on paint-

ings as evidence about life at the time. Schama 1987.

11 For insightful discussions of the inadequacies of paintings as sources of historical information, see de Vries 1991; Schwartz 1991; and Haskell 1993. Also useful is Rotberg and Rabb 1988.

12 See, for example, Kiers and Tissink 2000; and the review article of this exhibition, Riding 2000, 24.

13 Haak provides a discussion of the very limited extent to which paintings were found elsewhere than in private homes. Haak 1984, 36–58. See also Blankert 1975a.

14 Research by Montias indicates that half of all households in Amsterdam contained either no paintings at all or just one or two. Montias 1996, 80.

15 Montias 1982; Wijsenbeek-Olthuis 1987; Fock 1990; Loughman, 1992; Montias 1991; Bok 1997; North 1997; and Loughman and Montias 2000.

16 Especially valuable discussions of how individuals can be moved by visual images are found in Freedberg 1989; Leppert 1996; Nead 1992; Pointon 1990; and Elkins 2001.

17 The ideas on "picturing" presented here owe much to the excellent introductory section of Johnson and Grieco 1997. The editors note the ambiguity of the term in picturing women as the subjects, creators, patrons, and viewers of art.

18 Gombrich 1999, 6. The artist's concern with making a living is discussed at length in the classic study by Rudolf and Margot Wittkower (Wittkower 1969).

19 Paintings of interiors, for example, were intentional designs rather than literal representations. One of the present authors used such paintings as evidence about art in seventeenth-century Dutch homes in a co-authored article some years ago. Muizelaar and van de Wetering

1992. Peter Thornton makes considerable use of paintings of interiors in two books on interior decoration in seventeenth-century Europe (Thornton 1978 and Thornton 1984). He acknowledges that paintings were sometimes invented – or "edited" as he puts it – yet uses them for illustrative purposes throughout his work. According to him, paintings of interiors show rooms as they actually were, if a certain amount of editing is allowed for. Although acknowledging that artists did edit their paintings, Thornton insists that "the degree of licence is never all that large" so long as the artist is portraying a familiar aspect of the society in which he and his potential viewers lived. Thornton 1984, 8. In fact, as will be seen later, artists usually portrayed the interiors of wealthy homes in a highly idealized manner.

20 Comar 1999.

21 This is not to deny that men and women would have had aesthetic pleasure from viewing paintings. But there is no such thing as "pure" aesthetic pleasure, in which the viewer's experience is completely separated from a painting's representational content. Morgan makes the same point in a study of popular religious images. Morgan 1998. See also Wolff 1983.

22 This is the case with two recent discussions of female viewers in the seventeenth-century Dutch Republic: Kettering 1997; Honig 1997. Wierling argues that feminist scholars more generally ignore men in gender-oriented historical studies. Wierling 1995.

23 More is known about paintings in Amsterdam homes than in those elsewhere at the time. Much of the information is drawn from studies of inventories of people's household

goods carried out since the 1980s, as well as the appraisals of paintings in wealthy Amsterdam homes made by Jan Pietersz Zomer between 1687 and 1720. These are discussed in the Appendix. These inventories indicate that families also owned prints, but little is known about their content. They are usually just listed as a "print" or "two small prints" in inventories, with no further specification of their subject matter.

24 See the discussion in Phillips 1993.

25 Van Dillen 1970.

26 Van Deursen 1991a, 160.

27 The institutional arrangements and practices that settlers took with them to America also shed light on values and behavior in seventeenth-century Europe. Although the inequalities in America were somewhat less than in Amsterdam, the attitudes of the well-placed were similar. See Goodfriend 1992; Archdeacon 1976; Rink 1986; Burke 1991; and Fabend 1991, especially chapter 8.

28 Cited in Groenhuis 1977, 66. Authors' translation.

29 Although there is great difficulty in locating and identifying "female" materials for seventeenth-century Holland, increasing attention is being given to women at the time and the ways in which they resembled and differed from women elsewhere. See Kloek, Teeuwen, and Huisman 1994; and Kloek 1995.

30 Hufton 1995; and Keeble 1994.

31 Tuana 1993.

32 Haks 1985, 153–54.

33 Haks 1997, 94.

34 Evidence of male–female relationships in the seventeenth-century Dutch Republic often consists of what male poets, dramatists, and others wrote about women. It has since been examined and interpreted by historians – most of whom have also been men. Recent articles by feminist historians emphasize the patriarchal thinking in the writings of influential thinkers of the time. Sneller shows this for the moralist and writer Jacob Cats, who is discussed below (p. 152). Sneller 1994. Van Gemert also does so for the influential seventeenth-century Dutch physician van Beverwijck, as well as criticizing Simon Schama's interpretation of his writings. van Gemert 1994.

35 Van der Heijden 1998; Leuker and Roodenburg 1988.

36 A good discussion is found in van de Pol 1988b.

37 See, for example, Wiesner 1993; Hufton 1995, chapter 1, "Constructing Women;" van Gemert 1994; and van Oostveen 1994.

38 Thomas 1959.

39 See, for example, Geary 1998; Marwick 1988; McNeill 1998; and Potts and Short 1999. All four books draw upon, and summarize, a large number of empirical studies concerning the centrality of appearance.

40 For the most part, we speak of people viewing paintings and avoid using the term "gaze" that was made popular by Mulvey 1989. As noted by Olin, the term "gaze" is much like the word "stare" in everyday language. There is usually something negative about it. Olin 1996, 209.

41 Context rather than culture is preferred here, mainly because the latter is at present very much a contested concept in history, sociology, and anthropology. Bonnell and Hunt 1999; and Kuper 1999. With regard to context, a discussion by Mattick is particularly useful. Mattick 1996.

42 In his powerful and enlightening study, *The Voices of Silence*, written in the mid-twentieth century, Malraux was one of the first to emphasize the need to consider art works in the context in which they were origi-

nally encountered. Malraux 1978. Examples of work giving attention to various aspects of the context in which paintings were earlier located are Baxandall 1972; Muller 1989; Goldthwaite 1993; Halle 1993; Elsner 1995; Johnson and Grieco 1997; Leppert 1996; and Talvacchia 1999. Few however, consider paintings in the homes of identifiable families. More importantly, gender – as a concern for both men and women – is seldom given much attention.

Chapter 1

1 Israel 1995. For an excellent, older, study, see Barbour 1950.

2 Estimates for Amsterdam's size around 1700 vary from 200,000 to as much as 240,000. The most complete discussion of the size of the city from its origins until the end of the eighteenth century is found in Nusteling 1985. See also Nusteling 1997, where he suggests that the population may have been as much as 209,000 around 1700.

3 Noordegraaf and van Zanden 1997.

4 See, for example, Barbour 1950, 59.

5 Nusteling 1997, 80. It has been estimated that at least 153,000 and perhaps as many as 216,000 inhabitants came from elsewhere in Europe, and as few as 51,000 and as many as 114,000 from elsewhere in the Netherlands. Nusteling 1985, 47.

6 Ibid., 39.

7 Most people leaving with the Dutch East India Company (VOC) were born elsewhere. A high percentage was German. Many had been living in Amsterdam before departing. Amsterdam, according to de Vries, was "by far the largest recruitment centre of the VOC." De Vries 1984, 210. Men who worked for the VOC must have had literally no other

work available to them. For, as Lucassen points out, "It was the worst imaginable alternative for someone seeking employment: low wages, years of separation from home, a good chance of dying en route or in the Far East." Lucassen 1987, 156.

8 Hart 1976, 121. See also Israel 1995, 622–27.

9 Lucassen 1997, 370.

10 Noordegraaf 1995, 341–42. Writing about Hollanders more generally, van Deursen notes that they "did not want the foreigner to enjoy lives as good as their own: they thought the fat of the land should be reserved for natives." Van Deursen 1991a, 40.

11 To some extent, the work that men did was related to their nationality. A highly disproportionate number of Germans and Scandinavians, for example, were seamen and sailors. Moch 1992, 54–55.

12 Hart 1976, 126. Van der Zanden has found that men born in Germany made up 50 percent of the common laborers in the city, while only 1.3 percent were born in Amsterdam. Van der Zanden 1993, 53, Table 23.

13 Hart 1976, 35.

14 Van de Pol 1994, 75. Hart estimates a figure of at least 37 percent for the period 1601–1800. Hart 1976, 119.

15 Van de Pol 1994, 79.

16 Lucassen 1994, 86.

17 Hart 1976, 132.

18 Citizenship was also required for participation in the city government. In reality, however, only members of the rich elite ever filled high positions in the city. This is discussed below.

19 Although a phenomenon of rural than city life, there is something similar in Amsterdam. Roodenburg 1990, 236.

20 Van Deursen 1991, 33.

21 Van der Heijden 1998, 97.

22 Damsma 1993, 43.

23 Haks 1985, 117–19.

24 Kloek 1995; Dekker 1995.

25 Schmidt 2001.

26 Van de Heijden 1996, 43.

27 Ibid., and van der Heijden 1998, 53.

28 For a somewhat later period, McCants shows that each additional child decreased a widow's chances of remarrying by 12 percent, while the number of children a widower had made little difference to his chances of remarrying. McCants 1999.

29 The above is based on Kloek 1995; and Schmidt 2001.

30 Schmidt 2001; and Marshall 1989. For an excellent discussion of the desire of many widows in premodern Europe to remain unmarried and independent, see Bell 1999, 258–78.

31 A higher percentage of Dutch households had servants in the eighteenth than in the seventeenth century. Haks 1985, 167.

32 "When properly established and run," writes Schama, "the family household was the saving grace of Dutch culture." He goes on to say that "Its hierarchy and division of labor was established on a reciprocity of duties and obligations." Schama 1987, 388. Van Deursen also remarks on the hierarchical quality of gender relations in the seventeenth-century Dutch Republic, but in terms of "social inequality" between men and women. Because of widespread inequality, he argues, marriage was a great advantage for women. "The protection of marriage gave them the best social security the society of that period could offer." Van Deursen 1991a, 95. Schama and van Deursen agree, then, about the existence of a gender hierarchy in seventeenth-century Holland, but they emphasize its advantages for women.

33 Records for an Amsterdam tax assessment in 1742 – perhaps the first reliable source of evidence about women's occupations for the seventeenth and eighteenth centuries — indicate that about 15 percent of the taxable enterprises belonged to women. These included a bookshop, butcher shop, and an upholstery shop, as well as a *rentenierster* (a woman who lived on her investments). The source of earnings was listed for those with what was considered a "taxable" income at the time, and only a minority of workers qualified. Although there is no way of knowing from the remaining records, it seems unlikely that all of these women with higher incomes were widows. In any case, they were obviously not at all typical of working women more generally. Haks 1985, 156–57.

34 Soltow estimates a total of 12,000 servants working in Amsterdam. Soltow 1989, Table 3. See also Lucassen 1994, 85.

35 According to Dekker, great equality existed in Holland between a servant and the mistress of the house. He notes that the gap between employer and servant was small. His observations are based in part at least on the apparent intimacy revealed in paintings that "show a positive image, mistress and maid shopping, washing or scrubbing happily together." Dekker 1994, 100–01. It is doubtful, however, that the gap was actually small. Maza's comments about eighteenth-century France may well also apply to the seventeenth-century Dutch Republic: "So firm stood the invisible barriers of status that this freedom and intimacy posed not the slightest threats to the domestic and social hierarchy." Maza 1983, 195.

36 Carlson 1994, 94.

37 Informative in this regard is the first full census of the Dutch working population, taken in 1849. It revealed that 45 percent of employed Amsterdam women listed domestic work as their occupation. The second largest category, seamstress, applied to 25 percent. In other words, 70 percent of wage-earning women were employed either as a servant or a seamstress. It seems likely that the figures would have been still higher around 1700 when far fewer occupations were open to women. Hart 1976.

38 Nusteling 1985, 94.

39 Van de Pol 1996, 100.

40 A useful overview of schooling in seventeenth-century Amsterdam is found in van Doorninck and Kuipers 1993.

41 Houston 1988, 130.

42 Classes were from 8:30 until 11:00 and 2:00 to 4:00 during the winter, and from 7:30 until 10:30 and 2:00 to 3:30 during most of the summer.

43 Books published in Latin could be read by educated people anywhere in Europe. Only they had access to the full spectrum of culture. Houston 1988, 232.

44 The source here is a study by Fortgens of the Latin School in the seventeenth century. Fortgens 1958, 43–44, 56–60. See also Kuiper 1958.

45 Some girls, educated at home by private tutors, were an exception.

46 Kuijpers 1997, 507. Some perhaps learned in evening schools, while others were taught by friends or relatives.

47 For schooling and literacy in Europe more generally, see Houston 1988.

48 See Noordegraaf 1985, 52–55.

49 Nusteling provides a good discussion of guilds at the time. He gives a figure of 11,000 members for thirty-seven guilds in 1688. Nusteling 1985, 155. According to Lucassen, this figure excludes approximately 2,000 members of other guilds. Lucassen 1997, 406.

50 Kloek 1995; van Eeghen 1969b.

51 Barbour 1950, 71; Israel 1997.

52 Nusteling 1985, 151–52.

53 Nusteling 1985, 151.

54 At the beginning of the seventeenth century, a sharp distinction was made between surgeons and medical doctors. Surgeons had a much more practical training and were involved in the healing of wounds and minor injuries. Medical doctors were among the small percentage of men who had a university education, with an emphasis on studying the anatomy and internal organs of the human body. But over the course of the century, the distinction became blurred as the training of surgeons became closer to that of medical doctors. Nevertheless, medical doctors enjoyed far higher social status than surgeons. Doorninck and Kuijpers 1993, 47.

55 Montias 1982, 148–53; Bok 1997; Israel 1995.

56 Van de Wetering 1995, 223. Some, however, did earn an income during their period of training. See de Jager 1990.

57 De Visser 1998.

58 Van de Wetering 1995, 223–29.

59 Kloek 1998, 9–19.

60 Kloek, Sengers, and Tobé 1998.

61 Nevertheless, the research of Kloek and her associates located history paintings by fourteen female painters. Kloek, Sengers, and Tobé 1998.

62 Oldewelt 1945.

63 Montias 1982, 150–51; Bok 1997, 100.

64 This corresponds with the estimate of van der Woude 1991.

65 Van Deursen 1991b, LII. For a discussion of the merchant (*koopman*), see Kooijmans 1995.

66 Van Nierop 1997, 161.

67 Cited in ibid., 160.

68 Hell 1997, 137–48.

69 Faber 1997, 298.

70 See the excellent discussion of urban and rural crimes in Egmond 1993.

71 Spierenburg 1998.

72 A clear and extended discussion of the *regenten* is found in Israel 1995. The activities, responsibilities, and power of the city government are dealt with in Price 1994. For a study of elite families in the seventeenth-century Dutch Republic, see Adams 1994.

73 Price 1994, 95.

74 Van Nierop 1997, 166.

75 See the discussion in van Deursen 1991a, 161–70.

76 Price 1994, 32. For a discussion of the various sorts of loans that wealthy families made to the government, see 't Hart 1993.

77 Soltow and van Zander 1998.

78 Van Nierop 1997, 162.

79 See Wijsenbeek-Olthuis 1996b, 112.

80 In the last quarter of the seventeenth century, about 60 percent of the men in the Amsterdam city government had received an academic education. Prak 1985, 333.

81 Redford 1996, 21.

82 Burke 1992.

83 Haks 1997, 93.

84 De Vries and van der Woude 1997, 616.

85 Ibid., 562.

86 Nusteling 1985, 115.

87 De Vries and van der Woude 1997, 563.

88 Oldewelt 1945. A second source of tax data for the time is the *Liberaale Gifte* from 1747. See Levie and Zantkuijl 1980, 28–34.

89 Soltow, unpublished manuscript, 42. Commenting on this inequality, he writes (p. 47): "Here was a society at the zenith of its activity, but one producing the greatest disparity in the conditions, specifically the housing conditions, of its people."

90 De Vries and van der Woude 1997, 565.

91 Nusteling estimates that most earned between 180 and 200 guilders per annum. Nusteling 1985, 171.

92 Noordegraaf 1995, 319.

93 Ibid., 344–47.

94 See, for example, Diederiks 1987, 48–51; and Levie and Zantkuijl 1980.

95 Distinctions were made between the "deserving" and "non-deserving" poor, and people were treated accordingly. There is a good discussion in McCants 1997. Scholars disagree about why charitable arrangements existed at the time. Some of the reasons given include compassion, religious duty, control of the poor who might otherwise rebel or commit crimes, and the reinforcement of existing social arrangements. Whatever the combination of reasons, Christian values were probably not the main spur for charitable assistance. See Phillips 1993; and van Leeuwen 1994.

96 At the beginning of the twenty-first century, Amsterdam still has its rich and its poor, its haves and its have-nots. But the economic inequality in 1742 was more than twice the amount it is today. Soltow 1989. Like many other scholars, Soltow uses the "Gini coefficient" as a measure of the concentration and dispersion of income and wealth. The Gini ranges from 0, or complete equality, to 1.0, or complete inequality. Complete *equality* in the distribution of wealth exists when, for example, 50 percent of the people (or households) own 50 percent of the wealth, 60 percent of the people own 60 percent, and so on. Complete *inequality* exists – and the Gini is 1.0 – when one person or household owns everything. Income distribution is measured in the same way, that is, with a Gini ranging from 0 to 1. The Gini was .69 for the

earlier date compared to .37 late in the twentieth century.

97 Noordegraaf 1995, 45.

98 Ibid.

99 Oldewelt indicates there is no exact information about guild membership for 1742, but assumes that the number listed in guilds for 1688 would have remained about the same. This enables him to chart the earnings of men in different guilds. His figures are used here. Oldewelt 1945.

100 Ibid., 12.

101 De Vries and van der Woude 1997, 595.

102 Oldewelt 1945, 15–16.

103 A backhouse was a small building in the backyard, separate from the main house. Used by families as a summer kitchen in the first half of the seventeenth century, it was often rented out in the second half of the century. Levie and Zantkuijl 1980, 17, 31–32, 41, 46–47. The Jordaan quarter (as it has been called since the beginning of the eighteenth century), an area with a maze of narrow streets and alleys, had an especially high proportion of poor residents. With its lodging houses, semi-legal taverns, and pawnshops, it was also the center for the city's underworld of thieves and burglars. See Egmond 1993, 63.

104 In 1747, some 45 percent of Amsterdam households were reported to live in basements, rooms, and backhouses. The situation would have been similar fifty years earlier. Levie and Zantkuijl 1980, 31.

105 De Zeeuw 1978.

106 Van der Woude, Hayami, and de Vries 1990.

107 Wijsenbeek found that the inventories made for poor families in Delft indicated few candles or other sources of inside light. Thera Wijsenbeek-Olthuis 1987. Lighting

is discussed at length in the following chapter.

108 Chamber pots were sometimes used and then emptied elsewhere. At the end of the seventeenth century, strict controls were imposed against emptying chamber pots into the canals. Roding 1986.

109 Ibid., 33.

110 Wijsenbeek-Olthuis 1987, 162.

111 From Bakker 1977, 158.

112 Zantkuijl 1993, 256–57.

113 Ibid., 430; and van Nierop 1936.

114 Lesger 1986, 92.

115 Ibid., 10.

116 Ibid., 92.

117 In Delft, Montias found that with "small- and medium-level estates a couple's clothes frequently cost 60 to 80 percent as much as all the furnishings of their house," with beds and bedding being the next most costly items. Montias 1982, 262. Shammas examined a sample of inventories from England and the colonies, for the sixteenth to the eighteenth century, and found that beds, bedding, and clothing together constituted anywhere from one-third to 60 percent of the total value of household goods. Shammas 1990, 170, Table 6.3. Wijsenbeek-Olthuis 1987 provides a detailed listing of the household possessions of 300 families for the period 1706–95. She records the presence or absence of literally hundreds of items – including socks and shoes, salt and pepper, and pins and needles – in the homes of people of varying socio-economic standing.

118 For examples of houses built by master craftsmen and other small one-family houses, see Meischke and others, no date.

119 Zantkuijl 1993, 434.

120 Soltow has calculated the proportion of Amsterdammers with a country estate, horses, carriage, yacht, and

servants in each of several income classes. The higher the earnings, the greater the likelihood of owning a country estate, and the larger the number of servants employed. Soltow 1989, 76–77.

121 Hart 1976; van Dillen 1954. A valuable source in English is Spies and others 1993.

122 De Haan 1993, 40.

123 Levie and Zantkuijl 1980, 79–81.

124 Van der Pluym 1946, 14; Ottenheym 1989, 90–105.

125 Kok 1943, 174–85; de Vrankrijker 1981.

126 Many show bright rays of sunshine streaming through a window, some show open windows, and many others use unspecified sources of light to illuminate part of a room. Kraaijpoel 1996.

127 Ottenheym 1989, 254.

128 Quoted in Zantkuijl 1993, 422.

Chapter 2

1 See the discussion by the art historian and curator Ivan Gaskell. Gaskell 2000, 76, 229–31.

2 This is based on Zantkuijl 1993, and on information kindly provided by Dick van der Horst from Monumentenzorg, Amsterdam, about different Amsterdam houses.

3 Kooijmans 1997. For a somewhat later period, see Prak 1985, 153, 229–30.

4 Boissevain 1974.

5 These figures are based on the value of the coaches and horses owned by a wealthy family around 1700. See de Muinck 1965, 286–87. This useful book is based largely on a diary kept by the wife of a wealthy regent. It listed not only family births, deaths, marriages, and the like, but also practically all the household expenses. Only rarely, however, did

she include any personal remarks or observations.

6 De Vries and van der Woude 1997, 584.

7 Hunger and thirst are, of course, natural dispositions of the human body. The need to satisfy them is far more powerful and insistent than even the desire for sex. Yet, as Mintz notes, food receives little attention in the work of theorists of consumption. Mintz 1993, 261–73.

8 The sources used here are mainly Burema 1953; and Jobse-van Putten 1995.

9 Noordegraaf 1985, 15.

10 See Schama 1987, 150–87; and McCants 1997, 40–62.

11 For an excellent discussion of the concept of "separate spheres," see Vickery 1993a.

12 Some architects, as de Mare shows, provided for gender differentiation in their designs for the homes of the rich. De Mare 1994. See also de Mare 1993.

13 Kooijmans 1997, 156; and de Muinck 1965.

14 Honig 1997, 194.

15 For three recent studies presenting useful discussions of the furnishing of homes in past centuries, see Auslander 1996; Vickery 1998; and Smith 1998.

16 Montias 2000.

17 For a detailed discussion and many examples, see Kooijmans 1997.

18 Marshall 1984, 41–59.

19 Compared to ordinary families, of course, these wealthy Amsterdammers owned a large quantity of expensive furnishings. For an interesting study of material goods in the homes of people in two rural villages in seventeenth-century Holland, see Dibbits 1998.

20 Dibbits 1996.

21 The following discussion of household furnishings depends on house-

hold inventories presented in North 1997; in Loughman and Montias 2001; and the Zomer inventories of sixty-two wealthy Amsterdam families, which are discussed at some length in the Appendix.

22 Baarsen 1993, 44.

23 Baarsen 1993, 77.

24 Lunsingh Scheurleer 1952, 191–92.

25 For the city of Leiden, Fock reports the following as the percentages of rooms used for sleeping in different periods: the second half of the sixteenth century, 87 percent; the first half of the seventeenth century, 73 percent; the second half of the seventeenth century, 63 percent; the first half of the eighteenth century, 45 percent; the second half of the eighteenth century, 42 percent; the first half of the nineteenth century, 41 percent. Fock 1987, 199.

26 Lunsingh Scheurleer 1952, 208–11.

27 Baarsen 1993, 55.

28 Ibid., 58.

29 Gilt leather, notes Thornton, "was not in fact gilt at all; it was made with 'skins' (of calves) that were faced with tin-foil." He goes on to say: "During the second half of the century these prepared skins might be embossed by pressing into a wooden mould carved in intaglio with a pattern. In all cases, however, the ground was then punched with small sub-patterns that would reflect the light, and the main pattern was then painted in one or more colors. Those parts of the tin-foil ground that had not been painted were then glazed with a markedly yellow varnish which imparted a golden look to the tin-foil." Thornton 1978, 119.

30 Nowadays, notes Brown, "no artistic medium is less appreciated than the tapestry, which seems to enjoy about the same esteem as second-hand clothing." Brown 1995, 228.

31 Ibid., 228–29.

32 Thornton 1978, 109.

33 Ydema has made an extensive study of oriental carpets in Dutch paintings. He notes their presence in hundreds of seventeenth-century paintings, and suggests that they were used both to provide embellishment and color and to indicate the wealth and status of the people portrayed. Few were used as floor coverings. "The rarity and costliness of Eastern carpets," he writes, "usually warranted a careful treatment in actual use, whereby wear was minimized." Instead, the carpets were generally used to cover tables or other pieces of furniture such as trunks and chests. "Even so," he notes, "in the Northern Netherlands only three surviving examples of oriental carpets are known to have been in Dutch possession ever since the 17th century." Ydema 1991, 7.

34 Ibid., 11.

35 Wijsenbeek-Olthuis 1996, 29. See also Montijn 1996.

36 A weight-driven pendulum clock that went for thirty hours, but which did not strike, cost 48 guilders in late seventeenth-century Holland. A spring-driven clock, which went for thirty hours and could strike, cost 120 guilders. A spring-driven clock that went for eight days, and could also strike, cost 130 guilders. Plomp 1979, 32–3.

37 Grafton 1972, 242–47.

38 Koeman 1970, 46.

39 Ibid., 1.

40 Ibid., 41–42.

41 Staring 1956. This is sometimes argued on the basis of the large number of song books that were published at the time. Kettering 1983, 23; and Balfoort 1981. Balfoort specifies that it was mainly the rich who owned instruments to accompany their singing. Smits-Veldt dis-

cusses a small group of friends who frequently got together to eat, drink, recite poetry, and sing. Smits-Veldt 1994.

42 Among the wealthy families who are represented in the Zomer inventories, fewer than one-fifth owned musical instruments. In a study of wealthy families in The Hague, Wijsenbeek-Olthuis found that only one of forty-five families had a musical instrument in their home. Wijsenbeek-Olthuis 1996, 33. Hartevelt reports musical instruments in one-third of the wealthy Amsterdam homes whose inventories she examined. Hartevelt 1993. Most of the "musical evenings" depicted in interior paintings must therefore have been invented by Dutch artists, unless such evenings involved professional musicians from outside the household, hired to provide entertainment.

43 The following discussion depends on den Blaauwen 1979; Citroen, van Erpers Royaards, and Verbeek 1984; and Wttewaall 1987.

44 Harrisson 1986.

45 Gleeson 1998.

46 Loughman and Montias 2000, 53–56.

47 Brown 1995, 8.

48 Wijsenbeek-Olthuis reaches the same conclusion in comparing the results of her research into the furnishings of wealthy homes in The Hague with what is depicted in seventeenth-century paintings. Wijsenbeek-Olthuis 1996.

49 See the excellent discussions by Westermann 2001; and Fock 2001.

50 Although Kraaijpoel emphasizes the ways in which seventeenth-century Dutch artists suggested light in their paintings, he says nothing about how much light there might actually have been. Kraaijpoel 1996. The exhibition on light jointly presented by the Van Gogh Museum in Amsterdam and the Carnegie Museum of Art in Pittsburgh included interesting computer simulations. In one, four life-size panels show how the Rokin, an important Amsterdam street, was lit by various light sources over the centuries: by candlelight in 1750, oil lamps in 1800, gas light in 1850, arc lights in 1900, and electricity today. Another involved Vincent van Gogh's painting *Gauguin's Chair*, in which the artist depicted two light sources in the room: a candle on the chair and an open gas flame on the wall. The simulation enabled the visitor to see how the room would have been illuminated by either the candle or the gas flame alone. Neither this nor any of the other displays considered how paintings hanging on a wall would have appeared to a viewer under different lighting conditions. Blühm and Lippincott 2000.

51 Thornton 1978, 268.

52 "It is almost impossible for us, living in our hundred-watt age, to imagine how little light there was in houses after dark, certainly until the advent of gaslight in the nineteenth century." Bourne and Brett 1991, 8.

53 According to Walsh, these most common kinds of Dutch weather are seldom represented in paintings. Noting the lack of curiosity shown by writers on Dutch landscapes concerning the accuracy of depictions of skies, Walsh collaborated with a meteorologist. Walsh 1991, 95–96.

54 De Vries and van der Woude 1997, 21–23.

55 Zantkuijl 1993, 210.

56 This light was often inadequate for viewing paintings. Discussing museum exhibitions, Belcher gives 150 Lux as the recommended minimum light level for viewing oil paintings clearly (1 lux = 0.0929

footcandle), although paintings can be viewed even at 50 Lux. Belcher 1991, 117. An earlier study, done in connection with designing a system of artificial lighting for the Gementeemuseum in The Hague, arrived at 100 Lux as the most appropriate illuminating intensity for viewing paintings. Eymers 1935, 4.

57 Assuming that the weather was more or less the same in 1935 as it was at the end of the seventeenth century, the Eymers' study is relevant in assessing the quality and quantity of light in large Dutch homes at the end of the Golden Age. The research began by determining the outside illumination required to ensure an intensity of 100 Lux on the walls of a room. The figure arrived at was 4,000 Lux. In order to determine how often that outside level was achieved, measures were taken over a two-year period by the Royal Dutch Meteorological Institute (Koninklijk Nederlands Meteorologisch Instituut) each day at 9:00, 12:00, 14:00, and 17:00. Analysis revealed that the intensity of outside illumination between 9:00 and 17:00. fell short of 4,000 Lux on 10 percent of the days of the year.

58 Eymers 1935.

59 Thornton 1978, 263.

60 See Wijsenbeek-Olthuis 1987.

61 Thornton 1978, 388.

62 Bowers 1998, 20; and O'Dea 1958, 54.

63 The diary, mentioned earlier, that was kept by the wife of an enormously rich regent at the end of the seventeenth century is informative in this regard. The couple lived with their three children and ten servants in a large house in The Hague. As well as recording births, deaths, marriages, and other family matters in her diary, the woman listed expenditures for silver, wall hangings, paintings, mirrors, clothing, horses, carriages, and household expenses. The last included the amounts spent on turf, wood, and candles, as well as on meat, bread, butter, spices, beer, wine, and other items. From the costs of the food and wine, it is clear that many guests were entertained. Consequently, they burned 450 tons of turf and wood to provide heat during the year. Ordinary families, who could not afford wood, consumed roughly 6–8 tons of turf per year. Even the wealthy family in The Hague used mostly turf, probably burning wood mainly on special occasions. The enormous consumption of turf and wood suggests that fires were kept going much of the time. The diary is discussed in de Muinck 1965.

The family used about 450 pounds of tallow candles and 16 pounds of wax candles in an average year. According to de Muinck, there were about five tallow candles to a pound. Ibid., 327. The same may also be true for wax candles. The family consumed candles in large numbers: about 2,250 tallow candles and 80 or so wax candles during an average year. If each tallow candle burned for an hour (a generous estimate) and each wax candle for four hours, together they would provide 2,570 hours of candlelight over the course of a year. It is unknown when and where the candles were used.

To get a rough idea of how often this family used candles, and assuming that they lit a single candle for four hours per day when the house was dark during their waking hours, they would require a total of 1,460 candles. They actually consumed 2,570 candles, or about twice that number. Even if they kept two candles burning, this is not many for

a large house. According to our esti-
mate, a family living in a small house
would use 150–200 tallow candles
a year (and ordinary families far
fewer) and no wax candles. This is
only 10–15 percent of the amount
used by the wealthy family, which
means that they would never burn
candles as auxiliary light during the
daytime, and only rarely after dark.
This estimate is based on de Muinck
1965, 314.

64 Van Deursen mentions the Dutch
inclination, motivated by thrift,
to manage without heat and light
during the evening hours. Young
theologians at the States' College at
Leiden were forbidden fires and
light in the evenings, which lends
credibility to the observation of
an eighteenth-century visitor that
"Netherlanders of all classes did not
make fires in the evening." Van
Deursen 1991a, 134.

65 O'Dea 1958, 2.

66 Ibid., 19. While Keeper in the
Science Museum in London, O'Dea
conducted many practical investiga-
tions into various lighting devices,
including oil lamps and various sorts
of candles.

67 Ibid., 3.

68 Fock 1998. It is also possible that
they might have been regarded as
commonplace fixtures and fittings,
so not mentioned in inventories.

69 Fock 2001.

70 O'Dea 1958, 9.

71 Ibid., 8, 18. According to O'Dea, a
room measuring 30 × 40 feet (about
10 × 13 m) would be lit "quite cheer-
fully" by 100 candles, although it is
doubtful that anyone ever did so.
Apart from the enormous expense
involved, "One wax candle was said
to consume as much oxygen as two
men, and in addition each candle
flame added considerably to the heat
of the room." Ibid., 44.

72 Although they provided little inte-
rior light, from 1670 there were some
2,500 lanterns on posts or attached
to the walls of public buildings in
Amsterdam. Their primary purpose
was to reduce crime and make the
city safer at night. The talented Jan
van der Heyden, mentioned earlier,
invented a street lamp that burned
vegetable oils and let the smoke
escape without the wind entering.
Placed about 150 feet (*c.* 137 m) apart,
these street lights were lit each night
by 100 Amsterdam lamplighters. De
Vries 1984.

73 Blühm and Lippincott 2000, 54.

74 "From reading an inventory it is
far from easy to get an impression
of how paintings would have been
arranged on the walls of domestic
dwellings." Loughman and Montias
2000, 106.

75 Ibid., 118.

76 Ibid.

77 Ibid., 18.

78 These are the dolls' houses of
Petronella de la Court (assem-
bled 1670–90), Centraal Museum,
Utrecht and Petronella Dunois
(1676) and Petronella Brandt-
Oortman (*c.* 1700), both Rijksmu-
seum, Amsterdam.

79 Ibid., 110.

80 Ibid., 112.

81 Gombrich 1999, 112.

82 Loughman and Montias 2000, 112.

83 Ibid., 115.

Chapter 3

1 Montias gives the figure of 6
guilders as the cost of the least
expensive portraits in Delft; they
would not have cost any less in
Amsterdam. Montias 1982, 193. Por-
traits by minor masters cost 50–60
guilders, and those by recognized
master portraitists much more. This

estimate is based on ibid., on the costs of portraits commissioned by a wealthy regent's family in The Hague around 1700 (de Muinck 1965, 176–79), and the discussion in the following pages.

2 Huygens 1987, 75.

3 This can be seen in the sixty-two appraisals of paintings made by the art expert Zomer, as well as in the inventories presented in North 1997; and in Loughman and Montias 2000.

4 Leppert 1996, 154.

5 Montias presents a figure of 16 percent. Montias 1996, 83. Fock, in her study of wealthy families in Leiden, found that 20 percent of the portraits were of public figures. Fock 1983–91, vol. va, 18.

6 These are portraits owned by some of the families making up the Zomer inventories.

7 Leppert 1996, 159–60.

8 The source here is Nozick 1989, 13.

9 Cited in de Jongh 2001, 30.

10 A notable example of an overweight man is the *Portrait of Gerard Andriesz Bicker* (Amsterdam, Rijksmuseum) painted by Bartholomeus van de Helst around the mid-seventeenth century, in which the sitter is extremely obese.

11 Westermann 1996, 133–36; Smith 1982, 13–14, 72; and Adams 1997.

12 E. de Jongh 1986, 137–38.

13 Van Musscher was one of the sixty-two people whose paintings were appraised by Zomer. The household inventory listing the objects that follow can be found in the Gemeente Archives in Amsterdam (GAA), number NAA 4864, akte 36, folio 81 ev. 30 July 1699.

14 Ydema 1991, 53–54.

15 Dudok van Heel 1998, 33.

16 Dudok van Heel 1969.

17 According to Dudok van Heel, in official documents he is invariably given the title of "Sr." (sinjeur) or "mr." (master painter), as befitted "a tradesman from the prosperous middle class . . . He was never referred to as 'Heer' (a gentleman) during his lifetime and remained a painter-businessman who dealt in art." Dudok van Heel 1991, 65.

18 See also the argument of Jaap van der Veen 1992.

19 Among Rembrandt's earlier portraits was one of *Jacob de Gheyn* (1633). Constantijn Huygens, a friend of de Gheyn, wrote a Latin couplet about it, with the message that it is not possible to capture a man's spirit in a painted likeness. Strauss and others 1979, 97. Jan Six, however, apparently saw his spirit in the Rembrandt portrait. Ibid., 323. Huygens had his own portrait painted by Jan Lievens, who shared Rembrandt's studio at the time. Reacting to the portrait, he noted that his friends thought that it failed to reveal his vivacity. But, he wrote, "I can only respond that the fault is mine. During that time I was involved in a serious family affair and, as is only to be expected, the cares which I endeavoured to keep to myself were clearly reflected in the expression in my face and eyes." Quoted in Schama 1999, 258.

20 The "distance implicit in the full-length format tends to give the viewer a greater sense of being an *audience* than a participant in a social encounter." Smith 1982, 51. Italics added.

21 In such paintings, a woman is always placed to the left of her husband. Since the light usually falls from the left, this convention ensured that both sides of the woman's face were lit, while a portion of the man's face would be in shadow. It has been suggested that this is why the portrait of the wife is often less appealing

than that of the husband. Haak 1984, 99.

22 Smith 1982, 37–38.

23 Zantkuijl 1993, 418.

24 GAA, NAA 4845, folios 721–97, film no. 6023. 9 October 1709.

25 Jan Six's financial situation was apparently somewhat insecure at the time of his death in 1700. To raise money for his widow, many of the family paintings were auctioned off in 1702, and his library was auctioned in 1706. Most of the family portraits, however, remained in the house until after Margareta's death, when they were distributed among the couple's children. The source here is van Eeghen 1984.

26 Loughman and Montias 2000, 42–43.

27 GAA, NAA 5001. folios 425–549. 8 March 1709.

28 Dudok van Heel 1997, 135.

29 Families owning property outside Amsterdam often ignored the exclusive hunting rights of nobles. Wijsenbeek-Olthuis 1996b, 118–22.

30 De Jong 1987, 173.

31 Ibid., 174.

32 The source here is Elias 1903–05. For criticism of some of Elias's conclusions about the origins of various regent families, see Dudok van Heel 1990.

33 Adams 1994.

34 Zantkuijl 1993, 411–12.

35 Spies and others 1993, 283.

36 The de Graeff house, like that of the Jan Sixes and most of the other families studied here, was very large. According to the inventories, however, these houses had no more than a single *secreet*, which was apparently always located towards the back of the house. In the inventory of goods in the home of Jan Six, the *secreet* is described as closed. In addition to some buckets with scrubbing brushes, the room con-

tained a small chest with a few books and papers. In the de Graeff house, odds and ends are mentioned in the room. No other *secreten* are mentioned in the inventories.

37 These dimensions are based on figures in Zantkuijl 1993.

38 It is now in the Rijksmuseum, Amsterdam. The statue of *Johan de Wit* is in the Dordrechts Museum, Dordrecht.

39 Although most Dutch women breast-fed their children, wealthy families would often hire a wet nurse. Roberts 1998, 84. They were usually married country women, who were regarded as superior milk producers. Hufton 1995, 194.

40 Spies and others 1993, 123.

41 GAA, NAA 4997, folios 1521–22. 3 May 1707.

42 Dürer's trip to Venice and other cities in 1495 "may be called the beginning of the Renaissance in the Northern Countries." Panofsky 1945, 8.

43 GAA, NAA 4997, folios 1479–30. 9 June 1707.

44 Maria Elenora had attended the French school for girls in Amsterdam until her thirteenth birthday, gone to boarding school for almost a year when she was 15, and then lived with aunts in Amsterdam and The Hague for a few years as part of her training to run a wealthy household. Roberts 1998, 117.

45 Kooijmans 1997, 162–66.

46 Jansen provides an excellent discussion of rich people's clothing in the last decades of the seventeenth century. Jansen 1999.

47 See also Westermann 2001, 81.

48 GAA, NAA 4248, folios 1359–97, film no. 4325. 27 February 1702 to 19 January 1703.

49 Muller 1989, 42.

50 The portraits a family displayed "were considered to be a public

statement of allegiances and therefore subject to careful divisions of rank and relationship." Muller 1989, 42.

51 See, for example, the discussion in van der Veen 1992, 238, 249, 252–54.

52 Kooijmans 1997, 156–59.

53 Apart from the supposed superiority of her milk, reasons for hiring a wet nurse included consideration for a mother's health, her wish to avoid being tied down to a nursing schedule, vanity about her figure, a husband's jealousy at having to share his wife's body with an infant, and the couple's – or the husband's – desire to escape the cultural proscription to abstain from sexual intercourse as long as lactation continued (sexual relations were thought to spoil the mother's milk). These are all mentioned in discussions of breast-feeding and wet-nursing in earlier centuries in Roberts 1998; Ozment 1983; Perry 1992; and Bell 1999.

54 The source here is Roberts, who also cites the family archives. Roberts 1998, 79–80, 154–55.

55 Adams 1997, 169–72.

56 Westermann also adds: "Such ideal personhood was not accessible to all in equal measure. Women partook of it somewhat less than men." Westermann 1996, 64, 150–51.

57 "At the same time, any viewer who knew that they would never hold political office, or attain the wealth or social standing of the individuals pictured, would probably also experience deference." Adams 1997, 173.

Chapter 4

1 Van der Woude's study of seventeenth-century paintings in the Rijksmuseum in Amsterdam found history paintings to be the largest (averaging 175 × 175 cm) and genre paintings the smallest (averaging 61 × 61 cm). The portraits are somewhat smaller than history paintings, while still lifes, landscapes, and marine paintings are larger than genres but smaller than portraits. There are exceptions, however: a few history paintings are quite small, and marine paintings can be very large. Van der Woude 1991, 305–08.

2 Cole 1983, 35–36, 138–47.

3 Writing about paintings in sixteenth-century Venice that portrayed Christ's suffering, Rostand notes that one goal of the imagery was to evoke emotional identification and a compassionate response from the viewer. Rostand 1997, 142–43. See also Marrow 1986.

4 Pomian 1990, 34–37; and Gouwens 1998. Although only secondarily concerned with humanist influences on art, Rowland 1998 is particularly informative about humanism in the Renaissance.

5 Hall 1983, 239–50.

6 Goldthwaite 1993, 134–42.

7 Hall 1983, 1. See also Seznec 1972.

8 Martindale 1988, 151.

9 Llwellyn 1988, 154. In response to the claim by some scholars that Italian mythological paintings are allegorical in content, Hope argues that "there is nothing in the many surviving documents about them to support this kind of reading." He goes on to add: "[I]t was the way in which the artist recounted the familiar myths, not some hidden meaning, that really mattered." Hope 1983, 35–36.

10 According to Bette Talvacchia, some "were calculated to elicit diverse responses both from the libido and the intellect." Talvacchia 1999, 176.

11 Quoted in Hope 1981, 302–03.

12 Ibid., 303–04.

13 Meiss 1976, 213. Giorgio Vasari, the great biographer of Italian art, complained that Giorgione did not paint figures known to ancient or modern history and that it was not clear to anyone in Venice who his works were supposed to represent. Vasari 1965, 274–76. The painting is attributed to Titian in Joannides 2001, 180–82.

14 Humfrey 1995, 127; Hope 1983, 35; Fletcher 1983, 19; and Brown 1997, 159–60.

15 Leppert 1996, 7.

16 Meiss 1976, 225.

17 Ibid., 226–28.

18 For a discussion of rape scenes in western European art, from the twelfth century to the seventeenth, see Wolfthal 1999.

19 Lucie-Smith 1995, 214.

20 See Lucie-Smith 1995; and Sluijter 1999. Although the present authors agree with Sluijter about the erotic suggestiveness of such paintings, they do not share his view that depictions of Susanna (or Bathsheba) concerned un-chastity and that "related moralizing thoughts [were] always close at hand." Sluijter 1999, 61.

21 For scholarly works examining attitudes toward the naked human body and its significance, see Clark 1956; Steinberg 1983; Miles 1989; Bynum 1991; Brown 1986; and Leppert 1996.

22 Leppert 1996, 248.

23 Holmes 1997. See also Miles 1986.

24 Holmes 1997, 167.

25 Haskins 1993, 3.

26 Ibid., 231.

27 Ibid., 262.

28 Mormando 1999, 118.

29 "Their [the breasts of the Magdalene] immediate appeal to the male viewer now offers a first sensory step on his pathway towards salvation: they still catch his attention, but with fresh implications . . . Theolo-gians frequently treated Mary Magdalen as a bridge between Eve and the Blessed Virgin, a bridge which common humanity could cross. The combined appeal of earthy sexuality and spiritual salvation, coupled with the sustenance of the body by angelic food, helps to build that bridge." Hart and Stevenson 1995, 75–76.

30 Mormando 1999, 117.

31 Leppert provides an excellent discussion of the male nude. Leppert 1996, 247–74.

32 Haskell 1981, 47.

33 Rostand 1982, 303–04. At the time of Rubens's death in 1640, there were 150 of his own paintings in his Antwerp home. More than one-third were copies he had made after other masters. A further indication of Rubens's great admiration for these Venetian artists is the fact that he "decorated the rooms in his house partly with his own originals and partly with the copies he painted after Titian, Veronese, and others." Muller 1989, 15. Many were nudes. Several were among the paintings left in his collection when he died. It is said that his widow, Helena Fourment, "out of modesty had kept a few pictures with nudes separately, not wanting to see them sold." Held 1982, 306.

34 The main artists concerned with history paintings were: in Haarlem, Cornelis Cornelisz van Haarlem (1562–1638), Hendrick Goltzius (1558–1617), and Pieter de Grebber (c. 1600–c. 1652/53); in Amsterdam, Pieter Lastman (1583–1633), Rembrandt van Rijn (1606–1669), Jacob Backer (1608–1651), Jan Lievens (1607–1674), Govert Flinck (1615–1660), Ferdinand Bol (1616–1680), Gerbrandt van den Eeckhout (1621–1674), Nicolaes Berchem (1620–1683), and, at the

end of the century, Gerard de Lairesse (1641–1711); in Utrecht, Abraham Bloemaert (1564–1651), Gerrit van Honthorst (1590–1656), Hendrik ter Bruggen (1588–1629), Joachim Wttewael (1566–1638), and Dirck van Baburen (*c.* 1590–1624).

35 The following discussion of history paintings by Dutch artists is based on Blankert and others 1980; and de Vries 1998.

36 Cornelis Cornelisz of Haarlem, Joachim Wttewael, Pieter Lastman, Jan Lievens, Caesar van Everdingen (1617–1687), and Jacob Backer were among those turning out mythological works, most of which were based on Ovid's *Metamorphoses.*

37 Cited in Houbraken 1753, vol. I, 116–17.

38 Cited in Schatborn 1981, 17. "In contrast with artists who believed that ideal Beauty should be striven for, Rembrandt did not make his nudes any more beautiful than the models actually were." Schatborn 1981, 56. Still, many of the paintings are unusually erotic, as are Rubens's paintings of nude women. See the extended discussion in Schama 1999, 383–401. Highly relevant in this regard are the various contributions to Williams 2001. In Chapter 5, the true appearance of seventeenth-century men and women is considered.

39 De Jongh 2001, 30. Sluijter expresses a similar view. Sluijter 2001, 39.

40 These conclusions are based on the Zomer inventories, and the inventories presented in North 1997, and Loughman and Montias 2000.

41 Montias 1991, 356–57.

42 This is not to say that there were no such depictions by Dutch artists. Several, for example, were shown at the exhibition *Jezus en de Gouden Eeuw* held in the Kunsthal, Rotterdam, 9 September 2000–7 January 2001.

43 For excellent discussions of how religious works can function in everyday life, see Feagin 1997, 17–25; and Morgan 1998. David Freedberg has written of the power of religious images to arouse the empathy and passion of the viewer of such paintings. He points to "the human helplessness of the child, the human softness or beauty of the mother, and the tragedy of their subsequent suffering, pictured in terms of drops of blood and tears, weak and friable apprehensiveness, sweating fear, and bruised and welted pain." Freedberg 1989, 167.

44 GAA, NAA 6417, akte 389, folios 871–97. 21 November 1710.

45 The date is unknown, but they must have been painted after the couple's marriage in 1671 and before Jacob's death in 1678; born in 1644 or 1645, Paulijn is known to have been in Amsterdam around 1674.

46 The former was perhaps a version of a painting now in Rotterdam. Gerard Dou, *A Maid at the Window.* Rotterdam, Museum Boymans-van Beuningen.

47 Recounted in Loughman and Montias 2000, 49.

48 GAA, NAA 5801, folios 435–59. 27 October 1703. Their denomination is unknown, but they were not Catholics.

49 Fewer than half of all children in the seventeenth-century Dutch Republic reached adulthood. Wijsenbeek-Olthuis 1997, 71.

50 The painting measures 99.9 × 72.6 cm. This is based on Bruyn and others 1982, vol. I, 338. The painting is described in the Catharina Bode inventory as "een stuk schilderij, verbeeldende Christus aan het kruijs, van Rembrandt."

51 He was also the executor of Rubens's will. Snyders painted the fruit, flowers, and animals in some of

Rubens's paintings, and Rubens in turn did the human figures in some of his.

52 In the museum where it now hangs (Kassel, Gemäldegalerie), the figures are attributed to an unnamed student of Rubens. It is unknown whether they represent Rubens and his wife.

53 Hell 1997, 141.

54 Ibid., 145–46.

55 GAA, NAA 5652, folios 511–96. 24 November 1705.

56 Dudok van Heel 1969a.

57 Ibid., 236.

58 Ibid., 234.

59 Gleeson 1998, 134.

60 Although the *zaal* was a large room, measuring 5.93 × 9.75 m, its high density of furniture and decorations would have made it difficult for people to focus on the Rembrandt painting. The authors are indebted to Dick van der Horst from the Monumentenzorg, Amsterdam, for information about the size of the *zaal*.

61 GAA, NAA 6285, folios 834–78. 3 October 1703; NAA 4720, folios 505–712, film no. 6147. 17 July 1704.

62 Van der Veen 1992; and Montias 1993–94, 103–05. Montias examined 321 inventories, dated 1600–79, and found only 24 paintings attributed to Italian and 2 to French masters. There were also very few, he reports, in a sample of Amsterdam inventories for the period 1700–15. Of almost 1,100 attributed paintings, 29 were attributed to Italian and 3 to French painters.

63 None was valued at more than 25 guilders.

64 It is not indicated which of the prominent artists in the family is intended, but it was probably Annibale, since he is known to have made paintings of the saint.

65 Elias 1903–05, 513–15; Roldanus 1931; and Franken 1966.

66 Quoted in Leonhardt 1970, 187.

67 See the discussion of van Beuningen in Gaastra 1989, 200–02. The Scottish bishop and historian Gilbert Burnet knew van Beuningen well and described him as follows. "He was a man of great notions but talked perpetually, so that it was not possible to convince him, in discourse at least, for he heared nobody speak but himself. He had a wonderful vivacity, but too much levity in his thoughts. His temper was inconstant: firm and positive for a wile, but apt to change from a giddiness of mind rather than from any falsehood in his nature." Quoted in Elias 1903–05, 514.

68 GAA, NAA 5504. 17 December 1693.

69 Freedberg 1989, 360.

70 The term "informed viewer" is used by a number of scholars. See Kiers and Tissink 2000, 198; Sluijter 2000, 15; Jones 1999, 31; and Kettering 1997, 113.

71 Such representations may have allowed the viewer "to display his knowledge of classical antiquity," although this seems doubtful. Sluijter 1999, 69.

72 "Many people have sex in mind a great deal of the time. It is the mainspring of our existence and the very centre of our being. It is an unseen guide along all walks of our lives." Potts and Short 1999, 106.

73 "[W]e know virtually nothing about consumption by different family members and especially what part was played by women." Weatherhill 1993, 208.

74 De Vries 1993, 117.

75 "The historical prejudices against the female consumer are legion . . . women have been relentlessly derided for their petty materialism and love of ostentation." Vickery 1993b, 274.

76 "The desire of men to look at women, and *vice versa*, whether

clothed or naked, is after all deeply formed by sexual necessity, an activity fully sanctioned by society when involving lovers." Leppert 1996, 214. Along with Leppert 1996 and Freedberg 1989, other important studies are Clark 1956; Berger 1972; Lucie-Smith 1981; Pointon 1990; and Nead 1992.

77 Before the nineteenth century, writes Leppert, there was "a reasonably close balance between the sexes in representations of the nude." Leppert 1996, 212. This was not the case, however, in seventeenth-century Dutch paintings. Probably roughly half the representations were of women, a quarter of men, and another quarter of men and women together.

78 Potts and Short 1999, 32.

79 See, for example, de Munck 1998, 91–112.

80 Buss 1994; Fisher 1992; and Jankowiak 1995.

81 Potts and Short 1999, 106.

82 De Munck 1998.

83 Potts and Short 1999, 77; and Stoller 1988.

84 "[I]t would be futile to argue away the psychosexual dimension of the bare female breast in all cultures, or the exposed genitalia, male or female. The exact limits of the resonance of the breast in the psychopathology of everyday life may vary from one culture to another, but the limits are only somewhat variable, certainly not so much that they never intersect. The same applies to its sexual resonance." Freedberg 1989, 324.

85 Sluijter 2000, 14–15.

86 "For women that resonance may or may not be different from men; but again – leaving aside the maternal and mothering aspect – we must postulate the kinds of arousal that may spring from female awareness of the sexual implications of the breast for men." Ibid.

87 Keeble 1994, ix.

88 See, for example, Sommerville 1995; and the older, but very valuable, Kelso 1956.

89 Ovid 1982. As pointed out by the translator: "Whereas the male sexual instinct is controlled, that of women is 'rabid'." Ibid., 347

90 Ovid 1955, 82.

91 Both men and women were, however, surely aware of what Stone describes as "the capacity of the female for multiple orgasms far exceeding the male ability to keep pace." Stone 1977, 495.

92 Bartky's powerful study of sexual objectification leaves no doubt about this. Bartky 1990.

Chapter 5

1 Chapman 2001.

2 Westermann suggests a similarity between seventeenth-century paintings of men and women in Dutch interiors and advertising photographs today, in that both "mirror back and promote certain ideals of domestic living to their viewers." Westermann 2001, 18.

3 Brown 1984, 9.

4 Kiers and Tissink 2000, 169.

5 Schwartz writes of the need to dispel the "optical illusion" that genre paintings constitute a pictorial record of life three centuries ago. Schwartz 1991, 12.

6 Sutton 1984, lx.

7 Israel 1995, 563.

8 These conclusions are based on the sixty-two inventories in which Zomer appraised paintings, the inventories presented in North 1997, and those in Loughman and Montias 2000. The terms "high" and "low" were not used at the time.

9 Not only beauty, but appearance more generally was a salient characteristic in ancient Athens, in sixteenth-century France, and everywhere else. According to McNeill, a computer search in 1997 of scholarly articles with the word "attractiveness" in the title generated more than 1,000 articles. McNeill 1998, 276.

10 Montaigne, "On physiognomy." Montaigne 1991, 1199.

11 The source here and later is an excellent study by de Beer. Although concerned mainly with the nineteenth century, it contains a wealth of useful information about caloric needs, food consumption, energy expenditure, height, and weight. De Beer 2001, 164. Also useful are Wieringen 1972; and Floud, Wachter, and Gregory 1990.

12 It was not until 1875 that the nutritional value of the average Dutch person's diet reached a level that was adequate by modern recommendations. De Beer 2001, 165.

13 De Beer estimates that a 34-year-old man doing heavy physical work in the period around 1850 required about 3,500 calories per day to maintain a normal weight. Because he would actually receive much less, he would have been very underweight. The same is shown to be true for a 34-year-old woman and a 10-year-old boy doing heavy work; the former required around 2,600 calories per day and the latter 2,100. De Beer 2001, 26, 116.

14 Estimates of height in past centuries draw heavily on studies of military recruits, taking into account that most came from a working-class background and were shorter than more privileged young men. There are, however, no studies of recruits in seventeenth-century Europe. It seems that the only study of the height of people in the Dutch Golden Age is based on the analysis of the skeletons of those buried during the second half of the seventeenth century and the eighteenth century in the Pieters Church in Leiden. The source here is de Beer's interpretation of the results of that study. As in Amsterdam and elsewhere, only the well-to-do were buried inside churches. Most people ended up in the churchyard. See van de Pol 1994, 78–79.

The median height of the skeletons of fifty-one men and fifty-one women buried in the church in Leiden was 162.3 cm. De Beer assumes that men would have been around 10 cm taller than women and calculates a median male height of 167.3 cm and a median female height of 157.3 cm. With a correction for the shrinking that accompanies aging, he arrived at a probable median height of 169 cm for elite men in Leiden and 159 cm for elite women. The median height for the average man in Leiden is estimated at 166 cm and that for the average woman 156 cm. Men at the bottom of the hierachy would have had a height of about 164 cm and women a height of 154 cm. De Beer 2001, 156, 199, and personal communication dated 30 November 2001. There is no reason to think that privileged men and women in Amsterdam would have differed in height from those in Leiden.

15 De Vries and van der Woude suggest that virtually everyone in seventeenth-century Dutch society had a minimally adequate diet. De Vries and van der Woude 1997, 624. This seems a little too optimistic for the lower orders.

16 The elite were not, however, the only people who were overweight. This was also characteristic of men,

women, and children just below them in the city's hierarchies of income and wealth.

17 This estimate is derived from de Beer 2001, 156.

18 Schama 1987, 151–54. The most reliable evidence for Amsterdam comes from an excellent study by McCants involving sophisticated research on the diets of the children and staff in an Amsterdam orphanage. The Burgerweeshuis (Amsterdam Municipal Orphanage) was an institution for the offspring of prosperous, though not the richest, Amsterdam citizens. It was, argues McCants, intended to ensure that the orphaned children received the level of care necessary for them to maintain the relatively comfortable position of their deceased parents. Towards that end, the regents responsible for the budget and management of the orphanage saw to it that the children had a plentiful and healthy diet. It was, in fact, a diet that could have been afforded only by well-off Amsterdam families. McCants shows that in another city orphanage (the Aalmoezeniersweeshuis), intended for the children of the lowest strata of Amsterdam residents, orphans received two-thirds of the per capita resources. Their diet included no fish at all and less meat, and was generally deficient in nutritional value. In orphanages, as elsewhere in Dutch society, efforts were made to ensure that the social hierarchy was maintained.

Most relevant here is McCants's conclusion, based on account books for food purchases, that the energy provided by the diet for the children in the Burgerweeshuis was generally quite adequate. In the period 1680–99, it was at a level of 2,604 calories per day. This is considerably above the level of 2,100 per day that de Beer estimates was necessary for a 10-year-old child engaged in heavy work (see note 13). Many children in the orphanage must have been overweight, and the members of the staff certainly were. McCants found that the staff's diet provided more than 5,000 calories per day, and she notes that there must have been obesity. This level of calories exceeds by far de Beer's estimate of 3,500 calories per day as necessary for a man doing heavy physical labor. Given what would have been a superabundance of calories in the diets of members of the Amsterdam elite, there must have been obesity there as well. McCants 1997, especially chapter 3, "Diet, Well-Being, and Institutional Mortality."

19 The authors have learned much about food consumption, diet, the overweight, and obesity from Pasman 1998; Rookus 1986; de Boer 1985; and Verboeket-van de Venne 1993.

20 While most families spent only a small percentage of their food budget on meat, it was probably the main expenditure for wealthy households. Around 1700, an extraordinarily rich family in Rotterdam spent about 32 percent of the total food budget on meat and 33 percent on wine and beer. De Muinck 1965, 338. De Beer shows that higher meat consumption was related to national differences in height in the first half of the nineteenth century. De Beer 2001, 153, 168. It must also have been related to the average height of people occupying different ranks and positions in the Dutch Golden Age.

21 Franits 1993, 161.

22 Ibid., 175.

23 A few years ago, a smaller but similar *tronie* by Rembrandt depict-

ing a bearded old man against an unarticulated background sold for almost three million dollars to a private European collector. In fact, the model may have been the same for both. It measures 10.8 cm × 6.4 cm, and has been described as the smallest painting by Rembrandt. Item in *The Netherlander*, 8 February 1997, 3.

24 The best-known treatises were van Mander 1604; Angel 1642; van Hoogstraeten 1678; and de Lairesse, 1740. Other Dutch writings from the time are discussed in de Vries 1998, 110–11, 131, 147.

25 For two different interpretations of such paintings, see Stone-Ferrier 1985, chapter 5; and Kettering 1997.

26 Kettering 1997, 102.

27 Ibid., 112.

28 Ibid., 98.

29 Ibid., 101.

30 Ibid., 111.

31 GAA, NAA, 6399 A, folios 33–86. 8 May 1704.

32 Kettering 1997, 111.

33 Ibid., 224.

34 The drawing comes from Schatborn 1981, 86.

35 Ibid., 11.

36 Looking at high-life paintings today, it is often difficult to distinguish respectable women from those engaged in the business of prostitution. As Hollander observes, "The expensive prostitute, the chic matron, and the princesslike daughter are not easy to tell apart – they all wear the same expensive clothes, exchange letters with lovers and confidences with servants, look in the mirror, and practice deception as well as music." Hollander 1991, 128–29. It seems likely that seventeenth-century viewers had little trouble telling the women apart.

37 See, for example, the "Preface" in Sutton 1984.

38 See Sluijter 1991, 184; de Jongh 1996, 41; and Hecht 1992.

39 Van Mander 1604; van Hoogstraeten 1678; and de Lairesse 1740. For an excellent discussion, see Kemner 1998.

40 Roodenburg 1997, 180. See also Kemner 1998.

41 Many such treatises appeared in Italy, France, and England, as well as in the Dutch Republic. For the most part, they repeated directives concerning the kinds of images deemed appropriate for depiction and viewing. They had their roots in antiquity. See Hall 1983; and Lee 1967.

42 Desolate Boedelskamer (DBK), 5072/411, folios 2–16. 2 October 1711.

43 GAA, NAA 6671, akte 90. 1 March 1718.

44 Bruyn 1987, 84.

45 Westermann 1996, 67.

46 This, argues Vandenbroeck, had been their function in earlier centuries as well. Vandenbroeck 1984. See also Vandenbroeck 1987; Muchembled 1991, 142; and Leppert 1996, 109.

47 De Jongh makes this point in reference to Jan Steen, but it was surely true more generally. De Jongh 1996, 46.

48 Roodenburg 1997, 183–84.

49 Evidence about the height of military conscripts for the period 1851–62 shows that the province of North Holland (which includes Amsterdam) had the *highest* percentage of undersized conscripts in the country. Wieringen 1972, 87, Table 6.19.

50 For a detailed examination of historical evidence about the extent of deception, dissimulation, and other protective mechanisms in relations between the powerless and those who control their lives, see Scott 1990. A moving depiction of peasant life in early nineteenth-century France is found in Guillaumin 1983.

51 Although Maza writes of eigh-
teenth-century France, the same
would have been true in seven-
teenth- and eighteenth-century
Holland. See Maza 1983, 195.

52 Chapman 1996, 160, 162.

53 Thompson 1979, 186–87. See also
Addy 1989.

54 Santore 1997.

55 Hufton 1995, 309.

56 Kiers and Tissink 2000, 170.

57 Yalom 1997, 100.

58 Van de Pol 1988b, 61.

59 See Ruurs 1975, 145–46.

60 Blankert 1975b, 27. See also the dis-
cussion in Montias 1989, 146–47. In
addition to this bordello painting,
Maria Thins owned another work
that might be considered erotic:
Cimon and Pero. Ruurs 1975, 146. A
painting of *Cimon and Pero* appears
on the wall of Vermeer's *Music
Lesson*.

61 GAA, NAA 5335, folios 37–182. 7 Feb-
ruary 1702.

62 McCants 1997, chapter 5.

63 Sluijter 1991, 190. Similarly, Bedaux
argues that the demand for paintings
was determined solely by the visual
pleasure they provided, whether or
not they had an intentional didactic
content. Bedaux 1990, 13.

64 Franits writes that wealthy viewers
would have viewed paintings of
prostitution as "an amusing and
witty display of the dishonorable
proclivities of their social inferiors."
Franits 1999, 27.

65 Lyckle de Vries found that about
one-third of the genre paintings in
an exhibition at the Rijksmuseum in
Amsterdam concerned love or eroti-
cism. He notes: "A comprehensive
publication on the issues of love,
erotica, and sexuality as represented
in Dutch genre art does not exist."
De Vries 1991, 238. Most elite fami-
lies owned paintings concerning love
or eroticism.

66 Spight 1985; and Lindeman, Scherf,
and Dekker 1993.

67 De Baar and others 1996. Some of
van Schurman's writings are avail-
able in English translation in van
Schurman 1998.

68 Reactions to both women are dis-
cussed in Smits-Veldt 1994.

69 Personal writings that express dis-
satisfaction with their disadvantaged
position do, however, survive from
women elsewhere. This seems
to be best documented in the case
of England. See Henderson and
McManus 1985; Graham and others
1989; and Ottway 1998. Writing
about the correspondence of privi-
leged women in eighteenth-century
England, Vickery notes that sex was
a concern that was never committed
to paper. Vickery 1998, 11.

70 Women in England did respond to
this stereotype. In refuting it,
women presented a parallel stereo-
type of man as seducer. "Thus the
feminist authors see women as
chaste, sexually innocent creatures
whose virtue is assailed by crafty
and lustful men." Henderson and
MacManus 1985, 49.

71 What Ozment writes about letters
in early modern Germany holds for
the Dutch Golden Age as well:
"The dangers of discovery always
remained great, for one never knew
when a private letter might fall into
the wrong hands and a messenger
accidentally or intentionally open it,
or a careless recipient leave it lying
around for another to discover and
read." Similarly, private discussions
might be overheard. Ozment 1999,
208.

Chapter 6

1 Freedberg 1989, 324.

2 In the *Republic*, Plato writes of the

need to "supervise craftsmen of every kind and forbid them to leave the stamp of baseness, licence, meanness and unseemliness on painting and sculpture, or building or any other work of their hands." Plato 1935, 3.401.

3 Aristotle 1983, 7.17 (1336b).

4 Alberti 1540; Alberti 1972.

5 For an excellent discussion, see Lee 1967, 34–41.

6 Lee 1967, 38; Hall 1983, 265, 285.

7 Hope 1983, 36.

8 Findlen 1993, 54.

9 Martindale 1988, 161.

10 Pointon 1990, 17.

11 Matthew 5: 28.

12 Genesis 3: 1–7.

13 Hall 1983, 305; and Blunt 1978, 117–18.

14 Quoted in Findlen 1993, 57. See also Worcester 1999.

15 De Vries 1998, 93.

16 De Jongh 2000, 53.

17 Cited in Loughman and Montias 2000, 79. These writers believed, notes de Jongh, "that the visual arts, and 'sensual' art in particular, could have a deep and pernicious effect on the human soul." De Jongh 2000, 57.

18 "The beautiful nude was a sophisticated subject but also could be regarded as lewd . . . Where the dividing-line lay between these responses, and where they overlapped seems to me impossible to reconstruct." Blankert 1999, 18.

19 Honig 1997, 194.

20 Ibid., 192, italics added.

21 See, for example, Sluijter 1980, 59; and Loughman and Montias 2000, 49.

22 Talvacchia 1999, 45.

23 But a recent study by Halle of paintings in New York homes found that "Apart from objects of 'primitive' art, human nudity is rarely depicted in the houses studied." This is, of course, different from the situation

in Amsterdam three hundred years ago; it also differs from the situation there today. Halle 1993, 164.

24 Alberti 1988, 299.

25 Musacchio 1997, 52.

26 Murphy 1997, 127.

27 Laqueur 1990.

28 Quoted in Muller 1989, 43.

29 Hufton 1995, 173–74.

30 De Lairesse 1740, 72.

31 GAA, NAA 5115, folios 620–717. 11 February 1708.

32 When Vertangen is mentioned in dictionaries of art, it is mainly as a student of the well-known Cornelis van Poelenburgh. See, for example, Turner 1996, vol. v, 68.

33 GAA, NAA 4642, folios 475–500, film no. 5386. 28 January 1706.

34 The attraction of *National Geographic* for the generation of his youth, Leppert observes, surely had something to do with its frequent photographs of women's bodies. Leppert 1996, 215.

35 De Jongh 2001, 30.

36 Manuth 2001, 48.

37 Even Cats and van Beverwijk, who were mentioned earlier, should not be thought of as actually being prudes. See the discussion in Veldman 1996.

38 Van Eijnatten 1993, 22–23.

39 See Kooijmans 1997, especially 38–41; and McCants 1997.

40 Regin 1976, 205; McCants 1997, 3–15.

41 Marshall 1987, xx. Erasmus, in a series of short treatises published between 1500 and 1530, had set forth what might today be termed the rules of etiquette. They covered individual conduct, gestures, facial expressions, dress, behavior in church, while eating, and many other aspects of personal conduct. The emphasis was on individual self-control. Educated men in the Dutch Republic would have been familiar with these ideals. A selec-

tion of these writings is available in Rummel 1990.

42 Adams 1997, 167–74.

43 Shame and guilt are discussed at length in Phillips 1986, 210–23.

44 "The energy of life with which the Dutch conquered markets, iron mines, and coffee plantations," writes Regin, "was reflected in their embullient enjoyment of leisure." Wealthy Amsterdammers, he notes, seemed to exist in a rhythm of the reserved and the spontaneous, of stiff, waste-conscious discipline and loud, relaxed, outgoing indulgence. Regin 1976, 135.

45 Much of the drinking was in connection with various collective celebrations – what van der Stel refers to as ritualistic drinking. Van der Stel 1995, 55–62.

46 Noordam 1987.

47 Dekker 1997, 116.

48 Cited by Kettering 1983, 42–43.

49 Sneller 1994, 19–34.

50 Sommerville 1995, 2.

51 For a fascinating study of, mostly, sixteenth-century Italian advice manuals, see Bell 1999.

52 Emde Boas 1985, chapter 6.

53 Kooijmans 1997, 152–53.

54 She became pregnant at least eleven times: she had two miscarriages, two infants were still-born, and seven children survived infancy. She was 42 years of age when the last child was born.

55 Kooijmans 1997, 150.

56 Kok 1991, 23.

57 Hufton 1995.

58 Van der Woude 1972.

59 Franits 1993, 61.

60 This is based on Kooijmans 1997; de Jong 1987; and Prak 1985.

61 Haks 1985, 80.

62 There were, however, very few prosecutions for male adultery in Amsterdam. Van der Heijden 1998, 84.

63 Israel 1995, 680.

64 Van der Heijden 1998, 254.

65 Ibid., 127.

66 Grafton 1988, 62.

67 Male ejaculation was known to be necessary for conception, and the logic of physiological analogy indicated that female orgasm was also necessary. Thus, medical and legal authorities assumed that a woman had achieved an orgasm and experienced pleasure if she became pregnant.

68 The above discussion is based on Wingens 1990.

69 Van der Heijden 1998, 134–41.

70 Hufton 1995, 255.

71 Hekma and others 1989, 16.

72 Van der Meer 1988, 191. Cases are known, however, of women in the seventeenth century dressing as men and serving in the army or the navy. In some of these cases, women married other women and had sexual relations with them. See Dekker and van de Pol 1989, 58–63.

73 Van der Meer 1988, 192; van der Meer 1989, 33; and van der Meer 1992.

74 Van der Meer 1984, 186.

75 Mijnhardt 1993, 296.

76 Ibid., 290.

77 Noordam 1987, 145.

78 Venette 1687, 213.

79 For a detailed consideration of this and several other pornographic novels in the period 1670–1700, see Inger Leemans, *Het woord is aan de onderkant: Radicale ideeën in Nederlandse pornografische romans 1690–1700*. Nijmegen: Uitgeverij Vantilt, 2002.

80 Ibid., 207–08. Roger Thompson reaches the same conclusion for late seventeenth-century England. Thompson 1979, 197–210.

81 Despite the many mechanisms of social control with regard to illicit sexual conduct in the Dutch Repub-

lic and elsewhere in Europe, sexual "sin" was not the major concern it is usually assumed to have been. This, at least, is the conclusion reached by Bossy. "Altogether the signs of disturbance on the sexual front do not seem to amount to a case that by 1700 Christians of any denomination were generally being taught or believed that sexual gratification occupied the centre of the universe of sin. They may have come nearer to this in the eighteenth century when, in Catholicism at least, a revival of naturalistic ethics began to make mountains of things like masturbation and contraception." Bossy 1985, 136. The sin of the woman caught in adultery does not seem to have been considered more serious than the self-righteousness of her accusers. In fact, avarice and betrayal were considered the most serious sins in religious circles. See also Worcester 1998.

82 De Vries 1998, 131. See also Veldman 1996.

83 Bredius 1909. The words quoted above are from descriptions in an inventory of the collection of Charles I of England, who asked the Dutch government to release Torrentius from prison so that he could paint for the English Council. The inventory notes these paintings as "His other bawdye pictures such as: his friends say he intended should never be seen, are to be seen in the town house in Harlem." Quoted in Bredius 1909, 8. If the paintings were actually still in Torrentius's town house, then they had not been burned.

Chapter 7

1 Belcher 1991, 127.
2 Ibid., 191–92.

3 Gombrich 1979, 95.
4 Belcher 1991, 191–92.
5 Gaskell 2000, 91.
6 Ibid.
7 See, for example, Zolberg 1992.
8 Csikszentmihalyi and Robinson 1990, 185. See also the somewhat older study by Bourdieu and Darbel of museum visitors in different European countries. Pierre Bourdieu and Alain Darbel 1991 [1969]; and Bourdieu 1984. In the last (p. 273), Bourdieu quotes a musuem visitor as saying: "I think I got through it quickly because I wanted to be able to tell myself I'd done that museum."
9 Csikszentmihalyi and Robinson 1990, 167. "At the Smithsonian," according to Perin, "audiences are perceived as being either 'streakers,' who 'roller-skate' through exhibitions, 'strollers,' who take more time to engage the exhibitions, and 'readers,' who spend more time absorbing exhibitions and their texts." Perin 1991, 185.
10 For excellent discussions of the pace of modern life, see Young 1988; and Birkerts 1994.
11 This figure is based on several years of watching people look at paintings in museums in the Netherlands and elsewhere. There is, of course, considerable variation.
12 Elkins, himself an art historian, offers a scathing critique of this intellectual approach to paintings. Elkins 2001, especially chapter 6.
13 Freedberg 1989, 17–18.
14 Summers 1995, 9–24. More than anyone else, the pioneering art historian Erwin Panofsky is responsible for this approach. See Panofsky 1962. For criticism of this view, see Holly 1984; and Bann 1996. With Dutch paintings, de Jongh has been particularly influential. His most important articles from roughly the

15 Wheelock 1998, 32.

16 Ibid., 27.

17 De Jongh 1968–69; Franits 1993, 97–99.

18 De Jongh, whose iconological approach has been influential among Dutch art historians, is now highly critical of what he terms "the craze for interpretation that threatens to run more prudent iconology underfoot." De Jongh 1991, 121.

19 Bruyn 1987, 84.

20 Franits 1993, 16.

21 Kiers and Tissink 2000, 39, 49, 59, 198, 256.

22 Among studies emphasizing the representational content of paintings are Malraux 1978 [1949]; Freedberg 1989; Walton 1990; Elsner 1995; and Leppert 1996.

23 Alberti, the first important Renaissance writer on art, commented in 1435 on the capacity of paintings to make the absent present to their viewers. Alberti 1972, 60–61.

24 The present authors' conception of meaning has at least a family resemblance to the conceptions of Goodman 1969; Marrow 1986; Elsner 1995; Freedberg 1989; and Feagin 1997.

25 Useful in this regard are Rochberg-Halton 1986, 168–80; Csikszentmihalyi and Robinson 1990; Bann 1996; Carrier 1996; and Elsner 1995.

26 In her penetrating study of the centrality of visual images in the development of Christianity, Miles observes that representations of women (especially naked women) are amazingly constant over two millennia and across a broad geographical area. "In fact," she writes, "representations of women may be the cultural artifact on which men most find unanimity." Miles 1992, 171–72.

27 Bartky 1990, 40.

28 Ibid., 28.

29 Roberts 1998.

30 Brown 1984, 63.

31 Chong 1987, 104.

32 Van der Woude estimates a survival rate of perhaps 10 percent for the more expensive paintings that were sent abroad. Van der Woude 1991, 296.

33 Ibid., 294.

34 Even today, van der Woude observes, the survival rate is not all that much better for paintings other than the most famous. Ibid., 295.

35 Lang and Lang distinguish between the influence of recognition and of renown in their excellent study of the determinants of artistic reputation. Lang and Lang 1990. In a way, questions about the survival of artists' paintings parallel those about the survival power of scientific theories or world-views. See the discussion of the survival power of possibilities in Phillips 1977, 174–78.

36 Van der Woude 1991, 309.

37 Haskell 1980.

38 Gombrich, perhaps the leading art historian of the second half of the twentieth century, made the same point. Gombrich 1999, 7.

Appendix

1 Apparently the Calvinist Church made a moral distinction between insolvency and bankruptcy. In the case of the former, an individual's financial difficulties were not seen as his (or, rarely, her) fault. In the latter, they were viewed as resulting from deceit or fraud. Those who could not settle all their debts, however, were still viewed by the church as being in a more sinful category than those who could – whatever the reasons for their financial difficulties. See

the discussion in Roodenburg 1990, 377–81.

2 Such an individual was now in an unfavorable position in the eyes of the Calvinist Church, although there is no way of knowing how important this was to most people with serious monetary problems. Fewer than half of Amsterdam's residents were Calvinists, and for most people the financial consequences were most worrisome. Men who were unable to satisfy their creditors completely would, according to Dudok van Heel, "retire from the city and only return when rehabilitated." Dudok van Heel 1991, 61.

3 These activities were carried out on command of a body of the city government that existed specifically for bankruptcy: the Chamber of Bankruptcy (*Desolate Boedelskamer*). See Moll 1879; and Oldewelt 1942. For an appreciative contemporary description, see Montague 1696, 131–32.

4 Oldewelt 1962. The *curateur* publicly sold the land and real estate, while the household goods were sold by a *concierge* in the Chamber of Bankruptcy.

5 At any given time, a total of three clerks were used for the drawing up of bankrupt inventories in Amsterdam. Oldewelt 1962, 422.

6 Montias 1982; Montias 1991; and Wijsenbeek-Olthuis 1987.

7 Montias 1982, 221.

8 In the period 1670–79, reports Montias, attributions in Amsterdam reached a peak of 28.8 percent. Montias 1991, 349.

9 *Schatsters* were apparently recruited from the group of women known as *uitdraagsters*: women who traded in secondhand goods. For what is known, see van Eeghen 1969b; van Eeghen 1987; and Wijngaarden 1995. Van Eeghen indicates that they were

paid a fee equal to 1 percent of the goods they assessed. In their research, the present authors came across various amounts and no standard percentage was apparent. According to de Vries and van der Woude (who give no source), the four *schatsters* in Amsterdam *together* earned a yearly total of 1,350 guilders. If this is correct, the women earned about the average household wage for the time. De Vries and van der Woude 1997, 600.

10 Nothing is known about the background or training of the women who performed this important function. They had to be able to provide a monetary value for hundreds of different household goods, ranging from relatively inexpensive items like cups and combs to more expensive items such as jewelry, silver or gold, and paintings. Wijngaarden 1995 makes the same point. These women must have had some formal education and surely did not come from poor backgrounds, or else they would not have been familiar with the more expensive objects they had to appraise. Still, as noted above, they were not well paid. In any case, women were probably appointed to this position because they were generally more familiar than men with the value and prices of the goods that families had in their homes.

11 Special art appraisers were involved in only a small portion of the inventories in Montias's research in Delft and Amsterdam. In Delft, special art experts appraised the paintings of only thirteen families among the several hundred that Montias studied. The first was done in 1605, the last in 1678. See Montias 1982. With the 362 inventories that Montias drew upon in his Amsterdam research, paintings in twenty-four were appraised by twenty-four

different experts. Paintings in another fifty-seven were appraised by an unspecified number of special experts. Montias 1991.

12 Van Eeghen 1969a, 71.

13 For a discussion of these categories as used in the National Gallery of Art, Washington, DC, see Secrest 1980, 260.

14 Even today, of course, the difficulties of attribution are considerable. Pigment analysis, autoradiology, and other "scientific" techniques are used in making attributions or determining authenticity. But the invention of photography probably has had the most profound impact on the connoisseurship of the art appraiser. With the availability of photographs, art experts have been able to place pictures of paintings next to one another and examine them at length, which enables the systematic study of an artist's work. Although this could be done with drawings and prints in the seventeenth century, photographs have made the task easier.

The literature contains surprisingly few discussions of the process of making attributions. Especially helpful in this regard are Gibson-Wood 1988; Pomian 1990; and Brown 1995. A detailed, and neglected, discussion of attributing and its consequences is found in Secrest 1980. Attribution is also given attention by Montias 1991. Pomian gives a nice description of what is involved in making an attribution: the appraiser's "gaze switches from the canvas to the painter, or more accurately to the workmanship behind the result, to the 'touch and its manner.' Its meaning becomes less important than its substance, and the 'esprit' which presided over its creation surrenders its pre-eminence to the artist's dexterity." Pomian goes on to write of the necessity of memorizing the "painter's pictorial vocabulary in order to make comparisons between fresh new works and old familiar ones." This, he observes, is why only daily contact with paintings over several years can provide the necessary competence for making attributions. Although he is referring to eighteenth-century France, Pomian's description applies to seventeenth-century Holland as well. Pomian 1990, 155–56.

15 Brown 1995, 233.

16 Montias reaches the same conclusion, although not specifically with regard to the special art appraisers. "Both notaries and lay assessors [i.e., *schatsters*] probably also received information about the authorship of the works of art they inventoried from relatives of the deceased (in cases of inventories made after death), and *a fortiori*, from the bride and bridegroom to be (in cases of inventories of moveable assets contributed by both parties to the marriage)." Montias 1993–94, 103.

17 Whatever the differences among special art appraisers in earlier centuries, they can be viewed as what sociologists call "gatekeepers." These are individuals who, by virtue of their position as experts, decide what will and will not be accepted or rejected, included or excluded, defined as good or bad, as valuable or worthless, in art, music, literature, science, and elsewhere in the life of culture and ideas. Editors of scientific journals and in publishing houses, book reviewers, music critics, art critics, and gallery owners are among the gatekeepers who make authoritative decisions that affect the fate of scientific articles, novels, and other books, plays, movies, compositions, and paint-

ings. See, for example, White 1950; Bystryn 1978; Coser, Kadushin, and Powell 1982; and Mulkay and Chaplin 1982.

18 Zomer appraised the paintings in some additional surviving inventories that, for a variety of reasons, cannot be used. The inventories of 256 Amsterdam families of more modest standing whose household goods were valued by regular appraisers were also examined. But the appraisers provided only minimal details about the paintings. Most families owned few paintings, in any case. Only 20 percent of the paintings were described as to their content, and a mere handful had the name of an artist attached to them. This is consistent with the findings of other investigators and underscores the importance of relying on inventories done by a special art appraiser.

19 In our discussions of some of these powerful families, the present authors make considerable use of the two-volume opus by Elias, a detailed political-biographical register of the political elite and their families over a period of more than two centuries. Elias 1903–05.

20 For the known facts of Zomer's life, see Dudok van Heel 1977b.

21 Ibid., 106. See also Konst and Sellink 1965, 164.

22 Pomian 1990, 193.

23 Ibid., 194.

24 Prints and drawings were traditionally auctioned not by art dealers but by booksellers. The guild rule was changed in 1701, however, so that they, too, could be sold by art dealers. But this did not immediately go into effect. Until at least 1703, prints and drawings continued to be advertised for auction by booksellers. This is based on Dudok van Heel 1977b.

25 See Dudok van Heel 1977a, 10.

26 Maria Sibylla Merian is best known for colored drawings of insects and butterflies.

27 Von Uffenbach 1753, 539.

28 These are mainly Montias 1991; North 1997; and Loughman and Montias 2000.

29 Many of these inventories were collected and published by Dudok van Heel 1977a, but received no further study. Since their initial publication, several additional "Zomer inventories" have been located in the city archives, some of which are included among the sixty-two of concern here. Others discovered by archivists and researchers are not usable here because of inadequate information.

Bibliography

Adams, Ann Jensen. "The Three-Quarter Length Life-Sized Portrait." In *Looking at Seventeenth-Century Dutch Art*, edited by Wayne Franits. Cambridge: Cambridge University Press, 1997.

Adams, Julia. "The Familial State: Elite Family Practice and State-Making in the Early Modern Netherlands." *Theory and Society* 23 (1994): 505–39.

Addy, John. *Sin and Society in the Seventeenth Century*. London and New York: Routledge, 1989.

Alberti, Leon Battista. *De pictura libri III*. Basel, 1540.

—. *On Painting and On Sculpture: The Latin Texts of* De Pictura *and* De Statua, edited and translated by C. Grayson, London: Phaidon, 1972.

—. *On the Art of Building in Ten Books*, translated by Joseph Rykert and others. Cambridge: MIT Press, 1988.

Alexander, Victoria D. "Pictures at the Exhibition: Conflicting Pressures in Museums and the Display of Art." *American Journal of Sociology* 101 (January 1996): 797–839.

Alpers, Svetlana. *The Art of Describing: Dutch Art in the Seventeenth Century*. Chicago: University of Chicago Press, 1983.

Angel, Philips. *Lof der schilderkonst*. Leiden: Willem Christiaens, 1642.

Appadurai, Arjun. *The Social Life of Things: Commodities in Cultural Perspective*. Cambridge: Cambridge University Press, 1986.

Archdeacon, Thomas J. *New York City, 1664–1710: Conquest and Change*. Ithaca: Cornell University Press, 1976.

Aristotle. *The Politics*, translated by A. Sinclair. Harmondsworth: Penguin Books, 1983.

Auslander, Leora. *Taste and Power: Furnishing Modern France*. Berkeley: University of California Press, 1996.

Baar, Mirjam de, and others. *Choosing the Better Part: Anna Maria van Schurman (1607–1678)*. Dordrecht: Kluwer, 1996.

Baarsen, Renier. *Nederlandse meubelen, 1600–1800/Dutch Furniture, 1600–1800*. Zwolle: Waanders Publishers, 1993.

Bakker, Boudewijn. "The City as Seen by Dutch Draughtsmen." In *The Dutch Cityscape in the 17th Century and its Sources*, edited by Carry van Lakerveld. Amsterdam: Stadsdrukkerij, 1977.

Balfoort, D. J. *Het muziekleven in Nederland in de 17de en 18de eeuw*. 's-Gravenhage: Martinus Nijhoff, 1981.

Bann, Stephen. "Meaning/Interpretation." In *Critical Terms for Art History*, edited by Robert S. Nelson and Richard Shiff. Chicago: University of Chicago Press, 1996.

Barbour, Violet. *Capitalism in Amsterdam in the 17th Century*. Ann Arbor: University of Michigan Press, 1950.

Bartky, Sandra Lee. *Femininity and Domination: Studies in the Phenomenology of Oppression*. New York and London: Routledge, 1990.

Baxandall, Michael. *Painting and Experience in Fifteenth-Century Italy*. Oxford: Clarendon Press, 1972.

Becker, Howard S. *Art Worlds*. Berkeley: University of California Press, 1982.

Bedaux, Jan Baptist. *The Reality of Symbols: Studies in the Iconology of Netherlandish Art, 1400–1800*. 's-Gravenhage: Gary Schwartz/SDU, 1990.

Beer, Hans de. *Voeding, gezondheid en arbeid in Nederland tijdens de negentiende eeuw: Een bijdrage tot de antropometrische geschiedschrijving*. Utrecht: Aksant, 2001.

Belcher, Michael. *Exhibitions in Museums*. Washington, DC: Smithsonian Institution Press, 1991.

Beliën, H. M., A. Th. van Deursen, and G. J. van Setten, eds. *Gestalten van de Gouden Eeuw*. Amsterdam: Bert Bakker, 1995.

Bell, Rudolph M. *How To Do It: Guide to Good Living for Renaissance Italians*. Chicago: University of Chicago Press, 1999.

Bender, Thomas, ed. *The University and the City: From Medieval Origins to the Present*. New York: Oxford University Press, 1988.

Berger, John. *Ways of Seeing*. Harmondsworth: Penguin Books, 1972.

Bergvelt, Ellinoor, and Renée Kistemaker, eds. *De wereld binnen handbereik: Nederlandse kunst- en rariteitenverzamelingen, 1585–1735*. Zwolle: Waanders Uitgevers, 1992.

Birkerts, Sven. *The Gutenberg Elegies*. New York: Fawcett Columbine, 1994.

Blaauwen, A. L. den. *Nederlands zilver/ Dutch Silver, 1580–1830*. 's-Gravenhage: Staatsuitgeverij, 1979.

Blankert, Albert. *Kunst als regeringszaak in Amsterdam in de 17e eeuw*. Lochem: De Tijdstroom, 1975 [1975a].

—. *Vermeer of Delft*. Oxford: Phaidon, 1975 [1975b].

—. *Gods, Saints and Heroes: Dutch Painting in the Age of Rembrandt*. Washington, DC: National Gallery of Art, 1980.

—. "Classicism in Dutch History Painting." In *Dutch Classicism in Seventeenth-Century Painting*, edited by Albert Blankert and others. Rotterdam: NAi Publishers, 1999.

—, and others. *Dutch Classicism in Seventeenth-Century Painting*. Rotterdam: NAi Publishers, 1999.

Blühm, Andreas, and Louise Lippincott. *Light! The Industrial Age 1750–1790: Art & Science, Technology & Society*. London: Thames & Hudson, 2000.

Blunt, Anthony. *Artistic Theory in Italy, 1450–1600*. Cambridge: Cambridge University Press, 1978.

Boer, J. O. de. *Energy Requirements on Lean and Overweight Women*. Dissertation, Landbouwhogeschool te Wageningen, 1985.

Boissevain, Jeremy F. *Friends of Friends*. Oxford: Blackwell, 1974.

Bok, Marten Jan. *Vraag en aanbod op de Nederlandse kunstmarkt, 1580–1700*. Privately published, 1997.

Bonnell, Victoria E., and Lynn Hunt, eds. *Beyond the Cultural Turn: New Directions in the Study of Society and Culture*. Berkeley: University of California Press, 1999.

Bordo, Susan. *Unbearable Weight: Feminism, Western Culture, and the Body*. Berkeley: University of California Press, 1993.

Bossy, John. *Christianity in the West, 1400–1700*. Oxford: Oxford University Press, 1985.

Bourdieu, Pierre. *Distinction: A Social Critique of the Judgment of Taste*. Cambridge: Harvard University Press, 1984.

—, and Alain Darbel. *The Love of Art: European Art Museums and their Public*. Cambridge: Polity Press, 1991 (French original, 1969).

Bourne, Jonathan, and Vanessa Brett. *Lighting in the Domestic Interior: Renaissance to Art Nouveau*. London: Sotheby's, 1991.

Bowers, Brian. *Lengthening the Day: A History of Lighting Technology*. Oxford: Oxford University Press, 1998.

Bredius, A. *Johannes Torrentius, schilder, 1589–1644*. 's-Gravenhage: Martinus Nijhoff, 1909.

Bremmer, Jan, and Herman Roodenburg, eds. *A Cultural History of Gesture.* Cambridge: Polity Press, 1991.

Brewer, John, and Roy Porter, eds. *Consumption and the World of Goods.* London and New York: Routledge, 1993.

Broos, Ben, ed. *Great Dutch Paintings from America.* Zwolle: Waanders Publishers, 1990.

Brown, Christopher. *Scenes of Everyday Life: Dutch Genre Paintings in the Seventeenth Century.* London: Faber and Faber, 1984.

Brown, Christopher, Jan Kelch, and Pieter van Thiel, eds. *Rembrandt: The Master and his Workshop.* New Haven and London: Yale University Press, 1991.

Brown, Jonathan. *Kings & Connoisseurs: Collecting Art in Seventeenth-Century Europe.* New Haven and London: Yale University Press, 1995.

Brown, Patricia Fortini. *The Renaissance in Venice.* London: George Weidenfeld & Nicolson, 1997.

Brown, Peter. *The Body and Society: Men, Women and Sexual Renunciation in Early Christianity.* Boston: Faber and Faber, 1986.

Bruggeman, M., and others. *Mensen van de nieuwe tijd: Een Liber amicorum voor A. Th. van Deursen.* Amsterdam: Bert Bakker, 1996.

Bruyn, J. "Toward a Scriptural Reading of Seventeenth-Century Dutch Landscape Paintings." In *Masters of 17th-Century Dutch Landscape Painting,* edited by Peter C. Sutton. Boston: Museum of Fine Arts, 1987.

—, and others. *A Corpus of Rembrandt Paintings,* vol. 1. The Hague: Martinus Nijhoff, 1982.

Burema, Lambertus. *De voeding in Nederland van de Middeleeuwen tot de twintigste eeuw.* Assen: van Gorcum, 1953.

Burke, Peter. "The Language of Order in Early Modern Europe." In *Social Orders and Social Classes in Europe since 1550:*

Studies in Social Stratification, edited by M. L. Bush. London: Longman, 1992.

Burke, Thomas E., Jr. *Mohawk Frontier: The Dutch Community in Schenectady, New York, 1661–1710.* Ithaca: Cornell University Press, 1991.

Bush, M. L., ed. *Social Orders and Social Classes in Europe since 1500: Studies in Social Stratification.* London: Longman, 1992.

Buss, David M. *The Evolution of Desire: Strategies of Human Mating.* New York: Basic Books, 1994.

Bynum, Caroline Walker. *Fragmentation and Redemption: Essays on Gender and the Human Body in Medieval Religion.* New York: Zone Books, 1991.

Bystryn, Marcia. "Art Galleries as Gatekeepers: The Case of the Abstract Expressionists." *Social Research* 45 (Summer 1978): 392–408.

Carlson, Marybeth. "A Trojan Horse of Worldliness? Maidservants in the Burgher Household in Rotterdam at the End of the Seventeenth Century." In *Women of the Golden Age: An International Debate on Women in Seventeenth-Century Holland, England and Italy,* edited by Els Kloek, Nicole Teeuwen, and Marijke Huisman. Hilversum: Verloren, 1994.

Carrier, David. "Art History." In *Critical Terms for Art History,* edited by Robert S. Nelson and Richard Shiff. Chicago: University of Chicago Press, 1996.

Chapman, H. Perry. "Home and the Display of Privacy." In *Art & Home: Dutch Interiors in the Age of Rembrandt,* edited by Mariët Westermann. Zwolle: Waanders, 2001.

—, Wouter Th. Kloek, and Arthur K. Wheelock, Jr., eds. *Jan Steen, Painter and Storyteller.* Washington, DC: National Gallery of Art, 1996.

Chong, Alan. "The Market for Landscape Paintings in Seventeenth-Century Holland." In *Masters of 17th-Century Dutch Landscape Painting,* edited by

Peter C. Sutton. Boston: Museum of Fine Arts, 1987.

Citroen, K. A., F. van Erpers Royaards, and J. Verbeek. *Meesterwerken in zilver, Amsterdams zilver, 1520–1820.* Lochem: Uitgeversmaatschappij de Tijdstroom, 1984.

Clark, Kenneth. *The Nude: A Study in Ideal Form.* Garden City, NY: Doubleday, 1956.

Cole, Bruce. *The Renaissance Artist at Work.* New York: Harper & Row, 1983.

Comar, Philippe. *The Human Body: Images and Emotion.* London: Thames and Hudson, 1999.

Coser, Lewis A., Charles Kadushin, and Walter W. Powell. *Books: The Culture and Commerce of Publishing.* New York: Basic Books, 1982.

Csikszentmihalyi, Mihaly, and Rick E. Robinson, *The Art of Seeing: An Interpretation of the Aesthetic Encounter.* Malibu: Getty Museum, 1990.

Damsma, Dirk. *Het Hollandse huisgezin (1560–heden).* Utrecht and Antwerp, 1993.

Davids, Karel, and Jan Lucassen, eds. *A Miracle Mirrored: The Dutch Republic in European Perspective.* Cambridge: Cambridge University Press, 1995.

Davis, Stephen, ed. *Art and its Messages: Meaning, Morality, and Society.* University Park: Pennsylvania State University Press, 1997.

Dekker, Rudolf. "Maid Servants in the Dutch Republic: Sources and Comparative Perspectives." In *Women of the Golden Age: An International Debate on Women in Seventeenth-Century Holland, England and Italy,* edited by Els Kloek, Nicole Teeuwen, and Marijke Huisman. Hilversum: Verloren, 1994.

—. *Uit de schaduw in 't grote licht: Kinderen in egodocumenten van de Gouden Eeuw tot de romantiek.* Amsterdam: Wereldbibliotheek, 1995.

—. *Lachen in de Gouden Eeuw: Een geschiedenis van de Nederlandse humor.* Amsterdam: Wereldbibliotheek, 1997.

—, and Lotte C. van de Pol. *The Tradition of Female Transvestism in Early Modern Europe.* London: Macmillan, 1989.

Deursen, A. Th. van. *Plain Lives in a Golden Age: Popular Culture, Religion and Society in Seventeenth-Century Holland.* Cambridge: Cambridge University Press, 1991 [1991a].

—. "Rembrandt and his Age: The Life of an Amsterdam Burgher." In *Rembrandt: The Master and his Workshop,* edited by Christopher Brown, Jan Kelch, and Pieter van Thiel. New Haven and London: Yale University Press, 1991 [1991b].

Dibbits, Hester C. "Between Society and Family Values: The Linen Cupboard in Early-Modern Households." In *Private Domain, Public Inquiry: Families and Life-Styles in the Netherlands and Europe, 1550 to the Present,* edited by Anton Schuurman and Pieter Spierenburg. Hilversum: Verloren, 1996.

—. *Vertrouwd bezit: Materiële cultuur in Doesburg en Maasluis, 1650–1800.* Nijmegen: SUN, 2001 (doctoral dissertation, Universiteit van Amsterdam, 1998).

Diederiks, H. "Arm en rijk in Amsterdam: Wonen naar welstand in de 16e–18e eeuws." In *Amsterdam in Kaarten,* edited by W. F. Heinemeijer and others. Ede: Zomer & Keuning, 1987.

Dillen, J. G. van. "Omvang en samenstelling van de bevolking van Amsterdam in de 17de en 18de eeuw." In *Bevolking en taal in Amsterdam in het verleden,* edited by J. G. van Dillen and J. Daan. Amsterdam: Noord-Hollandse Uitgevers, 1954.

—. *Van rijkdom en regenten: Handboek tot de economische en sociale geschiedenis van Nederland tijdens de Republiek.* 's-Gravenhage: Martinus Nijhoff, 1970.

DiMaggio, Paul J. "The Museum and the Public." In *The Economics of Art Museums,* edited by Martin Felstein. Chicago: University of Chicago Press, 1991.

Doorninck, Marieke, and Erika Kuijpers. *De geschoolde stad: Onderwijs in Ams-*

terdam in de Gouden Eeuw. Amsterdam: Historisch Seminarium van de Universiteit van Amsterdam, 1993.

Dudok van Heel, S. A. C. "De Rembrandts in de Verzameling 'Hinloopen.' " *Amstelodamum* (1969): 233–37 [1969a].

—. "Het maecenaat De Graeff en Rembrandt." *Maandblad Amstelodamum* 56 (1969): 150–55 [1969b].

—. "Honderdvijftig advertenties van kunstverkopingen uit veertig jaargangen van de Amsterdamsche Courant (1672–1711)." *Jaarboek Amstelodamum* 69 (1977): 107–23 [1977a].

—. "Jan Pietersz Zomer (1641–1724): Makelaar in schilderijen (1690–1724)." *Jaarboek Amstelodamum* 69 (1977): 89–106 [1977b].

—. "Amsterdam burgemeesters zonder stamboom." *De Zeventiende Eeuw* 6 (1990): 144–51.

—. "Rembrandt van Rijn (1606–1660): A Changing Portrait of the Artist." In *Rembrandt: The Master and his Workshop*, edited by Christopher Brown, Jan Kelch, and Pieter van Thiel. New Haven and London: Yale University Press, 1991.

—. "Regent Families and Urban Development in Amsterdam." In *Rome, Amsterdam: Two Growing Cities in Seventeenth-Century Europe*, edited by Peter van Kessel and Elisja Schulte. Amsterdam: Amsterdam University Press, 1997.

—. "Duizend gulden voor een Portretopdracht aan Bartolomeus van der Helst." *Amstelodamum* 85 (1998): 33–40.

Eeghen, I. H. van. "Het Amsterdamse Sint Lucasgilde in de 17de eeuw." *Jaarboek Amstelodamum* 61 (1969): 65–102 [1969a].

—. "Uitdraagsters 't zij man of vrouw." *Maandblad Amstelodamum* 56 (1969): 102–10 [1969b].

—. "Anna Wijmer en Jan Six." *Jaarboek Amstelodamum* (1984): 33–69.

—. "Haes Paradij en de uitdraagsters." *Vrouwenlevens 1500–1800: 8e Jaarboek voor vrouwengeschiedenis*. Nijmegen, 1987.

Eijnatten, Joris van. *God, Nederland en Oranje: Dutch Calvinism and the Search for the Social Centre.* Kampen: Kok, 1993.

Egmond, Florike. *Underworlds: Organized Crime in the Netherlands.* Cambridge: Polity Press, 1993.

Elias, Johan E. *De vroedschap van Amsterdam.* 2 vols. Amsterdam: Israel, 1903–05.

Elkins, James. *Pictures and Tears.* New York and London: Routledge, 2001.

Elsner, Jas. *Art and the Roman Viewer: The Transformation of Art from the Pagan World to Christianity.* Cambridge: Cambridge University Press, 1995.

Emde Boas, Coen van. *Geschiedenis van de sexuele normen: Oudheid–middeleeuwen–17de eeuw.* Antwerp: Nederlandsche Boekhandel, 1985.

Eymers, Johanna Geertruida. *Fundamental Principles for the Illuminating of a Picture Gallery, together with their Application to the Illumination of the Municipal Museum at The Hague.* 's-Gravenhage: Martinus Nijhoff, 1935.

Fabend, Firth Haring. *A Dutch Family in the Middle Colonies, 1669–1800.* New Brunswick: Rutgers University Press, 1991.

Faber, Sjoerd. "Crime and Punishment in Amsterdam." In *Rome, Amsterdam: Two Growing Cities in Seventeenth-Century Europe*, edited by Peter van Kessel and Elisja Schulte. Amsterdam: Amsterdam University Press, 1997.

Feagin, Susan L. "Paintings and their Places." In *Art and its Messages: Meaning, Morality, and Society*, edited by Stephen Davis. University Park: Pennsylvania State University Press, 1997.

Felstein, Martin, ed. *The Economics of Art Museums.* Chicago: University of Chicago Press, 1991.

Findlen, Paula. "Humanism, Politics and Pornography in Renaissance Italy." In *The Invention of Pornography: Obscenity and the Origins of Modernity, 1500–1800*, edited by Lynn Hunt. New York: Zone Books, 1993.

Fisher, Helen E. *Anatomy of Love: The Natural History of Monogamy, Adultery, and Divorce*. New York: Norton, 1992.

Fletcher, J. M. "Patronage in Venice." In *The Genius of Venice: 1500–1600*, edited by Jane Martineau and Charles Hope. London: Weidenfeld and Nicolson, 1983.

Floud, Roderick, Kenneth Wachter, and Annabel Gregory. *Height, Health and History: Nutritional Status in the United Kingdom, 1750–1980*. Cambridge: Cambridge University Press, 1990.

Fock, C. W. "Kunstbezit in Leiden in de 17e eeuw." In *Het Rapenburg, geschiedenis van een Leidse gracht*, edited by Th. H. Lunsingh Scheurleer, C. Willemijn Fock, and A. J. van Dissel. 6 vols. Leiden: Rijksuniversiteit Leiden, Afdeling Geschiedenis van de Kunstnijverheid, 1983–91.

—. "Wonen aan het Leidse Rapenburg door de eeuwen heen." In *Wonen in het verleden*, edited by P. M. M. Klep and others. Amsterdam: Neha, 1987.

—. "Werkelijkheid of schijn: Het beeld van het Hollands interieur in de zeventiende-eeuwse genreschilderkunst." *Oud Holland* 112 (1998): 187–246.

—. "Semblance or Reality? The Domestic Interior of Seventeenth-Century Genre Paintings." In *Art & Home: Dutch Interiors in the Age of Rembrandt*, edited by Mariët Westermann. Zwolle: Waanders Publishers, 2001.

Fortgens, H. W. *Schola Latina*. Zwolle: N. V. Uitgevers-Mij, 1958.

Fout, John C., ed. *Forbidden History: The State, Society, and the Regulation of Sexuality in Modern Europe*. Chicago: University of Chicago Press, 1992.

Franits, Wayne. *Paragons of Virtue: Women and Domesticity in Seventeenth-Century Dutch Art*. Cambridge: Cambridge University Press, 1993.

—, ed. *Looking at Seventeenth-Century Dutch Art: Realism Reconsidered*. Cambridge: Cambridge University Press, 1997.

—. "René van Stipriaan's Concept of the Ludic in Seventeenth-Century Dutch Farces and its Application to Contemporary Dutch Painting." *De Zeventiende Eeuw* 15 (1999): 24–33

Franken, Martinus Antonius Maria. *Coenraad van Beuningen's politieke en diplomatieke activiteiten in de jaren 1667–1684*. Groningen: J. B. Wolters, 1966.

Freedberg, David. *The Power of Images: Studies in the History and Theory of Response*. Chicago: University of Chicago Press, 1989.

—, and Jan de Vries, eds. *Art in History/History in Art*. Santa Monica: Getty Center for the History of the Humanities, 1991.

Gaastra, Femme. *Bewind en beleid bij de VOC, 1672–1702*. Zutphen: Walburg Pers, 1989.

Gaskell, Ivan. *Vermeer's Wager: Speculations on Art History, Theory and Art Museums*. London: Reaktion Books, 2000.

Geary, David C. *Male, Female: The Evolution of Human Sex Differences*. Washington, DC: American Psychological Association, 1998.

Gemert, Lisa van. "The Power of the Weaker Vessels: Simon Schama and Johan van Beverwijck on Women." In *Women of the Golden Age: An International Debate on Women in Seventeenth-Century Holland, England and Italy*, edited by Els Kloek, Nicole Teeuwen, and Marijke Huisman. Hilversum: Verloren, 1994.

Gibson-Wood, Carol. *Studies in the Theory of Connoisseurship from Vasari to Morelli*. New York and London: Garland, 1988.

Gijswijt-Hofstra, Marijke, and Florike Egmond, eds. *Of bidden helpt? Tegenslag en cultuur in West-Europa, circa 1500–2000*. Amsterdam: Amsterdam University Press, 1997.

Gleeson, Janet. *The Arcanum: The Extraordinary True Story of the Invention of European Porcelain*. London: Bantam Press, 1998.

Goldthwaite, Richard A. *Wealth and the Demand for Art in Italy, 1300–1600.* Baltimore: Johns Hopkins University Press, 1993.

Gombrich, E. H. *The Sense of Order: A Study in the Psychology of Decorative Art.* Oxford: Phaidon, 1979.

—. *The Uses of Images: Studies in the Social Functions of Art and Visual Communication.* London: Phaidon, 1999.

Goodfriend, Joyce D. *Before the Melting Pot: Society and Culture in Colonial New York City, 1664–1730.* Princeton: Princeton University Press, 1992.

Goodman, Nelson. *Languages of Art: An Approach to a Theory of Symbols.* Oxford: Oxford University Press, 1969.

Gouwens, Kenneth. "Perceiving the Past: Renaissance Humanism after the 'Cognitive Turn,'" *American Historical Review* 103 (February 1998): 55–82.

Grafton, Anthony. *New Worlds, Ancient Texts: The Power of Tradition and the Shock of Discovery.* Cambridge: Harvard University Press, 1972.

—. "Civic Humanism and Scientific Scholarship at Leiden." In *The University and the City: From Medieval Origins to the Present,* edited by Thomas Bender. New York: Oxford University Press, 1988.

Graham, Elspeth, and others. *Writings by Seventeenth-Century Englishwomen.* London: Routledge, 1989.

Groenhuis, Gerrit. *De predikanten: De sociale positie van de gereformeerde predikanten in de Republiek der Verenigde Nederlanden voor 1700.* Groningen: Wolters-Noordhoff, 1977.

Guillaumin, Emile. *The Life of a Simple Man.* Hanover: University Press of New England, 1983 (originally published as *La Vie d'un simple,* 1904).

Haak, B. *Hollandse schilders in de Gouden Eeuw.* Amsterdam: Meulenhoff, 1984.

Haan, Jannes de. "The Greatness and Difficulty of the Work." In *The Canals of Amsterdam,* edited by Paul Spies and others. The Hague: SDU Uitgeverij Koninginnegracht, 1993.

Haks, Donald. *Huwelijk en gezin in Holland in de 17de en 18de eeuw.* Utrecht: HES, 1985.

—. "Libertinisme en Nederlands verhalend proza 1650–1700." In *Soete minne en helsche boosheit: Seksuele voorstellingen in Nederland, 1300–1850,* edited by Gert Hekma and Herman Roodenburg. Nijmegen: SUN, 1988.

—. "Family Structure and Relationship Patterns in Amsterdam." In *Rome, Amsterdam: Two Growing Cities in Seventeenth-Century Europe,* edited by Peter van Kessel and Elisja Schulte. Amsterdam: Amsterdam University Press, 1997.

Hall, James. *A History of Ideas and Images in Italian Art.* London: John Murray, 1983.

Halle, David. *Inside Culture: Art and Class in the American Home.* Chicago: University of Chicago Press, 1993.

Harrisson, Barbara. *Asian Ceramics in the Princessehof.* Leeuwarden: The Princesssehof Museum, 1986.

Hart, Clive, and Kay Stevenson. *Heaven and the Flesh: Imagery of Desire from the Renaissance to the Rococo.* Cambridge: Cambridge University Press, 1995.

Hart, Marjolein C. 't. *The Making of a Bourgeois State: War, Politics, and Finance during the Dutch Revolt.* Manchester: Manchester University Press, 1993.

Hart, S. "Onderzoek naar de samstelling van de bevolking van Amsterdam in de 17e en 18e eeuw, op grond van gegevens over migratie, huwelijk, beroep en alfabetisme," *Geschrift en getal.* Dordrecht: Hollandsche Studien, 1976.

Hartevelt, Margot. "Tussen pracht en praal: Representatieve vertrekken in de woningen van welvarende Amsterdammers gedurende de periode 1600–1750." Doctoraalscriptie Geschiedenis, Universiteit van Amsterdam, 1993.

Haskell, Francis. *Rediscoveries in Art: Some Aspects of Taste, Fashion, and Collecting in England and France.* Second edition. Oxford: Phaidon, 1980.

—. "Venetian Sixteenth-Century Painting: The Legacy." In *Patronage in the Renaissance*, edited by Guy Fitch Lytle and Stephen Orgel. Princeton: Princeton University Press, 1981.

—. *History and its Images: Art and the Interpretation of the Past*. London and New Haven: Yale University Press, 1993.

Haskins, Susan. *Mary Magdalen: Myth and Metaphor*. London: HarperCollins, 1993.

Hecht, Peter. "Dutch Seventeenth-Century Genre Paintings: A Reassessment of some Current Hypotheses." *Simiolus* 21 (1992): 85–95.

Heijden, Manon van der. "Secular and Ecclesiastical Marriage Control: Rotterdam, 1550–1700." In *Private Domain, Public Inquiry: Families and Life-Styles in the Netherlands and Europe, 1550 to the Present*, edited by Anton Schuurman and Pieter Spierenburg. Hilversum: Verloren, 1996.

—. *Huwelijk in Holland: Stedelijke rechtspraak en kerkelijke tucht, 1500–1700*. Amsterdam: Bert Bakker, 1998.

Heinemeijer, W. F., and others. *Amsterdam in kaarten*. Ede: Zomer & Keuning, 1987.

Hekma, Gert, and Herman Roodenburg, eds. *Soete minne en helsche boosheit: Seksuele voorstellingen in Nederland, 1300–1850*. Nijmegen: SUN, 1988.

—, and others. *Goed verkeerd: Een geschiedenis van homoseksuele mannen en lesbische vrouwen in Nederland*. Amsterdam: Meulenhoff, 1989.

—, Lorelies Kraakman, and Willem Melching, eds. *Balans & perspectief van de Nederlandse cultuurgeschiedenis: Grensgeschillen in de seks*. Amsterdam: Rodopi, 1990.

Held, Julius. "Rubens and Titian." In *Titian: His World and his Legacy*, edited by David Rostand. New York: Columbia University Press, 1982.

Hell, Maarten. "Een 'profitabel' ambt: Het inkomen van de schouten tijdens de Republiek." *Amstelodamum* 84 (1997): 137–48.

Henderson, Katherine Usher, and Barbara F. McManus. *Half Humankind: Contexts and Texts of the Controversy about Women in England, 1540–1640*. Urbana: University of Illinois Press, 1985.

Hollander, Ann. *Moving Pictures*. Cambridge: Harvard University Press, 1991.

Hollander, Martha. *An Entrance for the Eyes: Space & Meaning in Seventeenth-Century Dutch Art*. Berkeley: University of California Press, 2002.

Holly, Michael Ann. *Panofsky and the Foundations of Art History*. Ithaca: Cornell University Press, 1984.

Holmes, Megan. "Disrobing the Virgin." In *Picturing Women in Renaissance and Baroque Italy*, edited by Geraldine A. Johnson and Sara F. Matthews Grieco. Cambridge: Cambridge University Press, 1997.

Honig, Elizabeth Alice. "The Space of Gender in Seventeenth-Century Dutch Painting." In *Looking at Seventeenth-Century Dutch Art*, edited by Wayne Franits. Cambridge: Cambridge University Press, 1997.

Hoogstraeten, Samuel van. *Inleyding tot de hooge schoole der schilderkonst, anders de zichtbaere werelt*. Rotterdam: François van Hoogstraeten, 1678.

Hope, Charles. "Artists, Patrons and Advisers in the Italian Renaissance." In *Patronage in the Renaissance*, edited by Guy Fitch Lytle and Stephen Orgel. Princeton: Princeton University Press, 1981.

—. "'Poesie' and Painted Allegories." In *The Genius of Venice: 1500–1600*, edited by Jane Martineau and Charles Hope. London: Weidenfeld and Nicolson, 1983.

Houbraken, A. *De groote schouburgh der Nederlantsche konstschilders en schilderessen*. 3 vols. Amsterdam, 1718–21; second edition, The Hague, 1753. Facsimile reprint. Amsterdam: B. M. Israel, 1976.

Houston, R. A. *Literacy in Early Modern Europe: Culture and Education, 1500–1800*. London and New York: Longman, 1988.

Hudson, Kenneth. *Museums of Influence.* Cambridge: Cambridge University Press, 1987.

Hufton, Olwen. The *Prospect Before Her: A History of Women in Western Europe, 1500–1800.* London: HarperCollins, 1995.

Huizinga, Johan. *Dutch Civilization in the Seventeenth Century.* London: Collins, 1968 (originally published as *Nederlandse beschaving in de zeventiende eeuw: Een schets,* Haarlem: H.D. Tjeenk Willink & Zoon, 1941).

Humfrey, Peter. *Painting in Renaissance Venice.* New Haven and London: Yale University Press, 1995.

Hunt, Lynn, ed. *The Invention of Pornography: Obscenity and the Origins of Modernity, 1500–1800.* New York: Zone Books, 1993.

Huygens, Constantijn. *Constantijn Huygens: Mijn jeugd,* translated with commentary by C. L. Heesakkers. Amsterdam: Querido, 1987.

Israel, Jonathan. "A Vision of Dutchness." *Times Literary Supplement* (20–26 November 1987): 1267–68.

—. *The Dutch Republic: Its Rise, Greatness, and Fall, 1477–1806.* Oxford: Clarendon Press, 1995.

—. "The Jews of Amsterdam." In *Rome, Amsterdam: Two Growing Cities in Seventeenth-Century Europe,* edited by Peter van Kessel and Elisja Schulte. Amsterdam: Amsterdam University Press, 1997.

Jager, R. de. "Meesters, leerjongens, leertijd: Een analyse van zeventiende-eeuwse Noord-Nederlandse leerling-contracten van kunstschilders, goud- en zilversmeden." *Oud Holland* 104 (1990): 69–111.

Jankowiak, William, ed. *Romantic Passions: A Universal Experience.* New York: Columbia University Press, 1995.

Jansen, Frans. "Een witte satijne mantel met een bonte rand." In *Binnenkamers: Aspecten van stedelijke woon- en leefculturen 1650–1850,* edited by Charles de Mooij and Aart Vos. Zwolle: Waanders Uitgevers, 1999.

Joannides, Paul. *Titian to 1518.* New Haven and London: Yale University Press, 2001.

Jobse-van Putten, Jozien. *Eenvoudig maar voedzaam: Cultuurgeschiedenis van de dagelijkse maaltijd in Nederland.* Nijmegen: SUN, 1995.

Johnson, Geraldine A., and Sara F. Matthews Grieco, eds. *Picturing Women in Renaissance and Baroque Italy.* Cambridge: Cambridge University Press, 1997.

Jones, Pamela M. "The Power of Images: Paintings and Viewers in Caravaggio's Italy." In *Saints and Sinners: Caravaggio & the Baroque Image,* edited by Franco Mormando. Boston: McMullen Museum of Art, 1999.

Jong, Joop de. *Een deftig bestaan: Het dagelijks leven van regenten in de 17de en 18de eeuw.* Utrecht and Antwerp: Uitgeverij Kosmos, 1987.

Jongh, E. de. "Erotica in vogelperspetief: De dubbelzinnigheid van een reeks 17de eeuwse genrevoorstellingen." *Simiolus* 3 (1968–69): 22–74

—. *Portretten van echt en trouw: Huwelijk en gezin in de Nederlandse kunst van de zeventiende eeuw.* Zwolle: Uitgeverij Waanders, 1986.

—. "Some Notes on Interpretation." In *Art in History/History in Art,* edited by David Freedberg and Jan de Vries. Santa Monica: Getty Center for the History of Art and the Humanities, 1991.

—. "Jan Steen, So Near and Yet So Far." In *Jan Steen Painter and Storyteller,* edited by H. Perry Chapman, Wouter Th. Kloek, and Arthur K. Wheelock, Jr. Zwolle: Waanders Publishers, 1996.

—. *Questions of Meaning: Theme and Motif in Dutch Seventeenth-Century Painting.* Leiden: Primavera Pers, 2000.

—. "The Model Woman of Flesh and Blood." In *Rembrandt's Women,* edited by Julia Lloyd Williams. Munich, London, and New York: Prestel, 2001.

Karp, Ivan, Christine Mullen Kreamer, and Steven D. Lavine, eds. *Museums and Communities: The Politics of Public Culture*. Washington, DC: Smithsonian Institution Press, 1992.

Keeble, N. H., ed. *The Cultural Identity of Seventeenth-Century Women: A Reader*. London and New York: Routledge, 1994.

Kelso, Ruth. *Doctrine for the Lady of the Renaissance*. Urbana: University of Illinois Press, 1956.

Kemner, Claus. "In Search of Classical Form: Gerard de Lairesse's *Groot schilderboek* and Seventeenth-Century Dutch Genre Painting." *Simiolus* 26 (1998): 87–115.

Kessel, Peter van, and Elisja Schulte, eds. *Rome, Amsterdam: Two Growing Cities in Seventeenth-Century Europe*. Amsterdam: Amsterdam University Press, 1997.

Kettering, Alison McNeil. *The Dutch Arcadia*. Montclair: Boydell, 1983.

—. "Ter Borch's Ladies in Satin." In *Looking at Seventeenth-Century Dutch Art: Realism Reconsidered*, edited by Wayne Franits. Cambridge: Cambridge University Press, 1997.

Kiers, Judikje, Fieke Tissink, and others. *The Glory of the Golden Age: Dutch Art of the 17th Century, Painting, Sculpture and Decorative Art*. Zwolle: Waanders Publishers, 2000.

Kistemaker, R. E., ed. *Een kind onder het hart: Verloskunde, gezin, seksualiteit en moraal vroeger en nu*. Amsterdam: Meulenhoff, 1987.

Klep, P. M. M. *Wonen in het verleden*. Amsterdam: Neha, 1987.

Kloek, Els. "De vrouw." In *Gestalten van de Gouden Eeuw*, edited by H. M. Beliën, A. Th. van Deursen, and G. H. van Setten. Amsterdam: Bert Bakker, 1995.

—. "Guilds and the Open Market: 17th and 18th Centuries." In *Dictionary of Women Artists*, edited by Delia Gaze, 1, London and Chicago: Fitzroy Dearborn, 1997.

—. "Vrouwen en het kunstenaarsleven van de Republiek: Een inleiding." In *Vrouwen en kunst in de Republiek*, edited by Els Kloek, Catherine Peters Sengers, and Esther Tobé. Hilversum: Verloren, 1998.

—, Nicole Teeuwen, and Marijke Huisman, eds. *Women of the Golden Age: An International Debate on Women in Seventeenth-Century Holland, England and Italy*. Hilversum: Verloren, 1994.

—, Catherine Peters Sengers, and Esther Tobé. "Lexicon van Noord-Nederlandse kunstenaressen, circa 1550–1800." In *Vrouwen en kunst in de Republiek*, edited by Els Kloek, Catherine Peters Sengers, and Esther Tobé. Hilversum: Verloren, 1998.

Koeman, C. *Joan Blaeu and his Grand Atlas*. Amsterdam: Theatrum Orbis Terrarum, 1970.

Kok, A. A. *Amsterdamse woonhuizen*. Amsterdam: De Lange, 1943.

Kok, Jan. "The Moral Nation: Illegitimacy and Bridal Pregnancy in the Netherlands from 1600 to the Present." *Economic and Social History of the Netherlands* 2 (1990): 7–35.

Konst, Jan, and Manfred Sellink. *De grote schouwburg: Schilderbiografieën van Arnold Houbraken*. Amsterdam: Wm Querido's Uitgeverij, 1995.

Kooijmans, Luuc. "De Koopman." In *Gestalten van de Gouden Eeuw*, edited by H. M. Beliën, A. Th. van Deursen, and G. J. van Setten. Amsterdam: Bert Bakker, 1995.

—. *Vriendschap en de kunst van het overleven in de zeventiende en achttiende eeuw*. Amsterdam: Bert Bakker, 1997.

Kopytoff, Igor. "The Cultural Biography of Things: Commoditization as Process." In *The Social Life of Things*, edited by Arjun Appadurai. Cambridge: Cambridge University Press, 1986.

Kraaijpoel, D. "Licht in de huiskamer." *Kunstschrift* 1 (1996): 20–28.

Kraakman, Dorelies, and Gert Hekma. "Inleiding." In *Goed Verkeerd: Een*

geschiedenis van homosexuele mannen en lesbische vrouwen in Nederland, edited by Gert Hekma and others. Amsterdam: Meulenhoff, 1989.

Kuijpers, Erika. "Lezen en schrijven: Onderzoek naar het alfabetiseringsniveau in zeventiende-eeuws Amsterdam." *Tijdschrift voor Sociale Geschiedenis* 23 (1997): 490–522.

Kuiper, E. J. *De Hollandse "Schoolorde" van 1625: Een studie over het onderwijs op de Latijnse Scholen in Nederland in de 17de en 18de eeuw.* Groningen: J. B. Wolters, 1958.

Kuper, Adam. *Culture: The Anthropological Account.* Cambridge: Harvard University Press, 1999.

Lairesse, Gerard de. *Groot schilderboek* [1707]. 2 vols. Haarlem: J. Marshoorn, 1740.

Lakerveld, Carry van, ed. The *Dutch Cityscape in the 17th Century and its Sources.* Amsterdam: Stadsdrukkerij, 1977.

Lamont, Michele, and Marcel Fourniers, eds. *Cultivating Differences: Symbolic Boundaries and the Making of Inequality.* Chicago: University of Chicago Press, 1992.

Lang, Gladys, and Kurt Lang. *Etched in Memory: The Building and Survival of Artistic Reputation.* Chapel Hill: University of North Carolina Press, 1990.

Laqueur, Thomas. *Making Sex: Body and Gender from the Greeks to Freud.* Cambridge: Harvard University Press, 1990.

Laslett, Peter, and Richard Walls, eds. *Household and Family in Past Time.* Cambridge: Cambridge University Press, 1972.

Lavin, Irving, ed. *Meaning in the Visual Arts: Views from the Outside.* Princeton: Princeton University Press, 1995.

Lee, Rensselaer W. *Ut Pictura Poesis: The Humanistic Theory of Painting.* New York: Norton, 1967.

Leemans, Inger. Het Woord is aan de Onderkant: Radicale ideeën in Nederlandse pornografische romans 1670–1700. Nijmegen: Vantilt, 2002.

Leeuwen, Marco H. D. van. "Logic of Charity: Poor Relief in Postindustrial Europe." *Journal of Interdisciplinary History* 23 (Spring 1994): 589–613.

Leonhardt, Gustav. *Het huis Bartolotti en zijn bewoners.* Amsterdam: Meulenhoff, 1970.

Leppert, Richard. *Art and the Committed Eye.* Boulder: Westview Press, 1996.

Lesger, Clé. *Huur en conjunctuur: De woningmarkt in Amsterdam, 1550–1850.* Amsterdam: Historisch Seminarium van de Universiteit van Amsterdam, 1986.

Leuker, Maria-Theresia, and Herman Roodenburg. "'Die van hare wyven laten afweyen': Overspel, eer en schande in de zeventiende eeuw." In *Soete minne en helsche boosheit: Seksuele voorstellingen in Nederland, 1300–1800.* Nijmegen: SUN, 1988.

Levie, Tirtsah, and Henk Zantkuijl. *Wonen in Amsterdam in de 17de en 18de eeuw.* Amsterdam: Amsterdam Historisch Museum, 1980.

Lindeman, Ruud, Yvonne Scherf, and Rudolf Dekker, eds. *Egodocumenten van Noord-Nederlanders van de zestiende tot begin negentiende eeuw: Een chronologische lijst.* Rotterdam: Erasmus Universiteit, 1993.

Llwellyn, Nigel. "Illustrating Ovid." In *Ovid Renewed: Ovidian Influences on Literature and Art from the Middle Ages to the Twentieth Century*, edited by Charles Martindale. Cambridge: Cambridge University Press, 1988.

Loughman, John. *De zichtbare wereld: Schilderkunst uit de Gouden Eeuw in Holland's oudste stad.* Zwolle: Waanders Uitgevers, 1992.

—. "Een stad en haar kunstconsumptie: openbare en prive-verzamelingen in Dordrecht, 1629–1719". In *De Zichtbare Wereld: Schilderkunst uit de Gouden Eeuw in Holland's Oudste Stad*, edited by John Loughman. Zwolle: Waanders Uitgevers, 1992.

—, and John Michael Montias. *Public and Private Space: Works of Art in*

Seventeenth-Century Dutch Homes. Zwolle: Waanders Publishers, 2000.

Lucassen, Jan. *Migrant Labour in Europe, 1600–1900*, translated by Donald A. Bloch. London: Crown Helm, 1987.

—. "Female Migrations to Amsterdam: A Response to Lotte van de Pol." In *Women of the Golden Age: An International Debate on Women in Seventeenth-Century Holland, England and Italy*, edited by Els Kloek, Nicole Teeuwen, and Marijke Huisman. Hilversum: Verloren, 1994.

—. "Labour and Early Economic Development." In *A Mirror Mirrored: The Dutch Republic in European Perspective*, edited by Karel Davids and Jan Lucassen. Cambridge: Cambridge University Press, 1997.

Lucie-Smith, Edward. *The Body: Images of the Nude.* London: Thames & Hudson, 1981.

—. *Sexuality in Western Art.* London: Thames & Hudson, 1995.

Lükte, Alf, ed. *The History of Everyday Life: Reconstructing Historical Experiences and Ways of Life.* Princeton: Princeton University Press, 1995.

Lunsingh Scheurleer, Th. H. *Catalogus van meubelen en betimmeringen.* Amsterdam: Rijksmuseum, 1952.

—, Willemijn Fock, and A. J. van Dissel. *Het Rapenburg: Geschiedenis van een Leidse gracht,* 6 vols. Leiden: Rijksuniversiteit Leiden, Afdeling Geschiedenis van de Kunstnijverheid, 1983–91.

Lytle, Guy Fitch, and Stephen Orgel, eds. *Patronage in the Renaissance.* Princeton: Princeton University Press, 1981.

Malraux, André. The *Voices of Silence,* translated by Stuart Gilbert. Princeton: Princeton University Press, 1990 (originally published 1953).

Mander, Karel van. *Het schilder-boeck.* Haarlem: Voor Paschier van Wesbusch, 1604.

Manuth, Volker. "'As Stark Naked as One Could Possibly Be Painted . . .': The Reputation of the Nude Female Model in the Age of Rembrandt." In *Rembrandt's Women*, edited by Julia Lloyd Williams. Munich, London, and New York: Prestel, 2001.

Mare, Heidi de. "The Domestic Boundary as Ritual Area in Seventeenth-Century Holland." In *Urban Rituals in Italy and the Netherlands*, edited by Heidi de Mare and Anna Vos. Assen: Van Gorcum, 1993.

—. "A Rule Worth Following in Architecture? The Significance of Gender Classification in Steven Stevin's Architectural Treatise (1548–1620)." In *Women of the Golden Age: An International Debate on Women in Seventeenth-Century Holland, England and Italy*, edited by Els Kloek, Nicole Teeuwen, and Marijke Huisman. Hilversum: Verloren, 1994.

Marrow, James H. "Symbol and Meaning in Northern European Art of the Late Middle Ages and the Early Renaissance." *Simiolus* 16 (1986): 150–69.

Marshall, Sherrin. The *Dutch Gentry, 1500–1650: Family, Faith, and Fortune.* New York: Greenwood Press, 1987.

—, "Protestant, Catholic, and Jewish Women in the Early Modern Netherlands." In *Women in Reformation and Counter-Reformation Europe*, edited by Sherrin Marshall. Bloomington: Indiana University Press, 1989.

Martindale, Charles, ed. *Ovid Renewed: Ovidian Influences on Literature and Art from the Middle Ages to the Twentieth Century.* Cambridge: Cambridge University Press, 1988.

Martineau, Jane, and Charles Hope, eds. *The Genius of Venice, 1500–1600.* London: Weidenfeld & Nicolson, 1983.

Marwick, David C. *Beauty in History: Society, Politics and Personal Appearance,* c. *1500 to the Present.* London: Thames and Hudson, 1988.

Mattick, Paul. "Context." In *Critical Terms for Art History*, edited by Robert S. Nelson and Richard Shiff. Chicago: University of Chicago Press, 1996.

Maza, Sarah C. *Servants and Masters in Eighteenth-Century France: The Uses of Loyalty.* Princeton: Princeton University Press, 1983.

McCants, Anne E. C. *Civic Charity in a Golden Age.* Urbana and Chicago: University of Illinois Press, 1997.

—. "The Not-So-Merry Widows of Amsterdam, 1740–1782." *Journal of Family History* 24 (1999): 441–67.

McNeill, Daniel. *The Face.* Boston: Little, Brown, 1998.

Meer, Theo van der. *De wesentlijke sonde van sodomie en andere vuyligheeden: Sodomietenvervolgingen in Amsterdam, 1730–1811.* Amsterdam: Tabula, 1984.

—. "Zodoms zaat in de Republiek: Stedelijke homosexuele subculturen in de achttiende eeuw." In *Soete minne en helsche boosheit: Seksuele voorstellingen in Nederland, 1300–1850,* edited by Gert Hekma and Herman Roodenburg. Nijmegen: SUN, 1988.

—. "Evenals een man zijn vrouw liefkoost: Tribades voor het Amsterdamse gerecht in de achttiende eeuw." In *Goed Verkeerd: Een geschiedenis van homoseksuele mannen en lesbische vrouwen in Nederland,* edited by Gert Hekma and others. Amsterdam: Meulenhoff, 1989.

—. "Tribades on Trial: Female Same-Sex Offenders in Late Eighteenth-Century Amsterdam." In *Forbidden History: The State, Society, and the Regulation of Sexuality in Modern Europe,* edited by John C. Fout. Chicago: University of Chicago Press, 1992.

Meischke, R., and others. *Huizen in Nederland: Amsterdam.* Zwolle: Waanders Uitgevers, no date.

Meiss, Millard. *The Painter's Choice: Problems in the Interpretation of Renaissance Art.* New York: Harper & Row, 1976.

Meyers, Diana Tietjens. *Gender in the Mirror: Cultural Imagery & Women's Agency.* Oxford and New York: Oxford University Press, 2002.

Mijnhardt, Wijnand W. "Politics and Pornography in the Seventeenth- and Eighteenth-Century Dutch Republic." In *The Invention of Pornography: Obscenity and the Origin of Modernity, 1500–1800,* edited by Lynn Hunt. New York: Zone Books, 1993.

Miles, Margaret R. "The Virgin's One Bare Breast: Female Nudity and Religious Meaning in Tuscan Early Renaissance Culture." In *The Female Body in Western Culture,* edited by Susan Rubin Suleiman. Cambridge: Cambridge University Press. 1986.

—. *Carnal Knowing: Female Nakedness and Religious Meaning in the Christian World.* Kent: Burns & Oates, 1992.

Mintz, Sidney W. "The Changing Roles of Food in the Study of Consumption." In *Consumption and the World of Goods,* edited by John Brewer and Roy Porter. London and New York: Routledge, 1993.

Moch, Leslie Page. *Moving Europeans: Migration in Western Europe since 1650.* Bloomington: Indiana University Press, 1992.

Moll, Goswin. *De Desolate Boedelskamer te Amsterdam.* Amsterdam: De Roever-Kröber-Bakels, 1879.

Montague, William. *The Delights of Holland: A Three Months Travel about That and Other Provinces.* London, 1696.

Montaigne, Michael de. "On Physiognomy." In *The Complete Essays,* translated by M. A. Screech. London: Allen Lane, Penguin Press, 1991.

Montias, John Michael. *Artists and Artisans in Delft: A Socio-Economic Study of the Seventeenth Century.* Princeton: Princeton University Press, 1982.

—. *Vermeer and his Milieu: A Web of Social History.* Princeton: Princeton University Press, 1989.

—. "Estimates of the Number of Dutch Masterpieces, their Earnings and their Output in 1650." *Leidschrift* 6 (1990): 59–74.

—. "Works of Art in Seventeenth-Century Amsterdam." In *Art in History/History in Art,* edited by David Freedberg and

Jan de Vries. Santa Monica: Getty Center for the History of Art and the Humanities, 1991.

—. Review of *De wereld binnen handbereik*, edited by Ellinoor Bergvelt and Renée Kistemaker. *Simiolus* 22 (1993–94): 99–105.

—. "Works of Art in a Random Sample of Inventories." In *Economic History and the Arts*, edited by Michael North. Cologne: Böehlau, 1996.

—. "Auction Sales of Works of Art in Amsterdam (1597–1638)." *Nederlands Kunst-Historisch Jaarboek* 51 (2000): 145–61.

Montijn, Illeen. "De tafel, de gang en de vrouw." *Kunstschrift* 40 (1996): 6–11.

Mooij, Charles de, and Aart Vos, eds. *'s-Hertogenbosch binnenkamers: Aspecten van stedelijke woon- en leefculturen, 1650–1850*. Zwolle: Waanders Uitgevers, 1999.

Morgan, David. *Visual Piety: A History of Popular Religious Images*. Berkeley: University of California Press, 1998.

Mormando, Franco. "Teaching the Faithful To Fly: Mary Magdalene and Peter in Baroque Italy." In *Saints and Sinners: Caravaggio & the Baroque Image*, edited by Franco Mormando. Boston: McMullen Museum of Art, 1999.

Muchembled, Robert. "Gestures under the Ancien Régime in France." In *A Cultural History of Gesture*, edited by Jan Bremer and Herman Roodenburg. Cambridge: Polity Press, 1991.

Muinck, B. E. de. *Een Regentenhuis-houding omstreeks 1700*. 's-Gravenhage: Martinus Nijhoff, 1965.

Muizelaar, Klaske, and Ernst van de Wetering, "Kunst in het 17de-eeuwse binnenhuis." *Kunstschrift* 36 (1992): 14–21.

Mulkay, M., and E. Chaplin. "Aesthetics and the Artistic Career: A Study of Anomie in Fine-Art Painting." *Sociological Quarterly* 23 (1982): 117–38.

Mulvey, Laura. *Visual and Other Pleasures*. Bloomington: Indiana University Press, 1989.

Muller, Jeffrey M. *Rubens: The Artist as Collector*. Princeton: Princeton University Press, 1989.

Munck, Victor C. de. *Romantic Love and Sexual Behavior: Perspectives from the Social Sciences*. Westport, Conn.: Praeger, 1998.

Murphy, Caroline P. "Lavinia Fontana and Female Life Cycle Experience in Late Sixteenth-Century Bologna." In *Picturing Women in Renaissance and Baroque Italy*, edited by Geraldine A. Johnson and Sara F. Matthews Grieco. Cambridge: Cambridge University Press, 1997.

Mussacchio, Jacqueline Marie. "Imaginative Conceptions in Renaissance Italy." In *Picturing Women in Renaissance and Baroque Italy*, edited by Geraldine A. Johnson and Sara F. Matthews Grieco. Cambridge: Cambridge University Press, 1997.

Nead, Lydia. *The Female Nude: Art, Obscenity and Sexuality*. London and New York: Routledge, 1992.

Nelson, Robert, and Richard Shiff, eds. *Critical Terms for Art History*. Chicago: University of Chicago Press, 1996.

Nierop, Henk van. "Politics and the People of Amsterdam." In *Rome, Amsterdam: Two Growing Cities in Seventeenth-Century Europe*, edited by Peter van Kessel and Elisja Schulte. Amsterdam: Amsterdam University Press, 1997.

Nierop, Leonie van. "De huizen in het Noortsche Bosch." *Jaarboek Amstelodamum* 34 (1936): 89–125.

Noordam, D. J. "Lust, last en plezier: Vier eeuwen seksualiteit in Nederland." In *Een kind onder het hart: Verloskunde, volksgeloof, gezin, seksualiteit en moraal vroeger en nu*, edited by R. E. Kistemaker. Amsterdam: Meulenhoff, 1987.

Noordegraaf, Leo. *Hollands welvaren? Levensstandaard in Holland 1450–1650*. Bergen: Octavo, 1985.

—. "De arme." In *Gestalten van de Gouden Eeuw*, edited by H. M. Beliën, A. Th.

van Deursen, and G. J. van Setten. Amsterdam: Bert Bakker, 1995.

—, and Jan Luiten van Zanden. "Early Modern Economic Growth and the Standard of Living: Did Labour Benefit from Holland's Golden Age?" In *A Miracle Mirrored: The Dutch Republic in European Perspective*, edited by Karel Davids and Jan Lucassen. Cambridge: Cambridge University Press, 1997.

North, Michael. *Art and Commerce in the Dutch Golden Age*. New Haven and London: Yale University Press, 1997.

—, ed. *Economic History and the Arts*. Cologne: Böehlau, 1996.

Nozick, Robert. *The Examined Life: Philosophical Meditations*. New York: Simon & Schuster, 1989.

Nusteling, Hubert. *Welvaart en werkgelegenheid in Amsterdam, 1540–1860*. Amsterdam: De Bataafsche Leeuw, 1985.

—. "The Population of Amsterdam and the Golden Age." In *Rome, Amsterdam: Two Growing Cities in Seventeenth-Century Europe*, edited by Peter van Kessel and Elisja Schulte. Amsterdam: Amsterdam University Press, 1997.

O'Dea, William T. *The Social History of Lighting*. London: Routledge and Kegan Paul, 1958.

Oldewelt, W. F. H. "De desolate boedelskamer." *Amsterdamse Archiefvondsten*. Amsterdam, 1942.

—. *Kohier van de personeele quotisatie te Amsterdam, 1742*. Amsterdam: Genootschap Amstelodamum, 1945.

—. "Twee eeuwen Amsterdamse faillissementen en het verloop van de conjunctuur." *Tijdschrift voor Geschiedenis* 75 (1962): 421–35.

Olin, Margaret. "Gaze." In *Critical Terms for Art History*, edited by Robert S. Nelson and Richard Shiff. Chicago: University of Chicago Press, 1996.

Oostveen, Gisela van. "It Takes All Sorts To Make a World." In *Women of the Golden Age: An International Debate on Women in Seventeenth-Century Holland, England and Italy*, edited by Els Kloek, Nicole Teeuwen, and Marijke Huisman. Hilversum: Verloren, 1994.

Ottenheym, Koen. *Philips Vingboons (1607–1678), Architect*. Zutphen: De Walburg Pers, 1989.

Ottway, Sheila. *Desiring Disencumbrance: The Representation of Self in Autobiographical Writings by Seventeenth-Century Englishwomen*. Dissertation, Rijksuniversiteit Groningen, 1998.

Ovid. *Metamorphoses*, translated with an introduction by Mary M. Innes. London: Penguin Classics, 1955.

—. *Metamorphoses*, translated with an introduction and notes by Peter Green. London: Penguin Classics, 1982.

Ozment, Steven. *When Fathers Ruled: Family Life in Reformation Europe*. Cambridge: Harvard University Press, 1983.

—. *Flesh and Spirit: Private Life in Early Modern Germany*. New York: Viking, 1999.

Panofsky, Erwin. *The Life and Art of Albrecht Dürer*. Princeton: Princeton University Press, 1945.

—. *Studies in Iconology*. New York: Harper Torchbooks, 1962.

Pasman, Wilrike. *Obesity Treatment and Weight Maintenance*. Dissertation, University of Maastricht, 1998.

Pearce, Susan M., ed. *Interpreting Objects and Collections*. London and New York: Routledge, 1994.

Peeters, Harry, Lène Dresen-Coenders, and Ton Brandenbarg, eds., *Vijf eeuwen gezinsleven: Liefde, huwelijk en opvoeding in Nederland*. Nijmegen: SUN, 1988.

Perin, Constance. "The Communicative Circle: Museums in Communities." In *Museums and Communities: The Politics of Public Culture*, edited by Ivan Karp, Christine Mullen Kreamer, and Steven D. Lavine. Washington, DC: Smithsonian Institution Press, 1991.

Perry, Ruth. "Colonizing the Breast: Sexuality and Maternity in Eighteenth-Century England." In *Forbidden*

History: The State, Society, and the Regulation of Sexuality in Modern Europe, edited by John C. Fout. Chicago: University of Chicago Press, 1992.

Phillips, Derek L. *Wittgenstein and Scientific Knowledge: A Sociological Perspective.* London: Macmillan, 1977.

—. *Toward a Just Social Order.* Princeton: Princeton University Press, 1986.

—. *Looking Backward: A Critical Appraisal of Communitarian Thought.* Princeton: Princeton University Press, 1993.

Plato. *Republic*, translated by P. Shorey. London: Heinemann, 1935.

Plomp, R. *Spring-Driven Pendulum Clocks, 1657–1710.* Schiedam: Interbook International B.V., 1979.

Pluym, W. van der. *Het Nederlandse binnenhuis en zijn meubels, 1450–1650.* Amsterdam: Allert de Lange, 1946.

Pointon, Marcia. *Naked Authority: The Body in Western Painting, 1830–1908.* Cambridge: Cambridge University Press, 1990.

Pol, Lotte van de. "Beeld en werkelijkheid van de prostitutie in de zeventiende eeuw." In *Soete minne en helssche boosheit: Seksuele voorstellingen in Nederland, 1300–1850*, edited by Gert Hekma and Herman Roodenburg. Nijmegen: SUN, 1988 [1988a].

—. "Seksualiteit tussen middeleeuwen en moderne tijd." In *Vijf eeuwen gezinsleven: Liefde, huwelijk en opvoeding in Nederland*, edited by Lène Dresen-Coenders and Ton Brandenbarg. Nijmegen: SUN, 1988 [1988b].

—. "The Lure of the Big City: Female Migration in Amsterdam." In *Women of the Golden Age: An International Debate on Women in Seventeenth-Century Holland, England and Italy*, edited by Els Kloek, Nicole Teeuwen, and Marijke Huisman. Hilversum: Verloren, 1994.

—. *Het Amsterdams hoerdom: Prostitutie in de zeventiende en achttiende eeuw.* Amsterdam: Wereldbibliotheek, 1996.

Pomian, Krzysztof. *Collectors and Curiosities: Paris and Venice, 1500–1800.* Cambridge: Polity Press, 1990.

Potts, Malcolm, and Roger Short. *Ever since Adam and Eve: The Evolution of Human Sexuality.* Cambridge: Cambridge University Press, 1999.

Prak, Maarten Roy. *Gezeten burgers: De elite in een Hollandse stad: Leiden 1700–1850.* Amsterdam: De Bataafsche Leeuw, 1985.

Price, J. L. *Holland and the Dutch Republic in the Seventeenth Century: The Politics of Particularism.* Oxford: Clarendon Press, 1994.

Redford, B. *Venice and the Grand Tour.* New Haven and London: Yale University Press, 1996.

Regin, Deric. *Traders, Artists, Burghers: A Cultural History of Amsterdam in the 17th Century.* Assen: van Gorcum, 1976.

Riding, Alan. "A Dutch Moment of Genius in its Full Glory." *International Herald Tribune* (27 July 2000): 24.

Rink, Oliver A. *Holland on the Hudson: An Economic and Social History of Dutch New York.* Ithaca: Cornell University Press, 1986.

Roberts, Benjamin. *Through the Keyhole: Dutch Child-Rearing Practices in the 17th and 18th Century.* Hilversum: Verloren, 1998.

Rochberg-Halton, Eugene. *Meaning and Modernity: Social Theory in the Pragmatic Tradition.* Chicago: University of Chicago Press, 1986.

Roding, Juliette. *Schoon en net: Hygiene in woning en stad.* 's-Gravenhage: Staatsuitgeverij, 1986.

Roldanus, Cornelia Wilhelmine. *Coenraad van Beuningen: Staatsman en libertijn.* 's-Gravenhage: Martinus Nijhoff, 1931.

Roodenburg, Herman. *Onder censuur.* Hilversum: Verloren, 1990.

—. "How To Sit, Stand, and Walk: Toward a Historical Anthropology of Dutch Paintings and Prints." In *Looking at Seventeenth-Century Dutch Art*, edited by Wayne Franits. Cambridge: Cambridge University Press, 1997.

Rookus, M. A. *Body Mass Index in Young Dutch Adults: Its Development and the Etiology of its Development.* Dissertation, Landbouwhogeschool te Wageningen, 1986.

Rostand, David, ed. *Titian: His World and his Legacy.* New York: Columbia University Press, 1982.

—. *Painting in Sixteenth-Century Venice.* Cambridge: Cambridge University Press, 1997.

Rotberg, Robert I., and Theodore K. Rabb, eds. *Art and History: Images and their Meaning.* Cambridge: Cambridge University Press, 1988.

Rowland, Ingrid D. *The Culture of the High Renaissance: Ancients and Moderns in Sixteenth-Century Rome.* Cambridge: Cambridge University Press, 1988.

Rummel, Erika, ed. *The Erasmus Reader.* Toronto: University of Toronto Press, 1990.

Ruurs, Rob. "Documents." In *Vermeer of Delft*, edited by Albert Blankert. Oxford: Phaidon, 1975.

Santore, Cathy. "The Tools of Venus." *Renaissance Studies* 11 (1997): 179–207.

Schama, Simon. *The Embarrassment of Riches: An Interpretation of Dutch Culture in the Golden Age.* New York: Knopf, 1987.

—. *Rembrandt's Eyes.* London: Penguin Books, 1999.

Schatborn, Peter. *Dutch Figure Drawings from the Seventeenth Century.* The Hague: Government Printing Office, 1981.

Schmidt, Adriadne. *Overleven na de dood: Weduwen in Leiden in de Gouden Eeuw.* Amsterdam: Prometheus/Bert Bakker, 2001.

Schurman, Anna Maria van. *Whether a Christian Woman Should Be Educated and Other Writings from her Intellectual Circle*, edited and translated by Joyce L. Irwin. Chicago: University of Chicago Press, 1998.

Schuurman, Anton, and Pieter Spierenburg, eds. *Private Domain, Public Inquiry: Families and Life-Styles in the Netherlands and Europe, 1550 to the Present.* Hilversum: Verloren, 1996.

Schwartz, Gary. "History as Art." In *Art in History/History in Art*, edited by David Freedberg and Jan de Vries. Santa Monica: Getty Center for the History of Art and the Humanities, 1991.

Scott, James C. *Domination and the Arts of Resistance: Hidden Transcripts.* New Haven and London: Yale University Press, 1990.

Secrest, Meryle. *Being Bernard Berenson.* London: Weidenfeld & Nicolson, 1980.

Seznec, Jean. *The Survival of the Pagan Gods.* Princeton: Princeton University Press, 1972.

Shammas, Carole. *The Pre-Industrial Consumer in England and America.* Oxford: Clarendon Press, 1990.

Shilling, Chris. *The Body and Social Theory.* London: Sage, 1993.

Sluijter, Eric Jan. "Depictions of Mythological Themes." In *Gods, Saints & Heroes: Dutch Painting in the Age of Rembrandt*, edited by Albert Blankert and others. Washington, DC: National Gallery of Art, 1980.

—. "Didactic and Disguised Meanings: Several Seventeenth-Century Texts and the Iconological Approach to Northern Dutch Paintings in this Period." In *Art in History/History in Art*, edited by David Freedberg and Jan de Vries. Santa Monica: Getty Center for the History of Art and the Humanities, 1991.

—. *Seductress of Sight: Studies in Dutch Art of the Golden Age.* Zwolle: Waanders Publishers, 2000.

—. "'Horrible Nature, Incomparable Art': Rembrandt and the Depiction of the Female Nude." In *Rembrandt's Women*, edited by Julia Lloyd Williams. Munich, London, and New York: Prestel, 2001.

Smith, Alison A. "Gender, Ownership, and Domestic Space: Inventories and Family Archives in Renaissance Verona." *Renaissance Studies* 12 (1998): 375–91.

Smith, David. *Masks of Wedlock: Seventeenth-Century Dutch Marriage Portraits.* Ann Arbor: UMI Research Press, 1982.

Smits-Veldt, Mieke B. *Maria Tesselschade: Leven met talent en vriendschap.* Zutphen: Walburg Pers, 1994.

Sneller, Agnes A. "Reading Jacob Cats." In *Women of the Golden Age: An International Debate on Women in Seventeenth-Century Holland, England and Italy*, edited by Els Kloek, Nicole Teeuwen, and Marijke Huisman. Hilversum: Verloren, 1994.

Soltow, Lee. "Annual Inequality through Four Centuries: Conjectures for Amsterdam." Unpublished manuscript, no date.

—. "Income and Wealth Inequality in Amsterdam, 1585–1805." *Economisch-en-Sociaal-Historisch Jaarboek* 52 (1989): 72–95.

—, and Jan Luiten van Zander. *Income and Wealth Inequality in the Netherlands, 16th–20th Century.* Amsterdam: Spinhuis, 1998.

Sommerville, Margaret R. *Sex and Subjection: Attitudes to Women in Early-Modern Society.* London and New York: Arnold, 1995.

Spierenburg, Pieter. *De verbroken betovering, Mentaliteitsgeschiedenis van preindustrieel Europa.* Hilversum: Verloren, 1988.

—. "Knife Fighting and Popular Codes of Honor in Early Modern Amsterdam." In *Men and Violence: Gender, Honor and Rituals in Modern Europe and America*, edited by Pieter Spierenburg. Columbus: Ohio State University Press, 1998.

Spies, Paul, and others. *The Canals of Amsterdam.* The Hague: SU Uitgeverij Koninginnegracht, 1993.

Spight, P. *Het ontstaan van de autobiographie in Nederland.* Amsterdam: van Oorschot, 1985.

Staring, A. *De Hollanders thuis.* The Hague: Nijhoff, 1956.

Starn, Randolph. "Pleasure in the Visual Arts." In *Meaning in the Visual Arts: Views from the Outside*, edited by Irving Lavin. Princeton: Princeton University Press, 1995, pp. 151–62.

Steinberg, Leo. *The Sexuality of Christ in Renaissance Painting and in Modern Oblivion.* New York: Pantheon, 1983.

Stel, J. C. van der. *Drinken, drank en dronkenschap: Vijf eeuwen drankbestrijding en alcoholhulpverlening in Nederland.* Hilversum: Verloren, 1995.

Stoller, Robert J. *Observing the Erotic Imagination.* New Haven and London: Yale University Press, 1988.

Stone, Lawrence. *The Family, Sex and Marriage in England, 1500–1800.* New York: Harper & Row, 1977.

Stone-Ferrier, Linda A. *Images of Textiles: The Weave of Seventeenth-Century Art and Society.* Ann Arbor: UMI Research Press, 1985.

Strauss, Walter L., Marjon van der Meulen, and others. *The Rembrandt Documents.* New York: Abaris Books, 1979.

Suleiman, Susan Rubin, ed. *The Female Body in Western Culture.* Cambridge: Cambridge University Press, 1986.

Summers, David. "Meaning in the Visual Arts as a Humanistic Discipline." In *Meaning in the Visual Arts: Views from the Outside*, edited by Irving Levin. Princeton: Princeton University Press, 1995.

Sutton, Peter. *Masters of Seventeenth-Century Dutch Genre Painting.* Philadelphia: Philadelphia Museum of Art, 1984.

—, ed. *Masters of 17th-Century Dutch Landscape Painting.* Boston: Museum of Fine Arts, 1987.

—. "Recent Patterns of Public and Private Collecting in America." In *Great Dutch Paintings from America*, edited by Ben Broos. Zwolle: Waanders Publishings, 1990.

Talvacchia, Bette. *Taking Positions: On the Erotic in Renaissance Culture.* Princeton: Princeton University Press, 1999.

Thomas, Keith. "The Double Standard." *Journal of the History of Ideas* 20 (1959): 194–95.

Thompson, Roger. *Unfit for Modest Ears: A Study of Pornography, Obscene and Bawdy Works Written or Published in England in the Second Half of the Seventeenth Century*. London: Macmillan, 1979.

Thornton, Peter. *Seventeenth-Century Interior Decoration in England, France and Holland*. New Haven and London: Yale University Press, 1978.

—. *Authentic Decor: The Domestic Interior, 1620–1920*. London: Weidenfeld and Nicolson, 1984.

Tuana, Nancy. *The Less Noble Sex: Scientific, Religious, and Philosophical Conceptions of Woman's Nature*. Bloomington: Indiana University Press, 1993.

Turner, Janet, ed. *The Dictionary of Art*. 34 vols. London: Macmillan, 1996.

Uffenbach, Zacharias Conrad von. *Merkwürdige Reise durch Niedersachsen, Holland und England*. Ulm, 1753.

Vandenbroeck, Paul. "Verbeeck's Peasant Weddings: A Study of Iconography and Social Function." *Simiolus* 14 (1984): 79–121.

—. *Beeld van de andere, vertoog over het zelf: Over wilden en narren, boeien en bedelaars*. Antwerp: Koninklijk Museum voor Schone Kunsten, 1987.

Vasari, Giorgio. *Lives of the Artists*. Harmondsworth: Penguin Books, 1965.

Veen, Henk Th. "Uitzonderlijke verzamelingen." In *De wereld binnen handbereik: Nederlandse kunst- en rariteiten verzamelingen, 1585–1735*, edited by Ellinor Bergvelt and Renée Kistemaker. Zwolle: Waanders Uitgevers, 1992.

Veen, Jaap van der. "Dit klein vertrek bevat een weereld vol gewoel." In *De wereld binnen handbereik: Nederlandse kunst- en rariteiten verzamelingen, 1585–1735*, edited by Ellinor Bergvelt and Renée Kistemaker. Zwolle: Waanders Uitgevers, 1992.

Veldman, Illja M. "Calvinisme en de Beeldende kunst in de zeventiende eeuw." In *Mensen van de nieuwe tijd: Een Liber amicorum voor A. Th. van Deursen*, edited by M. Bruggeman and others. Amsterdam: Bert Bakker, 1996.

Venette, Nicolas. *Venus minzieke gasthuis*. Amsterdam: Timotheus ten Hoorn, 1687.

Verboeket-van de Venne, W. P. H. G., *Pattern of Food Intake, Diet Composition and Human Energy Metabolism: An Experimental Approach*. Dissertation, Rijksuniversiteit Limburg te Maastricht, 1993.

Vickery, Amanda. "Golden Age of Separate Spheres? A Review of the Categories and Chronology of English Women's History." *Historical Review* 36 (1993): 363–414 [1993a].

—. "Women and the World of Goods: A Lancashire Consumer and her Possessions, 1751–81." In *Consumption and the World of Goods*, edited by John Brewer and Roy Porter. London and New York: Routledge, 1993 [1993b].

—. *The Gentleman's Daughter: Women's Lives in Georgian England*. New Haven and London: Yale University Press, 1998.

Visser, Wendy de. "De schildersopleiding van kunstenaressen." In *Vrouwen en kunst in de Republiek*, edited by Els Kloek, Catherine Peters Sengers, and Esther Tobé. Hilversum: Verloren, 1998.

Vrankrijker, A. C. J. de. *Mensen, leven, en werken in de Gouden Eeuw*. 's-Gravenhage: Martinus Nijhoff, 1981.

Vries, Jan de. *European Urbanization, 1500–1800*. London: Methuen, 1984.

—. "Introduction." In *Art in History/History in Art*, edited by David Freedberg and Jan de Vries. Santa Monica: Getty Center for the History of Art and the Humanities, 1991.

—. "Between Purchasing Power and the World of Goods: Understanding the Household Economy in Early Modern Europe." In *Consumption and the World of Goods*, edited by John Brewer and Roy Porter. London and New York: Routledge, 1993.

—, and Ad van der Woude. *The First Modern Economy: Success, Failure, and Perseverance of the Dutch Economy,*

1500–1815. Cambridge: Cambridge University Press, 1997.

Vries, Lyckle de. *Jan van der Heyden*. Amsterdam: Meulenhoff, 1984.

—. "The Changing Face of Realism." In *Art in History/History in Art*, edited by David Freedberg and Jan de Vries. Santa Monica: Getty Center for the History of Art and the Humanities, 1991.

—. *Gerard de Lairesse: An Artist between Stage and Studio*. Amsterdam: Amsterdam University Press, 1998.

Walsh, John. "Skies and Reality in Dutch Landscapes." In *Art in History/History in Art*, edited by David Freedberg and Jan de Vries. Santa Monica: Getty Center for the History of Art and the Humanities, 1991.

Walton, Kendall L. *Mimesis as Make-Believe*. Cambridge: Harvard University Press, 1990.

Weatherhill, Lorna. "The Meaning of Consumer Behavior in Late Seventeenth- and Early Eighteenth-Century England." In *Consumption and the World of Goods*, edited by John Brewer and Roy Porter. London and New York: Routledge, 1993.

Weitz, Rose. *The Politics of Women's Bodies: Sexuality, Appearance, and Behavior*. New York: Oxford University Press, 1998.

Westermann, Mariët. *The Art of the Dutch Republic, 1588–1718*. London: George Weidenfeld and Nicolson, 1996.

—. "'Costly and Curious, Full of Pleasure and Home Contentment': Making Home in the Dutch Republic." In *Art & Home: Dutch Interiors in the Age of Rembrandt*, edited by Mariët Westermann. Zwolle: Waanders Publishers, 2001.

Wetering, Ernst van de. "De schilder." In *Gestalten van de Gouden Eeuw*, edited by H. M. Beliën, A. Th. van Deursen, and G. J. van Setten. Amsterdam: Bert Bakker, 1995.

Wheelock, Arthur K. Jr. *A Collector's Cabinet*. Washington, DC: National Gallery of Art, 1998.

White, David Manning. "The Gatekeeper: A Case Study of the Selection of News." *Journalism Quarterly* 27 (Fall 1950): 338–90.

Wieringen, J. C. *Seculaire groeiverschuiving: Lengte en gewicht surveys 1964–1966 in Nederland in historisch perspectief*. Leiden: Netherlands Institute for Preventive Medicine TNO, 1972.

Wierling, Dorothee. "The History of Everyday Life and Gender Relations: On Historical and Historiographical Relationships." In *The History of Everyday Life: Reconstructing Historical Experiences and Ways of Life*, edited by Alf Lüdtke. Princeton: Princeton University Press, 1995.

Wiesner, Merry E. *Women and Gender in Early Modern Europe*. Cambridge: Cambridge University Press, 1993.

Wijngaarden, Hilde van. "Barber Jacobs en andere uitdraagsters: Werkende vrouwen in Amsterdam in de 16e en 17e eeuw." *Tijdschrift voor Vrouwenstudies* 16 (1995): 334–47.

Wijsenbeek-Olthuis, Thera. *Achter de gevels van Delft*. Hilversum: Verloren, 1987.

—. "Haagse boedels." *Kunstschrift* (1996): 29–35 [1996a].

—. "Noblesse Oblige: Material Culture of the Nobility in Holland." In *Private Domain, Public Inquiry: Families and Life-Styles in the Netherlands and Europe, 1550 to the Present*, edited by Anton Schuurman and Pieter Spierenburg. Hilversum: Verloren, 1996 [1996b].

—. "Ziekte en tegenslag: Ziektebeleving in de hoogste kringen van de Republiek in de zeventiende eeuw." In *Of bidden helpt? Tegenslag en cultuur in Europa, circa 1500–2000*, edited by M. Gijswijt-Hofstra and F. Egmond. Amsterdam: Amsterdam University Press, 1997.

Williams, Julia Lloyd, ed. *Rembrandt's Women*. Munich, London, and New York: Prestel, 2001.

Wingens, Mac. "Jeugdige lichtzinnigheid en losbandigheid, seksueel gedrag en

seksuele beleving van studenten ten tijde van de Nederlandse Republiek." In *Balans & perspectief van de Nederlandse cultuurgeschiedenis: Grensgeschillen in de seks*, edited by Gert Hekma, Dorelies Kraakman, and Willem Melching. Amsterdam: Rodoli, 1990.

Wittkower, Rudolf, and Margot Wittkower. *Born under Saturn: The Character and Conduct of Artists*. New York: Norton, 1969.

Wolff, Janet. *Aesthetics and the Sociology of Art*. London: Allen & Unwin, 1983.

—. *The Social Production of Art*. London: Macmillan, 1993.

Wolfthal, Diane. *Images of Rape: The "Heroic Tradition" and its Alternatives*. Cambridge: Cambridge University Press, 1999.

Worcester, Thomas. "Trent and Beyond: Arts of Transformation." In *Saints and Sinners: Caravaggio & the Baroque Image*, edited by Franco Mormando. Boston: McMullen Museum of Art, 1999.

Woude, Ad van der. "Variations in the Size and Structure of Households in the United Provinces of the Netherlands in the Seventeenth and Eighteenth Centuries." In *Household and Family in the Past*, edited by Peter Laslett and Richard Walls. Cambridge: Cambridge University Press, 1972.

—. "The Volume and Value of Paintings in Holland at the Time of the Dutch Republic." In *Art in History/History in Art*, edited by David Freedberg and Jan de Vries. Santa Monica: Getty Center for the History of Art and the Humanities, 1991.

—, Akira Hayami, and Jan de Vries, eds. *Urbanization in History: A Process of Dynamic Interactions*. Oxford: Clarendon Press, 1990.

Wttewaall, B. W. G. *Nederlands klein zilver, 1650–1880*. Amsterdam: Uitgeverij Allert De Lange, b. v., 1987.

Yalom, Marilyn. *A History of the Breast*. New York: Viking, 1997.

Ydema, Onno. *Carpets and their Datings in Netherlandish Paintings, 1540–1700*. Zutphen: Walburg Press, 1991.

Young, Michael. *The Metronomic Society*. London: Thames and Hudson, 1988.

Zanden, J. L. van der. *The Rise and Decline in Holland's Economy: Merchant Capitalism and the Labor Market*. Manchester: Manchester University Press, 1993.

Zantkuijl, H. J. *Bouwen in Amsterdam: Het woonhuis in de stad*. Amsterdam: Architectura & Natura, 1993.

Zeeuw, J. W. de. "Peat and the Dutch Golden Age: The Historical Meaning of Energy-Attainability," *A. A. G. Bijdragen* 21 (1978): 3–31.

Zolberg, Vera L. "Barrier or Leveler? The Case of the Art Museum." In *Cultivating Differences: Symbolic Boundaries and the Making of Inequality*, edited by Michele Lamont and Marcel Fournier. Chicago: University of Chicago Press, 1992.

Photograph Credits

Index